Micromuseology

Micromuseology

An Analysis of Small Independent Museums

FIONA CANDLIN

Bloomsbury Academic
An imprint of Bloomsbury Publishing Plc

B L O O M S B U R Y
LONDON · OXFORD · NEW YORK · NEW DELHI · SYDNEY

Bloomsbury Academic

An imprint of Bloomsbury Publishing Plc

50 Bedford Square 1385 Broadway
London New York
WC1B 3DP NY 10018
UK USA

www.bloomsbury.com

BLOOMSBURY and the Diana logo are trademarks of Bloomsbury Publishing Plc

First published 2016
Paperback edition first published 2017

British Library Cataloguing-in-Publication Data
A catalogue record for this book is available from the British Library.

ISBN: HB: 978-1-4742-5495-3
PB: 978-1-3500-4010-6
ePDF: 978-1-4742-5498-4
ePub: 978-1-4742-5497-7

Library of Congress Cataloging-in-Publication Data
A catalog record for this book is available from the Library of Congress.

Typeset by Newgen Knowledge Works (P) Ltd., Chennai, India

For Alex Candlin

CONTENTS

ILLUSTRATIONS

Unless otherwise stated, all photographs are copyright of the author and with the kind permission of the museum depicted.

ACKNOWLEDGEMENTS

I am grateful to Birkbeck College for a School of Arts research grant, which allowed me to conduct initial research on micromuseums, and for supporting my work with generous sabbatical leave. I am also indebted to the Leverhulme Trust for a research fellowship that funded more extensive fieldwork and time to finish the book. Several colleagues gave me the opportunity to test run my material. I would like to thank David Howes for inviting me to deliver an early version of 'Open House' at the American Anthropological Association conference in 2011 and for supporting my book proposal; the Centre for Museums, Heritage, and Material Culture Studies at University College London for the invitation to give a seminar on micromuseological methods; Steph Berns for asking me to lecture on the Museum of Witchcraft at 'Encountering the Sacred', a study day at the British Museum in 2013; and the Friends of the Museum of Witchcraft for inviting me to speak at their annual meeting. Yvonne Dröge Wendel included a section of Chapter One in the journal *Open* while Michelle Hennings and Sharon Macdonald published a version of Chapter Two in Volume Four of Blackwells' *International Handbook of Museum Studies*. All these scholars provided constructive comments and editorial advice for which I am grateful.

The kindness of strangers often helped me when I was away from home and travelling between museums. One night I was camping in a Scottish village, far from any shops, when a woman parked her ice-cream van alongside my camper van, produced a much-needed pint of milk for my breakfast, and offered me a free Cornetto. Hungry, tired, and lost somewhere on the outskirts of Portlaoise, I stopped a couple to ask for directions. They invited me into their home, fed me, and then escorted me to a campsite that their friends opened especially for me. These people remain in mind, as do others, particularly the passer-by who directed me to a tiny carpark overlooking a remote beach on the west coast of Donegal. It was one of the most beautiful places that I have ever been and was a perfect place to stay the night. Thank you to everyone who made me cups of tea, pointed me in the right direction, found me somewhere to stay for the night, or otherwise offered assistance.

I would also like to thank the museum proprietors, staff, and volunteers who gave so generously of their time and expertise. I am especially grateful to those who own or work in the museums that I discuss in the chapters to

follow. They include Michael Davis, chairman of the Andrew Logan Museum of Sculpture Trust; Patrick Cook at the Bakelite Museum; Phillip Collins at Barometer World: Jimmy Nelson at the British in India Museum; John and Leonard Grandison at the Cornice Museum of Ornamental Plasterwork; Max and Roman Piekarski at Cuckooland; Diane Clements at the Museum of Freemasonry; Peter MacAskill at the Giant Angus MacAskill Museum; Paul and Hazel Evans at Internal Fire: Museum of Power; Susan Hickey and Johnny at the Irish Republican History Museum; Des Pawson at the Museum of Knots and Sailors' Ropework; Patrick Wildgust and Chris Pearson at Shandy Hall; Val and Pam Ripley at Ty Twt Doll's House and Toy Museum; Paul and Hilary Kennelley at the West Wales Museum of Childhood. In particular I would like to thank the curators who read and gave me feedback on the chapters that concerned their organizations. They are: Gerry and Eilean Wells at the Vintage Wireless Museum; Sandra Coleman, manager of The Valiant Soldier; Graham King at the Museum of Witchcraft; Jim Mclmurray at the Lurgan History Museum; Kathryn Marsden and Jean Marsden at the British in India Museum. They were immensely helpful in pointing out errors, although any misapprehensions remain my own responsibility.

I am also grateful to my colleagues, friends, and family. Jo Morra brought considerable intellectual acuity to bear on the final draft of the book and encouraged me to further develop some of its key ideas. Ray Guins provided an extremely supportive report on my project and later made good teacherly comments on the manuscript. Ben Burt recommended museums which feature here and gave useful feedback on an early version of my introduction. Louise Lambe kept her careful eyes on a complicated research budget and proof-read the manuscript. David Cunningham, Matthew Holder, Simon Hollis, and Marq Smith all suggested useful reading material and ways of conceptualizing the project. Paul Morgans helped with the photography, as did Alex Candlin who also accompanied me on a trip to Welsh micromuseums and was an all-round source of wisdom. Anne Candlin noticed that everything in the British in India Museum had been given, while Joseph, Gregor, Colette, Abigail and Elisha Candlin, Graham Ramsay, and Clara Ursitti all provided hospitality and taxi services when I visited the museums in their local areas. Celitta Butler looked after the cat while I was away, Liz Orton stayed in regular contact when I was travelling in Scotland and Ireland and her phone calls buoyed me up when the weather was bleak, Jo Episcopo gave moral support and very generously lent me her car for three months so that I could travel and complete the photography for the book, and the marvellous Peg Rawes listened to endless stories about small museums without (much) demur. I would also like to thank Kieron Corless, Oona Grimes, Tony Grisoni, Karen Long, and Jordan McKenzie for their support. I am lucky to have such stalwart allies who have been so ready to offer their assistance, food, drink, holidays, distraction, and intellectual challenge as required. Without them, this book would never have been finished.

Micromuseology:
An introduction

During the 1970s and 1980s some 1,600 new museums opened in the United Kingdom.[1] Reflecting upon these fledgling organizations and those being launched across North America and Europe, Kenneth Hudson, founder of the European Museums Forum, remarked that most of them had three traits in common: they were small, which he defined as having less than ten paid members of staff, they were independent, and they concentrated on single subjects or themes that fell outside of the academic disciplines.[2] He noted that whereas traditional institutions had names such as the Montreal Museum of Fine Art, Rochdale Museum, and the National Ethnographical Museum, the emergent organizations were called The Irish Whiskey Corner Museum, The German Carburettor Museum, or the Gas Museum. Overall, Hudson concluded, the change in style 'amounts to a revolution – the word is not an exaggeration – in museum philosophy and its practical application'.[3]

When Hudson remarked on the revolution in 'museums philosophy' he was presumably referring to the ethos of the new organizations and not to their analysis. Although small independent single-subject museums – which I call micromuseums – certainly transformed the sector, they attracted very little scholarly attention. During the 1980s and 1990s commentators who wrote about the burgeoning museum sector either concentrated on the atypically large institutions, such as Ironbridge Gorge, Wigan Pier, and Beamish: Museum of the North, or they considered smaller museums as a cultural phenomena and a symptom of wider social trends.[4] Robert Hewison, for instance, thought that their increasing numbers evinced cultural malaise and Neil Ascherson deemed them a product of Thatcherite policy.[5] The historian Raphael Samuel celebrated micromuseums because he thought they indicated a growing historical consciousness among the populace at large, but he still listed venues rather than investigating them in detail.[6] No one actually examined individual organizations, much less the implications that specific exhibitions might have for the study of museums.

More recently, scholars interested in postcolonial and post-conflict situations have written on small community museums in Africa and Latin America, while a handful of academics have examined modestly sized western museums in relation to community.[7] Although these analyses are thoughtful, the fact that micromuseums are predominantly considered in terms of community can suggest that their importance is restricted to their immediate locale or to a particular kind of group activity and that they have little or nothing to offer wider debates on curation, museum architecture, visitors, interpretation, or ideas of the institution. Discussions on these topics rarely, if ever, include micromuseums of any description and this neglect homogenizes and limits our conceptions of what museums are and might be.[8] As long as commentators continue to concentrate on major foundations, it is easy to assume that all museums are institutions (with the status and longevity that the term implies), that they hold economically and culturally valuable collections, are invariably concerned with conservation and the safe-keeping of objects, and that they maintain standards commensurate with those set by the Museum Association and Arts Council. Similarly, some level of financial support tends to be taken for granted, and because museums that receive public funding are expected to respond to government priorities, a degree of instrumentality on the part of the state.

Conversely, shifting the spotlight from culturally dominant to marginal organizations affords a way of demonstrating the heterogeneity of museums. It shows that museums can be ad hoc do-it-yourself undertakings, family concerns, group enterprises, and business operations as well as large-scale commercial ventures or institutions held in trust. It establishes that curators are not necessarily trained professionals and that knowledgeable staff and creative displays are found outside of established venues. Changing focus also shows that museums do not always provide a public service or that it may be differently conceived; that they are not bound by policy or directed by managerial logic. In turn, revising received notions of museums and how they run offers an opportunity to reconsider dominant debates within museology.

This book, then, is an experiment to see whether the study of micromuseums *can* revolutionize 'museum philosophy' and, if so, how. Less dramatically, would researching the Southport Lawnmower Museum or the National Coracle Museum in Camarthenshire instead of, say, the Louvre or the British Museum, be a way of testing, refining, and expanding the discipline? Would a focus on small museums help generate new perspectives on current debates within museum and heritage studies? Could they enable researchers to reconceive notions of curation, collections, the public, of what it means to visit a museum, and of the knowledge that is generated therein?

Armed with my questions, I enthusiastically embarked upon my project, but as my work progressed I gradually came to realize studying

micromuseums involves a number of logistical, definitional, and methodological challenges, which I detail below. It turned out that other scholars may have had good reasons for eschewing the topic, and so by way of introduction I will outline the various issues concerned, how I have attempted to resolve or circumnavigate the attendant difficulties, and what the study of micromuseums entails.

Travelling abroad

The first set of problems involves finding micromuseums and having the funding and the time to visit them. The Museums Association Yearbook provides the most complete register of museums within the UK but it relies on each organization submitting their own details. The smaller the museum, the less likely it is to do so, and in consequence the majority of micromuseums are not listed in the Yearbook. In the absence of any directory or authoritative source, locating micromuseums entails trawling through popular travelogues and guidebooks, consulting tourist boards, and following word-of-mouth recommendations. Sometimes the sole clue to their existence is provided by a flyer on display in a hotel foyer or at another local tourist attraction (Figure 0.1), so unearthing these venues requires potential researchers to go to the region and look for information.

FIGURE 0.1 *Flyers advertising micromuseums and other local attractions.*

Having established the presence and whereabouts of a given micromuseum, visiting can also be arduous. Although some micromuseums are located in city and town centres, they are more usually on their outskirts of towns and perhaps most commonly in the countryside. They are rarely accessible by public transport and they have limited opening hours. The vast majority of micromuseums are only accessible to visitors during the summer months or in school holidays and even then access may be restricted to certain days. For example, the Museum of Straw Crafts and Basketwork, in Buck Brigg, Norfolk, opens between Easter and the end of October on Wednesdays and Saturdays between 11 a.m. and 4 p.m. (Figure 0.2), while the Violette Szabo Museum in Herefordshire can 'usually' be visited on Wednesdays from April to October. The website of this later Museum reminds visitors that it is shut for lunch and recommends telephoning in advance; advice which is equally applicable elsewhere because family engagements, staff illness, or a shortage of volunteers may result in venues temporarily closing without prior notice. Micromuseums also close permanently without due warning and unwary travellers can be caught out by redundant websites and recorded voice messages that still recite the admission times of defunct organizations.

Visiting micromuseums therefore requires a vehicle, or at least the money for long taxi rides, time, considerable flexibility, and patience. In

FIGURE 0.2 *Signpost outside the Museum of Straw Crafts and Basketwork, Buck Brigg, Norfolk.*

the course of conducting this research I travelled several thousand miles, zigzagged across the UK, and gratefully accepted hospitality from friends and relatives who lived conveniently close to potentially interesting venues. Later, I spent all my research funds on petrol and cheap bed & breakfast accommodation, before finally renting a camper van. Parked up in empty caravan sites with the rain pouring down, waiting for a local famine museum or collection of basketry to open on the morrow, I could certainly understand why my colleagues would choose to conduct archival research or to concentrate on art galleries that were conveniently placed in their cities of residence.

Travelling from place to place within the British Isles and being conscious of the cultural and economic variations within this relatively small landmass, I decided to confine this study to the UK. Although micromuseums can be found in most parts of the world there are significant regional differences in their subject matter. 'Minority museums' are common in the United States but rare in the UK where – to my knowledge – there are two museums of Judaism and two devoted to Romany history.[9] There are also differences as to when they were founded. Raphael Samuel observed that the majority of English museums of rural life and the recent industrial past were established between the late 1960s and late 1980s, while Fath Davis Ruffins notes that American museums of slavery started during the 1980s, Holocaust museums have proliferated since the early 1990s, and that South African community museums have only been established since 1994, when the African National Congress came to power.[10] According to Sharon Macdonald, such differences can be attributed to 'the distinctive development of nation states, their differential patterns of industrialization, urbanization, and social mobility, variable definitions and practices of "citizenship", and to "different levels of centralization or regionalization"'.[11]

Interestingly, in the course of writing this book, presenting my initial work, and seeking publication, a few respondents commented unfavourably on its apparently parochial character. I found this curious, because there are numerous monographs that focus solely on single major institutions or museums based within capital cities, but such studies are assumed to have an international reach. This book, which discusses some sixty museums located over four countries (England, Ireland, Scotland, and Wales), was not considered to have a sufficiently wide remit. Again, the implication is that any interest in small museums is necessarily limited to the local and that their study has no bearing on issues or debates within museum studies and professional practice. In order to clarify, therefore, my aim is to show how the study of these small venues can impact upon the international sphere of museology. This book is intended to bring the apparently 'limited' or 'local' character of micromuseums into question.

Defining micromuseums

The second issue concerns definition and which museums should fall within the scope of my study, or in other words, what a micromuseum is deemed to be. Kenneth Hudson wrote about 'small', 'independent', 'single-subject' 'museums' with relatively little qualification, but issues of clarity, competing forms of categorization, and questions of exclusion are all attendant upon the use of these terms. To begin with, there is no consensus on what counts as a small museum, or for that matter, a 'medium' or 'large' institution. Hudson defined 'small' as having less than ten paid members of staff, whereas the Museums Association UK equates small with fifteen or fewer employees and 'very small' with one or two workers.[12] The Canadian Heritage Information Network classes small museums as those that have two or fewer paid staff and in *Help! For the Small Museum: Handbook of Exhibit Ideas and Methods* Arminta Neal suggests that small museums are 'staffed essentially by volunteers'.[13]

Other organizations designate size according to audience. In a report of 2010 the Association of Independent Museums judged that a small museum attracted a maximum of 10,000 visitors a year, but elsewhere it gives the figure of 20,000.[14] Alternatively, scale is judged according to income. The Small Museums Committee (United States) suggests that a small museum typically has an income of less than $250,000, although it states that other characteristics including its physical size and the scope of its collections should also be taken into account.[15] An early edition of the *Manual of Curatorship* used floorspace as a measure and suggested that 929 square meters should be considered the upper limit for a small organization while, to complicate matters further, a recent study that was sponsored by Unesco defined a small museum as one with less than 5,000 objects.[16]

Generally, these different stipulations match. If museums have a small workforce they tend to have low visitor numbers and can only generate a moderate or tiny income. With meagre financial resources they are more likely to operate out of physically small premises and are unlikely to have a budget for acquisitions. However, there are numerous venues where this degree of concurrence is not found. The Museum of Witchcraft in Boscastle, Cornwall has one full-time and two part-time members of staff and routinely attracts some 50,000 visitors a year. Depending upon the definition employed it is either a small or a large organization. The Ipswich Transport Museum has approximately 2,325 square metres of floorspace (Figure 0.3), but no paid members of staff and it only attracts some 7,000 visitors per year, so it similarly qualifies as both small and large, as does the Hamilton Toy Museum in Callander which occupies a terraced house but holds well over 5,000 objects (Figure 0.4). For the purposes of this study, I could adopt one of the criteria mentioned above but to do so would disqualify organizations that otherwise have many commonalities. I

FIGURE 0.3 *Ipswich Transport Museum. Photograph by Brian Dyes.*

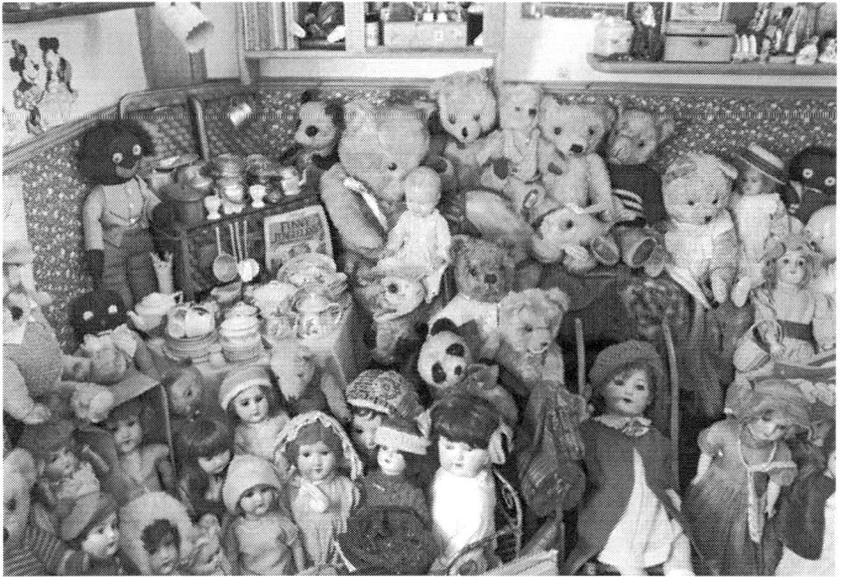

FIGURE 0.4 *Dolls and cuddly toys on display at the Hamilton Toy Museum, Callander, Perthshire.*

therefore understand small museums as operating within a nexus of related conditions, namely, low incomes, few staff, and relatively limited physical space.

Returning to Hudson's characterization of new museums, there are also problems with defining them as being devoted to 'single subjects or themes that fall outside of the academic disciplines'. Several of the museums that Hudson cites, such as those of asparagus and gas, do fall within these traditional disciplinary parameters, but would more usually be positioned as one element within a broader schema. Gas, for instance, is incorporated within museums devoted to natural history and to science and technology. It would therefore be more accurate to describe some micromuseums as being focused on things that are commonly placed in the lower strata of classificatory tables. In addition, the parameters of the disciplines have changed since Hudson was writing and many of the subjects that he mentions, such as sports celebrities and computer games now come within the remit of academic study, indeed given the flexibility of the disciplines almost anything could come within a scholarly orbit.

In some micromuseums, subjects that fall in the furthest reaches of the academic disciplines, such as knots and barometers are treated in a scholarly fashion. Both Des Pawson, the curator of the Museum of Knots and Sailors' Ropework in Ipswich, and Phillip Collins at Barometer World in Merton, Devon, have researched and published on their subject and both present their collections in a relatively academic manner. In other museums, though, the opposite situation obtains and academic subjects of long standing, such as geology, are treated in a manner that could not possibly be described as 'scholarly'. As I will discuss in the chapters that follow, many micromuseums do not adhere to conventions of impartiality, and may prioritize autobiography above factual information, or entertainment above rigour. Thus micromuseums have a non-standardized relationship to academic disciplines. They are devoted to single-subjects that may or may not fall within the compass of contemporary academic disciplines and they may take a scholarly approach to their material, but generally do not.

Confusing the situation somewhat, Hudson included 'personality museums' and collections dedicated to particular themes within the rubric of 'single-subject'. This categorization makes sense because the tight focus on an individual or on a topic parallels the strong emphasis on a particular type of object. At the same time, it can also be misleading because the term 'thematic' is sometimes used to denote a very specific kind of organization. In his list of museum types Steven Conn maintains that 'thematic museums' have three key characteristics. As well as being dedicated to events or to specific ideas, he observes that venues including the National Underground Railroad Freedom Centre in Cincinnati, the Civil Rights Museum in Memphis, and the Holocaust Museum in Washington DC are 'concerned with confronting difficult contemporary dilemmas' and have 'themes rather

than collections'. In the place of objects, Conn adds, they 'use languages and images – in various old-fashioned and newer electronic forms'.[17]

The thematic museums that Conn is referring to are large institutions. In the UK at least, small thematic museums are rarely concerned with difficult issues and are almost invariably packed with objects. There may be text and images but these are in addition to and not instead of the collections, which remain the focus of the displays. Indeed, it would be impossible to write a book on *small* thematic museums that subscribed to Conn's definition because in the course of my research I have only encountered one that vaguely approximates to the description he outlines, that being the Museum of Methodism in central London which communicates much of its message through text and is principally concerned with the egalitarian aspects of that religion.[18] This book thereby uses the term 'thematic' in Kenneth Hudson's more general sense.

The third term in Hudson's description of emergent museums was 'independent' and this particular quality has far-reaching consequences for the status of micromuseums and for my study. Like the designation 'small', the term 'independent' has been variously interpreted. In 1984, the first *Manual of Curatorship* noted that a 'crude definition of independent museums might be those that are not administered directly by any central or local government agency or authority'.[19] The author observed that within this group of organizations 'there is a wide variety of constitutional framework ranging from unincorporated societies and associations to charitable companies'.[20] Four years later, the UK Museums and Galleries Commission on independent museums specified the types of independent museums more clearly. The first three classes comprised of large professionally staffed organizations such as the Ironbridge Gorge Museum; old established independent institutions including the Salisbury and South Wiltshire Museum which dates from 1860; and museums set up by local authorities as an alternative to direct provision. The next three types were small, community-based museums run on an amateur basis; company museums run by firms as a public relations exercise; and finally museums that were privately owned, although the authors of the report also noted that 'some would also include historic houses in the list'.[21] Irrespective of size, history, or form of governance, this classificatory system premised independence on the organization's administrative distance from public bodies.

The notion of independence changed in 1998 when the Museums Association agreed on a new definition of museums. Whereas in 1984, the Museums Association had described a museum as 'an institution which collects, documents, preserves, exhibits and interprets material evidence and associated information for the public benefit', in 1998 they changed the rubric to state that they are 'institutions that collect, safeguard, and make accessible artefacts and specimens, which they hold *in trust* for society'.[22] To 'hold in trust' is a legal term wherein a person or institution has a fiduciary

role, which in this case means that the museum is not the absolute owner of a collection but guards it on behalf of the wider community. In this definition then, the designation 'museum' became tied to public ownership and to a particular form of governance. Museums had to be structured so that collections could not be disposed of, were accountable to trustees or to the public, and were protected in the longer term.[23]

The new definition meant that venues that were owned outright by families, individuals, or businesses, or which operated as for-profit companies no longer counted as museums and the category of independence was only extended to organizations that had 'charitable status or the equivalent'.[24] A few subsequent publications introduced the additional nomenclature of 'private' or 'business' museums, but more generally these non-charitable bodies ceased to be mentioned within professional discourse.[25] Strictly speaking, then, many micromuseums are not independent and, importantly, their study cannot revolutionize museology because they are not officially recognized as museums.

In principle, I could circumvent these particular problems of definition by adhering to the Museum Association's rubric and only focus on organizations that are registered trusts, but at this scale there is little to distinguish them from privately run foundations. For instance, the Cornice Museum of Ornamental Plasterwork, in Peebles, Scotland, is owned by the Grandison family who have been specialists in that field for three generations and is located on their business premises.[26] Like them, the Vintage Wireless Museum in Dulwich, South London, is a family firm, in this case run by father and daughter, and similarly comprises of the goods produced and acquired in the course of the proprietors' working lives. The difference is that, having turned 80, Gerry Wells who owns the Vintage Wireless Museum, became concerned about the future of his collection, specifically the possibility that it would be sold to cover inheritance tax, and so he placed it on a charitable footing. The museum now has an official status but the trustees are his daughter and close friends, and to all extents and purposes it remains a family concern, functioning in an identical way to the Cornice Museum of Ornamental Plasterwork.[27] Separating these organizations on the grounds of governance would therefore overlook the far greater number of characteristics that they have in common.[28]

Alternatively, I could drop the term 'museum' and refer to these privately run organizations as being 'museum-like', a term that is sometimes employed in professional literature.[29] The problem with doing so is that it would misrepresent the proprietors', staff and volunteers' conceptions of what they own or organize, namely, that they are in charge of museums and that they are engaged in the traditional curatorial activities of collecting, storing, arranging, and interpreting objects. Using the nomenclature 'museum-like' also takes major institutions as the standard, and it assumes that they provide a model for practice while micromuseums are pale imitations of such august bodies. (It is akin to calling amateur dramatic

societies 'theatre-like' or neighbourhood choirs 'choir-like'.) As such, the term takes major institutions as the norm when the intention of this project is to bring that supposition into question.

By stipulating that organizations have to adopt particular forms of governance and ownership to qualify as museums, the Museums' Association confines the institution to the official realm. That designation is echoed and reinforced by other bodies such as the Museums Libraries Archives Council and latterly the Arts Council, and it effectively de-legitimates informally run museums, the expertise therein, and the experiences they offer. Such prescriptions disregard the time and labour invested by thousands of volunteers, employees, and owners, and they equally overlook the possibility that museums could take different forms and still make important or innovative contributions to local and national culture.

There is some irony in this situation because the Museums Association strongly advocates for inclusive museums – which are open to everyone and not just the upper and middle classes who historically dominated museum audiences, but they simultaneously disqualify museums that are founded and run by people who do not necessarily belong to an institutional or professional elite. Equally, the association recommends that museums reach out to audiences in all their diversity, actively seek the views of communities, value the contribution they make, and 'uphold the principle of equal opportunities for all'.[30] The ostensible aim of such declarations is to improve public participation in museums, but given that the association does not acknowledge the existence of informally run venues, the rubric only recognizes contributions to officially sanctioned organizations. Participation, it seems, occurs on authorized ground and the agency of those groups or individuals who have founded and manage their own museums is largely unacknowledged.

Democratizing museums potentially requires a double move. As the Museums Association advises, major museums need to acknowledge and represent diverse views. Individual institutions should be open to the populace at large but it is also important to re-evaluate official conceptions of museums, of how they operate, who runs them, and to what purpose: democratization requires that other types of museums are recognized.[31] At stake here is the question of whose knowledge and experience is given credence within professional organizations, in academia, and beyond. If micromuseums are unacknowledged then swathes of cultural practice fall from wider purview and this situation can suggest that areas outside of the capital or major cities have little object-based culture or history that is worth preserving.

For the purposes of this study, then, volunteers, staff, or owners need only declare their collection to be a museum and open their doors to strangers for it to be acknowledged as such. Being open to strangers (rather than just friends and acquaintances) involves a degree of publicity, and with

one exception which I discuss in Chapter Three, all of the micromuseums covered in this book have a sign outside the venue, a leaflet, or a website (in some cases, all three).

Reviewing the issues raised by the question of definition, small, independent, single-subject museums can more precisely be described as: collections that are variously run by trusts, businesses, special interest groups, and private individuals, and are open to the public; that concentrate on types of objects, themes, or individuals, that fall outside of the traditional academic compass, occupy a low level in the hierarchy of traditional academic classificatory tables, or that take a non-scholarly approach to subjects that could be encompassed by academe; and finally, are small insofar as they have relatively low visitor numbers and /or modest incomes and/or occupy a physically limited space. Regularly employing such a detailed definition would rapidly become tedious, so in the spirit of economy, I have elected to call them 'micromuseums'. This nomenclature nods to Raphael Samuel's discussion of 'do-it-yourself curators and mini-museums' since, like 'mini', the prefix 'micro' indicates the museums' size and additionally has the apt connotations of 'focusing on a restricted area'.[32]

This book includes a wide range of micromuseums. The Museum of Witchcraft is perhaps the most financially successful venue that I visited and attracts some 50,000 paying visitors a year. In contrast the Vintage Wireless Museum and the Lurgan History Museum in County Armagh, which concentrates on Irish republicanism, receive about a thousand visitors a year and neither venue charges for admission, indeed the proprietor of the latter venue has ethical objections to charging visitors to see artefacts connected to republicanism. The micromuseums I discuss are also scattered across the UK and address subjects ranging from Freemasonry to diesel engines, and from lifeboats to cuckooclocks.

There is also some variance in the standing, ownership, and management of the micromuseums under discussion. The Valiant Soldier is a community-based venue, while at the time of my initial visit to the Museum of Witchcraft was owned by the curator and was run by him and by paid staff who were unrelated to him. The collection has since come under the auspices of the Museum of British Folklore, which is established as a trust. The Vintage Wireless Museum was established and run by Gerry and Eilean Wells but during the course of this research the collections have similarly been transferred into the hands of a trust. The Dartmoor Prison Museum in Devon stretches the definition of a micromuseum since it is run under the auspices of the Prison Service, while the Lurgan History Museum is an entirely private enterprise, as is the Bakelite Museum, and the British in India Museum. These three were all established by individuals and in the latter two venues are run with the help of family members and volunteers. Only The Valiant Soldier in Buckfastleigh, Devon, and the Andrew Logan Museum of Sculpture in Berriew, Powys, which I discuss in Chapter One are accredited by the Arts Council.

I have not included local history museums in my study. Local history has been largely excluded from the academic discipline of history so they can fit within my definition of a micromuseum on that count, but they are generalist, whereas the other museums under consideration are more tightly focused on a carefully defined subject. I have also chosen not to focus directly on micromuseums run by corporations, such as the Clark's Shoe Museum in Street, Somerset; professional museums, such as the British Optical Association Museum in London; or on guild museums, such as the exquisite Clockmaker's Museum in London Guildhall, although I do mention some of them in passing. These micromuseums are relatively similar in form to major museums (a term I use to include public sector and large independent institutions). They are often reasonably well funded, professionally run, and adhere to commonly held standards of practice. It would be possible to write a book about how such micromuseums could inform museology and they certainly raise interesting questions about the links between museums and branding, capital, and the status of the professions and trades. In this publication, however, I am particularly concerned with the different material forms that museums may take and hence I concentrate on micromuseums that have a more improvised, ad hoc character.

Developing micromuseology

The third and perhaps most difficult challenge in studying micromuseums involves the range of methods that can be employed. Without any authoritative data on the subject, it is impossible to conduct any kind of quantitative analysis or to make any broad claims on the subject. One cannot, say, compare the numbers of toy museums with those devoted to religion, those run by guilds versus those managed by enthusiasts, or examine the geographical distribution of museums that pertain to extant or redundant forms of manufacture.

Micromuseums also resist detailed historical analyses. Unlike major museums, their exhibitions are not routinely discussed in the media and it is rare for them to have archives or even to document their collections in any way. With few or no records pertaining to the holdings or life of the organization, attempting conventional institutional biographies is utterly impractical, as are sociohistorical analyses that consider constructions of meaning or the operations of power at a particular juncture.[33]

Critically analysing professional practice is similarly unproductive since many micromuseums do not attain the most basic standards of collections care, display, or education. Largely operating outside of state-funding systems, micromuseums are primarily reliant on income from ticket sales or any retail outlets they may have, and while a few venues do attract tens of thousands of visitors a year, many micromuseums can only aspire to

such audiences. The Giant Angus MacAskill Museum in Dunvegan on the north coast of the Isle of Skye averages eight visitors a day which amounts to 1,440 over the season, and Barometer World, which is located in a tiny hamlet, attracts 700 or 800 people a year.[34] Low visitor attendance means that museums do not generate a significant income, and operating with tiny budgets, they make do with home-made vitrines, display boards recycled from offices hand-written or typed labels (Figure 0.5), and make-shift facilities (Figure 0.6). Nor can they afford to employ professionals and although there are some notable exceptions, the staff at micromuseums often lack the capacity, skills, money, or inclination to comply with health and safety legislation, to store and display the exhibits in a way that minimizes damage, or to develop interpretation strategies.

Judged within dominant paradigms of good practice, micromuseums do not and cannot provide exemplars. At best, they suggest ways of surviving on scant resources and at worst they illustrate the pitfalls of running a museum with an inadequate income. For commentators who review models of museum practice, highlight innovative institutions, and are committed to improving ethical and educational operations, there is literally nothing to write about. One could, of course, detail the venues' failings with respect to professional standards but these museums are not institutions. They are run by a handful of people, often for no or little economic reward and finding fault with their work would have a very personal tenor. Equally, academics could advocate change but since the curators are not generally

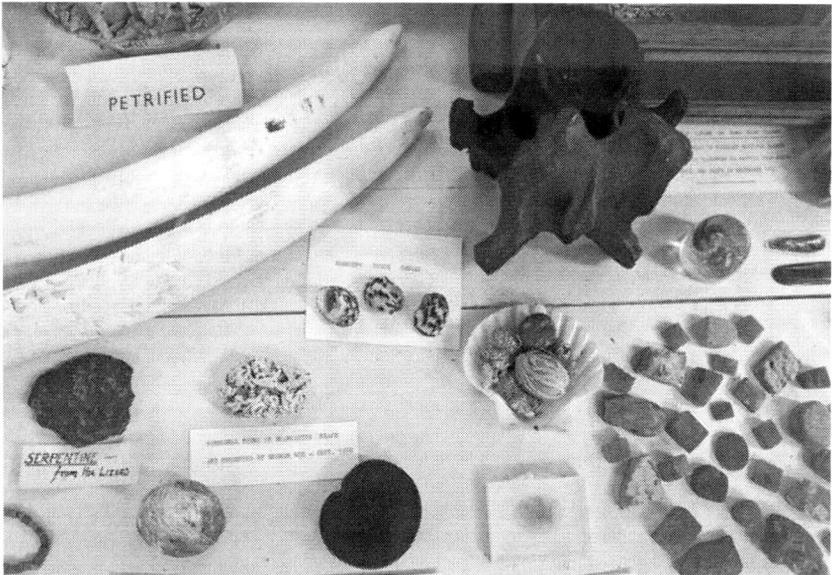

FIGURE 0.5 *Display at the Shell Museum, Glandford, Norfolk.*

FIGURE 0.6 *Colbost Croft, Dunvegan, Isle of Skye.*

in a position to improve their processes, it would also be useless to pursue this avenue of discussion.

Having written on various aspects of museums for over two decades and having used various forms of analysis, I did not expect to be stymied by the issue of how to study micromuseums. This did prove to be the case, however, and it slowly became clear that this research required a method that differed from those offered by mainstream museum studies and that was responsive to the specific characteristics of micromuseums. If, in its literal sense 'museology' means the branch of knowledge dedicated to museums, then my project demanded a means of knowing about micromuseums or, in short, a micromuseology.[35] The question, then, was: what form would this micromuseology take?

Given the difficulties of historical analysis or professional critique, I began by photographing and writing long descriptions of individual micromuseums, paying attention to their setting, accommodation, collections, and forms of display. I considered the landscapes in which they were situated, neighbouring buildings, entrance halls, lighting, signage, and the museum cases as well as the objects on exhibition and the way in which they were arranged. In doing this work it also became clear that I also needed to examine a further topic, that of the staff and of my interactions with them. Popular journalists regularly describe the founders or curators of these venues as 'mad', 'eccentric', or 'quirky' and in *My Search for Britain's Maddest Museum* Hunter Davies declares his intention of seeking

out the original curator or 'guiding spirit' of each mad museum and finding out as much about 'his or her life and associated madnesses, as about their museum's content'.[36] While this approach makes for entertaining reading, it is problematic because it draws an analogy between the supposed mental state of the founder and the apparent oddity of the collections. Doing so obviates the input of other workers. Although the owners may have impelled the foundation of a museum, they usually receive practical help and direction from many other sources including family, friends, paid workers, or volunteers. Other museums were established by a group and had no individual 'creator'. More generally, attributions of eccentricity and madness are made in relation to a set of conventions, which in this case are provided by state-funded or large independent museums. While popular journalism enjoyably celebrates the idiosyncrasy of micromuseums, the terminology does little to bring standard museum practice into question. On the contrary, it reinforces distinctions between major institutions and micromuseums.

In this book I do not attempt to diagnose individual members of staff or position them as the guiding spirits of their museums, instead I am interested in how their presence contributes to and shapes a museum visit. (By 'staff', I mean owners, employees, unpaid family members, and volunteers, any of whom may also be a curator.) In methodological terms, however, their presence presents something of a challenge because it introduces a level of contingency. Depending upon individual members of staff, whether sightseers are greeted on arrival, or taken on a tour, or left to look around by themselves, and on the events of the day, visitors can have a high degree of contact with the curators or none at all.

The identity of the visitor and what they bring to the encounter also has a bearing on the museum visit. I had originally intended to visit micromuseums without declaring my purpose, but I soon discovered that the proprietors often enquire as to your reason for visiting. The reasons for this vary. In some cases it is simply a way of welcoming visitors: the owner of the Laurel and Hardy Museum in Cumbria asks if visitors are fans of the comedians and when they inevitably answer 'Yes', he replies, 'Then I'm sure you're going to love this' or 'Enjoy yourself!' Members of staff may want to know who their visitors are in order to correctly pitch their guided tour and they are often on the alert for fellow enthusiasts with whom they can exchange ideas. When I visited Barometer World, the owner Phillip Collins, asked 'Are you an expert?'

In the course of this research, I was often explicitly asked 'why are you here?' In venues that attract few tourists and where my accent distinguished me from the local residents, the query referred to my presence in that region, while in museums devoted to transport, boats, model railways, and the like, it meant: why was an unaccompanied woman visiting a museum that normally appealed to men or to women who were seeking entertainment for their children. Members of staff also asked about my

personal life and to a lesser extent my work (Are you married? Where do you live? Is the campervan yours? Do you find it easy to drive? Aren't you frightened travelling alone? So you're a doctor? Will we be able to buy a copy of your book?). My status as an academic and author meant that some curators were unusually keen to explain and discuss their museum. They often interpreted my presence and interest as a validation of their enterprise and I was regularly offered tea and cake, lunch, or even a bed for the night. At other times, my career disinclined staff to talk or meant that I was a less interesting prospect than a fellow enthusiast. Conversation might be peremptory and, when I was the sole visitor, I was told exactly how long I could stay. After all, staff have numerous duties, often another job entirely, and are under no obligation to spend hours explaining the collections unless they so choose.

These conversations are distinct from the semi-structured interviews that more usually form the basis of academic studies. I did not plan the conversations that I had with staff and visitors; instead they emerged out of those meetings and were regularly instigated by others. When I went to the Museum of Straw Crafts and Basketwork there were three other visitors who immediately recognized the proprietor as a fellow believer in spiritualism. In consequence, the tour of the collections not only encompassed an explanation of basketry but also a discussion that ranged over family histories, experiences of psychic healing, and the presence of angels. These conversations may be tangential to the displays as such but nonetheless it is important to attend to such interactions because they are one of the key ways that information is circulated and the artefacts are understood. To ignore the spoken exchanges that occur in micromuseums and concentrate on the more conventional forms of exhibition interpretation, such as wall-texts, could easily lead researchers to assume that very little information was disseminated and nothing could be learned from such visits when the opposite situation may well be true.

Since the length and nature of a visit to a micromuseum depends on what visitors bring to the encounter, the presence of other spectators, the curator's disposition, their commitments, and the occurrences of that day, I have included all these elements within my descriptions. Rather than just concentrating on the exhibitions or indeed the site, I treat museum visits as events that include various individuals and spoken exchanges as well as objects, displays, and buildings. Reporting on this material involves mentioning my own contributions to a conversation and my reactions to places or to a situation. At times I cite visitors' books, online resources, or guidebooks to show that there is a generic or common reaction to a venue, and elsewhere write in the first person in order to indicate that my comments refer to a particular set of circumstances.[37]

Having generated a great deal of descriptive material about the settings of numerous micromuseums, their buildings, curatorial style, labelling, ambience, and interactions with staff, and having considered what those

assemblages do in specific circumstances, I faced the question of their import. Within academia there is a well-established practice of producing detailed reviews of major museums but the force of this writing often relies upon the status of the institution concerned. Every year, several million people will see the exhibitions at the National Gallery or at the Science Museum and the associated websites, publications, and educational material garner an even wider audience. Whether or not commentators make the point explicit, these institutions are worth addressing because they have a high degree of public impact and occupy a position of cultural authority. With audiences in the hundreds or low thousands and little or no official standing, it is hard to argue that individual micromuseums are worth comparable scrutiny, unless, that is, their description informs the analysis of museums and wider cultural issues.

The problem is that discussing micromuseums in relation to scholarly debates also requires some care. Only an unwitting (or extremely wry) scholar would explicate the displays at Cuckooland in Cheshire via Jacques Derrida's concept of the frame or detail notions of subjectivity through an examination of the Baked Bean Museum of Excellence in Port Talbot (Figure 0.7), although both theses are entirely feasible. Placing micromuseums in such scholarly discourses could suggest that I was mocking the theoretical models concerned or that I had entirely missed

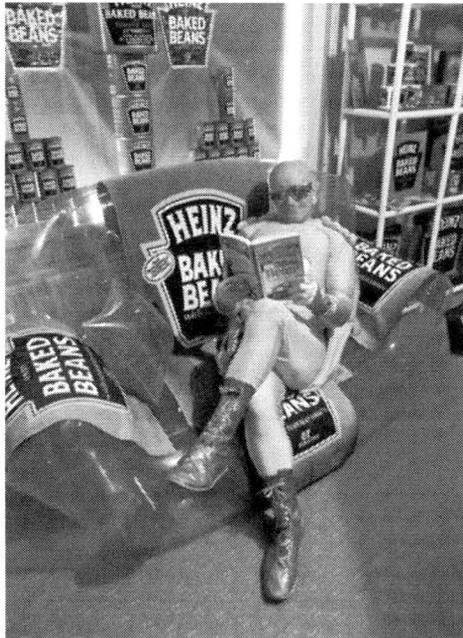

FIGURE 0.7 *Captain Beany in the Baked Bean Museum of Excellence, Port Talbot.*

the humour and the strangeness of these curious venues. In addition, I am reluctant to use theory to *explain* micromuseums as that would render the organizations passive and would hardly demonstrate their 'revolutionary' potential.

Fortunately, the work of anthropologist Clifford Geertz provided a useful lead. Pointing to the chasm between detailed observations and 'the great themes of Power, Change, and Authority', Geertz suggested a method for creating dialogue between small facts and big issues. This involves a close relationship between thick description – recognizing and understanding the meaning of fine detail within a given context – and diagnosis, wherein the anthropologist explains what that description and the knowledge that it generates demonstrates about the society in which it was found, and beyond that, about social life as such.[38] For him, this approach enabled anthropologists to 'draw large conclusions from small but very densely textured facts'.[39]

There are undoubtedly differences between the project that Geertz describes and my own. While drawing on anthropological methods of participant observation, interviewing, transcription, making comparisons, and so on, my research places a much higher degree of emphasis on the role of artefacts in constructing meaning and forms of interaction. Another of my concerns is to consider how the environment and material infrastructure of micromuseums can orient or de-stabilize the process of interpretation or indeed what it is possible to experience. Whereas Geertz is primarily interested in what objects mean, I am more concerned with what they do.[40] My research also concentrates on concepts of and operations in museums rather than on 'social life' as such, but nonetheless this project began in earnest once I began to follow Geertz's lead in moving from detail (which is always interpretative) to diagnosis. This approach also bears an affinity to microhistory, which was championed by Carlo Ginzburg, and which attends to the details and textures of small-scale community, family, or individual life.[41] In this context, the historians' focus on the minute was linked to a widespread dissatisfaction with the generalities of macrohistory and provided a means of testing its presumptions.[42] At the same time, microhistory sought to 'ask large questions in small places' and thus to comment on the broader picture.[43] Although my project is not a history, it is similarly motivated and has an identical remit.

Somewhat later in the course of my writing I was introduced to *Anecdotal Theory* by Jane Gallop and this text presented another way of conceiving the relationship between specific experiences and theoretical discourse. The essays in Gallop's volume start with an anecdote, most of which involve herself. Gallop then attempts to 'read' her account for the theoretical insights it affords and to 'think through anecdote'.[44] That last phrase has a doubled meaning insofar as it refers to the process of unpicking the significance of anecdotes for wider discussions and suggests that anecdotes enable or motivate thinking. As she points out, 'a whole lot of theory turns

out to be anecdotal: that is, the thinking is inspired, energized, or even made necessary by some puzzling, troubling, instigating life event'.[45] Most of the events that motivate her enquiry are very personal and while some are institutionally significant, others are relatively slight – such as a sense of intense pleasure in impressing a student and experiencing a rather nagging crush – but in each case Gallop uses these incidents to interrogate major questions of pedagogy, sexuality, feminism, and intellectual enquiry.

This book addresses completely different subjects but my process of working is similar in that I have concentrated on venues that prompted an emotional reaction or a feeling of perplexity. My sense of feeling slightly shaken on leaving the Museum of Witchcraft led to a chapter on the idea of objects being alive, and my deep ambivalence about some of the stories that I was told at Lurgan History Museum directly motivated the discussion of partisanship in Chapter Three. Less obviously, I wrote about conceptions of the museum as a public space after looking at my images of the Vintage Wireless Museum and realizing that I had photographed every room apart from the kitchen, despite it being used as a reception area. The fact that I had done the washing up at that same venue also stuck in my mind because it was hardly usual behaviour for a museum visitor. On this and on other occasions I took my reactions as cues for thinking about how the micromuseums were arranged, managed, and functioned. I was interested in how those venues operated to produce these responses in me.[46]

Unlike Gallop, my writing is not directly structured around particular incidents, but like her, I describe real-life events and attempt to unpick their resonance both for myself and for wider theoretical debates. All my chapters proceed from descriptions of places and events to an analysis of those same experiences. Gallop's work also provides a useful model in that she does not use anecdotes to produce an over-arching theory on a particular theme. Instead, she often recounts marginal and atypical incidents as a means of intervening in theoretical debates. For her, the specificity of particular incidents has the potential to interrupt the smoothness of dominant discourses; it provides a wedge with which to open up chinks in standard theoretical positions. Likewise, I do not attempt to construct a definitive account of micromuseums, much less a theory of museums. Rather, this book is an attempt to show how the consideration of these small and often idiosyncratic venues can disrupt received wisdom on the subject of museums more generally.

Overall then, this study, and by implication 'micromuseology', examines micromuseums in detail, considers knowledge and experience generated therein, and deliberates on the implications of those findings in relation to museological debates. More specifically, I aim at being attentive to the specific conditions of micromuseums; to their settings, the buildings they occupy, their staff, the input of visitors, the objects on show, and their modes of display. I examine the ways in which objects of all kinds combine or jar to create specific conditions that in turn enable or stymie particular

responses in visitors. Instead of assuming that exhibitions are more-or-less discrete from the buildings they occupy, or from the surrounding landscape, I conceive of museums as assemblages wherein the neighbouring rivers, streets, shelving units, lighting systems, or proffered cups of tea may all be important elements both in how those places are experienced and what happens therein.[47] Some of these topics are commonplace within museology, but this analysis differs in that I seek to consider the mutual effects and interactions of things, and insofar as I include various contingent elements within my descriptions, including my own reactions.

As I have outlined, 'micromuseology' is tailored to the study of micromuseums, and in consequence, some aspects of this approach are not particularly relevant to major museums. One rarely meets the curators or talks to the gallery assistants and so the experience of visiting is more standardized. It is also more difficult to look across different aspects of a museum's environment, exhibitions, and staffing when the institution is on the scale of the British Museum or the Metropolitan Museum in New York. Even so, it is possible to conceive of a micromuseology of major museums insofar as one can study them as complex entities that interconnect with their wider environments and, in turn, to use that as a launching pad for the analysis of museums and of culture more broadly.

Areas of enquiry

For the rest of the book, I investigate micromuseums and how their analysis introduces new perspectives on particular debates. Each chapter addresses a specific theme in conjunction with at least one micromuseum, and can be read independently of the others and in any order.[48] There is, however, a loose schema should anyone choose to read from beginning to end. Chapter One, 'Open house: Rethinking the "public" museum' considers the degree to which micromuseums can be deemed public venues. Conventional museums are public in the sense of being removed from the private sphere of the home and insofar as their collections are held in trust for wider society. Such institutions are usually supported by the state and in consequence do not count as 'public spheres', this being a designation that is applied to forums that function independently of government. Reviewing a wide spectrum of micromuseums, I show that the size of their operations and their structures of governance generally make them ineligible for grants and that they rarely respond to state directives. In the absence of external funding, micromuseums find alternative ways of surviving on small budgets and one strategy, which has further implications for their public status in the sense of being accessible to all-comers, is to situate the exhibitions alongside linked businesses or within the home. At the Vintage Wireless Museum the collection is virtually coterminous with the owner's private

residence and I examine how that accommodation informs the protocols of visiting and the types of 'public' exchange that can occur.

One of my concerns in Chapter One is how the exhibition venue can enable or deter particular kinds of interaction. In Chapter Two, 'Vital objects: How to keep museum exhibits alive', I consider micromuseums' locations more broadly. My focus here is on the idea that museums are akin to mausoleums in that they 'kill' objects by removing them from non-museological circuits of use and belief. This process generally serves to suppress visitors' embodied, emotional, and spiritual responses to the exhibits in favour of aesthetic attention or historical analysis, but at the Museum of Witchcraft visitors find themselves persuaded that the objects retain their magical powers. In order to account for their reactions I ask whether, and if so, how, these items have remained connected to their originating contexts. This enquiry encompasses a discussion of the museum's immediate environment and, importantly, the curation and interpretation of the objects. Since it is tempting to ascribe the potency of the exhibits on display at the Museum of Witchcraft to their magical character, I then move on to consider comparable situations at The Valiant Soldier and the Dartmoor Prison Museum.

At the Museum of Witchcraft, long and often lyrical labels are appended to the exhibits. Many of these directly address the visitor. There are no labels at the Vintage Wireless Museum but the owner-curator outlines the original circumstances in which the objects were produced and consumed, and he proffers forthright views on that and other subjects. Although there are differences in the mechanisms by which the curators' knowledge is communicated, both venues present the exhibits from their own particular standpoint and make no attempt to include the views of other constituencies. The curator at the Vintage Wireless Museum does not elucidate the contrary opinions of digital radio enthusiasts and the Museum of Witchcraft gives no credence to the teaching of the Christian church. This approach contrasts strongly with current professional advice, which recommends that museums represent the interests of diverse groups. Chapter Three, 'Partisans reviewed: The problematic ethics of multi-perspectival exhibitions', considers another avowedly partisan venue – the Lurgan History Museum – to reconsider the merits of multi-perspectival displays. Again I consider location and accommodation but I primarily concentrate on the curators' spoken narrative and ask how the ensuing conversation impacts upon the exhibition narrative and my experience of it. More broadly, I ask whether a multi-perspectival approach is necessarily balanced or more egalitarian than a partisan account.

The Lurgan History Museum presents a critical response to conventional accounts of the Troubles in Northern Ireland, and many other micromuseums function similarly in that they dispute or supplement orthodox histories. While it is tempting to characterize micromuseums as counter-cultural venues, it is also important to recognize that they adopt

narrative positions that range from the critical and radical to the ultra-conservative, even racist. Indeed, some micromuseums present narratives and histories that would be deeply unpalatable to even the most orthodox of major museums. One such micromuseum is the British in India Museum in Lancashire, which provides the focus for Chapter Four, 'Caring for the dead: Small-scale philanthropy and its motivations'. I have chosen to focus on this venue not only to demonstrate that micromuseums can reinforce as well as refute establishment narratives, but also because the founder kept detailed records of who made donations to the museum and exhibited artefacts according to who made them.

Most of the micromuseums discussed in the preceding chapters are packed with vast quantities of exhibits, many of which have been given by members of the public. There is no literature on such small-scale gift-giving and the paucity of record keeping in most micromuseums makes it difficult to establish what exactly has been donated or why. Unusually, however, the founder of the British in India Museum in Lancashire kept all the letters that he exchanged with the museums' patrons and this correspondence makes it possible to establish the donors' motivations for giving, discover what they gave, and ascertain what it was that they expected from the museum. As in Chapter Two which touches on the agency of objects, this section of my book points to the highly porous boundary between persons and things. It also, like the discussion of the Witchcraft Museum, Bakelite Museum, and the Lurgan History Museum, suggests that the identity and role of museums can be conceived in quite different terms to those proffered by public sector institutions.

Chapter Five, 'Choosing clutter: Curiosity and the history of museums', returns to museology, albeit tangentially so. Numerous writers have commented that museums have moved from exhibiting numerous objects from their collections to showing very few such artefacts. On the whole, this shift is seen in positive terms since the careful selection and arrangement of objects enables exhibitions to construct educative narratives about particular topics or themes. Micromuseums are entirely out of synch with this tendency and here I focus on the Bakelite Museum in Somerset to consider what is enabled and what is prohibited by profuse displays. My investigation leads me to compare micromuseums and curiosity cabinets, and hence to draw an analogy between the selective displays found in major museums and the progressive histories of museums. Museology, I suggest, needs to be more cluttered.

In each of these chapters, my analysis focuses on the curatorial style, location, and subject matter of specific organizations, but almost all of my arguments could be made about different venues. Although I discuss the Lurgan History Museum in terms of partisan exhibitions, it also provides a locus for audiences who are interested in debating matters that broadly relate to the subject of the collection and it could have featured alongside or instead of Vintage Wireless Museum in my discussion about public spheres.

The Museum of Witchcraft, which I address in relation to 'live' objects, could equally provide material for a discussion on partisanship since it is an advocate for a particular group while, conversely, the dissension that accompanies the exhibition of republican artefacts, such as those shown at the Lurgan History Museum, shows them to be highly emotive and in this sense 'live'. I examine the British in India Museum for the chapter on public service and gift-giving, but numerous micromuseums receive copious amounts of donations and could have been considered in similar terms. The Bakelite Museum is unusual in that its exhibition critically engages with dominant museum practice and that section of my book could not be written about another venue, but even so, many other micromuseums offer similar opportunities for exploration and visual pleasure, characteristics that are key to my discussion in that chapter.

The advantage of concentrating on individual micromuseums is that it is possible to consider how all their site, curation, and interpretation strategies interact with specific effect. The disadvantage is that it does not easily enable an overview of micromuseums or of the traits that they have in common. Nor does it allow me to directly address the broad question of how attending to micromuseums may change received notions about what a museum is and does. Thus, in my concluding chapter, 'Other worlds: The distinct traits of micromuseums', I switch tack to focus on the different components of museum visiting. Recapping on the organizations that have featured in the central chapters of the book and examining numerous additional venues, I thematize setting, accommodation, curators, visitors, objects, and display in order to elucidate some of the shared characteristics of micromuseums and why they matter.

CHAPTER ONE

Open house: Rethinking the 'public' museum

The historian and theorist Tony Bennett has considered some of the different ways in which museums may or may not be considered public. He comments that they 'are public both in the sense of being outside the private sphere of the home and – usually – in the sense of their dependence (whether direct or indirect) on public funding', but he cautions against them being considered 'public spheres'.[1] As Bennett indicates, this concept derives from the work of Jürgen Habermas and refers to 'a realm of our social life in which something approaching public opinion can be formed'.[2]

Habermas maintained that the public sphere was specific to the eighteenth century and developed when bourgeois men began to subscribe to critical journals, to follow news and comment, and to meet in coffee houses and clubs to discuss matters of mutual concern. Other scholars have conceived the public sphere in more generic terms. For instance, the political theorist Nancy Fraser writes that it designates 'a theatre in modern societies in which political participation is enacted through the medium of talk' and points to times where women and working-class groups have met to articulate and advance their common interests.[3] Hannah Arendt, whose account predates that of Habermas, envisaged the public 'realm' as a space of political freedom that comes into being whenever citizens speak and act in dialogue. For her, the public realm or sphere enables individuals and groups to make their diverse experiences known and to examine issues from multiple, competing perspectives.[4]

Despite these varying formulations, Bennett argues that museums cannot be defined in such terms. His key point is that public spheres are situated outside of state control and potentially provide a platform for contesting vested power, whereas museums are generally reliant on government funds, and since the mid-nineteenth century at least, have sought to shape

the behaviour and identity of the populace. Public sector museums have operated as intermediaries of the state and although Bennett does not make the point explicit, his argument suggests that the notion of the museum being a forum for the free exchange of views should be regarded with some scepticism.[5]

Although Bennett's analysis is undoubtedly well founded in regard to national, municipal, and local authority institutions, it may not be so easily applicable to micromuseums. This chapter discusses whether or not micromuseums can be considered public in any of the three capacities that Bennett outlines – do they rely on public funding, are they outside the home and by implication open to the population at large, and do they provide a non-governmental area wherein citizens can meet and converse.

Museums of independent means

As Bennett notes, most museums are supported by government or municipal bodies. In Britain national museums are funded by the Department of Culture Media and Sport, which also appoints their trustees, while local authority museums are administered and financially supported by parish, borough, city, or county councils. University, hospital, and armed services museums are owned by those establishments which are partly or wholly supported by taxpayers. Independent museums are not directly funded by the state but providing they are suitably constituted, may apply for support from various government programmes. My first question then, is: to what extent do micromuseums secure funding from the public purse and by extension operate as intermediaries of government?

Some micromuseums have established close links with local authorities and funding councils. For instance, when The Valiant Soldier pub in Buckfastleigh, Devon, was offered for sale in 1995, local residents realized that it had remained completely unchanged since its closure in 1965 and they petitioned Teignbridge council to preserve the property. The council duly stepped in, bought the premises, and then worked with interested parties to create a trust that subsequently leased the building, undertook the necessary conservation work, and managed it as a museum after it opened in 2010. The newly formed trust also received help in applying for project grants and won significant awards from various sources.[6] In this case, the council's priorities and practices and those of the local people were well matched. Some residents had been concerned with preserving the period interiors, others had wanted to establish a museum in the town, and it was generally agreed that a tourist attraction would be advantageous to the local economy.[7] In 2010 the Buckfastleigh Trust bought the leasehold of The Valiant Soldier from Teignbridge council which then ceased to have any direct involvement in the enterprise, although they did award a

£500 'make a difference grant' which contributed to match funding for a successful Heritage Lottery bid and enabled them to develop a local history archive. This funding did not cover the museum's running costs or pay for a member of staff and the museum relies on ticket sales to cover these costs.

Andrew Logan and Michael Davis tried to make a similar arrangement with the local authorities when they were planning the Andrew Logan Museum of Sculpture in Berriew in Powys, Wales. The council had agreed to buy the former village school and lease it to the new museum, but a week before the building came to auction they told Logan and Davis that local authorities had been prohibited from making this kind of capital investment.[8] Logan and Davis eventually used their own money to buy a former squash court and then secured funding to have it converted into a gallery. The Welsh Development Board contributed £20,000, John Sainsbury gave them £10,000, Concord lighting ensured that the space was exquisitely lit, and CyMAL: Museums, Archives, Libraries. Wales helped pay for equipment. The museum opened in 1991 and in 1999 Davis applied to the Heritage Lottery for money to employ a director, and to CyMAL for an access officer. The grants were awarded and subsequently renewed, but in 2004 funders started financing projects rather than staff, and both posts were lost. Davis secured some funding for a series of mini-festivals in 2005 but otherwise the museum went into abeyance until 2010 when Jessica Callon, a young arts graduate, volunteered and secured Arts Council grants for an outreach series. She then worked with Davis to organize two festivals that combined public workshops with provision for schools. CyMAL and Powys County Council funded both projects.[9]

Like the other public bodies to which Davis and Logan applied, Powys County Council used funding to achieve certain ends. In this particular case, they expected projects to meet at least one of the aims outlined in their corporate plan: improving health, social care, and well-being; ensuring learning opportunities for all; supporting economic and social development; and enhancing the natural and built environment.[10] Davis and Logan recognized that funds were disbursed to achieve particular goals and stated that the 2012 festival would not only bring glamour to people's lives but would also help develop the sustainability of Berriew, improve well-being, develop active citizenship, encourage tourism, and foster visitors' appreciation of the beautiful rural setting.[11] They delivered on their claims by offering classes for adults, poetry readings, an exhibition of local artists at the Old School Hall, and by organizing workshops at the local primary school. Ninety-five children studied different aspects of the ancient Greek Olympic Games and produced banners, togas, wreaths, and medals, which they used or wore as they paraded through the village at the end of the festival. The local bed and breakfast and two village pubs provided catering and all their rooms were booked out for the duration of the event.

The event was successful in that it achieved the aims outlined by Powys Council, albeit on a small scale, and it was certainly glamorous. Davis and Logan were also sympathetic to the aim of boosting the local economy and improving the social and creative opportunities on offer, but in other respects there was a mismatch between what funders could offer and what the museum needed. Project funding only covers the costs incurred in running an event and it does not pay for the upkeep of the building or for staff. If the museum does not generate enough money from ticket sales to cover wages, then there is no one to make grant applications or to clean, maintain, or open the museum so that the projects can run. These tasks can sometimes be covered on a volunteer basis, but someone is needed to recruit, support, and manage the people who are prepared to help. Andrew Logan pays the bills for the museum bearing his name and covers the wages for two assistants to open it over weekends during the summer season while Michael Davis works on an unpaid basis, but this is not an option open to everyone and project funding really only suits organizations that already have an infrastructure and team. Museums either need to be able to comfortably maintain themselves on retail and ticket sales in order to be in a position to secure public monies or they already need to have core-funding from the state.

Although such monies only cover projects and not maintenance or staff costs, The Valiant Soldier and the Andrew Logan Sculpture Museum show that it is possible for micromuseums to obtain public funding. Yet even these limited successes are rare because there are a number of reasons why micromuseums find it difficult to access grants. One key factor is that like The Valiant Soldier and the Andrew Logan Sculpture Museum, many micromuseums operate without any remunerated staff. In 2010 the Association of Independent Museums conducted a survey in which they asked their members if they had any paid employees and twenty-four of the eighty-one museums that replied said 'no'.[12] Given that a disproportionate number of responses were from large- and medium-sized institutions (defined as receiving over 10,000 or over 50,000 visitors a year) and that membership of the Association indicates a level of professionalism, it is likely that the proportion of independent museums that are run entirely by volunteers is much higher within the sector as a whole.[13] In the main, volunteers do not have the requisite experience to bid for grants since this requires an overview of the relevant government policy, different funding streams, a clear understanding of why museums are financed, and the ability to present a business case. Then, even if they are successful in gaining an award, they are often reluctant to commit themselves to regular hours or to take on the management responsibilities that would be essential if the museum was awarded project-funds.[14]

In many ways, however, the situation is not markedly different when micromuseums do have paid employees. Having surveyed the independent museums in their county in 2007, Museums, Libraries, Archives Yorkshire

discovered that only seventeen out of sixty-five venues had professionally trained staff.[15] While that report did not elucidate on the background of paid workers, the micromuseums that I have researched usually employ people who have had some practical experience of that area. The curator at Dartmoor Prison Museum is a former employee of the prison service while the part-time workers at the Boscastle Museum of Witchcraft are practitioners and researchers in that field. Otherwise, the income from micromuseums supports the owners of those venues who frequently start out as collectors, later opening museums in order to show their wares to the public.[16] Their families will often assist, sometimes taking a wage, and tend to accrue their knowledge of the collections by working onsite. Specialist expertise and practical know-how do not prepare staff for making grant-applications.

Given the low numbers of paid staff and their specific areas of expertise, it is not surprising that the Association of Independent Museums found that smaller organizations 'often lack the capacity and/or expertise to advocate effectively, and lever support from strategically focused regional and national organisations'.[17] Their report also stated that small museums 'often struggle to make a strategic economic case for support' and cited the Ironbridge Gorge Museums Trust as an independent museum that had made a strong case for investment. Their project, the authors noted, had a strong 'economic rationale, made on the basis of delivering clear returns on investment in terms of jobs created and sustained, along with the projected economic benefits to Shropshire and the West Midlands of increased visitor numbers'.[18] Already a massive operation, the Ironbridge Gorge Museum secured the funding that it had bid for and duly attracted an additional 141,000 visitors, but it would be impossible for small museums to offer comparable returns. With audiences in the hundreds or low thousands, most micromuseums cannot argue that grant funding will have a substantial economic effect.

Ironbridge received its funding from Advantage West Midland, a regional development agency which tries to improve economic conditions, but other grant-awarding bodies do not place such an explicit emphasis on regeneration, increased tourism, or economic impact. Nonetheless, they often require the applying institution to attract a certain number of visitors and this also mitigates micromuseums' capacity to attract awards. Since 2002, the Renaissance scheme has been one of the main sources of funds for non-national museums and their Major Grant programme specifies that applicants must have a minimum attendance of 150,000 per year, which obviously excludes small organizations, while the 15,000 visitors demanded by the Strategic Support fund is still beyond the reach of many. No audience figures are specified under the Museum Development strand but applicants are required to make a 'major contribution' to the Arts Councils' five strategic targets, one of which is that '*more* people experience and are inspired by museums'.[19] Although small organizations may meet these

criteria if they collaborate and produce a collective bid, doing so requires
a network of co-operative peers, and as the Association of Independent
Museum has established, small- and medium-sized organizations almost
invariably work in isolated conditions.[20]

A final stumbling block to securing public monies concerns the status
and governance of small independent museums. While The Valiant
Soldier and the Andrew Logan Museum of Sculpture are registered as
charitable trusts, many micromuseums are privately owned. Some operate
on an ad hoc basis and have no legal standing which disqualifies them
from applying for any grants, while others operate as limited companies
who could, in principle, join a bid for the Renaissance Major Grants
scheme, but are ineligible for funds from the Renaissance Support Fund
(at the time of writing the Renaissance schemes are the principle channel
through which the Arts Council disburses money to museums) or the
Heritage Lottery fund.[21] Micromuseums that are registered as not-for-
profit-organizations do qualify for these schemes but they still fall outside
the remit of the Clore Duffield grant scheme and other foundations that
only fund charities.[22] Neither limited nor not-for-profit companies can
claim gift-aid whereby the tax paid on admission fees or donations is
refunded.

A museum's status can also present a problem in relation to Arts Council
accreditation and this has serious implications for funding. Accreditation
is intended to provide an authoritative benchmark for professional
standards and since it 'gives investors confidence in the organisation'
many grant-awarding bodies insist upon it.[23] In order to be accredited,
however, the organization must meet the Museums Association's 1998
definition of a museum, which excludes privately owned collections,
even if they are open to the public.[24] Hence, these micromuseums cannot
apply for grants from Arts Council England, CyMAL or from many local
authority schemes.[25]

It might therefore seem logical for the proprietors of micromuseums to
change the status of their organizations. They generally refrain from doing
so because one of the steps involved in establishing charitable status is that
museums must appoint trustees and no one who works for the organization
can be nominated. This means that the owners of micromuseums have to
choose between oversight of their museum – becoming a trustee – and
employment within it. If they took the latter option they would also be
forced to pay for staff to work in their stead. This is possible in some cases,
but more usually the owner works on the premises and draws a modest
salary from the takings whenever possible. Alternatively, the founders and
owners could work for nothing, and like Michael Davis freely contribute
innumerable hours to making grant-applications and running festivals, but
this option depends upon having another source of income. Becoming a
charitable trust is therefore not a choice that most proprietors are willing
or able to make. Besides, other factors such as the size of their audiences

and the lack of paid staff would still make successful funding applications somewhat unlikely.

There are, then, a number of reasons why small independent museums do not qualify for or are unable to secure funding. The eminent American museologist and curator Stephen Weil was deeply sceptical about the notion of independence and stated that 'even the most ostensibly private' of museums 'receives a substantial measure of public support'.[26] Although many of the larger independent museums do benefit from the public purse, either directly through funding or indirectly through tax relief, the same does not apply to the smaller organizations, which for better or worse, tend to be self-sufficient. To all extents and purposes micromuseums do operate independently of the state and are not supported by the public sector, even indirectly, which means that they are under no compunction to work towards goals and priorities set by government bodies. Besides, lack of funding means that they are generally ill-equipped to develop projects which would function as economic or civic technologies. Thus, micromuseums are not public in the sense of being supported by the taxpayer, they do not function on behalf of the state, and so they are not automatically disqualified from being public spheres.

At home, in the museum

In the absence of external funding, collectors and special-interest groups have to find other ways of surviving and some of their solutions have consequences for the museums' status as public spaces in the sense of being open to all-comers. A handful of micromuseums sustain themselves from ticket sales. For instance, the Museum of Witchcraft at Boscastle attracts some 50,000 visitors a year and at £4 for adults and £3 for children and elders, the owner, Graham King, is able to maintain the building and associated library, support himself, and pay two part-time members of staff. Other micromuseums work in tandem with or are entirely supported by auxiliary businesses. The Norfolk Tank Museum shares space with a caravan site as does the West Wales Museum of Childhood, which is run alongside a toy-shop and café (Figure 1.1). At this latter venue, the combination of attractions is aimed at providing an added inducement for holidaymakers to come to the premises and the four businesses operate a cross-subsidising whole, but more often one or the other enterprise dominates. The Fossil Museum occupies a side room in the immensely popular Square and Compass pub in Dorset, while the museum at Barometer World in Devon is an adjunct to a successful shop and restoration business run by Phillip Collins, an author, craftsman, and world-expert in the subject. He charges an admission fee of £2 but once he has paid the insurance on the museum and spent approximately £7,500 on printing and delivering publicity

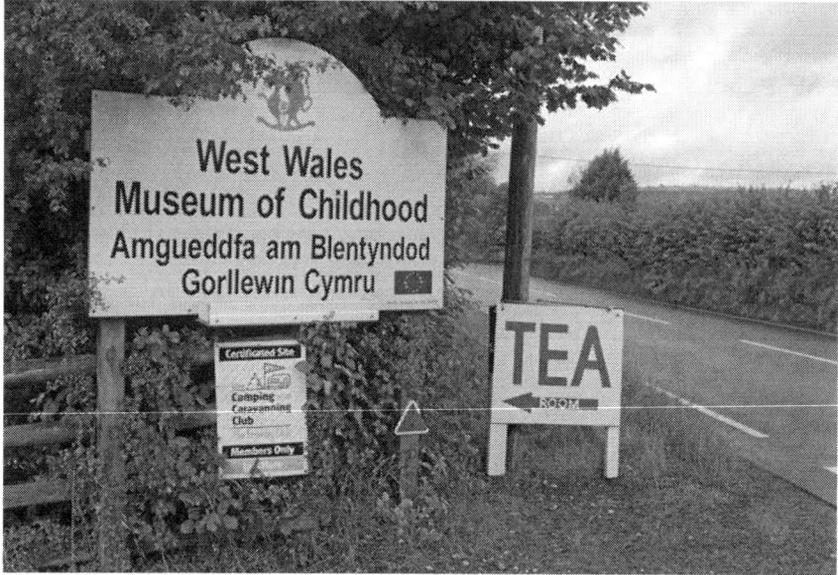

FIGURE 1.1 *Signs for the West Wales Museum of Childhood, its café, and caravan park, Pen-ffynnon, Camarthenshire.*

leaflets, he runs at a loss. As Collins rather wryly observed the museum is 'not about the bottom line'.[27]

Another way of operating on a budget, and an approach that has repercussions for public access, is to live on the premises. Patrick Cook occupies the house that directly abuts the Bakelite Museum, which he owns, and on sunny summer afternoons he can sometimes be found with his family and friends taking tea on the lawn where the tourists also consume their refreshments. At the Pollock Toy and Model Museum in central London, the manager lives in a small flat adjacent to the galleries. A green baize curtain conceals the door to the apartment but when I visited I could hear a small dog barking and the smell of coffee drifted through to the exhibition space. Here, and in other micromuseums, the domestic environment subtly intermingles with the spaces of exhibition, blurring the borders between public and private realms.

At the Bakelite and the Pollock Toy Museum, the private, domestic spheres are located at the very edge of the public space, but are separate from it. The distinction between the two zones is slightly less clear at the Violette Szabo Museum near Hereford which is owned and run by Rosemary Rigby and is situated in a solid, purpose-made block at the bottom of her garden. Szabo, who was an undercover agent during the Second World War, spent some of her childhood holidays at the house, and given that connection, Rigby never considered locating the museum anywhere else. She raised the

£22,000 required for the construction of the outbuilding by organizing cake sales, pounding the streets of local towns with a collecting tin and by securing £600 in sponsorship from a brewery that used Szabo's image on a bottle of 'Resistance Ale'.[28] Rigby's museum is open on Wednesdays, but as she is the only person who can open the building and is not always available, potential visitors are recommended to ring ahead.

Likewise, the Museum of Knots and Sailors' Ropework, which occupies a small, beautifully designed building, is set at the end of the owner's garden. In this case, the museum can only be reached through the owner's house and consequently can only be visited by appointment. The Museum of Straw and Basketwork in Norfolk is even closer to the owner's living accommodation. The bulk of the collection is on show in a group of five large sheds erected in her back yard and the remainder is on display in two rooms of her bungalow (Figure 1.2). In these two cases the owners have used their own resources to create museums and receive visitors; they are located on private properties by necessity.

Bennett observed that museums are public in the sense of being outside the private sphere of the home, but there is almost no divide between public and private space at the Baked Bean Museum of Excellence, which occupies a flat in a Port Talbot council block. Baked-bean paraphernalia covers the orange walls of the hallway and living room-come-office, while the main bedroom has been turned into a small museum. It includes an inflatable

FIGURE 1.2 *Museum of Straw Crafts and Basketwork, Buck Brigg, Norfolk.*

orange sofa bearing the Heinz logo and the museum proprietor lounges on its plastic cushions to show how he spends his leisure time. Here, the kitchen and bedroom are off-limits whereas, in contrast, the Vintage Wireless Museum is fully coterminous with the owner's West Dulwich home. From being a young man, Gerry Wells collected old valve radios and televisions, and as the collection increased, it gradually took over every space in the house including the living room and the bedroom where Wells still sleeps.

The Vintage Wireless Museum is at once a home and a Museum. In the next two sections I investigate how this arrangement informs the protocols of visiting. To what degree is the Vintage Wireless Museum open to the public? Operating without financial assistance from the state, is there any scope for considering it a public sphere?

Visiting the Vintage Wireless Museum

The Vintage Wireless Museum is open, free of charge, to anyone who telephones or emails in advance. On my appointed day, a tall man wearing heavy square glasses and a white lab coat opened the front door, introduced himself as Gerry and invited me into the kitchen for tea.[29] The square rather old-fashioned room had a large wooden dresser stocked with pretty blue and white china and a plain solid wood dining table. A kettle, a tea-caddy, sugar bowl, and other regularly used items stood on the surface of the 1960s kitchen units. There was a faint smell of gas and coal tar soap. Doors lead out to the hallway, a sitting room, the back garden, and a downstairs bathroom; the kitchen was clearly the hub of the house.

In his mid-eighties and recovering from a recent stroke Gerry was slightly shaky as he brewed a pot of tea and undid a packet of petite madeleines (the small sponge cakes which prompted Marcel Proust's recollections in *Remembrance of Things Past*). As we sat down, there was a knock at the back door and Frank Goddard, a friend of Gerry's and a supporter of the museum entered followed by Gerry's cat, which purred around our ankles. They asked me what I do, where I live, and where I come from, and because I grew up near Wigan in Lancashire, this led to a conversation about the merits and demerits of meat-pies and tripe, foods that are associated with the area. More tea was poured and the two men moved on to the topic of digital broadcasting. Frank mentioned that Nick Clegg, the deputy prime minister, was planning to revoke the decision to switch off AM and FM stations once 90 per cent of homes can receive a digital radio signal. They told me that analogue broadcasting is far superior and explained that the DAB (digital audio broadcasting) processors squeeze too much information onto a relatively narrow frequency and that this flattens the sound. Apparently, the best quality of sound is found on medium wave and

the two men are glad that the new coalition government had 'finally seen some sense'.

When they were ready, they took me on a tour. Every available space was covered: shelves filled with Phillips radios run down the sides of the hallway and Victorian instruments for testing early telephones are lined up on the window ledge. As we ascended the stairs Gerry explained that this was his family home, and indicating the wallpaper, said that he had chosen to keep the decoration in the style of the 1930s. Pink roses on a cream background cover the walls of the landing while those of the small front bedroom, where Gerry was born, are relatively plain. This latter room now contains masses of portable radios organized by type and arrayed on shelves that reach from waist-height to ceiling (Figure 1.3). Standing beneath them on the floor are large radiograms and two glass cabinets, one housing a collection of gramophone needles, the other, bits and pieces of Bakelite. These objects were collected and arranged by Gerry's daughter who later took over the management of the museum. They were affectionately referred to as 'Eilean's cupboards'.

The next room is decorated in a paper suitable for the bedroom it once was – cornflowers on cream – and contains more radiograms and a number of gramophones (Figure 1.4). Sitting in a large carver chair Gerry pointed out some of their features while Frank explained how they were originally aimed at different markets. One has a handmade fretwork depicting birds

FIGURE 1.3 *Rickard Taylor 4AF Room, Vintage Wireless Museum, Dulwich, London.*

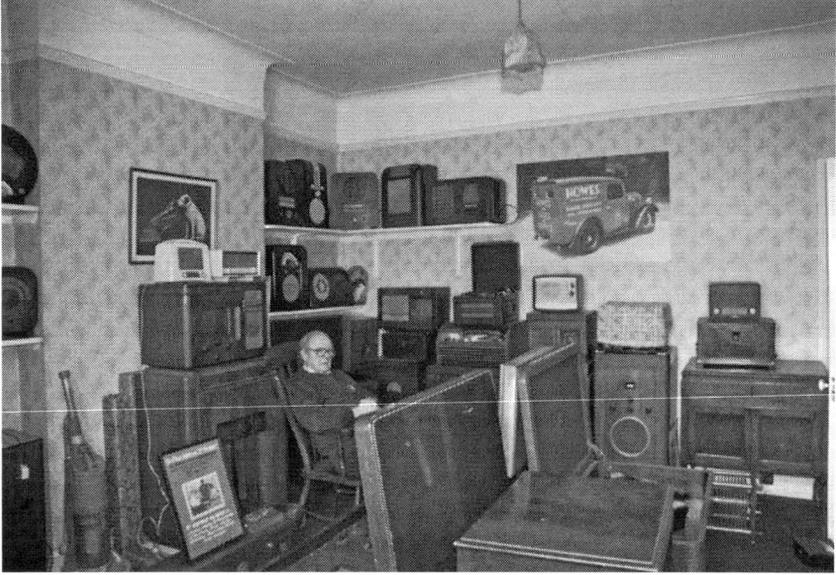

FIGURE 1.4 *Gerry Wells in the Marconi Room, Vintage Wireless Museum.*

and another is decorated with circles in an art deco fashion, while some are plain. The former were made for wealthier consumers, the others were cheaper. 'Radiograms by postcode', Frank remarked. They also show me a radiogram that was the first to have radio stations named on the dial – prior to that it was just frequencies – which made them easier for non-specialist audiences to use. There is a lacquered chinoisserie record player from the 1960s that is kept under a cover because otherwise 'the cat would do four-point turns on it' and two sets with grilles made by Eileen are also on display. She had carved a silhouette of Peter Pan to cover one speaker and a low relief of Mickey Mouse for another.

Looking through these radiograms and some of the later radios, Gerry and Frank explained that every area had at least one repair firm. In Norwood High Street (which is close to the Vintage Wireless Museum) there were five, and Gerry said that 'if your wireless went wrong, you were led to believe a valve had gone, but the average shop owner didn't know his job properly and it was usually a bad connection or faulty condenser. When televisions became more popular', Gerry continued, 'customers would take them out of the box and expect them to work. Those of us in the trade began to realize that you had to unpack new sets in the shop to remake any badly soldered joints and centre up the picture. Then we'd repack the set and take it to the customer, but if you sold an HMV 1807 on the Saturday you knew you would get it back first thing on Monday. They were useless. Most of them were made by British firms', he added, 'and they all went

out of business in the 1960s when the imports began arriving'. I hadn't known that numerous small British companies had produced television sets so Gerry and Frank listed them before going on to outline the advantages of the Japanese models.

A third room holds loudspeakers, trumpets, horns, along with the fittings from a shop once run by Mr McMichael, a radio pioneer (Figure 1.5). Leaning against the old counter, they told me that there is one object in the room that 'collectors would kill for' and challenged me to pick it out. When I was unable to do so they indicated a wooden box with a handle protruding from one side and told me that it is the first gramophone ever made. John Paul Getty Jr bought it at auction and later sent it to Gerry to be repaired. Later, Getty's assistant came to visit the museum, liked it, and recommended it to Getty who sent a Christmas food parcel from Harrods, subsequently paying the rates when Gerry was ill. He then donated his father's 1937 television set and finally gave the precious gramophone. Gerry wound it up and 'I Passed By Your Window' recorded in 1917 by Walter Glynne crackled out of the horn. I expressed my surprise that it played as well as it does, and in response Gerry started up a number of machines, all in full working order. A 1938 cabinet radio that has automatic tuning locates the nearest station and immediately begins broadcasting a Bollywood sound track. 'Take-away music' he remarked.

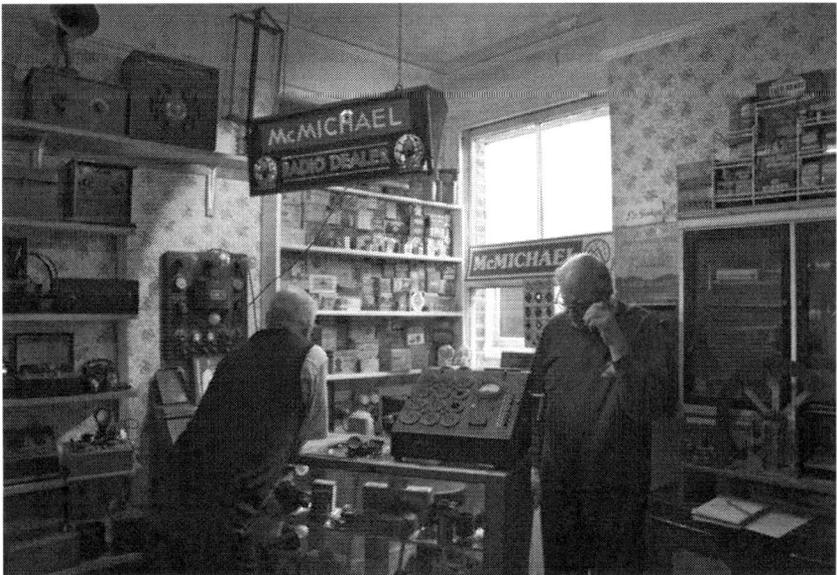

FIGURE 1.5 *Gerry Wells and Frank Goddard at Mr McMichael's shop counter, the Getty Room, Vintage Wireless Museum.*

Each of these rooms has a name. The Getty Room is named for his sponsor, the Rickard Taylor 2AF room refers to an early wireless enthusiast who coincidentally lived in the house from 1908 to 1914, AF being his call sign; while the Newton room is called after the town in Lancashire, which is a significant place for Gerry. Explaining, he tells me that aged 13 he was spotted removing electrical components from bombsites, was prosecuted, and sent to a remand school. On being released he resumed stealing, stripping the local vicarage of its electrical fittings and pinching the Belmont wireless from the front window of a shop which was located on Norwood High Street. The delivery man gave chase in his van, caught Gerry, and called the police who then found the vicar's property stashed under the floorboards of the shed in the Wells family's garden. As a result Gerry was sent to Liverpool Farm School, in Newton-Le-Willows, West Lancashire, now known as Red-Bank secure unit. He said that this was the saving of him because Ted Hackett, the deputy headmaster, recognized his skills and encouraged him to learn by repairing radios. The Kingswood Room which doubles as Gerry's bedroom is named after a dormitory at the school and the Hackett room in the attic is named in honour of the deputy headmaster and his wife. Photographs of them and of Red-Bank are placed on a bureau with a handwritten dedication thanking the couple for forty-seven years of care and support.[30]

The attic room is mainly used on Fridays. Once the supporters group have dusted and cleaned the house and collections, they gather upstairs to talk about radios, eat fish and chips, and drink red wine. Gerry also hides up here when there are too many visitors or when Americans, whom he generally dislikes, arrive. Long benches run along the walls to accommodate the enthusiasts, there is an armchair, which Frank occupies, and leaning against a wall is a mattress awaiting the return of Ben, a former chief engineer at Digital Hire who now lives in Italy but sleeps here whenever he returns to England. A single long store cupboard built under the eaves on three sides of the room is filled with tens of thousands of spare parts, all packed into small brown cardboard boxes. Frank declared that there are enough valves in there to repair radios for decades to come and I'm invited to see what's inside. I crawled round the tight dark space, listening to the men chatting as I circumnavigated the room.

By this time Gerry was tired and we went back downstairs to the living room. It has high ceilings, cornices, plasterwork, and a bow window looking out over a small front garden. A dining table with six straight-back chairs is placed in the bay. The dark wood of the furniture, of numerous television and radio sets, and of the polished floor give the room a sense of warmth, which is deepened by a large dark-red Persian carpet. All the available surfaces are covered with paraphernalia relating to broadcasting, and to a far lesser extent, with photographs of family and friends. Gerry and Frank retired to a pair of large armchairs placed on either side of the fireplace, which is blocked by the television that belonged to Getty's father.

The friends showed me how it works and watching a daytime chat show flickering anachronistically on the ancient set, comment that it will stop working once the analogue television signal is withdrawn.

Prompted by the thought of analogue signal coming to an end Gerry recalled that, at first, television broadcasting was limited to London. 'It was just the BBC', he said, and 'the programmes were all fairly highbrow, but then other transmitters began to open up – Sutton, Coldfield Holme Moss, Wenvoe and Kirk O'Shotts'. In 1954, he continued, 'the ITA (Independent Television Authority) was formed and they broadcast on alternative channels, but a small box had to be fitted to the existing BBC receivers so that customers could pick up the signal'. Gerry made his own converters or bought them at a cost of £6 and charged £11 for both fitting and parts, which was good value at a time when televisions were a luxury item. 'I was soon doing more conversions than Billy Graham (the American evangelist)' he said, with the air of repeating a well-rehearsed joke. 'The problem was though', he added, 'that the BBC moved their transmitter from Alexandra Palace up to Crystal Palace (which is just above his house) and that was only about a mile from the ITA's transmitter. We had wonderful pictures on the BBC' he said, 'we didn't even need an aerial. You could pick up the signal with a piece of string on the set and the sound came through everything – hearing aids, car radios, and all our amplifiers, but the little ITA station didn't stand a chance and it was completely swamped out. Everyone was doing their nut. I had to get all the sets back in the workshop and redesign the converters.'

Tiring of '*Tricia*', Gerry and Frank opted to listen to a record played at immense volume on a vast gramophone that was designed, and is still used for fund-raising garden parties (Figure 1.6). While they listened to the music, I went and made a pot of tea, did the washing up while waiting for it to brew, and brought out more cakes. Popping upstairs to the bathroom I realized that there were more rooms that I had not been shown. These were named for David Adams who spent his retirement cataloguing the whole collection, and for the brothers Fred and Bill Watts, who donated their collection to the museum. Bill died ten years ago, but Fred still comes in every Friday.

After tea, I was invited to see a public address system that operates out of the old morning room. Here, net curtains and long pale pink damask drapes hung over the original French windows, framed prints of Victorian hunting scenes adorn the walls, and a beautiful pale green replica of an art deco radio that Gerry made was positioned on the mantelpiece. We ignored a single bed and some of Gerry's personal possessions to concentrate on a large desk with a double turntable and microphone. With this equipment it is possible to broadcast to each room in the house. The loudspeaker system extends into the workshops at the bottom of the garden where Gerry once ran his business. Long repair benches and a carpentry room are still in situ, but the former workshops now provide more display space for the collections

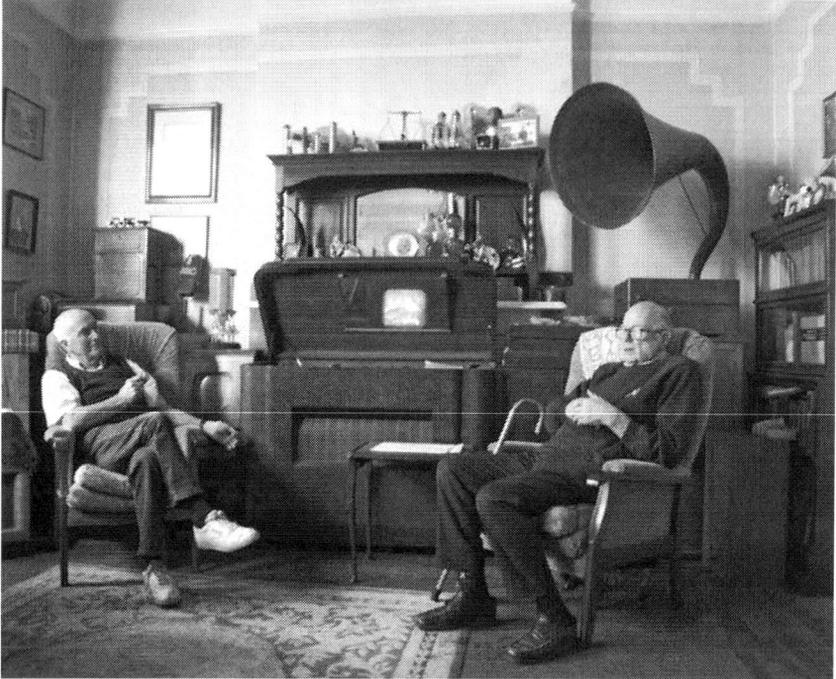

FIGURE 1.6 *Gerry and Frank listening to the garden gramophone in the living room, Vintage Wireless Museum.*

and are as packed as the rooms inside the house. As Gerry demonstrated the fine-tuning of an amplifier, Frank remarked, 'he made that, he's a real expert, you know'. They wander around inspecting and commenting on different sets until a young woman arrives. She is introduced as his granddaughter and has come to cook dinner for Gerry. Everyone returns to the kitchen, and then shortly afterwards I take my leave.

Reconfiguring public and private space

At the Vintage Wireless Museum the conventional boundary lines between public and private space are reconfigured in a variety of ways. This has implications both for the levels of access to the premise, that is, for how public the venue is, and for interaction within the museum, which is to say, its capacity to function as a public sphere.

As the museum is located in his home and since he is not answerable to the state, Gerry is not obliged to admit everyone on the same terms. Instead, the length of each stay can depend on Gerry's time and health or upon how

visitors acquit themselves – groups of Americans who speak too loudly for Gerry's tastes may find their visits curtailed, whereas my Lancashire accent served me in good stead because it reminded him of his days at Redbank. Having gained admittance, visitors are not encouraged to wander at will and the extent of their tour depends upon their host. I was not shown the Adams and Watts rooms although I was taken into the storage cupboards under the eaves and the morning room cum bedroom. Even if visitors were left to look around by themselves, little would be gained from doing so. Public sector museums have labels, wall-texts, and catalogues, which may be read or ignored as desired, but finding out about this collection is reliant on having it explained.

In some respects then, the Vintage Wireless Museum is less public than conventional museums. Visitors' levels of access are limited by the appointment system, Gerry's preferences, and the availability of textual information. In other respects, though, aspects of museum practice that are less evident in major institutions or which are actively kept private are brought into view. One such instance of this process concerns the people involved in the foundation and ongoing running of the venue. In major museums, the founders are often well known to visitors: in London, the Tate Gallery is clearly linked to Henry Tate of Tate and Lyle, the John Soane Museum to John Soane, and the Horniman Museum to Frederick John Horniman. Less obviously Hans Sloane's collection is housed in the Enlightenment Room at the British Museum and a text reminds viewers that his bequest motivated the foundation of that institution, while some contemporary institutions are clearly associated with their founders and owners of the collections, the Saatchi Gallery in London and the Thyssens Collection in Madrid being notable cases in point. Likewise, the directors of major museums may have a strong public presence and lead that institution in very particular ways, as Neil McGregor has, first at the National Gallery and then at the British Museum, or Nicholas Serota at Tate. Lower down the institutional hierarchy, individual curators may have their names attached to particular exhibitions by way of an introductory wall text or essays in a catalogue.[31] Alternatively, major museums may bring in an independent curator and their name and vision brands a particular exhibition. 'Nicolas Bourriaud' and 'Hans Ulrich Obrist' would both be typical in this regard.

Nonetheless, while visitors to major museums may know who established that venue, they cannot meet a founder who lived and died two centuries ago, and unless they actively research the history of museums, they are unlikely to know much about them. In principle it is possible that visitors may come in to contact with the founders of contemporary exhibition but it remains unlikely for most. Although visitors may know something about the people in question (for instance, Saatchi's media saturated break-up from Nigella Lawson), they are unlikely to be familiar with why that person started collecting, how the museum came to be in that location, or why it

took the form it did. Equally, the curators in major museums are known in their professional capacities but not in other more personal ways. Visitors are not generally aware of why Nicholas Serota first became interested in art, say, or of Nicolas Bourriaud's class background, or Neil McGregor's income or religious beliefs.

In contrast, visitors to the Vintage Wireless Museum find out a great deal about the person who initially established the collections and the circumstances in which that happened. We know that Gerry amassed his collection in the course of his work as a radio and television repair man because he tells visitors that when customers updated their outmoded or broken radiogram he would take the old model and store it, and eventually those sets were used to create a display. Visitors are told that he lives in the house and worked from the workshop at the bottom of the garden, and they also find out about his childhood interest in electricity and how he acquired his skills in that area. Equally we find out about how the rooms and collections are organized. He explains that one cabinet contains Eilean's things, that the objects in two rooms previously belonged to other collectors and have been kept together, and that further rooms are arranged according to the type of object on show. In short, visitors come to understand why the museum is located in this particular place, why it addresses the subject of vintage wirelesses and televisions, where the objects came from, and why they have been arranged thus.

Visitors also find out about the broader social and economic circumstances of Gerry's life and by extension the context of the museum. He explains that he inherited the house and gives details about his life, but even if he were unaccountably absent, the surroundings provide clues as to his identity and situation. The solid Victorian five- or six-bedroom house furnished with damask drapes and mahogany clocks denote a respectable middle-class household. The extensive workshops and kit indicate a level of expertise, a time of full employment and the cessation of that business, while the unchanged kitchen units and smell of gas heating suggest a certain level of privation – most people now have fitted kitchens and central heating. The unwashed crockery indicates that the owner-curator may require some assistance in running a large house and we can deduce that he is white, elderly, lives alone, has regular visitors, is fond of cats, sleeps in a downstairs room, likes jazz and dance bands, drinks tea, and has a sweet tooth. Thus, the museum and the collections are situated with respect to a particular individual and, crucially, one who is placed with respect to class, gender, age, and to the history of twentieth-century British manufacture. It is somebody's collection and it has been formed under particular economic and social conditions.

There are also other operations that largely remain hidden in major museums but which are made public at the Vintage Wireless Museum. Major museums may credit the curator of a show and may acknowledge the collaborative work of several people. For example, the publicity for the

collections show *Ruins Lust*, held at Tate Britain in 2013–14, gave curatorial credit to Brian Dillon who is the British editor of *Cabinet* and author of the book *Ruins of the twentieth century*, Emma Chambers who is the Tate Curator of Modern British Art, and to Amy Concannon, the Assistant Curator of British Art. Yet the exhibition material did not acknowledge the other people involved in the construction of the show. There is no mention of any archivists who may have supported their research into the collections, the conservators who hung the work, the technicians who lit the exhibition, the ticket sellers, cafe-workers, or of people who cleaned the gallery, much less of the partners and families who supported that work through their unremunerated domestic labour; indeed, such a list would be most unwieldy. Effectively, then, there is a division in the forms of labour that are acknowledged in the preparation of an exhibition. While curatorial work is recognized, that of others is not.

In contrast, the collective labour involved in running the Vintage Wireless Museum is made public as are the variety of jobs and the numerous people involved in that task. The young cook is not sequestered away, visitors are likely to meet Eilean and various supporters, and should they arrive on Fridays they will encounter the museum's supporters who catalogue and clean the collections. Furthermore, because the Vintage Wireless Museum is virtually coterminous with a private house, there is no strict demarcation between the various types of labour. Dusting, making tea, washing up are domestic duties and they pertain to the museum. In washing up, one is looking after Gerry's needs, as well as those of the museum, and curating the manifold exhibits is simultaneously understood to be an exercise in tidying up. It is precisely the private character of the venue that brings such activities into view and which gives them a public status.

Although the Vintage Wireless Museum is a so-called private venue, the normative divides between public and private space are implicitly brought into question. Whereas it is less public in the sense of being open to audiences than a major institution, the business of the museum – the authorship of displays, the labour involved, the people who work there, and its financial standing – is much more public. In turn, the particular dynamic of this partially private, partially public organization has effects on its potential to operate as a public sphere.

The launch of the museum made the house relatively publicly accessible, but its architecture, Edwardian decor and furniture show that this is a private residence and Gerry's demeanour is that of a host rather than a professional museum curator. New arrivals are offered somewhere to sit, a glass of water, tea and cake, and are then asked about their interest in the collection. This enables Gerry, along with his friends and the volunteers, to respond to visitors as individuals. Having ascertained that I was entirely ignorant about radios Gerry and Frank carefully elucidated the differences between valve and transistor sets, the variations in their sound, and explained what an analogue system actually is. Likewise, aware that I was researching

small independent museums, Gerry told me that he had reservations about Hunter Davies's book *Maddest Museums*, which included a chapter on the Vintage Wireless Museum, although he did approve of a short film called *Valveman* and a BBC radio programme titled 'The Wireless World of Gerry Wells'. Frank later sent me a copy of this broadcast.

Since Gerry is in his own home and because he is not in receipt of public funding, he can also introduce the exhibits in any way he chooses. On the whole, the objects serve as the initial prompts for snippets of information and personal stories. The prototype gramophone motivates anecdotes of John Paul Getty Jr arriving at the museum and being amazed that anyone would charge a billionaire a mere sixty pounds for work completed. The garden gramophone recalls Gerry to the numerous parties held outside and a poster of an Austin Seven delivery van to vehicles that he once owned. Given the private character of the museum, Gerry is also free to air strong and potentially divisive opinions on any of these subjects and to make comments about 'take-away music', the supposed idiocy of Americans, or the right-minded qualities of the coalition government. These disquisitions often begin and circle around his own experience but they often have a bearing on wider issues such as the lives of children who lived through the Blitz, the treatment of 'delinquent' teenagers, the acquisition of skills and knowledge, international trade, obsolescence, the demise of the British manufacturing industry, and the lives of the elderly in contemporary society. Beginning with the personal, his comments and the ensuing discussions also encompass issues of more general social interest, particularly the shift towards digital broadcasting, and on my subsequent visits the museum's supporters variously commented on how frequencies have been sold off to private companies, on the profits thereby accrued, and on the diminishing sound quality of radio.

Conversely, visitors are treated as guests and this obliges them to behave in a certain manner.[32] In this case they need to be alert to Gerry's well-being and level of energies and they cannot insist that the tour continues or that they see particular sections of the museum. If appropriate they may help with the preparation of tea. Above all, however, the etiquette of home visiting necessitates attention and response. Visitors are expected to listen to their hosts' stories, prompting where necessary, and to join in the conversation, contributing anecdotes and opinions of their own. Even if they disagree with Gerry's sentiments, the circumstances make it difficult for visitors to entirely ignore their host or to reply abruptly. Although they are at liberty to signal their disapproval, visitors must do so with some tact and steer discussion onto other subjects, ask questions, or move on to the next exhibit. Equally, the hosts cannot (entirely) ignore their guests and everyone has the opportunity to consider the implications of what each other say, see, and hear.

In major museums visitors are presented with a pre-formed narrative. If they do not like the opinions or version of history expressed in the labels

or wall texts, they can leave comments in the visitors' book or write to the curators but there is rarely any opportunity for a more sustained exchange. If the Vintage Wireless Museum had adopted the conventional forms and practices of a public sector museum, storytelling would similarly be a predominantly one-way process. As it is, the discussions that take place are collaborative, they develop according to the identity, interests, and knowledge of the individuals concerned, and visitors to the Vintage Wireless Museum play an active part in establishing the exhibition narrative.

Simultaneously open to the public *and* a domestic space, the Vintage Wireless Museum creates a space for the moderated exchange of views and for interaction between strangers who may disagree on certain issues. Indeed, it is partly because the museum is a home, and thereby prompts the hosts and visitors to adopt a diplomatic form of conversation that it can operate as a public sphere.

Micromuseums as public spheres

Not all micromuseums function in such a manner. There are plenty of venues where the proprietor delivers a pre-rehearsed spiel and has little time to interact with others. Nonetheless, many owners, employees, and volunteers do engage with visitors on a one-to-one or small group basis. These micromuseums are not always located in the home but they often occupy private premises and the staff adopt a similarly interactive stance in relation to the collections. As at the Vintage Wireless Museum conversations usually begin by focusing on individual exhibits or the theme of the museum but segue into wider matters. When I visited the Colbost Croft Museum the curator and I talked at length about rural unemployment and population migration, and at the Bakelite Museum we had a long conversation about conceptual art, sculpture during the 1970s, and their relationship to capitalism. In Chapter Three I report on a lengthy discussion about republicanism that I had with the proprietor of the Lurgan History Museum.

The Vintage Wireless Museum and other micromuseums do lack the political muscle that characterized the groups described by Habermas, but this does not disqualify them from being considered public spheres. To use Nancy Fraser's term, micromuseums are 'weak public spheres' where the participants can air or formulate their views but have no direct access to power or clear means of making their views impact upon future legislation.[33] Micromuseums are also small. They do not play host to many thousands of people, but then the coffee houses that enabled the development of the eighteenth-century English public sphere were also small-scale ones. The first such venue to open in London comprised of little more than a shutter for shelter and a brazier to heat water but for Habermas, the size

of the premises or audience was irrelevant because no matter how small the gathering, the participants in conversation understood themselves as members of a wider public. [34] In twenty-first century micromuseums, the staff, volunteers, and enthusiasts often see themselves as members of special interest groups, which is to say a specific public. Like the men who attended eighteenth-century coffee houses they subscribe to journals or papers, join clubs, and meet to comment on matters of concern. The status of museums as public venues means that members of the general public can also visit and find out or contribute to these discussions.

The domestic or semi-private nature of these premises may also be considered a stumbling block to conceiving of micromuseums as public spheres but, along with coffee houses, Habermas took salons as a model for the eighteenth-century public sphere and these were often held in houses of the bourgeoisie. [35] Following this logic, micromuseums that are located in private homes, can be understood as twenty-first-century versions of salons. Although some strictures are in place (at the Vintage Wireless Museum these principally concern American visitors) and micromuseums are not equally open to everyone, arguably they are still more accommodating than the eighteenth-century salon because their audiences extend beyond the educated and bohemian upper classes.

Micromuseums, then, can operate as independent zones for the exchange of views and discussion on matters of concern. Possible and actual public

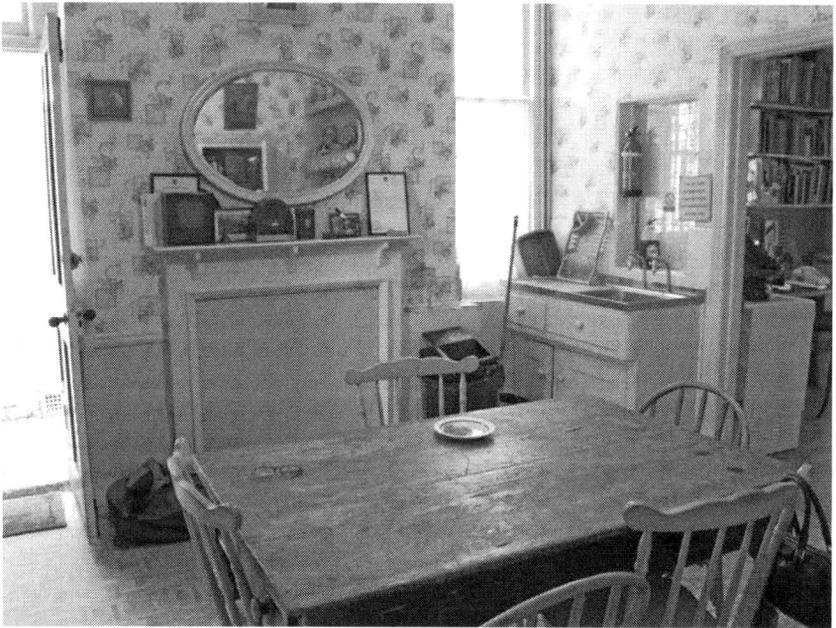

FIGURE 1.7 *Kitchen table, Vintage Wireless Museum.*

spheres, they can be conceived in still more precise terms. The Vintage Wireless Museum is not just a convenient meeting space. Rather the objects provide both the stimulus for conversation and the means to attract visitors. Enthusiasts are enticed by the sheer quantity and range of audio-visual equipment, the merely curious are attracted by the array of charming objects, while journalists, broadcasters, and academics recognize a hook for an article or a programme that is in turn viewed or heard by others. The collection generates a public who engage in conversation.

Hannah Arendt described work as the activity that corresponds to the human capacity to build and maintain material things. It is, she observed, the process by which we transform nature into artefacts that constitute the physical world for political life. To illustrate her point she imagined a table that lasted long enough to provide a site for discussion. The table is a place where people could draw together but it also separated them; arrayed around its edge their differing intellectual or emotional perspectives became manifest.[36] The Vintage Wireless Museum and other comparable micromuseums could be viewed in similar terms. The objects, the labour that has gone into collecting and maintaining them, and the work involved in opening a museum combine to create a context that stimulates diverse individuals to meet and converse. They are relatively stable places wherein distinct views and opinions may be broached. Rather than being conceived as forums which suggests an expansive, open, and obviously public space, micromuseums are better compared to tables such as that in Gerry's kitchen (Figure 1.7), where the family and strangers gather to tell their stories, air their opinions, and, possibly, to plan action.

CHAPTER TWO

Vital objects: How to keep museum exhibits alive

The Museum of Witchcraft in Boscastle, Cornwall (Figure 2.1), concentrates on the 'wayside' or 'hedgerow' magic that is associated with wise-women and rural life. Within this tradition, which involves healing, protection, divination, curses, charms, and weather working, objects are often thought to possess magical power.[1] Some things – usually glass bottles or balls filled with colourful materials – are made to capture spirits that may offer help to the holder. Other objects – such as the museum's Cock Rock fertility charm – are considered to be inherently magical or they can become so. A shoe that has been enchanted in order to control its owner belongs to this latter category, as do oyster shells incised with love charms. According to practitioners of witchcraft these things can continue to have power long after their spell has been cast.[2] They do not revert to ordinary things once their influence has been wrought.

The museum has a large collection of such objects and visiting witches regularly attest to their potency. In the collection of essays published to mark the museum's sixtieth anniversary, a contributor called Arizona remembers 'feeling that everything behind the glass was alive', while Judith Noble recalls 'a black glossy bag in a black glossy cup, a phallic stone, a box studded with pins, two bees in a bag, horn cups [. . .] All were made for magic [. . .] They had their own logic and what mattered most was that they exuded a strength; a power that flowed out of them through the dusty glass cases and into me'.[3] Given their world-view, it is expected that witches would feel that the collections were powerful but it is surprising to discover that non-practitioners often respond in similar terms and over the years the proprietors have received several letters from visitors who neglected to leave donations and subsequently suffered misfortunes. Mrs Holly Janek declared that 'While we are not normally superstitious, one of my sons feels

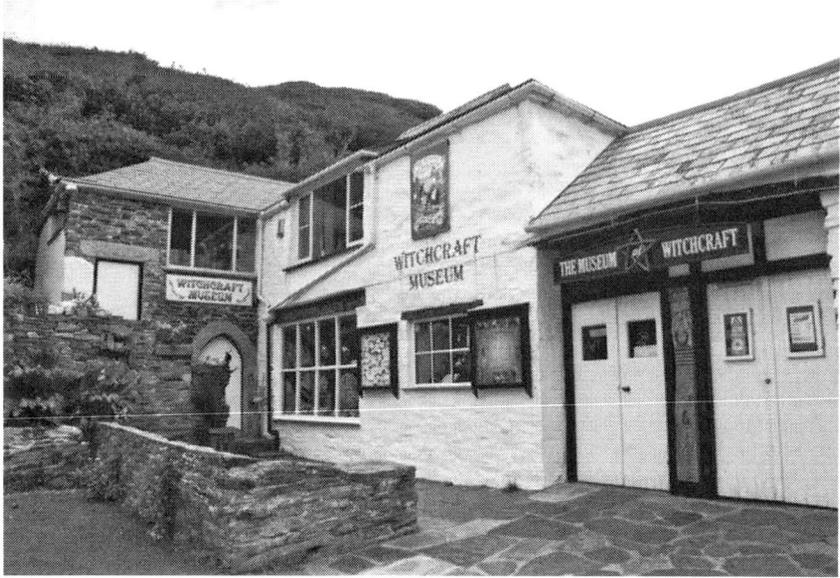

FIGURE 2.1 *The Museum of Witchcraft, Boscastle, Cornwall.*

that it may be prudent after all to make up for the omission and our belated contribution is enclosed.'[4] Mr M. wrote to say that he had 'laughed at the poem on the witches collection box and didn't give a coin', which he had since regretted because in the two weeks that followed his visit to Cornwall he contracted food poisoning, slipped a disc, and suffered an inflammation of the knee. 'Please do me the favour of accepting these coins', he entreated the owner.[5] More recently, a series of walking sticks have arrived by post. The museum provides them for visitors should they decide to venture onto the steep coastal paths which lead up from their doorstep, but asks that they be returned. Wives often send them back on behalf of their husbands, with apologies and accounts of recent tribulations.

The museum's comments box is also full of notes that employ the term 'scary' or otherwise remark on the potency of the exhibits. Reeling between pleasure and shock an anonymous tourist stuttered 'It was very nice. I can't believe my eyes. It is an abnormal museum 10/10', while 'Clare' wrote 'I believe in witches now'. Chris from Essex declared 'Some weird and wonderful items and may God keep us safe', and another contributor found the museum frightening because 'you never know what the voodoo dolls are doing at this very moment in time'.[6]

These responses are striking because museum exhibits are often assumed to be inert and in need of revivification. Writing on the National Museum of American History website, the education specialist Jenny Wei comments that 'most history museums face the challenge of bringing objects to life'.[7] Her strategy involved one of the institution's landmark exhibits, the John

Bull locomotive, temporarily being put back into service. Museum staff, dressed in period costume, fired up the train and filmed it being driven along a track, subsequently using the video for an education programme aimed at school children.

At this institution, the process of 'bringing objects to life' involved hands-on interaction (driving the train and being able to touch it in situ) and educational material on the social history of the train's production and use. When the National Museum of Scotland 'identified five subjects they wanted to bring to life' they also organized hands-on events and designed interactive digital materials that provided background information for each exhibit.[8] The British Museum took a slightly different tack in their 'Talking Objects' programme which has been re-run in other UK museums. Focusing on a Neolithic bone carving known as 'swimming reindeer', young people from Westminster Kingsway College worked with curator Jill Cook 'to take a closer look at this magical object. As part of this project the young people created a performance to bring the object to life'.[9]

In contrast, the Museum of Witchcraft does not employ any of the tactics commonly used to resuscitate objects. There are no digital materials, no educational resources, and the majority of its exhibits are presented in old-fashioned wood and glass display cases that were acquired from the Natural History Museum when it refurbished its galleries. The only interactive provision consists of a reconstruction of a stone circle and a coin-operated tarot card reader. The visitors' responses to the Museum of Witchcraft exhibits also differ significantly from other instances where objects are perceived to be powerful. In her book, *Making Representations*, Moira Simpson explains that Maori, Australian Aboriginal, and Native American communities believe that some objects have a life-force and need to be cared for appropriately, whether they are located in museums or elsewhere.[10] Crucially, however, only members of the correlative communities consider these museum artefacts to be animate beings or to be imbued with strong, spiritual powers. As Simpson remarks, the vast majority of viewers think that they are inanimate objects that vary in significance and status according to each individual's perspective. To the collector they may be curiosities or valuable works of art, to a curator or anthropologist they provide evidence of cultural traditions or religious beliefs while 'they may well be of no more than passing interest' to the museum visitor.[11]

A similar dynamic occurs with regard to museum exhibits from a Christian tradition. As part of her PhD research on museum visitors' engagement with the divine, Steph Berns observed and interviewed visitors at the British Museum's 2011 exhibition *Treasures of Heaven*, which focused on sacred masterpieces of medieval Europe. Berns noted that some Catholic and Eastern Orthodox believers meditated or prayed in front of exhibits and touched crosses or pictures to the glass display cases in order to produce 'contact relics'. For them, the objects on exhibition provided a means of making active connections with the saints and ultimately with

God. Other attendees did not respond similarly, indeed Berns found that over-hearing the sceptical comments made by non-believers sometimes disrupted the spiritual encounters of devotees.[12]

Practitioners and believers similarly perceive the Museum of Witchcraft's collections to be powerful, but importantly visitors who are not affiliated to that community or belief-system share their view. This situation is analogous to a European museum visitor seeing a carved ahayu:da on display and being struck by the presence of the Zuni war god that it embodies, or a Hindu visiting the *Treasures of Heaven* exhibition and feeling that they must acknowledge the power of the Christian God. Given this anomaly, it might be tempting to ascribe the obeisant responses made by erstwhile non-believers to the objects' reputedly magical properties, but many public sector museums display similar objects without them having comparable effects. Although the British Museum holds the Elizabethan astrologer Dr John Dee's black scrying mirror and the National Museum of Scotland has a collection of objects used for cursing, they do not prompt visitors from other faiths or with no religious affiliation to declare a newly discovered belief in witches. According to a curator at the latter museum, they elicit a slight frisson or shiver at most.[13]

Why, then, do visitors who are 'not normally superstitious' feel the artefacts at the Museum of Witchcraft to be potent? What qualities does the Museum of Witchcraft have or what does it do to achieve this end? In order to address these questions it is important to first understand why museum exhibits are conventionally considered 'dead'.

Killing the artefacts

The idea that museums neutralize their collections dates back to Antoine-Chrysostome Quatremère de Quincy, who began writing on the subject as the first public art galleries were being founded. During the French Revolution religious monuments were torn down as were those connected with the monarchy and while some carvings were destroyed, others were removed for safekeeping to the newly formed Museum of French Monuments.[14] At the same time, sculptures looted by the French Army as it conquered the Austrian Netherlands, Flanders, and the Italian peninsula were flooding back to Paris, and in 1796 Napoleon made the surrender of artworks a condition of armistice.[15] Artworks by Rubens, Van Dyck, and Flemish masters were duly seized from the vanquished states and brought in triumph to the newly opened Louvre.

Quatrèmere was voluble in his criticisms of such removals and focusing on classical sculpture, argued that carvings were inextricably linked to their surroundings. To illustrate his point Quatrèmere imagined a temple located in a sacred grove. The outside of the building was entwined with roses and

myrtle, while inside it was resplendent in purple and gold. A mysterious veil hung at the centre of the room, and then when sacred music played the curtain dropped to reveal a statue of a deity standing amid clouds of perfumed incense, or as Quatrèmere puts it, 'the goddess suddenly blazes on the sight'.[16] Here, the effect of the carving relied on the setting, on the accompanying sensory experience of music and scent, and on the spiritual framework within which the sculpture was situated. The devotee's faith in the deity amplified their aesthetic response, while conversely the allied sensory pleasure reinforced their belief.

According to Quatrèmere the principal function of these carvings was to produce and maintain religious commitment, and prised away from this structure of worship, stripped of social utility, they lost their ability to 'appeal to feelings', becoming 'mere matter'.[17] 'How many monuments owe the loss of their powerful effect to their being removed from their original situations!' lamented Quatrèmere. 'How many works have lost their real value in losing their use!'[18] Museums, he wrote, 'kill' art in the name of historical investigation. 'It is a living being attending its own funeral' he announced. Museums do not write the history of art, 'but its epitaph'.[19]

One objection to Quatrèmere's rhetoric is that antique statuary had long since lost its ritual function. Even if it remained in the place for which it was made, it would no longer be appreciated in the manner he described. Anticipating such a charge Quatrèmere argued that objects also had a specific relationship to their immediate physical surroundings. For him, the glory of the Temple of the Sibyl at Tivoli was not simply the architecture but its position on a precipice, 'where from abyss to abyss the roaring Anio' flows, gilded by the solar ray, relieved by the azure sky' and surrounded by the ruins of ancient Rome.[20] Now imagine, wrote Quatrèmere, if the temple was taken piece by piece and erected in the middle of a Parisian garden. 'Under a different sky', he stated, it would become 'silent and ineffective'. [21]

Although Quatrèmere referred to classical sculptures as 'living beings', he did not mean that they were animate in the same way that the exhibits at Museum of Witchcraft are considered to be. Nor was he saying that museum collections are entirely without effect or interest, although the idea of 'killing' something might suggest that. Rather, he contended that taking objects from their original context changed their status and the way that they are perceived. Museums enable antiquarian interest or scholarly erudition not aesthetic, emotional, spiritual, or imaginative engagement.

Quatrèmere's proposition has been repeatedly reworked, perhaps most notably by the Frankfurt School philosopher Theodore Adorno.[22] Remarking that 'museums are like the family sepulchres of works of art', Adorno agreed that objects were altered by their removal, but he differed from Quatrèmere in linking aesthetic effect to the gallery and not to daily life. To explain his position, Adorno conjured someone who lives in and knows every corner of an historic town, yet whenever visitors remark

on its beauty, replies with a peremptory 'yes, yes'. While the residents
are intimately familiar with each building and painting, they view the
architecture or art with some indifference, barely noticing it on a day-to-day
basis. The implication of Adorno's story is that museums place everybody
in the position of the admiring tourist who views the surroundings with
some remove. This conceptual distance creates the conditions for aesthetic
appreciation, effectively transmuting objects into 'Art', but because an
object's 'life' derives from being embedded in an environment, placing
things on exhibition also raises the question of their 'vitality'. This, says
Adorno, would probably never occur to anyone who was 'at home with art
and not a mere visitor'. [23]

Unless one adheres to a pagan or animist world-view, the idea of artefacts
living or dying is a conceit; a shorthand device to indicate their transition
from complex functional environments to exhibits. Museums also rely
on and generate systems of belief and their collections are still used, but
emotional, embodied, and spiritual responses are actively suppressed in
favour of aesthetic attention or historical analysis. Still the terms 'live'
and 'dead' are useful in that they abbreviate lengthy arguments, and more
importantly, because they provide a way of conceptualising and trying to
account for the otherwise elusive qualities of effect and response. If an
exhibit is 'dead' it means that the practices and responses associated with
its former functions have been sidelined and that scholarly and aesthetic
responses dominate. If, in contrast, an object is 'live' it has the capacity
to prompt reactions that are more appropriate to its former role in a non-
museum world – in this case as a magical instrument or spell. The notion
of 'dead' and 'live' objects also points to an object's putative ability to act.
Owing to its transposition into a gallery, the former type of object can no
longer contribute to religious feeling or aid in spell casting, whereas the
latter category of things retains that instrumental capacity.

In their discussions, Quatrèmere referred to gravestones, sarcophagi,
temples, pillars, chalices, monuments, carvings, paintings, architectural
features as being 'Art'. The American art historian Daniel Sherman
has suggested that the argument about museums killing objects could
encompass almost any kind of exhibit interred within a museum, but Philip
Fisher develops Adorno's point when he argues that museums actually
convert objects into Art.[24] For example, he writes, a warrior's sword may
have a number of uses. In battle it is a weapon, after his death it might have
ceremonial functions or be seized as loot and thereby become a symbol
becoming of somebody else's wealth and power. How it is understood
changes, although in each case it is a tool or an implement that functions
within a broader society and contributes to the formation of power
structures, religious life, or civic wealth. In the museum, however, the
sword is detached from a life-world that is thick with biography, exchange,
belief, and power. It becomes a piece of decorative art, or a purely historical
artefact, inciting neither fear nor respect.

Fisher's argument breaks away from the idea that the original context is the only valid one and instead places emphasis on the object's place in a changing repertoire of social practice. It is also important because he considers museums as agents in the process whereby objects 'die'. Quatremère and Adorno both suggested that objects lose their vitality partly because they are removed from a context of belief and use, and partly because they are separated from their original material environments, but also as a result of the conditions established within museums. Fisher gave further nuance to this latter aspect of the debate, pointing out that museums arrange objects chronologically or geographically, provide technical or historical information, avoid any extraneous decoration or sensory cues, and post signs instructing visitors not to touch. In doing so, they create 'a script that makes certain acts possible and others unthinkable'.[25] 'It would be 'an act of madness' Fisher writes, 'to enter a museum, and kneel down in front of a painting of the Virgin to pray for a soldier missing in battle, lighting a candle and leaving an offering on the floor near the picture before leaving'.[26]

At the Museum of Witchcraft, practitioners do light candles, some leave offerings, and others meditate. Many non-practitioners feel that they should proceed cautiously and with some due deference, at the very least. Understanding why this venue produces the emotional, spiritual, and embodied engagement that characterizes 'live' objects involves following the logic of Quatremère and Adorno's analyses and considering the qualities or connections that museums are presumed to lose. Accordingly, I investigate the museum's relationship to associated circuits of (non-museological) belief and practice, that is, to its immediate community and spiritual context. Then, in order to consider why visitors who are 'not normally superstitious' feel that the exhibits are potent, I examine the museum's 'script'. What forms of presentation keep these objects vital and make these responses possible?

A magical environment

The Museum of Witchcraft was founded by Cecil Williamson in 1951, the year that the Witchcraft Act was repealed. It was originally located on the Isle of Man, which is situated in the Irish Sea, mid-way between the islands of Great Britain and Ireland, but it moved three times before opening at its current site in Boscastle on the north coast of Cornwall. The first relocation was prompted by disagreements between Williamson and his partner Gerald Gardner while subsequent removals were a response to local antagonism.[27]

After leaving the Isle of Man, Williamson moved to Windsor, acquiring premises near the castle but the new museum had only been open a short

time when it was visited by 'two grey suited gentlemen from the castle'. He claimed that they offered him a good financial incentive to move again and he did so, this time to Bourton-on-the-Water in the Cotswolds. Here, the village priest preached on the evils of witchcraft, some residents staged protests outside the museum, the local press ran libellous articles, Williamson received death threats and dead cats were hung from trees in the garden until, finally, an arson attack destroyed one wing of the building and in 1961 Williamson shifted premises for the last time.

Williamson's early years in Cornwall were almost as fraught as his earlier ventures. The windows were daubed with paint and he claimed that a curse comprising of a dog's heart pierced with thorns was left on his doorstep, but local dissension gradually passed. He continued to run the museum until 1996 when, at midnight on Halloween, it was sold to Graham King.[28] Like Williamson, King also encountered antipathy from neighbours. Staff at the Boscastle Visitor Centre, which is located in the same building as the museum, refused to put his leaflets on display and a long correspondence with the neighbourhood heritage office ensued. Mention of the museum was omitted from tourist maps, the local authority declined to erect the usual brown signpost allotted to attractions and, in 1997, an application to open a small shop on the premises elicited numerous strong objections. In his letter to the planning office, a Mr Hague opined that 'the witchcraft museum has been the black spot of an otherwise beautiful place and to have its influence extended by a retail outlet would be a dreadful thing'.[29] His protests were echoed by the Rev John Ayling, the only protestor who actually visited the museum, and by the Methodist minister Rev Leslie J Barnes who opposed the proposal on behalf of his seven parishes.

Mr MacLeod, Elder of the Church of Nations in Camelford, was more forceful in his protests, writing of the 'dangers occultism and such matters often carry with it', and his parishioners appended a petition in support of his warning. Mrs Webster who ran the Harbour Light shop sent three letters, one of which claimed that 'over the years we have seen a disturbing increase in occult activity in this area', while a local preacher commented that 'there are some 300 witches and covens in Cornwall and to think of the evil effect it has on the community is unbelievable'. This correspondent took the opportunity to quote the verse from Ephesians that reads 'that in this life we fight not against flesh and blood but against Principalities and Powers of Darkness, Rulers of this World'.

Eventually though, the Museum of Witchcraft was given permission to sell souvenirs and today stocks a very small range of books, postcards, candles, and t-shirts. The irony is that many of the local shops were already selling merchandise pertaining to magic and entirely out-paced the museum in the range of products they offer, as they do now. 'Crafty' which is situated on the main street has a large window that is packed with clay models of wizards and hook-nosed witches wearing black pointy hats. Across the road is 'Rocky Road' which offers stone toads, a skull with Gothic decorations,

crystals, and dream catchers while the neighbouring store called 'Things' stocks a range of mugs that bear the legend 'I'd rather be in Boscastle' and a range of witch balls for protecting one's home against evil spirits. Contrary to the protestors' fears, however, this trade annuls rather than promotes witchcraft. Whereas objections to the museum selling supposedly magical merchandise credited witchcraft with having power, the current retail outlets offer commodities that align it with the caricatures of storybooks or with a benign interest in new-age topics. Witchcraft becomes a matter of gift-giving, interior decoration, self-reflection, or spiritual enquiry, and not a magical force capable of animating objects or bringing misfortune upon ungenerous tourists.

Nonetheless, the outcry shows that witchcraft is a contentious subject and is not simply a matter for history books. In their letters of complaint, the protestors pointed to the presence of witchcraft and 'occult' practices in the area.[30] Along with Glastonbury and Penwith, which is famous for its standing stones, the North Cornwall coast is an important locus for practitioners of neo-Celtic spirituality, a catch-all term for Goddess Worshippers, neo-pagans, druids, and advocates of Earth Mysteries (which encompasses ley lines, power sites, dowsing, and astrology), all of whom share in a continuum of belief.[31] The focus of their attention is Tintagel, a neighbouring village to Boscastle, where according to the twelfth-century-chronicler Geoffrey of Monmouth, the legendary sixth-century hero, King Arthur, was conceived and born. Later versions of the story identify the castle with Camelot and since advocates of Earth Mysteries connect Arthurian legends to the Zodiac, they treat the area as a site of spiritual power. Other practitioners of neo-Celtic spirituality concentrate on Merlin's cave, which is at the base of the Tintagel headland or visit the nearby village of Bossiney where two small carvings of labyrinths are etched into the walls of a valley. Close by is St Nectan's Glen where the sixth-century saint reputedly lived and its status as a pilgrimage destination is made evident by the makeshift altars, clouties (fabric-strips tied to trees), and offerings that decorate the site.

Since modern British witchcraft overlaps with these various interest groups and faiths and is similarly held to be a continuation of Celtic religions, the cultural geographer Amy Hale and the anthropologist Helen Cornish, argue that the sites at Tintagel and Bossiney, are functionally interrelated with the Museum of Witchcraft.[32] The Pagan Federation of Devon and Cornwall clearly see some concordance because they recently donated half of the proceeds of their annual raffle to the museum (with the other half going to the Woodland Trust).[33] Likewise, the people who protested against the museum extending into retail drew a similar conclusion: that the museum's collections are echoed by 'occult' practices in the area.

Whether it is viewed positively or negatively, the Museum of Witchcraft operates in an environment that is broadly consonant with its interests. Although individual objects may have been geographically relocated, its

collections are shown within a context that is congruent with their use. For Quatremère and later commentators, removing objects from a relevant working or functional environment was one of the factors that rendered them 'dead' and, following the same line of thought, the Museum of Witchcraft's location in an area that is a focus for neo-Celtic spirituality helps account for why the exhibits are perceived to be 'live'. Extending his point, Quatremère also argued that an object's 'life' was tied to the physical landscape in which it was housed, and just as the splendour of the Temple of the Sibyl at Tivoli was connected to its situation on the edge of a precipice, the Museum of Witchcraft is enhanced by its setting. More specifically, it prepares visitors to conceive of the collections as 'live'.

Visitors to Boscastle turn off the Atlantic highway and make their way along winding lanes bordered by stunted trees that grow away from the prevailing wind. The sea is momentarily visible from the crest of the ridge but the road turns sharply and plunges into a steep valley where ancient stone walls support the shale cliffs. Half way down the slope, car radios and mobile phones cut out, and the crackling signal followed by silence creates a sense of having stepped out of a modern, media-friendly world. The village itself is strung along the banks of two rivers that flow down the valley, converge, and run into a narrow harbour, which provides the only safe landing on this stretch of the north Cornish coastline. Oddly, the sea remains out of view. Beyond a medieval quay, the river winds its way between dark cliffs, twisting in a dog-leg and the tiny port appears to be land-locked when seen from the village. High up on the rocks above is a blowhole and in winter, water is forced through an underground fissure and erupts, sending spray across the inlet with a loud retort. It is known as 'the Devil's Bellows'. [34]

The museum is located at the mouth of the harbour. When I first visited, buzzards were circling overhead and standing at the riverbank with my back to the museum, I saw the water turn and flow uphill. It took half a minute, during which time I stood in fascinated horror, for me to realize that the tide had turned. Surrounded by high cliffs in the oddly claustrophobic village, I had forgotten that I was close to the sea and for that moment the usual rules of nature seemed not to apply. If water could run uphill, then witchcraft could be wrought. [35]

The Museum of Witchcraft

The experience of travelling to and reaching Boscastle is fundamental to visitors' understanding of the museum and its collections. To paraphrase the anthropologist Christopher Tilley, this landscape exerts its muted agency in relation to us. It makes an impact. [36] Moreover, even if museums are located in surroundings appropriate to their subject, their architecture

or presentational mode can still create a degree of dislocation. High walls, forecourts, flights of steps, ramps, or lobbies create buffer zones between the artefacts and adjacent spaces, while academic styles of interpretation can imply that the material belongs to another age or to distant others. The social and material environment is kept at bay. In contrast, the Museum of Witchcraft actively emphasizes its connections to the landscape and to the elements. At the front of the whitewashed stone building is the box holding the wooden walking sticks that visitors borrow when they set off along the paths that lead from the museum and up over the cliffs. Above the sticks, the museum's sign shows an old woman and two fishermen who have evidently taken the adjacent path for the picture shows them standing on the hillside above the museum. The woman is passing a knotted rope to the men, and the inscription 'Selling the Wind' indicates that it is an enchanted object; the sailors undo one knot to raise a breeze, two for a strong wind, and three for a tempest. The sticks gesture to the earth and the sign to the wind, and there is also a reference to water. Next to the top of the doorway is a green strip marked 'Flood Level 16/08/2004' the date when, after successive thunderstorms, the river Valency breached its banks and sent a wave of water surging through the village.

Stepping inside the museum, visitors find themselves in a small stone-flagged lobby at one end of which is a grotto that has been built around a natural spring. Lit by candles, scented with incense, figures of the Great or Mother Goddess are perched upon the ledges on the rock crag and a sign notes that it is a place for quiet contemplation. Unlike the exhibits that Quatremère describes, these collections have not been prised away from the habits and interests of the community. On the contrary, the museum is conceived in relation to its physical and spiritual context. Open to its surroundings, it is continuous with an environment that is closely associated with magical and spiritual practices.

For Quatremère and Adorno the life of objects is intricately connected to their surroundings and to their use. The objects must have a connection to that place, contribute to religious or civic life or be generally sewn into the warp and weft of a society's life. At the Museum of Witchcraft the exhibits are connected to the elements and to its immediate surroundings, but as the exhibition progresses, it gradually becomes clear that displays do not simply refer to witchcraft as it is employed outside the museum: rather, members of staff are witches and they use magic within the museum.

Having paid the entrance fee, visitors are directed into the first gallery, which presents a relatively conventional overview of images of witches, while the second room outlines the history of their persecution. The third room, however, has huge mirrors joined at right angles. In the space between them are three standing stones interspersed with branches and the floor is strewn with flat rocks. The illusion is momentary but striking: walking in, visitors see themselves standing inside a large stone circle (Figure 2.2). As

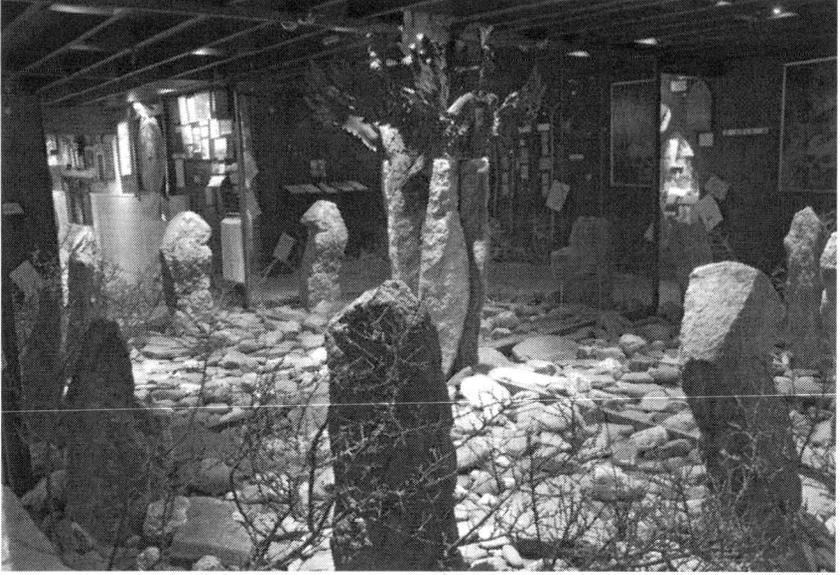

FIGURE 2.2 *Stone circle, the Museum of Witchcraft.*

if subject to a fleeting enchantment, they appear to have been transported out onto the moors.

The stone circle reiterates the museum's relationship to the locality and it also marks a change in the conceptual framework of the museum. From here onwards, the exhibition stops portraying witches as historical or literary figures and starts presenting witchcraft as a matter of fact. In the next display a series of objects are labelled: 'spell crafts by Kate McCarthy. Kate is making these protection dolls from horsehairs etc. She also makes herbal remedies, cat-calling oils, horse enchanter oils'. Similarly, a notice pinned outside the recreation of a wisewoman's cottage reads:

> The spells Joan speaks are traditional and collected locally. Many are still used by witches today. Please don't be frightened of witches. Most are like Joan and believe in helping, healing, and in harming no-one.

The references to living witches and the use of the present tense, which continues throughout the museum, situate witchcraft in the contemporary world and assert that the exhibits are not simply historical artefacts but belong to a continuing tradition. This perspective prepares visitors to conceive of the objects as functional, possibly functioning, and, indeed, subsequent displays are presented in these terms.

In the upstairs gallery are cases containing objects used for cursing and for protective magic (Figure 2.3). The former display includes a number of

FIGURE 2.3 *View of upstairs gallery, Museum of Witchcraft.*

poppets – the name given to dolls made in the image of an individual. One poppet which has a large pin through its mouth, is wrapped in thorns, and was made to stop an ex-lover from gossiping after the end of an affair had originally belonged to the Museum of Pagan History in Glastonbury, but because it was believed to emit such strongly negative energies, they decided that it was more appropriate to place it under the control of the Museum of Witchcraft. The implication, of course, is that the Boscastle staff can control the poppet and that they are more capable of doing so than the curators at the Museum of Pagan History. Indeed, so many individuals and organizations have sent King potentially troublesome items that he considered holding an exhibition of objects that their owners considered too dangerous to keep. [37]

The poppet shares space with a number of other items including things that were removed from Williamson's house after he died. One object consists of a forked stick in which is lodged an effigy of a face made with wax and human hair. The accompanying label informs readers that Williamson's family asked the museum for help in clearing away his magical tools and the staff found this in the centre of an upstairs room. Recognizing that it was a spell in process and believing it to be potent they used magic to protect themselves and cleanse the room before removing the spell and bringing it to the museum. They did not, the text informs us, know at what or whom the curse was directed.

In order to further contain or defuse potentially malevolent spells, the curators employ modes of magical defence within the galleries. The

exhibition of protective magic informs visitors that hagstones – naturally pierced stones – avert malevolent spirits, while lemons that have been woven about with red string can absorb curses: their power is destroyed as the fruit withers and blackens. Likewise, labels note that glass witches balls can capture troublesome spirits and mirrors can deflect negative energy. Looking around, visitors may notice that these objects are not only the subject of the exhibition but are used within the galleries. Mirrors line several cabinets, lemons suspended in woven strings are hung above the case of curses, and a group of poppets have been laid on a large flat hagstone.

The cases containing curses have also been placed directly opposite those containing protective magic and Graham King confirmed that the arrangement is intended to ensure both conceptual and magical balance.[38] One of the most alarming objects in the museum is an exquisitely rendered rag doll. She has minutely embroidered blue eyes and pursed pink lips, and a small dagger obtrudes from her red nurse's uniform with its white apron (Figure 2.4). It was made to induce a miscarriage. Another poppet – the name given to dolls made in the image of an individual – has the same function, but countering them, a spell in the facing case was worked to maintain a pregnancy. Made by a local witch, this spell comprised of a swift wrapped tightly in the bedclothes used when the woman lost a previous child. The bird has been offered in exchange for the child's life to come. Likewise, the case of curses contains a dog's heart that has been stuck through with thorns and there are similar objects in the collection of protective magic. Placing protective objects opposite the display of curses implies that both forms of magic are functional: that the curses need managing and that the protective spells do so. The curation suggests that both types of objects are operational, that they are in this sense 'live'.

The tenor of the exhibition changes again in the penultimate room. As before, the texts reinforce the idea that magic is a matter of daily practice and that the staff are experts, but additionally, several of the labels suggest that the visitor could potentially require magical assistance and proffer advice on how to achieve it. A display on sea magic notes that King sold the wind to a sailor who found himself becalmed in the bay and thereby reiterates the magical proficiency of the staff. Additionally, however, several of the labels suggest that the visitor might potentially require magical advice or assistance. One label written by Cecil Williamson tells visitors that they should never open a witches' charm bag while another reads: 'If you conjure up a spirit what do you do with it? Kate Honiton filled this lace-maker's globe magnifier with hundreds and thousands and invited the spirit to make itself at home.' Williamson's question can be interpreted as rhetorical or as an actual query: what would you do if you conjured a spirit? He then offers a suggestion – you could make a house

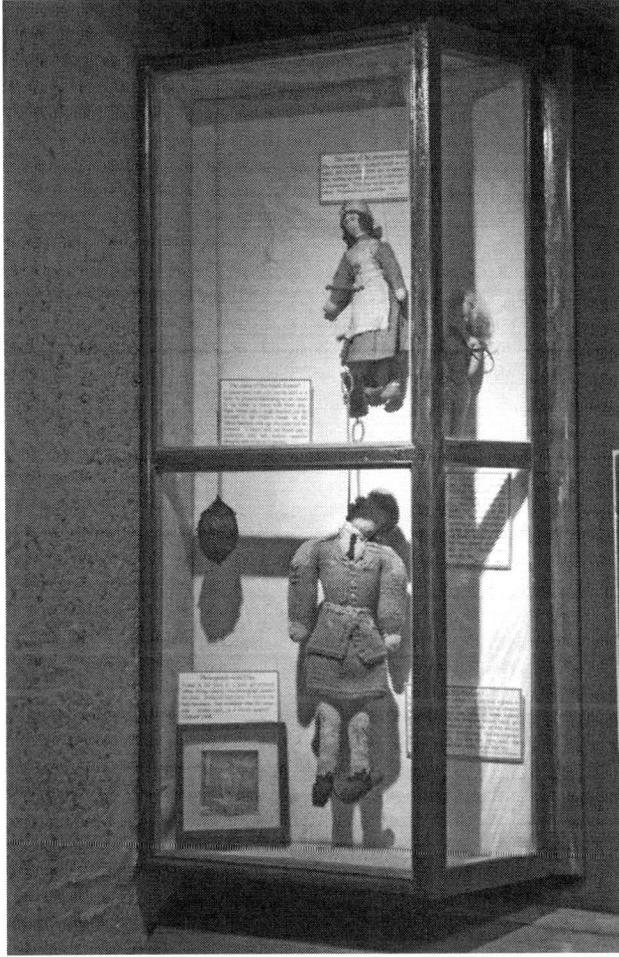

FIGURE 2.4 *Nurse poppet hanging above WAF poppet,*
Museum of Witchcraft.

filled with shiny things to distract and amuse it. Other notices similarly instruct the reader:

> Candle magic is simple, effective and popular.
>
> Carefully choose the colour of a candle and inscribe a rune, name or magical sign in the wax or magically charge a pin or two and push them in. Light the candle at an appropriate time and watch it while meditating on the desired outcome. This forms the basis of many a powerful spell.

While several of the displays indicate that practitioners use the objects, these labels implicitly invite the visitor into a community of practice.

That invitation is repeated more forcefully in the display on sea magic. The main panel announces that the Church considered all tempests to be the work of the devil and his minions, the witches. They found their proof in the fact that the witches 'frequented vantage points, set high up on the cliff tops when seas and storms were raging. There in unison and harmony with the storm, they swirled and turned, shrieking and howling into the face of the wind'. The text continues:

> Yes witches did and still do dance with the wind in high places above the sea. You should try it some time. It is an experience never to be forgotten. I can guarantee that you will be carried away by the wind. You will experience greater emotional release and revelation than is obtainable through the most potent, and lethal, of drugs. For you have cast yourself into the arms of the universal creator.

Thus, the text invites visitors to join the witches, to act, and to feel as they do. The tense then changes at the end of the passage. 'You *have* cast yourself' into the wind. Williamson proposes that it has already happened, that the visitor has decided to take a leap into a magical world and they have joined the group.

As they are about to leave, visitors might spot a small note pinned to a rabbit skin amulet. The text admits that the museum staff do not know the object's exact purpose, adding 'if you are familiar with this type of charm please let us know'. Of the 50,000 people who come to the museum every year, approximately one-third are pagans and it is likely that someone will be able to identify the charm, but the text also includes people who are non-practitioners. It credits them with magical knowledge.

The Museum of Witchcraft takes its visitors on a journey. It begins with a history and then shifts its conceptual framework. Once visitors have passed through the stone circle, the museum intimates that the world might not be entirely amenable or subject to reason. It suggests that magic is in everyday use and presents spectators with objects that are understood to have powerful functions or effects. It gives visitors some strategies for coping with such forces and assumes that they may want to use them. It then addresses them as if they have already joined the ranks of the witches and can contribute to the museum. To adapt Adorno's image, then, visitors to the Museum of Witchcraft are like tourists who come to visit an ancient town. Indeed, most of the visitors *are* tourists and they start by looking at the exhibits as though viewing carvings that have survived from ancient days. They are then welcomed into the buildings and are given the opportunity to see and experience these objects from the perspective of a resident. Instead of being distanced from the exhibits, the visitors start to view them as part of a functioning environment. Finally, they are tacitly invited to stay.

Life elsewhere

At the Museum of Witchcraft, the architecture connects the collections to a wider environment, while the curation and labelling locates the objects within an ongoing community of practice. In presenting the exhibits as functional and integral to the habits and interests of the witches, the museum implicitly grants permission for practitioners to treat it as a resource and as a site of pilgrimage. For many contemporary witches the museum does not displace objects from a context of use; it *is* a sphere for practice and their responses are more akin to ritual than they are to a conventional museum outing. Non-believers register this 'script', and recognizing that witchcraft is part of contemporary life within that area, judge the magical objects to be powerful.

The museum creates a situation in which the objects are live in the sense that Quatremère and Adorno meant. In this specific display the objects were used with magical intent and so, in creating the conditions for 'life', the exhibits are felt to be powerful or animate. Importantly, it would be a mistake to think that the objects are live because their provenance is magical. Rather, the perception of magical potency is predicated upon the recognition of the objects' utility and agency.

If, then, the collections at the museum are felt to be live because of their continued use and their connection to a relevant group, the same conditions could apply elsewhere. In order to develop that point I will briefly discuss two further micromuseums that are not connected with magic or with spiritual belief. Again, I will consider the ways that their collections are perceived to be vital.

The Valiant Soldier is in the small village of Buckfastleigh, Devon, and it ran as a public house from 1813 until 1965 when the brewery withdrew the license. On the final evening, when the last customers left the premises, the landlord and lady, Mr and Mrs Roberts, simply shut the door behind them and retreated to the upstairs accommodation. Mr Roberts died in 1969 but his wife, Alice stayed there until 1995 when the building was offered for sale. On gaining access to the premises, local residents realized that the pub had remained untouched and that the flat was relatively unchanged. Anxious to keep this time capsule intact, they successfully campaigned to open The Valiant Soldier as a museum.

Visitors buy their tickets in the modern reception block next door to The Valiant Soldier and are then left to enter the inn alone. They step onto the hard dark red linoleum floor of a hallway, which has one room to either side. A brown door with stains around the handle leads to the public bar where long wood benches are fixed against two of the walls (Figure 2.5). Heavy plastic ashtrays, filled with the butts from unfiltered cigarettes, rest on the tables, while two unwashed beer glasses, a packet of cigarettes and some matches stand on the bar, behind which are rows of optics, still half

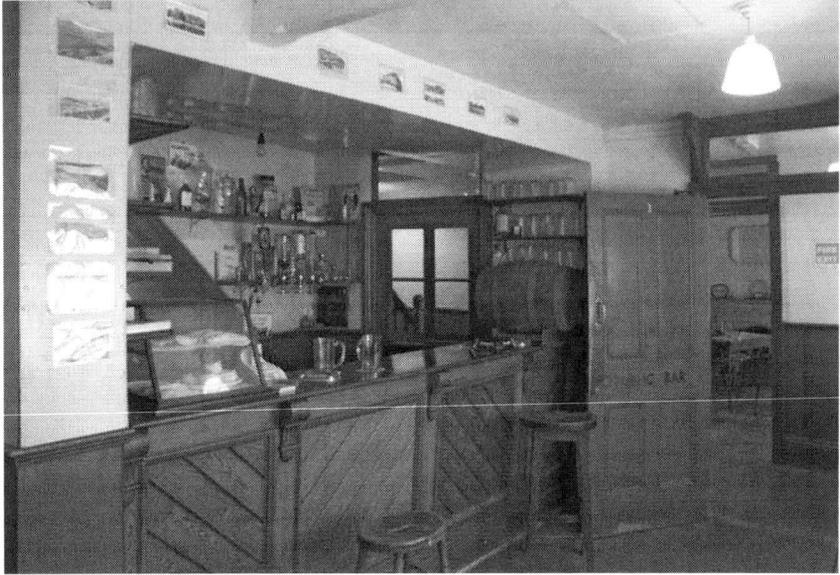

FIGURE 2.5 *Public bar, The Valiant Soldier, Buckfastleigh, Devon.*

filled with spirits. On the other side of the hallway is the 'ladies' snug' which has a number of faded Lloyd Loom basketry chairs and tables arranged in front of a 1930s tiled fireplace.

An audiotape plays quietly in the bar. It features men talking in Devon accents and snippets of news programmes read in the plummy tones of 1950s broadcasters. A recording of people who remember drinking in the pub can be heard in the snug, but neither of these sound-tracks conjures the presence of customers so much as the ingrained odour of tobacco smoke and the fainter aroma of bitter beer. The smell has not been artificially enhanced and as the volunteers threw almost nothing away, the cigarette butts are those that were left behind on the night that the pub closed. Sandra Coleman, the volunteer museum manager, commented 'sometimes the smell is stronger than others, as if someone's been in here overnight'. Laughing slightly nervously, she said she often wondered if anyone else had a key and had let themselves into the building, only to disappear out the back entrance when she arrived in the morning.[39]

Behind the bar is a steep uncarpeted flight of stairs that lead up to a narrow landing. A door opposite the head of the stairs stands open to reveal a small dimly lit room with a queen-sized bed that has been made up in white flannelette sheets and a blue satin counterpane. A cotton nightdress has been casually folded on the pillow while lacy and crocheted bed jackets hang over the headboard. Hatboxes and hats have been stored on top of a small wardrobe and a row of worn shoes is lined up beneath. An alarm

clock, bible, various pamphlets, a glass water bottle, saucers, and other odds and ends sit on the bedside table while the dresser bears a similar array of clutter.

Throughout my visit I had a strong sense of intruding into someone's private space. Afterwards Sandra concurred and remarked that every morning she felt 'like someone will stop and ask me what I'm doing here'. This sense that the building is still occupied and at any minute the owner may return to question our presence is created by the museum's relation to its surroundings and to other aspects of its 'script'. Although mainstream museums often arrange rooms in period style these exhibits are framed by the infrastructure of reception desks, explanatory panels, directional signs, and conventional galleries. At The Valiant Soldier, visitors buy their ticket at a separate tourist centre and then step directly from the high street into the pub. On first arriving there is no indication that the venue is in fact a museum, and with the exception of a low and very discreet Perspex screen to prevent visitors from sitting on the basket chairs in the ladies' snug, the rooms have been left unprotected.

Visitors not only enter the pub by themselves, but are often left unaccompanied for the duration of their stay. The venue is run by volunteers so the building is sometimes left unstaffed, and with limited resources for publicity, the venue only attracts audiences of 2,000 or 3,000 people per annum. If there were guards, other tourists, or actors playing roles (as they do in the recreated houses at the Blists Hill Victorian Town in Ironbridge Gorge), then their presence would legitimate that of the lone visitor. Even mannequins would be reassuring since they would point to the simulated quality of the experience, but as it is, wandering through the unpeopled building feels close to trespass.[40]

The feeling of intrusion is also connected to the venue's sensory cues and to the mass and disposition of the objects. There are shoes and cosmetics for different occasions and several bed-jackets, providing Mrs Roberts with a choice for warm or cold nights or allowing her to wash one while wearing another. Some of the objects are slightly misplaced: an old pipe has been left in the china cabinet, a tea-towel is draped across the back of a dining room chair, and an ironing board stands next to the living room sideboard. It is as if the residents had been in the process of using something and deposited it wherever convenient, as one might at home. These objects have also been worn. Nothing has been drastically restored, thoroughly cleaned or replaced with new. The shoes are scuffed and moulded to the shape of Mrs Roberts's feet, the soap in the bathroom is half-used, and the doors are stained with the grease of repeated touch.

Although some outdoor folk museums have buildings that are left unstaffed, are free of mannequins, and which may be relatively quiet, their rooms generally feature indicative objects rather than being recreations of inhabited space. Those that do simulate a domestic environment, such as the Skye Museum of Island Life, which Sharon Macdonald has discussed,

tend to use mannequins.[41] Historic houses have unstaffed, furnished rooms, and rarely include dummy-figures but everything remains in its correct and logical place and there is little personal litter or strong odour. Here the combination of minimal institutional infrastructure, unattended rooms, the smell of tobacco, beer, and cold tar soap, the densely packed and mismatched accoutrements of daily life, and the signs of wear create the sense that the owner has only just stepped out of the flat. These objects are perceived to belong to someone, to be embedded in an environment and part of an ongoing intimate life, and hence to be vital.

Twenty miles east of The Valiant Soldier, motorists pass a police notice that reads 'No stopping on this road'. The sign is there because, from this vantage point, there is a clear view across the moors to HM Prison Dartmoor. The road continues on through Princetown, where most of the officers live, skirts the penitentiary walls, and passes a barricaded entrance before reaching the old prison dairy where the museum is located. Identical blue metal signs, each printed with a white crown and lettering which reads 'HM Prison Service' and 'Dartmoor Prison Museum' are positioned on either side of the heavy double doors while numerous concrete garden ornaments are rather incongruously arrayed across the forecourt (Figure 2.6). Several ornaments depict idyllic country cottages, others read 'welcome', and a set of three painted pigs enact the phrase 'See no evil, hear no evil and speak no evil'.

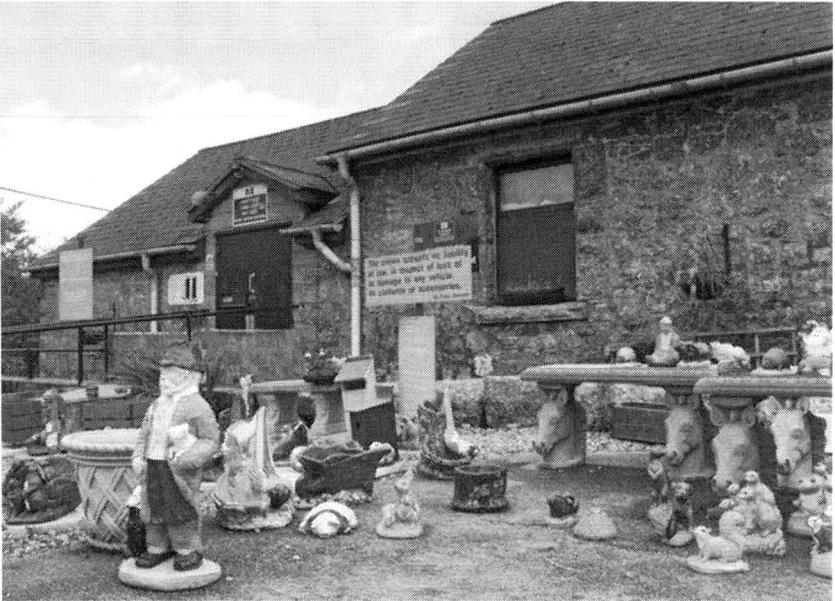

FIGURE 2.6 *Concrete garden ornaments, Dartmoor Prison Museum, Princetown, Devon.*

Inside the museum the temperature noticeably drops, the granite walls resisting any warmth from the sun. More garden ornaments are arrayed around the reception area along with a price list and a note that informs visitors that they have all been made by inmates. A man in uniform stands at the reception desk and as I pay my admission fee, he introduces himself as an ex-officer who worked at the prison 'across the road' for thirty-nine years. Unprompted, he tells me that the prison was never a high security unit but a hard-labour camp, that it was notorious for the severity of its regime, and that it had housed some of the most dangerous of British criminals.[42] Continuing his introduction, the ex-officer explains that when inmates have been 'D-catted' (those who can be trusted not to escape and are designated 'Category D') they are allowed to work under supervision at the current prison farm. If this assignment progresses smoothly then the inmate can be employed outside of the prison grounds at either the guards club or at the museum where they clean, undertake maintenance work, build exhibitions, and write labels as required. Recounting this information leads the ex-officer to an anecdote about an elderly woman visitor who prodded one of the prisoners with her finger and asked him what he was in for. The prisoner replied 'being stupid' and the ex-officer commented: 'I know him, and what he did, and I wouldn't have poked him in the back'. His implication is that men who were and may still be dangerous are working in the building.

The exhibition itself consists of a number of cases containing a mish-mash of objects and images pertaining to the prison. One cabinet displays tiny carvings that the French prisoners of war, who were incarcerated in the first decades of the nineteenth century, made from bones and fruit stones. There is a tunic button from 1879 and trophies from prison competitions although it is unclear if the inmates or the officers won these cups. A collection of contemporary improvised weapons includes a plastic toothbrush that has been sharpened to a point, razors set into toothbrushes and sticks, and a shard of black plastic that has been bound at the blunt end to create a handle and which resembles a giant claw (Figure 2.7). This display also includes makeshift tattooing equipment constructed from biros and batteries while the neighbouring exhibit is devoted to items of restraint and punishment that are no longer used. Escape tools smuggled in by recent visitors, tobacco tins with hidden sections for smuggling contraband, and equipment for smoking cannabis or crack cocaine are shown alongside photographs of a nineteenth-century flogging frame in a room full of shackles, and an early twentieth-century restraint book that lists the names of prisoners who were kept in lock-down.

The combination of historic and contemporary objects conveys the impression that little has changed over the past 200 years. Whereas most mainstream museums present narratives of progress, these exhibits seem to blur past and present and thereby prevent the strait jackets, flogging frame, or peat railway being viewed as a moment in social history: instead

FIGURE 2.7 *Case of weapons and makeshift tattooing equipment taken from inmates in Dartmoor Prison, Dartmoor Prison Museum.*

they seem to be part of an ongoing situation. The lack of differentiation, in this case, between the warder's punishment apparatus and the inmate's weaponry, also creates an image of continuing violence. The implication of the display is that all the men behave brutally and this undermines any notion that the guard's presence guarantees either the inmates or the prison visitors' safety.

At the end of the gallery is a fire-exit covered in a thick plastic curtain and above it is a sign that reads 'to the quarry' (Figure 2.8). I could hear music, and assuming that prisoners working on a lower level were listening to the radio, felt nervous of going through the door by myself. After some hesitation I did so, followed a passageway to metal stairs that dropped into a huge deserted milking-parlour and then walked through to a diorama of shackled men working with pick axes. Barely pausing, I hurried through to the rest of the lower floor and looked through a window to check if anyone was in the yard outside. Relieved to find that it was empty, I paid only cursory attention to the mock-up cells and quickly returned upstairs by a second staircase. The final room was light and painted white and a video about the progress that prisoners had made while enrolled on contemporary rehabilitation schemes was playing, but somewhat unnerved, I left.

The museum is a department of the prison, and although that information is not announced it can be deduced from the announcement that prisoners work there and from their painted concrete wares. The connection between

FIGURE 2.8 *Entrance to the quarry dioramas, Dartmoor Prison Museum.*

the museum and prison is further reinforced by the presence of ex-officers who on retirement move from the prison on one side of the road to the museum on the other, by jokes they make about visitors being admitted for a stay, and by the architecture of the building which adheres to a common perception that penitentiaries are dark and cold. Instead of being physically and organizationally removed from the prison, the museum functions as an extension of it. Precisely because the museum operates as a precinct of the prison, the collections have not been removed from but are repositioned within their original context. To visit the museum is to enter into the prison complex and because the displays portray the penitentiary, inmates, and officers in the most adverse light, the museum feels unsafe; live in the most oppressive of ways.

Conditions for living

Quatremère, Adorno, and Fisher proposed that objects lose their vitality once they are moved into museums and detailed the precise conditions that lead to this death. As they explained, the exhibit is removed from circuits of use and belief and thereby taken out of a multisensory environment filled with music or perfume (such as a working temple) and away from a landscape that may be redolent with history or have its own aesthetic affects. It is then placed in a new context where non-visual sensory experience is kept to a minimum and

it is arranged with other objects in order to create an historical narrative or to enable viewers to make judgements about its formal qualities. While objects may gain a new role insofar as they become art or historical documents, they are not used in any other capacity and can no longer prompt the practices or emotions that were common to their earlier lives.

Given the prevalence of the technical and epistemological forms of major museums, it is unsurprising that commentators presume that most of their exhibits are perceived to be inert. Even so, not all museum objects are subject to the transformations that Quatremère, Adorno, and Fisher observed and if one shifts the focus from national or the major independent institutions to consider smaller venues, such as those I have concentrated on here, a very different picture emerges. Although the three micromuseums I have discussed differ in terms of their subject matter, in their precise modes of presentation, and their architecture and location, as well as in the identity of their staff, it is still possible to detect a series of traits or procedures that create the conditions in which objects retain vitality.

According to Quatremère, objects die when they were removed from their original landscapes, but in the three micromuseums that I have discussed is noticeable that the objects retain an emotional charge or sense of power, and that there is a link between the subject of the collections, the setting, and the buildings. There is no history of witchcraft in Boscastle, where the Museum of Witchcraft is located, but North Cornwall is associated with myth and neo-Celtic religions, and as I discuss at more length in the final chapter, micromuseums can also create the place in which they are situated. Although Boscastle had no prior connection with magic, the museum has established that link and the village has become a destination for practising witches and pagans, hence the objects are in place. The Valiant Soldier is site specific in that the building is the subject of the museum's commemoration, while the Dartmoor Prison Museum is opposite the prison gates and occupies a building that was once the prison diary and is still owned by the Prison Service. Although the function of both of these buildings has changed, the objects have remained largely in place. Rather than being relocated and moved out of context, that context has changed around them.

The objects on display in the three micromuseums are not perfectly synonymous with their sites. The vast majority of the artefacts on show at The Valiant Soldier derived from that site but they have been restored and a few new objects – such as models of food in the larder cupboard – have been inserted into the displays. At the Dartmoor Prison Museum newspaper cuttings and a video installation are shown alongside objects that came from the jail, while the Museum of Witchcraft includes collections from Belgium as well as objects that were used in various parts of the British Isles, not just Cornwall. Even so, the close links between the subject of these museums and their settings suggests that while these exhibits have been removed from their original settings they have been shifted to new locations of use.

The conditions for object-life are also improved by the relative absence of boundary markers. At The Valiant Soldier, visitors step directly into the premises without passing through a reception or having their tickets checked. There is a ticket office at the Museum of Witchcraft but it shares space with a candle-lit grotto, and while the entrance to the Dartmoor Prison Museum is more obviously institutional, the concrete ramp and Her Majesty's Prison Service (HMPS) signs align it with the prison rather than with a museum. In these organizations, as in other micromuseums where object-life is in evidence, there is little or no indication that one is making a transition into a separate museum zone. Again, this reinforces the sense that the objects have not been taken out of their original environmental context, as does the ambience of the buildings. Instead of aspiring to the sensory neutrality of most major museums, The Valiant Soldier smells of beer, cigarettes, and coal-tar soap, the Dartmoor Prison Museum is cold and dark and recalls a prison interior, while candles at the Museum of Witchcraft invoke a temple or other space of worship.

To varying degrees the three micromuseums are also situated within specific communities and circuits of use or belief. Members of the local community, some of whom lived in the village when the pub was open, run The Valiant Soldier and previous occupants are conjured by the sound recordings in the downstairs bar. Retired prison guards and current prisoners work at the Dartmoor Prison Museum, and while the biro-knives and whipping chair thankfully are not used as instruments of attack or punishment, prisoners do use them insofar as curating and caring for the collection is part of their rehabilitation. More directly, the Museum of Witchcraft is staffed by witches, a large proportion of the visitors are practitioners, and the two groups both register the activity of various artefacts on display and actively continue to use them. Carole Talboys, a volunteer at the museum, reported that the crystal balls of divination were releasing strong energies on the morning of the flood, and when the Friends Association collect together they often consult the mechanical tarot card reader in the downstairs gallery, or on an individual basis, use Cecil Williamson's scrying mirror.[43]

The curatorial voice further positions the objects in relation to a specific group of users or practitioners. This may be a spoken disquisition, such as when the ex-guard at the Dartmoor Prison Museum began telling tales about former inmates, while in others it takes the form of written labels. The knowledge and perspective of Cecil Williamson, who was a practising witch, are conveyed in the numerous texts in the Museum of Witchcraft. In both these cases, as in many other micromuseums, it is clear that the exhibitions have been arranged by a practitioner and that their interests are to the fore. These are not objective exhibitions but come from a specific sphere of use (a theme which I pursued in the previous chapter and will develop in chapter three).

Finally, the conditions for life are created by the specific arrangements of objects. At The Valiant Soldier the mass of objects and the misaligned objects (such as spectacles in a china cupboard and tea-towels on armchairs) create the impression that the objects are still being moved around and are still in use. At the Dartmoor Prison Museum, historical objects are set alongside those from the current era, including the concrete garden ornaments made by the inmates to earn some money. Here, the boundaries between past and present and between objects of use and objects on exhibition are weakened, making it easy to imagine that the cat-o-nine-tails or the d-i-y flick-knife might in fact be put back into action. At the Museum of Witchcraft, the curses and the protective magic are set opposite each other or else protective devices are inserted into the cases that house particularly problematic artefacts and there is a clear and manifest assumption that the objects have agency.

Writing about the practices of everyday life Michel de Certeau commented that the phrasing or style of an activity matters as well as the form.[44] If, on the one hand, we consider the overall form of museums and understand them to be buildings that present objects to the public then it is easy to presume that all objects fall prey to the kind of death that Quatrèmere, Adorno, and Fisher describe. If, on the other hand, we consider the phrasing of the buildings, the style of the exhibits, the curators' articulations, and how those different components combine with each other and with the wider environment, then it is clear that exhibits' connections to their prior contexts of use and belief are variable and that equally, their levels of animation may be similarly inconstant.

Quatremère, Adorno, and Fisher used the terms 'live' and 'dead' as a way of describing the emotional and spiritual losses and intellectual gains incurred when objects were put on display. As such, they presented that change as a fact, something that necessarily occurred, but depending on the museum's situation and the conditions established therein, it is possible for things to live on. Instead of assuming that the vast majority of artefacts wither and die once they are incarcerated in museums, it is more productive to consider the heterogeneity of museums and the varying degrees of vitality within their displays. Understood thus, conceptions about the life or death of objects become a useful means of understanding why some exhibits have certain effects and others do not. It is a discourse that is less about the fixed state of objects and more about the way in which their combinations can make us feel.

CHAPTER THREE

Partisans reviewed:
The problematic ethics of
multi-perspectival exhibitions

Writing in 2000, Eilean Hooper-Greenhill argued that over the previous twenty-five years there had been a dramatic shift from 'the modernist museum as a site of authority, to the post-museum as a site of mutuality'.[1] She explained that the former model was the product of the nineteenth century, that it had retained its institutional power through the twentieth century and that one of its characteristics was the promulgation of 'master narratives'.[2] These 'holistic and apparently inevitable visual narratives, generally presented with anonymous authority, legitimized specific attitudes and opinions, and gave them the status of truth', meaning that display was 'a one-way method of mass communication' and that 'the voice of the visitor was not heard'.[3] By way of contrast, Hooper-Greenhill pointed to the emergent post-museums, which reject such unilateral positions and include 'many voices and many perspectives'. In these new institutions, she remarked, 'there is no necessary unified perspective – rather a cacophony of voices may be heard that present a range of views, experiences and values. The voice of the museum is one among many'.[4]

In this account, Hooper-Greenhill was both describing and advocating a trend in museum practice. Her recommendations chimed with those offered by other professionals and since then an increasingly strong consensus has formed – that multi-perspectival exhibitions and programmes are more egalitarian than those that adopt a single position.[5] This is partly because multi-perspectival approaches 'give voice' to groups that were previously under-represented or entirely marginalized and partly because providing a range of viewpoints on a given topic is understood to be impartial and balanced. In this situation the museum is deemed to act as an arbiter of

information rather than the sole authority and visitors are thereby left free to draw their own conclusions on the topic to hand. [6]

Despite the growing agreement that exhibitions should adopt multiple perspectives, micromuseums rarely offer a range of opinions on their subject matter. Some adopt an ostensibly objective viewpoint as was and to some extent is still common in public sector museums. More often, the explanatory material proffered by micromuseums is devised in relation to a specific set of beliefs or concerns. The Museum of Witchcraft, discussed in Chapter Two, presents that subject from the perspective of a practising witch, while Gerry Wells proprietor of the Vintage Wireless Museum, which I discussed in Chapter One, explains his collection from the standpoint of a retired television and radio engineer. Like traditional public sector institutions, these later micromuseums take a single perspective or unilateral position on the subject of the exhibition, but unlike them make no claim to neutrality. On the contrary, many micromuseums are unabashed about manifesting their own interests and could be described as partisan in that they show strong allegiance or devotion to a belief, way of life, set of practices, or group. In this chapter I use the term 'partisan' to distinguish such exhibitions from museums that present a single, apparently objective narrative.[7]

Hooper-Greenhill's analysis is concerned with the shift away from the conventional displays of major museums but, unusually, museological discussions on multi-perspectivalism sometimes include micromuseums, specifically those in Northern Ireland. In her essay 'An Exploration of the Connections among Museums, Community and Heritage', Elizabeth Crooke concentrates on the Museum of Free Derry. As she explains, this venue was founded by the Bloody Sunday Trust in 2006 and seeks to commemorate and publicize the events of 30 January 1972 when a civil rights march ended in a clash with the security forces and the death of fourteen civilians. Crooke notes that the Trust believed that the true story of these events had been hidden and that the exhibitions aim at providing 'the community's story told from the community's perspective' but, for her, the exhibition is problematic because it excludes other groups who also had first-hand experience of the Troubles (the period of conflict that lasted from the late 1960s until the Good Friday Peace Agreement in 1998).[8] Crooke is also concerned that this particular narrative is given authority by being told within a museum and that it represents 'a certain political agenda' which, she implies, involves leverage within the wider political context of Northern Ireland.[9]

Reiterating these points in a slightly later article titled 'The Politics of Community Heritage: Motivations, Authority and Control', Crooke draws a parallel between the Museum of Free Derry and major museums that take a single perspective on a subject. Comparing the Museum of Free Derry with the Community History Project run by the Mid-Antrim Museums service, she comments that the latter project was 'aligned to contemporary thinking in relation to museums and access', whereas 'the Bloody Sunday

Trust project [. . .] has not evolved from a desire to renegotiate the traditional power structures of the Museum'.[10] Her implication is that the Museum of Free Derry is retaining the authoritative modes of practice that were common in major 'modernist' museums and that it would be vastly preferable if the venue provided multiple-perspectives on the subject.

Crooke notes that the Museum of Free Derry was founded and run by an independent trust. She also registers that it explicitly aims at providing an alternative history to that supplied by the government and media, and more broadly that such venues, can 'be an exercise in resistance'.[11] Nonetheless, for Crooke, the single exhibition narrative at the Museum of Free Derry echoes those of establishment venues that are neither independent, nor an attempt to provide an alternative history, and which do not constitute an exercise in political resistance. My question, then, is: do all single narrative exhibitions have a similar status and effects? To what degree do the venues and the styles or 'phrasing' of those exhibitions matter when making assessments about the legitimacy of single and multi-perspectival approaches?

In this chapter I focus on the Lurgan History Museum in County Armagh, which concentrates on the theme of Irish republicanism. As in my chapters on the Vintage Wireless Museum and the Witchcraft Museum, I am interested in the relationship between form and content, that is, how location, accommodation, and display techniques impact upon museums' narratives and the visitors' experience. An additional aspect of this infrastructure and the one that I concentrate on here is that the curators of micromuseums often present information verbally. In these circumstances the 'museum's voice' does not only consist of the visual narrative constructed by the exhibition, but of spoken tours, stories, or conversations between visitors and members of staff. At the Lurgan History Museum, as in many other venues, these exchanges are an important part of the visit. I report on the conversation that took place and consider its implications for debates on multi-perspectival exhibitions. In turn, I consider the collection in the wider context of representation and ask whether a single narrative is necessarily less egalitarian than an account that encompasses several viewpoints.

Talking to Jim

I first found out about the Lurgan History Museum from a brief article in *The Guardian*. Under the title 'Irish Republicans Honour Heroes of the Troubles in a Garden-Shed Museum' and subtitle 'It's Strictly Invitation Only to Study IRA Artefacts in a Secret Location in Northern Ireland – but Even Loyalists Have Visited', the author, Henry McDonald wrote that the owner 'is so security-conscious he doesn't allow his name or the museum's address to be published' and that 'all visits are arranged quietly on the

"republican grapevine"'.[12] Not having access to such networks I asked the staff at the Irish Republican History Museum in Belfast if they knew about the venue and they provided a name and a telephone number. I called and arranged to visit the following day.

The museum is located on a large well-maintained residential estate where the houses are painted cream, front-lawns are neatly kept, and five-door cars are parked on the drives. With no indication of where the museum was located it took me a little while to find the correct address. On arriving, the owner, Jim McIlmurray, came out of his house to greet me and pointed to an outbuilding that I had initially taken to be a domestic garage. It comprised of a single room lined with cases that contained prison handicrafts and a huge quantity of ephemera, including photographs, pictures, and statuettes, although slightly incongruously, one large display consisted of household products from the 1970s including packets of Beech Nut chewing gum, Radiant washing power, Ajax (A Bucket of Power), and Ready Brek. Larger items including weaponry and mannequins wearing uniforms stood between the glass vitrine. Nothing was labelled and, as at the Vintage Wireless Museum, which was the focus of Chapter One, Jim explained the provenance and significance of the exhibits to his visitors. To a large degree, the conversation and the objects on which it focuses are directed by the visitors' and in this case my questions, interests, and prior knowledge (or lack of it).

Given the way in which I had heard about the museum, we began by talking about *The Guardian* article. Jim said 'The reporter made it sound like it was all undercover' and explained that the museum started as a private collection.[13] That began to change in 1994 when the Irish Republican Army (IRA) agreed a ceasefire and there was a sense that the conflict had drawn to a close. Around this time, local schools started to ask Jim to bring objects into the classroom and to talk to the pupils about the history of the conflict. This involved packing his collection into boxes, carrying it from the loft to his car outside, and unpacking when he arrived at his destination so he decided it would be more sensible to open a museum and ask the schools to come to him. Two years later he did so, word spread, and gradually more visitors began to arrive. At present, it attracts around 1,000 visitors a year. I asked why Jim chose not to publicize the venue in any way. He said it was partly because it enabled him to screen visitors in advance and 'if some boys arrive on the doorstep asking to "see the guns", I can deny all knowledge of a collection', and partly because Jim worked full-time as an occupational health therapist in the National Health Service so he could not routinely open the collection. Having recently taken early retirement he still prefers to regulate the size of the audience.

'Who comes to visit?' I asked, and Jim told me that one morning a man with a strong Yorkshire accent had arrived at the door of his house and enquired about the museum. Jim was guarded but the man explained that he had been an ATO (Ammunitions Technical Officer) and had worked

in bomb disposal. It was forty years since he had been in Ulster and was on a 'nostalgia trip'. Jim invited the ex-soldier in to see the collections whereupon it transpired that his fellow servicemen and their two wives had been waiting cautiously around the corner until they knew whether or not it was safe to go in. Two of Jim's friends, both of whom had been in the IRA arrived shortly afterwards and the seven of them looked through the collections and talked until late into the evening, stopping only for sandwiches. Before leaving, they all exchanged telephone numbers. 'They were all men in their sixties', Jim said, 'it was in the past tense for them', by which he meant that all personal enmity had passed. I said that I was still surprised that they had wanted to visit and Jim replied that for both the Army and the IRA 'going through the Troubles was like living with a grenade in your pocket, you didn't know whether you'd see the next day. Everyone involved knew what the other lot had been through'. According to him, the soldiers and the IRA members understood one another's experience and could talk to each other in a way that was not possible with non-combatants.

Continuing on the theme, Jim told me that curators from the National Museum of Ireland had visited, as had university students and youth groups of Protestants and Catholics. On one occasion, a young Protestant woman mentioned that her father had been in the Ulster Special Constabulary or the 'B-Specials' as they were commonly known. Jim explained that this was an almost exclusively Protestant police force which was run on military lines until it was disbanded in 1970 as part of an attempt to make the Northern Irish security services less partisan. The woman visitor said that she had grown up thinking that Catholics should have no rights, but visiting the Lurgan History Museum had opened her eyes. I pulled a sceptical face at this comment. It seemed unlikely to me that anyone could now think in these terms, but catching my expression Jim retorted 'yes, it's pretty blinkered, but you don't know what it was like here', and began to tell me about his own upbringing.

Jim was born a Catholic but no longer practises. His father was a tailor and was apolitical while Jim's paternal uncles served in the Royal Air Force (RAF). They gave him military badges as presents and he gradually built up a small collection, which is now on display. The family lived in a predominantly Protestant neighbourhood and Jim said that when he was young all the local children were friends, but once the Troubles started the Catholic families became increasingly isolated, and loyalists targeted their houses. Jim told me that his own home was petrol-bombed and that the ensuing fire destroyed all of his father's work. 'We always had a good idea of who had set the fires', he remarked, 'because they were usually related to the kids we'd played with. In the end we moved to an all-Catholic area'. Beneath the military badges is a large pair of tailors' scissors and spools of cotton which had belonged to Jim's father and which we paused to inspect.

I commented on the fact that his first collection had been of RAF mementoes and asked when he had started collecting republican artefacts. Jim explained that in 1971 the British government launched Operation Demetrius wherein anyone suspected of armed republicanism and, to a much lesser extent, loyalism, was rounded up and imprisoned without trial (although notoriously, the key players in the IRA eluded capture and many innocent men were jailed).[14] Jim's older brother, a civil rights activist, was interned on the Maidstone prison ship and it was at this juncture that he started collecting materials relating to the Troubles. 'I had anti-internment posters down before the glue dried' he said. 'A shield or a helmet from the British soldiers was a war trophy and all the kids collected shell cases and rubber bullets from the street riots'. Some of those posters, a collection of shell cases, rubber bullets, and a hat ribbon from the HMS Maidstone are now on display in the museum.

The museum also contains a large collection of harps carved by internees at the Long Kesh detention centre, more commonly known as the Long Kesh cages (Figure 3.1). By the time Operation Demetrius was curtailed in 1975, almost 2,000 people had been imprisoned and because internees had the status of political prisoners, they were given access to craft materials.[15] Many of them made ornaments which were bought by Catholic families who wanted to show their support and Jim said that to begin with, the harps were given pride of place on top of the television set, but then council tenants were given the right to buy and women started going out to work in

FIGURE 3.1 *Prison crafts, Lurgan History Museum, Co. Armagh.*

order to pay the mortgage. This meant that they socialized with Protestants to a greater extent – 'the women always did mix more' he said – and sometimes before an office party or outing the whole group would meet in one of the homes for a drink. When the Catholic women were hosts they would move the ornaments to avoid offending their Protestant colleagues. Also, Jim remarked, fashions changed and people started having very neutral interiors. 'IKEA killed off the tradition of displaying Irish prisoner handicrafts', he said, 'although it was good for me. Lots of people passed the harps on to the Museum'.

Not all of the handicrafts date from the 1970s. There is a matchstick model of the Basque country made by Fermin Vila Michelena who has been linked to the separatist group ETA and in 2012, when I first visited the museum, he was in Maghaberry Prison awaiting extradition to Spain. There are also four large Celtic crosses made by Martin Corey who is a close friend of Jim's. He previously served nineteen years of a life sentence for the murder of two Royal Ulster Constabulary officers (RUC) and having been released in 1992, was re-arrested in April 2010 on the basis of 'closed evidence', that is, information which cannot be brought into the public domain. As in other cases where closed evidence is cited, Corey was not informed as to the exact content of the accusations made about him.[16] 'I don't have much faith in the judiciary system', Jim commented, 'what's happened to Martin is not justice. David Cameron talks about fighting for human rights in Burma (the prime minister had recently visited Aung San Suu Kyi) but we have internment without trial here. The Good Friday Agreement promised impartiality but it hasn't happened'. I confessed to not knowing that closed courts were being used or that internment was still current in Northern Ireland and Jim retorted, 'Well you wouldn't, it doesn't get reported in the British press' (here, 'British' is taken to be synonymous with 'English').

By this point some two or three hours had passed and Jim went into the house to make coffee, returning with two mugs and a box of jam doughnuts which he placed on a glass display case next to one of the key exhibits – a deactivated RPG7 rocket-propelled grenade launcher which was one of the weapons used by the IRA. While eating, we talked about the Irish Republican History Museum In Belfast, which I'd visited the previous day, and I commented that I had found it difficult to gain an overview of the different groups involved in the history of republicanism. Taking a series of mannequins dressed in uniforms as his illustrations, Jim responded by clarifying the differences between the Irish Citizens Army, which consisted of trade unionists, and the Irish Volunteers, which included members of Sinn Féin, the culturally oriented Gaelic League and the Hibernian Rifles.

The one uniformed female mannequin on display was dressed in a black skirt, shirt, tie, and beret (Figure 3.2). Her black bomber jacket has a large D containing a dog's head emblazoned on one side and Jim told me that she was wearing the women's uniform for the Belfast Brigade's D-company.

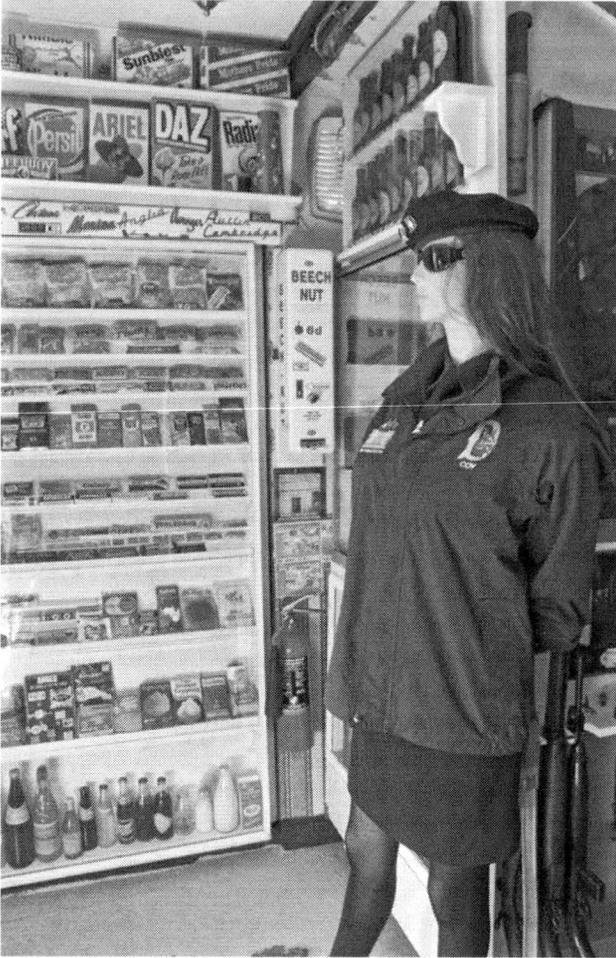

FIGURE 3.2 *Mannequin wearing D-company, Belfast Brigade, Irish Republican Army uniform, Lurgan History Museum.*

Until I visited the Irish Republican History Museum, I had not understood that the IRA was divided into brigades, companies, and ranks and Jim explained that they also had different units including an intelligence group that researched targets; medical assessors; the green cross who gave aid to families; and internal security which vetted new recruits, interrogated suspected informers, and was informally known as 'the nutting squad'. I mentioned that Eileen Hickey who founded the Irish Republican History Museum had been an Officer Commanding (OC) when she served time in Armagh Gaol and asked how the command structure operated in that context. Jim said that the OCs liaised with prison staff, drilled the men and women, and organized political lectures. Gesturing towards a model of the

Long Kesh cages he said that discipline was very strict and told me a story about two internees who were temporarily released to attend their mother's funeral. Afterwards had gone out drinking, and when the men failed to return to the camp, members of the IRA found them, beat them, and dumped them back at the door of the detention centre. Jim commented that 'if one man strayed, then the others stood to lose privileges, so it was important to maintain order'. 'Jesus!' I said, 'It's still brutal'. 'Yes', he replied, 'but it was a war' and added that the loyalists behaved in the same way. To prove his point he told me that Protestant and Catholic internees were kept in adjacent pens at Long Kesh and that in the winter of 1975, they had a snowball fight. One of the Protestant men put a rock in his snowball and it injured one of the Catholics, so the next day, the republicans were told to face the wire fence and their counterparts were similarly lined up in the opposite cage. The loyalist Commanding Officer brought out the person who had thrown the stone and proceeded to break the man's fingers by dropping a concrete block onto his hands. 'We'd have done the same', said Jim.

We continued looking through the collections in some detail. Among many other exhibits, there is a scale model of the British Army headquarters at Lurgan where Jim was detained and interrogated on three occasions. There is also a photograph of his cousin, the eminent human rights solicitor Rosemary Nelson who died when a bomb exploded under her car.[17] Notably, many of the exhibits have been signed. A bed sheet is emblazoned with a felt-tip drawing of shackled inmates and bears the signatures of the Crumlin Road Hunger Strikers of 1972.[18] Jim told me that one of the signatories – Denis Donaldson – became an informer for M15 and the Police Service of Northern Ireland (which replaced the RUC). Four months after being exposed as such, he was found dead in the remote Donegal cottage where he had been living. Jim said that the Real IRA took responsibility but that his family were pressing for an inquiry into whether the police force leaked the information that led to his death.[19]

Other exhibits have also been signed by visitors. A large photograph that was taken in the museum bears the heading 'The 40th anniversary reunion of the hooded men', which was an event that Jim organized in 2011. As he explained, the thirteen 'hooded men' were all internees who were tortured by the British Army. After two government enquiries found that there was no case to answer a priest called Fr Raymond Murray persuaded the Irish government to take the case to the European Commission who found that torture had been approved at the highest levels and was not, as the British government claimed, due to the misplaced excesses of individuals.[20] The photograph shows the remaining ten men and Fr Murray meeting for the first time since their release (Figure 3.3). Opposite the photograph of the reunion was a bin lid, which they all signed, appending the numbers that had been painted on the backs of their right hands and by which they were known. (During the Troubles women banged bin lids on the ground to alert their neighbours of approaching troops and so they have become a symbol of resistance). 'The men are of different political persuasions', said Jim, 'some

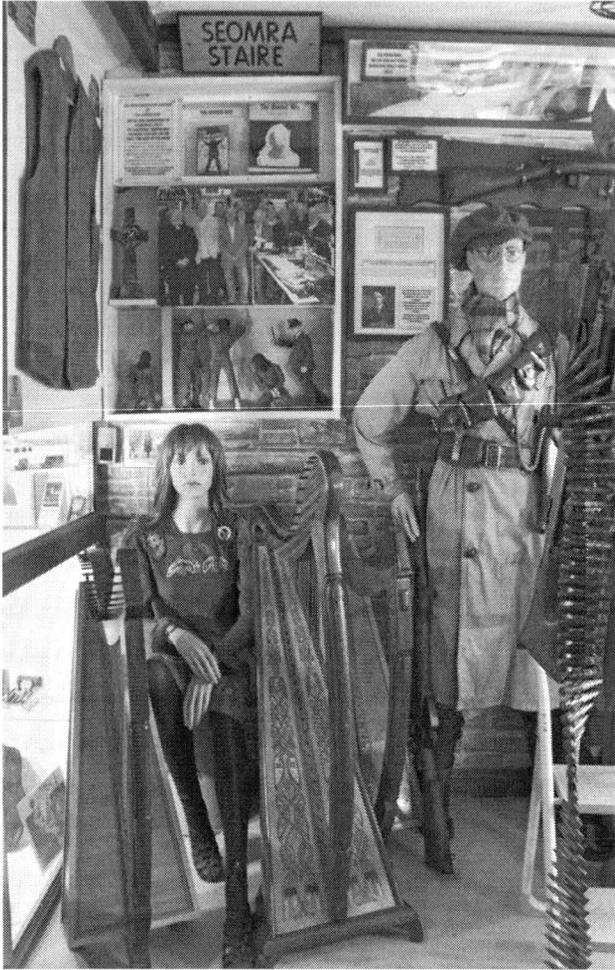

FIGURE 3.3 *Display (with image of the reunion of the hooded men in the top left) Lurgan History Museum.*

are in Sinn Féin, some don't agree with Sinn Féin, some have dropped politics altogether, or were never involved, but it was a very emotional day'.

There are also numerous small autographed photographs of Jim with leading IRA members who have come to see the collections but the last object he showed me, and which lifted up from behind the rocket-grenade launcher, was an Irish flag densely covered in signatures (Figure 3.4). The green portion bears the names of local republicans who died in service of that cause while the other sections carry the names of those who have been to visit the museum and has been signed by members of the Official, Provisional, Real, and Continuity IRA, Saor Uladh (Free Ulster), and the INLA (Irish National Liberation Army). In most cases these visitors have

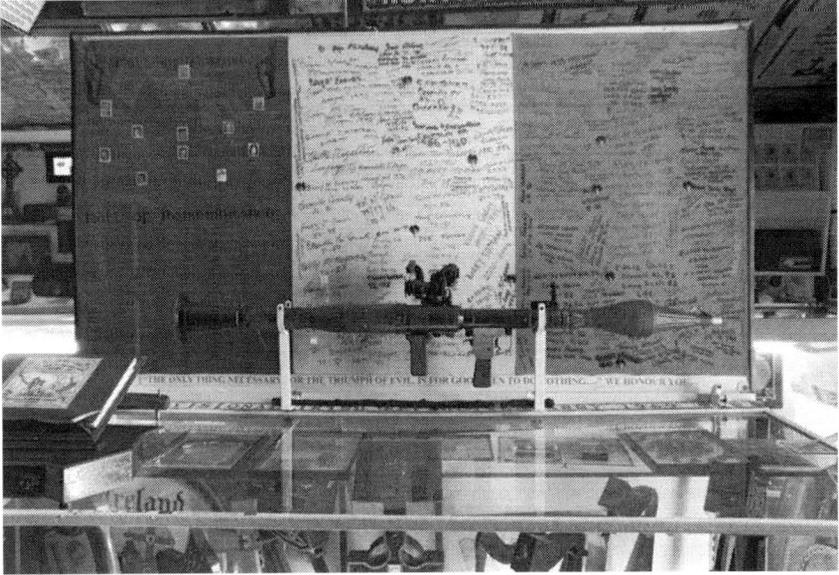

FIGURE 3.4 *Rocket-grenade launcher as used by the IRA with signed Irish flag to rear, Lurgan History Museum.*

noted the dates and whereabouts of their prison terms. Small black ribbons and gold crosses have been placed next to those who have since died and at the base of the flag is a dedication: '"The only thing necessary for the triumph of evil is for good men to do nothing . . . " we honour you.'

Towards the end of my stay, two men arrived at the museum. One, Seamus, whom Jim knew well, apologized for turning up unannounced and asked if he could show the collections to his friend, Malachy, who was visiting from the Republic of Ireland. They were both invited in and they examined the exhibits while Jim and I talked. Prompted by the flag with the names of men who had been convicted, I reported that a curator at the Irish Republican History Museum had said that people no longer have any stomach for violence and, at this point, the two visitors looked slightly askance. When prompted, Malachy told me that a friend of his had recently been caught with two makeshift bombs in the boot of his car and was now in Portlaoise jail. 'It was a shock to everyone', he continued because the man in question 'is in his late sixties and he's in poor health. He has breathing problems now and old burns from an explosion. He got a twenty-year sentence, he won't come out'. I asked why the man had re-engaged in armed combat. Malachy said, 'I think he was probably persuaded into it. There are a lot of young men who have started up again and they just don't have the expertise. They can't build bombs or process explosives from raw materials. They just don't know how. These young men look up to the old men who served, they hero-worship them and maybe they polished his ego'. 'What!' I said,

'they flattered him back into action?' 'Yes', Malachy said, 'I think that is what happened. It's like those old men you see dancing with young girls. It's like going out with nineteen year olds or buying a Porsche'. Taking a more sympathetic line on the story, Jim added that a lot of older men come to the museum and tell him that they were the first to have shot a rocket-launcher in a particular area, or they were the ones who planted a certain bomb. 'You can hear that they are angry for not being acknowledged; their names aren't down in any records'.[21] 'Could it also be an exaggeration' I asked, 'like all those people who say they were at the first Sex Pistols gig?' 'Yes, a bit of that too', Jim replied, 'but they want to be remembered and who can they tell?' 'They need to feel that they have been important?' I queried, and Jim nodded. 'They see that most of their life is behind them. Maybe this guy wanted to recapture his youth, he concluded.

Complex narratives

To recall, Elizabeth Crooke was concerned that the exhibition at the Free Museum of Derry gained in status from being presented within a museum context. She also thought that its single-narrative exhibition uncritically retained the authoritative modes of practice that are found in major institutions, which as Hooper-Greenhill explained, perpetrate an anonymous, unified, and holistic account of a given topic. Like the Free Museum of Derry, the Lurgan History Museum is adamantly partisan. Jim McIlmurray is clearly an advocate for Irish republicanism, is an articulate critic of the British government, and while he does not support the resurgence in violence, certainly understands why republicans did engage in armed struggle. He leaves visitors in little doubt as to his beliefs and political position but unlike major museums, the building that houses the exhibition does not assert its institutional or establishment status. It is clearly not an official venue but a do-it-yourself museum that is attached to someone's home. This architecture and the location frame the collection and spoken narrative so it is evident that the exhibition is constructed by Jim rather than being a publicly sanctioned exposition. In turn, visitors meet Jim who shows them round the exhibition, enters into conversation and explains the artefacts in relation to his own family and friends. His narrative of the Troubles is inextricably linked to his own history and perspective on the world.

In both modernist and 'post-museums', the curator's authority is linked to impartiality. In the former instance it is supposedly guaranteed by the curators' professional disinterest, in the latter the inclusion of different opinions or 'multiple-perspectives' supposedly guarantees objectivity. Jim's authority is not anonymous or impartial, it is grounded in personal experience and is intricately tied to his autobiography. His ability and licence to comment derives from commitment to and involvement with the subject

to hand and not from distance, institutional status, or balance. At the same time, his narrative cannot be dismissed as an individual's anecdotes or personal opinions because his lived experience is literally counter-signed by people who were or are involved in republicanism.[22] By writing their names on photographs, exhibits, and even on the display cases, they testify to the verity of Jim's narrative, the authenticity of the artefacts, and the standing of the museum.

Nor does Jim present a unified narrative. Granted, he does not represent the views or experience of the government, the British Army, Protestants, unionists, or loyalists and he definitely advocates for republicanism, but at the same time he registers difference within that movement. In the course of his account, Jim comments that republicans were variously engaged in struggles for Home Rule, independence, civil rights, and the re-unification of Ireland, he notes the presence of multiple groups operating in the current sphere, and mentions diplomatic versus armed responses. His remarks on his Irish Catholic uncles serving in the RAF, his father being apolitical and the hooded men's allegiances acknowledge that there were and are disparities of opinion, a spectrum of possible political choices, and levels of engagement. Republicanism and nationalism are not understood as being identical and Catholicism is not taken to be synonymous with either position.[23] Rather than portraying a coherent, unified community, Jim described a shifting conglomeration of peoples, approaches, and interests, not all of whom or which concur.

In many ways, the narrative that Jim presents is fragmented and brooks no easy resolution. A statuette of a hunger striker with the raised fist suggests resistance and the mannequin wearing sunglasses is distinctly glamorous. The RPG7 rocket-launcher occupies pride-of-place in the middle of the museum, and the exhibition includes guns and other weaponry. These exhibits and aspects of Jim's narrative cast republicans as freedom fighters but he also discusses the less salutary aspects of their internal history such as punishment beatings, the nutting squad, and the murder of informers. Jim registers the difficulty of old men who feel that their lives are past and their exploits forgotten, but also thinks that the dissidents' attempts to resume armed combat are futile, not least because of the sophistication of British counter-intelligence and the willingness of members of the nationalist community to provide information to the security forces. Republicanism is seen as a legitimate and honourable cause, but also as unsuccessful and probably doomed. The portrayal of other groups is also complicated. Although he recounts how Protestant neighbours were responsible for setting his family house on fire and it is likely that his cousin was killed by loyalists who were in turn informed by the British security services, Jim also talks about having Protestant friends as a child and about Catholic and Protestant women socializing together. Similarly, British soldiers are understood to have assisted in government oppression and simultaneously to have shared in the trauma of violence.

Jim's account retains the texture and contradictions of lived experience. Instead of providing a unified or holistic position from which to view the subject, his narrative actively destabilizes any neat responses to it and does not lend itself to easy assimilation on the part of the visitor. Importantly, it also emerges in dialogue. As Jim explained, the display of 1970s household products is aimed at visitors who might find it difficult to talk about the Troubles and is intended to provide them with a gentle starting point for thinking about that period of time. Once involved in conversation, the visitor may bring their perspective to bear on the subject, as Malachy did, or where they have no direct experience of the Troubles, as was the case for me, can ask numerous questions. Thus while Jim's narrative did not incorporate challenges from other groups, the structure of the museum visit makes query, contestation, and explication possible as it does in many other partisan micromuseums.[24] Far from denying visitors a voice, as Hooper-Greenhill comments in relation to major modernist museums, this arrangement enables them to talk at length.

One of the key ideas to underpin multi-perspectival approaches to exhibition making is that there are different viewpoints on a history or an event. In her article 'Contentiousness and Shifting Knowledge Paradigms' Fiona Cameron observes that 'the long-established practice of exhibiting "the facts", "truth", "national history", or unproblematic conceptions of other places is no longer wholly sustainable in an environment where the self-evidence of all these things is under question' and she therefore endorses exhibitions that represent various positions. Yet this is not the only way to respond to notions of contested truth.[25] The problem with modernist museums is not necessarily that they delivered single narratives, rather that their accounts were and are presented in terms of impartial and detached truth. In Donna Haraway's terms they performed the 'god-trick' of speaking from nowhere.[26] Thus, an alternative strategy is to make one's own position manifest so that an audience can grasp why particular forms of information are being disseminated and to what ends, as is the case at the Lurgan History Museum. In this case as in similar micromuseums, it is clear that the account is produced within a particular environment, that it takes a specific position, and that it does so with an agenda.

The problem of 'balance'

Within the debates on single- and multi-perspectival approaches, judgements of 'balance' are made in relation to individual exhibitions. In addition, professional discussions usually emphasize the *process* of representing different views. A democratic orientation is signalled by including a range of viewpoints that represent all aspects of a topic, almost irrespective of what those ideas or beliefs are. The problem with these conjoined approaches is

that they elide the wider context in which exhibitions occur and evacuate the specificity of various positions. In contrast, taking a wider view on the specific issue that is the subject of the exhibition potentially alters ideas of balance and thus the assessment that multi-perspectival approaches are egalitarian by default.

Taking a broader perspective in regard to the Lurgan History Museum and other republican micromuseums, involves the consideration of other forms of media and of neighbouring institutions. As Jim suggested during my visit to the Lurgan History Museum, media coverage of the Troubles and of Irish republicanism has been uneven, to say the least. In 1971, conservative politicians were conscious that negative reports about the British army in Ireland or sympathetic coverage of charismatic nationalists could lead to the public withdrawing their already shaky support and pressured the BBC to police their broadcasts. Reporters had to seek permission from the director-general before interviewing members of the IRA and every programme had to be 'internally balanced' which meant that dissident views had to be immediately countered by those of the government (although broadcasts that supported the establishment were not compelled to acknowledge republicans).[27]

In the years that followed numerous television and radio programmes on the subject of Northern Ireland were heavily edited or cancelled. The nationalists were excluded from political debates that had media coverage and even pop videos that featured documentary footage of Northern Ireland were censored.[28] Self-censorship was later replaced by legislation and in 1988 it became illegal to broadcast the voices of Sinn Fein supporters, including elected members of parliament; a restriction that was lifted in 1994 after the announcement of a ceasefire. Books were also prohibited: *The Guinea Pigs*, which detailed the story of the hooded men and is on display in the Lurgan History Museum, was taken off the market following pressure from the British government.

This one-sided situation was in no way remedied by public sector museums in Northern Ireland. During the Troubles the national and county museums tried to ensure that their institutions were 'oases of calm' by completely excluding any explicit references to sectarianism.[29] Ulster Museum, which houses the region's historical collections, did likewise but as various commentators have argued the exhibition implicitly represented the values of the establishment. Writing in 1994, the anthropologist and curator Anthony Buckley described the displays as a 'rhetorical statement of the ideals of the new protestant semi-independent state [depicting] the somewhat aggressive triumph of Protestantism, Capitalism and the British Empire'.[30] Similarly in 2000 Anthony Smyth noted that Ulster Museum had 'long been a temple to subtle evasion, a place where a studiously applied veneer of impartiality masked a muted if definite celebration of unionism'.[31]

The galleries have been overhauled since then, and in 2009 the museum became the first public sector museum in Northern Ireland to have a

permanent display devoted to the Troubles. The exhibition is located
in the last room in a larger suite of galleries, which cover the history of
Ireland from early settlement to the present, but unlike the other displays it
consists of text and images. The staff had initially planned to shows objects
pertaining to the Troubles, as it had in two temporary exhibitions held from
2003 to 2006, but later abandoned that approach as being too contentious.
According to William Blair, Head of Human History, this strategy worked
because 85 per cent of 700 visitors thought that the subject was handled
sensitively, but media coverage was far more ambivalent about the success
of the displays.[32] Fionnuala O'Connor from *The Irish Times* wrote that the
Troubles gallery was a disappointing example of good intentions inhibited
by the fear or giving offence while Fionola Meredith, a journalist for the
same newspaper, thought similarly, adding that while it was 'safe' it was
also 'bland' and 'a cop-out – a definite case of don't mention the war'.[33] She
concluded that the exhibition was 'so cautious as to be entirely anodyne';
an assessment that has also been echoed by scholars.[34]

In this context, then, the Lurgan History Museum can be understood
as a response to the historical lack of representation in the media and in
major museums. Like other partisan micromuseums, it seeks to proffer an
alternative history to that represented within dominant accounts. If the
mainstream media represented Irish republicans as terrorists, then the
Lurgan History Museum could make a case for the validity of their cause
and aims; where major museums ignored the Troubles until comparatively
recently, micromuseums would collect and display the artefacts relating to
that period and group; if the new exhibitions at Ulster Museum gave an
anodyne version of events, Lurgan History Museum and other venues could
explain the personal costs and beliefs involved; and where republicans and
Catholics had been adversely depicted or marginalized, Jim and the staff in
other partisan micromuseums would take more control over images of their
own political community. In that sense Lurgan History Museum assists
in the process of creating multiple perspectives because it supplants and
challenges existing unilateral accounts. Rather than, as Karine Bigand has
maintained, impartial exhibitions being required to counter the 'biased use
of history' in partisan displays, the Lurgan History Museum can be seen
as a collective attempt to redress an already skewed terrain.[35] Encouraging
multi-perspectival approaches could then be interpreted as perpetuating
imbalance, because given the history of media representation in Britain
and museum displays in Northern Ireland, it is clear that republicans and
the government did not and arguably do not have parity of representation.

Moreover, encouraging internally 'balanced' exhibitions and programmes
could be viewed as actively oppressive. Crooke clearly thought it was
inappropriate for the Museum of Free Derry to present a unilateral account
of Bloody Sunday, but in 2010 (the same year that her article was published)
Lord Saville released the findings of the second government inquiry into
that event. He reported that British paratroopers had fired the first shots

on civilians, that they had done so without prior warning, and that there had been no initial fire from republicans as sometimes was claimed. He also stated that none of the dead had been armed (with the probable exception of Gerald Donaghey) and that British soldiers had subsequently given false testimony about the events of that day.[36] Addressing the Commons about the content of the report, the Conservative Prime Minister David Cameron described its findings as 'shocking', the conduct of the Army as 'unjustified and unjustifiable', and offered an unequivocal apology to the families of those concerned.[37] The report effectively corroborated the Museum of Free Derry in its account of the proceedings and while there are other stories that could have been told (such as why the soldiers opened fire), the Museum of Free Derry was undoubtedly justified in its attempts to draw attention to a history that had been systematically concealed.

Once these histories are taken into account then advising Catholics, nationalists, or republicans to represent the views of, say, the British establishment would be to recommend that they give voice to their oppressors and such a gesture could be understood as redoubling the initial wrongs. It would be analogous, say, to advising South Korean curators to consider the interests of their Japanese colonizers or to suggest that American museums of black history contemplate the discomforts of whites after segregation ended.

In the specific case of Lurgan History Museum, support for a single-perspective could be interpreted as endorsing nationalist claims. Conversely, if one maintained that the British government was right to suppress violent unrest in Northern Ireland using the means that it did, that republicans were unjustified, or that they were unequivocally terrorists, and that they are not comparable to peoples who are officially recognized as having been colonized or subjugated, then a republican or nationalist perspective on the Troubles would be unwarranted. In this situation encouraging multi-perspectivalism could suggest adherence to a government position. Importantly, then, assessments of the legitimacy of partisan or indeed multi-perspectival exhibitions are tied to appraisals about the validity of the histories told therein. Irrespective of one's personal opinions on the subject of Northern Irish republicanism, estimations of balance require political and ethical judgements. Multi-perspectival approaches do not provide an automatic guarantee of impartiality and nor do they circumvent the need to make ethical or political decisions. Rather, the insistence on multi-perspectival exhibitions and programmes is itself political and in actuality there is no means of avoiding judgements on the issues to hand.

At stake here is the lack of connection between balance and justice. Exhibitions that include the viewpoints of diverse or opposing groups are fair insofar as their diverging opinions or interests are represented, but are not necessarily just. As I have argued, an insistence on multi-perspectivalism can ignore a wider situation wherein one group's opinions have been inadequately articulated or actively suppressed. In some contexts

it might be a more just response to support partisan exhibitions. It is therefore important that the multi-perspectival approaches are not treated as a generically applicable form, but that precise, accountable judgements are made as to who is constructing the exhibition, about whom, and in what context.

CHAPTER FOUR

Caring for the dead: Small-scale philanthropy and its motivations

In April 2008, five months into the global financial crisis, and aware of impending funding cuts, a group of major British arts organizations collectively launched a campaign called 'Private Giving for Public Good'. In a collectively authored document, the Arts Council, National Museum Directors Council, and Museums Libraries Archives Council (MLA) reminded readers that museums were established with the contributions of individual philanthropists: that the British Museum was founded on a legacy and the British Library on a royal gift of books, that Andrew Carnegie had created 660 public libraries, and that the names of Tate, Bowes, Whitworth, and Sainsbury were still associated with the galleries that they had funded.[1] According to the report these donors had been 'driven by the conviction that citizens' quality of life would be enhanced by access to important objects' and the group announced their commitment to build on that legacy by promoting a culture of philanthropy.[2]

'Investing in collections is a privilege open to everyone', announced Roy Clare, chief executive of MLA and the cover of the launch document carried a photograph of 10-year-old Matthew Hughes who had given £5 of his pocket money to the Tate.[3] Nonetheless, while the campaign celebrated small donations, the group obviously had larger sums of money in their sights. The report informed readers that while Gift Aid allowed charities to reclaim basic level tax on any donations, the donor could claim the difference between the standard and higher rate of tax for themselves and declared: 'The bigger the gift, the bigger the return'.[4] 'Private Giving for Public Good' also endeavoured to encourage individuals and companies to give pre-eminent objects to museums, and following their recommendations in 2012 the government instituted the Cultural Gifts Scheme, which permitted tax relief on objects and collections 'of special artistic or historical interest'.[5]

In this context, the gifts of people living on more modest means tend to fall from purview. A recent report published by the National Museum Directors Conference noted that private contributions are concentrated around a few high-level benefactors, and with only cash gifts in mind they stated that 'ordinary' museum-goers rarely make donations.[6] That situation does seem to be the case where financial donations are concerned, but 'ordinary' visitors often try to give artefacts to major museums and are refused. Recognizing that visitors often make such offers, the Museums Association states that museums should only accept donations if they 'can provide adequate, continuing long-term care for the item and public access to it', and advise institutions to 'refuse tactfully but firmly to accept an offer of a gift or bequest if items do not meet criteria set out in the museum's collecting policy'.[7] In such circumstances, the association adds, that institutions should consider informing would-be benefactors, 'about other registered museums, archives, or public institutions that may be interested in the unwanted items'.[8]

Having been turned down by major institutions, donors do sometimes present objects to micromuseums, for instance, the Vintage Wireless Museum has an early Cossor television that the donor first offered to the Science Museum. Other donors go straight to the museum in question, as was the case when Fred and Bill Watts gave the Vintage Wireless Museum several hundred early and mid-twentieth-century radios or when Bob Richel bequeathed a large number of occult drawings to the Museum of Witchcraft in Boscastle. These particular donors all gave established collections, but more often donations consist of single unexceptional items or a group of miscellaneous artefacts: an Irish harp, a china ornament, some shells, or a stack of magazines dating from the 1950s. Where the donors have made themselves known, the curator may affix a label bearing their name and it is common to visit micromuseums and find numerous artefacts thus identified.

While the displays demonstrate the frequency with which gifts are presented, it is less clear what motivates individuals to make such slight donations. These gifts do not render the giver eligible for tax breaks and, unlike people who give to major museums, such low-level donors are not rewarded with invitations to special dinners, events, or previews. Although two of the rooms at the Vintage Wireless Museum are titled for their benefactors, small-scale philanthropists do not generally have galleries named in their honour and it also seems unlikely that such benefactors believe that the lives of their fellow citizens will be improved by the display of their shells or vacuum cleaners. What, then, motivates ordinary visitors to make these gifts? Why do they give such inconsequential presents to micromuseums?

It is difficult to find out about the benefactors and their reasons for giving. Part of the problem is the informality with which the gifts arrive. While some patrons write or telephone in advance to ask if the museum

would care for their donation, other well-meaning donors arrive in person with their gifts tucked into their handbags or packed into the boots of their cars. Many donors send objects through the post or leave them on the doorstep, often neglecting to supply their names or addresses, and occasionally members of staff find that additional items have been inserted directly into the displays. An extra vacuum cleaner was anonymously added to those already on show at the Bakelite Museum, the manager of The Valiant Soldier found a supplementary pair of shoes tucked alongside those from the collection, and a collection of 'spinners' made from lollipop sticks were surreptitiously inserted into a display at the West Wales Museum of Childhood. In all cases, the curators left these rogue artefacts in place.

Any enquiry on gift-giving is also hampered by a widespread indifference to record keeping on the part of micromuseums. It is rare for micromuseums to have complete catalogues of their collections or even to keep a note of where objects originally came from. However, one notable exception is provided by the British in India Museum in Nelson, Lancashire where the founder and owner Henry Nelson carefully registered every donation that he received over a forty-year period, anonymous and otherwise. In addition, whenever donors arrived in person, Mr Nelson would show them round the museum and subsequently write to thank them formally, as he did if benefactors included their contact details when they sent artefacts by post.[9] He also followed telephone conversations with a letter and sometimes sent donors a book, pamphlet, or photograph as a token of appreciation. These reciprocal gifts and Mr Nelson's talent for correspondence resulted in detailed written exchanges wherein some donors alluded to their immediate circumstances and what had motivated them to make a donation. This written material is now stored in the museum's archives.

The British in India Museum is also atypical in that micromuseums are generally built around an individual or a group's collection that is acquired over a long period of time and subsequently launched as a museum. Only then does the founder begin to receive gifts from donors other than family or friends. Mr Nelson operated differently and contacted potential benefactors for objects that were then used to establish a museum. Although he later bought some artefacts, mainly brass ornaments, the museum displays principally comprise of gifts, presented both before and after the venue was opened. Like major institutions, it has been established by philanthropists, albeit of a much more modest kind. Moreover, some of these objects are arranged to form part of a thematic display such as 'regimental ties' or 'medals', but the majority of the exhibition is organized according to the original owner of the artefacts. If a donor has given a number of items, then these are generally clustered together and labelled as such. (Other micromuseums may label gifts according to the giver but these objects are then distributed across the displays.) This curatorial technique makes it possible to see who donated the objects, who they originally belonged to

(where that differs), and what combination of things were given: gift-giving is made visible.

This chapter and discussion draws on the exhibition and Mr Nelson's papers to extend the compass of the literature on gift-giving. Just as the professional discourse concentrates on major patronage, thereby equating philanthropy with objects of pre-eminent value or large sums of money, the rather sparse academic literature on the subject has a similar focus and is unconcerned with worn pairs of shoes or a 1950s vacuum cleaner.[10] Nonetheless, it is important to consider small-scale gift-giving because the current emphasis on objects of value ignores the agency of ordinary people and their relation to the objects in question.

Examining this form of benefaction also raises questions about how gift-givers and other visitors conceive the purpose of museums. In Chapter Two I outlined the argument that museums are akin to mausoleums in that they enclose objects and separate them from the contexts of use that gave them meaning. As I noted there, this deadening effect is viewed with considerable disapprobation and commentators have repeatedly called for such venues to put their objects to work in some respect, usually for the purposes of education.[11] I also showed how the objects in the Museum of Witchcraft retained links with ongoing circuits of belief and practice, but in this chapter I consider whether micromuseums can usefully function as mausoleums or as their close kin, the storehouse.[12] Is it possible that the storehouse does provide a service to the public? I pursue that theme by examining why donors made presents, what they gave, and what they suppose the museum to be.

Giving gifts

Henry Nelson was stationed in the Indian sub-continent between 1943 and 1946 when he served with the Chindits, one of the allied Special Forces formed during the Second World War. After the end of hostilities he returned home to Colne in North Lancashire where he set up a small publishing company, ran a bookshop, and in 1972 opened the British in India Museum. The exhibition remained in Colne until 2004 when he decided to transfer the collection to the neighbouring town of Nelson where the family owned an old textile mill which had provided office and warehousing space for the bookshop and publishing business and, latterly, the site for Doorstep Removals and Storage, the business run by his son Jimmy Nelson. Moving to this premises kept running costs low and it meant that Jimmy and his staff would be able to help oversee the museum, admitting visitors when they arrived. Mr Nelson died in 2011 and since then the museum has been managed by Kathryn Marsden who works one day a week on a semi-voluntary basis.

When Mr Nelson first resolved to open a museum he began by approaching British dignitaries with news of his incipient exhibition, asked for information about the addressee's Indian career, and tactfully enquired whether they had retained any artefacts from that time.[13] Some respondents simply expressed good wishes for the new venture while others were slightly more obliging: the Earl Mountbatten sent an autographed formal portrait and a snapshot of the Countess with Mahatma Gandhi; Viscount Scarsdale gave a photograph of his uncle, Lord Curzon of Kedleston who was a former Viceroy of India, while the Marquis of Lansdowne, Earl of Halifax, and Dowager Marchioness of Reading similarly delivered photographs of their illustrious relatives.[14] Judging from Mr Nelson's 'gifts books', none of these eminent figures actually sent artefacts.

Mr Nelson also joined the Museums Association and this brought his potential exhibition to the notice of other institutions, some of which passed their unwanted artefacts onto the museum. The British Museum sent two temples made from pith, Major General MacLennan sent a number of cards from the Royal Army Military Corps Historical Museum informing Mr Nelson that they 'are not relevant to us, although they do have some artistic merit and are well produced', while shortly afterwards the Centre for South Asian Studies at Cambridge sent some Indian 'charms' with a note to say that they did not collect 'relics'.[15] Major institutions continued to send artefacts once the museum was open and in 1980 Victoria Murphy, a curator at the Victoria and Albert Museum, contacted Mr Nelson after receiving 'a photograph, "simultaneous graphs" and pamphlets from the aged Dr Peshoton Sorabji-Goolbai Dubash of Karachi'. Despite being 'perplexed' by his offering, and although she feared that 'it didn't seem to quite fit into any of the categories of our collections', Murphy 'felt that the material ought to be preserved' and she continued by writing 'the old man harks back so nostalgically to the days of the Raj that our keeper suggested that I should venture to send it direct to you, hoping you may be able to find a place for it'.[16] The 'simultaneous graph' consists of a scroll decorated with Indian banknotes and a lengthy text extolling the virtues of Empire. Mr Nelson placed it on display, later adding a chair that had been carved circa 1880 by a prisoner for the governor of Bombay Jail and which also arrived courtesy of the V&A (Figure 4.1). While these objects undoubtedly fell outside the museums' remits for collecting, their lack of fit also seems to have been a polite excuse for passing on objects that were deemed to have little historic or aesthetic worth.

Donations from other museums ceased once the Museums Association revised its code of practice to stipulate that surplus artefacts should only be passed on to organizations that had been registered with them. This scheme pre-dated that of accreditation and was designed to improve standards of practice, but like many micromuseums the British in India Museum was not registered. From the early 1990s onwards, no museums sent artefacts to the Lancashire venue although they did give a few redundant wall-texts

FIGURE 4.1 *Chair carved by a prisoner in Bombay Gaol, circa 1880, British in India Museum, Nelson, Lancashire. Photograph by Alex Candlin.*

and display images. [17] Nonetheless, gifts continued to arrive. Mr Nelson advertised in *The Lady*, *The Times*, the *Daily Express*, and the Indian Army Association newsletter and these notices proved a rich source of donations, as did those in the local newspapers.[18] Not unexpectedly, these publications did not garner donations from Indian donors and there is a correspondingly meagre representation of Indians who lived and worked under British rule. The exhibition includes portraits of a number of Maharajas, not all of whom are named (Figure 4.2), photographs that depict Indian servants standing alongside the families whom they served, and three large cases contain terracotta models of Indian trades-people and peasants that were made by Bengali folk artists and collected by a nineteenth-century English missionary. There are also some passing references to the Gurkas, the elite Nepalese fighting force, but only in relation to daggers that were presented to British army officers and, taken as a whole, the exhibition is entirely concerned with the British, or more precisely with the English in India.

The colonial slant of the exhibition is reinforced by the labelling which presents Indian history and culture from the point of view of the British of that period. The text next to a portrait of Dunleep Singh, the youngest son

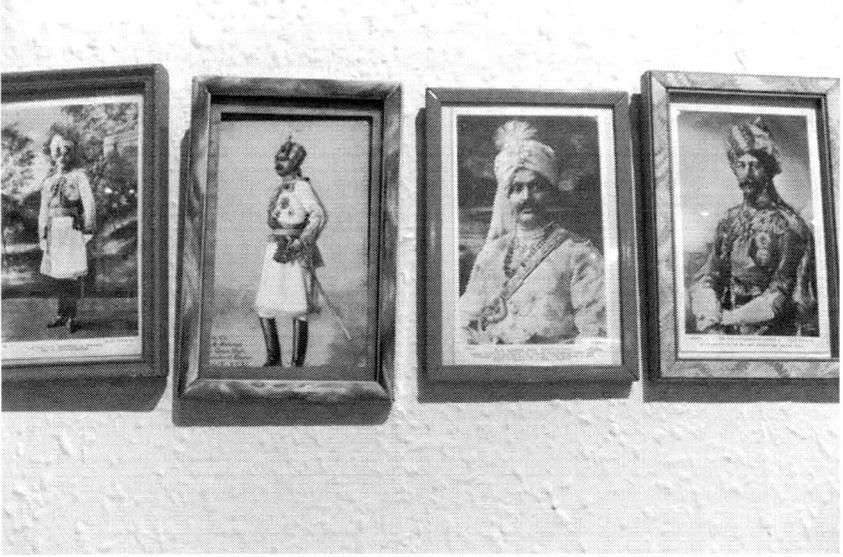

FIGURE 4.2 *Portraits of maharajas, British in India Museum.*

of the Maharaja of Lahore, notes that 'at the age of nine he gave Queen Victoria the Koh-i-noor diamond, a centrepiece of the crown jewels', but there is no mention of the ongoing calls for the jewel to be restored to India or of the fact that the young prince was compelled to give the diamond to Victoria after Lahore had been seized by the British.[19] Equally, a case which contains a book titled *The Amritsar Massacre: Twilight of the Raj* and a photograph of General Dyer has a long text which states that, following a series of riots in which thousands of Indians had run riot through Amritsar, looting and burning European property, a 'small group' of soldiers opened fire on the packed mass killing or wounding 1,500 men, women, and children. The label concludes that 'General Dyer was relieved of his command, but many Europeans applauded his action claiming that he had averted a second mutiny'. Although this assertion is true because Dyer's actions were praised in the House of Lords, more recent commentators have utterly condemned the slaughter of unarmed civilians.[20]

The Eurocentric perspective on the British in India, indeed the very choice of subject of the collection, is also likely to have dissuaded Indian visitors from making gifts. As a result, it was only people who had been actively involved in the British administration or army, or had relatives who served in these capacities, who gave objects to the museum. Their donations were often directly motivated by changing personal circumstances and, in many cases, the benefactors were moving house. Iris Portal, the author of an article published to mark the opening of the museum, resumed contact with Mr Nelson in the mid-1980s.[21] 'I am about to move house into a very small flat and I have a few Indian relics I do not want to destroy.

I thought I would send out an arrow in your direction to see if you are still there and would like any more exhibits'.[22] Finding herself in similar circumstances Yvonne Lewis wrote that 'in moving house on retirement I find I must dispose of many of my things and these include mementoes of life in India in the 1930s'. Among other items she posted two dresses, both of which had been made for her as a child. One is a copy of an Indian ayah's costume, the other was made when 'the dancing class I attended in Delhi did a display at a garden party for Lady Willingdon (Lord Willingdon was then the Viceroy)'.[23]

Likewise, Mrs Pett volunteered the large blackwood table which now stands at the entrance to the museum and which was bought by her parents when they lived in Bombay. 'Since my husband and I are not getting any younger', she wrote, 'the house we are living in will soon be too big for us and the table would not go into a modern house'. She added that 'I also do not like the idea of it going anywhere to be ill used' and wondered if 'you would like it for your museum where it would be loved'.[24] Mrs Birrell offered to donate a tent, camp bed, and 'other bits' that had originally belonged to her father. In the course of a discussion concerning the delivery of these items, she commented that 'we are now forward with leaving the farmhouse for a retirement house'.[25] Shortly before moving, she wrote again, supplied Mr Nelson with their new address, and remarked: 'How strange it will be to live in a row of houses. Two rooms are already full of boxes so I am thankful to be rid of those I sent on to you. We have accumulated far too much I see but will surely cut it down.'[26]

As these letters make clear, the owners are downsizing because they are ageing. Other correspondents are gradually arranging their affairs as a precursor to their demise. Mrs Blacklaws, got in touch to say that her husband was in India for over forty years and that she had a book of sketches of Indian life dating from 1890. 'I wonder if you would be interested in it', she asked, 'as I am now 75 years of age and feel it silly to keep it any longer'.[27] Mrs Munckton enquired as to whether the museum accepted 'deposits of paper etc.' since 'I should like to know that they were sent to somewhere of use when the time comes', while in 1980 Mrs Phyllis Pengree wrote to say that she was making her will and inquired if the museum would appreciate two pairs of elephant tusks that had been mounted alongside a gong from the Himalayas.[28] She wrote again in September 1983 asking if she should send the trophy more immediately but evidently it was not delivered because her solicitors later wrote to announce that she had died in November and that they wished to arrange for its conveyance.[29]

Donors also gave artefacts to the museum because they were clearing the effects of people who had recently passed away. Sometimes the executors are adhering to the wishes of the deceased. Mr T. M. Hards wrote that 'a friend of mine died and left instructions to send certain items to the museum. He was a railway enthusiast. There are three packages. I have not opened them but they are recorded to contain maps of Indian railways, a

Bradshaw, photographs, and extracts from periodicals of the day.'[30] In a later letter he asked Mr Nelson to write to the widow because 'the amount of stuff left by Lt. Col. Wingfield to be worked through and disposed of according to his wishes has been a sore task for her'.[31] Mr Nelson did so, 'kindly commenting that the items are fascinating especially the railway tickets, which are in such good condition'.[32] Other legatees received no such guidance but nevertheless made similar donations. Mrs Hill wrote that 'my husband died a few months ago and I am slowly trying to clear up his effects'. She offered four railway tickets and a pair of tankards marked with regimental insignia to the museum.[33]

Sometimes a donor found a book or some brassware in a charity shop and thought that it would be better placed in the museum. At other times no explanation was given for the gift, but where motives are recorded, the donors are predominantly moving house, putting their affairs in order, or clearing the effects of others. This accounts for the timing and the immediate circumstances of gift-giving, but it does not explain what exactly was given and why. I will now turn to that issue.

Ancestors' relics

In all the correspondence that Mr Nelson retained only Prof. Sprott of King's College Cambridge ever suggested that his gift was of historical significance. He stated that 'I have in my possession, in accordance with his will, the ceremonial dress worn by Mr E. M. Forster when he was an official at the Court of the State of Dewas [. . .] I am told by a Dr Narlika, a Fellow of King's and a friend of Forster, that they are of some historical interest.'[34] Prof. Sprott was in a position to take informed advice but lacking professional guidance, other donors are more tentative and are certainly not driven by the conviction that citizens' quality of life would be enhanced by access to these objects as the 'Private Giving Campaign' claimed of the founders of major institutions. Mrs Gray wrote to say that her father-in-law 'had died recently and we have some photographs and documents from his lifetime in India that *may* be of interest to you. If you would care to see them you would be welcome to take any you think may be suitable'.[35]

Other donors suspect or insist that their gift is of little worth. Mrs D. E. Townsend sent a trumpet used by her father during the First World War and a pair of beautifully embroidered shoes, remarking that 'these things are not very important, but I just thought that they might fill in a gap somewhere'.[36] Mrs Rowland hoped that Mr Nelson would be willing to accept one or two little things, although 'I am afraid they are not of any value'.[37] Other donors only gave items *because* they had no worth. Offering the Museum a silk picture from Cawanpore, Mrs Amberton noted that she had considered selling it, 'but it is unlikely to make much in financial

terms', while Mr D. W. Hellings wrote confirming that 'in the opinion of the executors', Harold Arrowsmith's judicial robes 'have no financial value and we are therefore content that they should be donated to the British in India Museum'.[38]

Whether or not donors made the point explicitly, no one gave valuable or historically significant objects. At the same time, most people did not give complete junk or entirely random articles. On the contrary, the donations fall into several interrelated categories, one of which is that they represent military or civic success. The family of Samuel E. Hollins, Companion of the Indian Empire (CIE.) and Inspector General of Police in the United Provinces gave a large framed photograph of the man in his uniform, miniatures of the medals that are shown in the portrait, a rolled parchment declaring that he has been awarded a 'Degree of Honour for Eminent Proficiency in the Language of Urdu', a silver scroll holder, and a copy of a congratulatory speech made in his honour (Figure 4.3). They also donated two small silver cups won for rowing, a novel he authored, and a number of padlocks, one of which bears the legend 'Jhangi Open Married Quarters'. Collectively, these objects assert that Samuel E. Hollins was a married man of authority and of multiple talents. They also indicate his qualities as well as his achievements – duty, service, intelligence, physical strength, and responsibility. Less obviously, Mrs Pratt donated a number of newspaper cuttings relating to Hamilton and Co., which was a high-

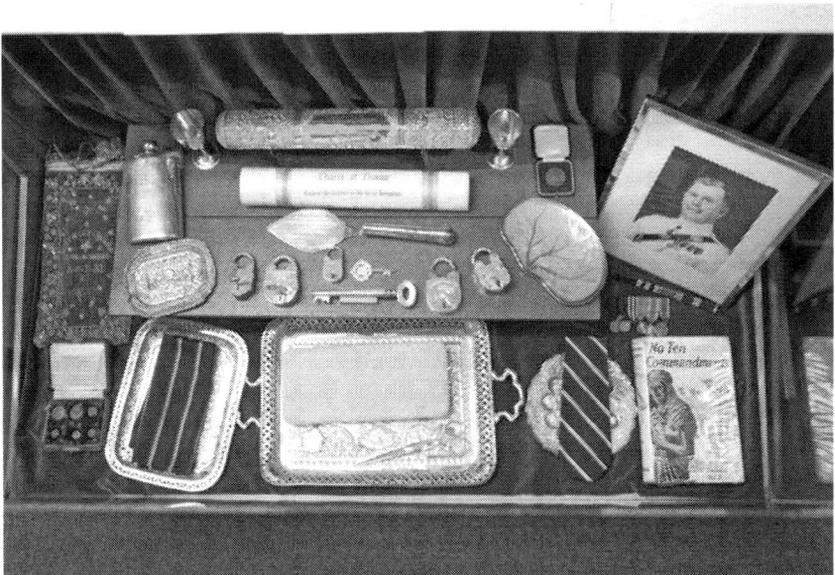

FIGURE 4.3 *Case containing items belonging to Samuel Hollins, British in India Museum. Photograph by Alex Candlin.*

class jewellers based in Kolkata (then Calcutta). The label on the material notes that her husband spent his working life with the firm and so, by implication was a reliable man of professional standing. Invitations to balls, regimental dinners, high-profile weddings and the races, which have been donated in large quantities to the museum, had a similar function in that they demonstrated that the recipient was acknowledged and accepted within polite society.

If some artefacts indicate official and social recognition, others demonstrate marksmanship and bravery. When Mrs Pengree offered to donate the mounted tusks and gong, she wrote a long letter which explained that, in 1911, a government official had asked her husband to shoot a rogue elephant. She described how he tramped through dense jungle until gravel began to rain down on his topi. Peering through the thick undergrowth, her husband saw the elephant some twenty or thirty feet away, throwing mud over its shoulders. With one shot Pengree felled the elephant, which collapsed without a sound. Then, before he had time to take a breath, he looked up and saw a second elephant preparing to charge. In an instant Pengree took aim and with his one remaining bullet, shot it between the eyes. At this time, Mrs Pengree wrote, it was a world record. He had killed two elephants with a left and a right shot (presumably from a double-barrelled shotgun).[39]

Most of the individuals who had originally owned (or killed) these things had been responsible for maintaining British rule across the empire and were variously involved in the late nineteenth-century Afghan and Anglo-Burmese wars, punitive expeditions on the North West Frontier, and the Second World War Burma campaign. Civilians would also have witnessed hardship and violence. Even if Mr Pratt, say, had remained ensconced in his high-class Kolkata jewellery shop he would have still witnessed the bombing of the city during the Second World War and the Bengal famine of 1943. Even so, only two exhibits in the whole museum so much as hint at insalubrious events, these being a group of postcards showing victims of the Quetta earthquake (about which no additional information is available) and Hollins's novel, which was titled *No Ten Commandments: Life in the Indian Police*. Otherwise, no one donated arms or trophies that relate to disasters, violence, or aggression. Nor are there newspaper cuttings about hardship, injury, or death. The two bullets that are on display were presented by survivors, a bayonet was given to one Lt Green in thanks for his saving a man's life, the two daggers were tokens of appreciation from Gurkas, and most of the swords were made to wear with dress uniforms rather than to be used. Even the tiger skin that is stretched across the gallery wall came from an animal that was killed to ensure the safety of a village community and not for the purposes of sport.

A common trait, then, is that all the donations relate to high points in their owner's biographies. They are things, and by extension, roles and events to be proud of. So far as it is possible to judge, these donations did

not recall periods of fear or dishonour, rather they conjure the authoritative police inspector, the respectable shop manager, the colonial administrator treading warily but bravely through the jungle, or the prettily dressed child dancing in the Viceroy's garden. Even lone items operate similarly in that a single medal, most of which are carefully labelled with the name of the recipient, denote a significant achievement and mark that person out as distinct from others. The majority of the donations are also of a particular type in that they are all, in some respect, things that have been won or achieved. These items are not commodities that have been bought or traded but things that have been awarded or proffered. Although other people would also have gained certificates of proficiency in Urdu, trophies for rowing, or medals for valour, these specific objects pertain or belong to that particular individual by dint of their labour, position, or qualities, or because they have actively been fought for. In theory, a second person could purchase Hollins's trophies or the bayonet given to Lt Green but at some level these objects remain allied to the people who initially won them.

Annette Weiner refers to things that are 'imbued with the intrinsic and ineffable identities of their owners' as being inalienable.[40] Such objects, she notes, blur the boundary between persons and things because they symbolize an individual's personal experience, indicate identity, expand their social status and, more strongly, may embody the spirit of the owner. This latter conception is most closely associated with the writing of the anthropologist Marcel Mauss who observed that Melanesians and specifically Maoris distinguished between two types of property: *taonga* were closely bound up with the individual, clan, and land, and were the vehicles for religious, magical, and spiritual power, while *oloa* denoted other types of property, particularly anything foreign. Mauss suggested that marriage mats, emblems, talismans were all *taonga*, and that the spirit of its owner and their homeland animated these objects. Importantly, for this discussion, Mauss commented that 'the thing itself is a person or pertains to a person. Hence it follows that to give something is to give a part of oneself'. When giving *taonga*, the donor gave away part of one's nature and substance, and conversely 'to receive something is to receive part of someone's spiritual essence'.[41]

As Weiner pointed out, Mauss was not claiming that all gifts carry the spirit of their owner or are akin to persons, only those that relate to *taonga*. At the British in India Museum the majority of donations, like *taonga*, are bound up with clan (the British in India and with specific regiments), with land (India and the notion of the Empire), and are emblems of belonging and achievement. These objects may not have religious or magical significance but they are signs and vehicles of military might or civic worth and while donors may not specifically conceive of these objects as persons, the constant references to the original owners show that they are seen as closely pertaining to those individuals. Moreover, a large proportion of the objects that were given to the museum are items

that have been worn. The spectacles, watches, walking uniforms, hats, and other garments all invoke the presence of their original owners, as do the army-issue camp beds and chairs that are shiny with use or that have been mended where the occupant's hands grasped the sides and wore away the canvas. The donors were not giving the museum, say, a regimental tie from the East Lancashire Regiment, but their grandfather's tie: something that stood for his achievements, social standing, and which he had worn around his neck for so long that the cloth was worn. In passing these objects on, donors were also passing on something of the owner's 'nature and substance'. These objects are fragments of the person; relics of ancestors and selves.

The museologist Sharon Macdonald has made a similar point in her article 'On Old Things: The Fetishization of Everyday Life' where she draws on anthropological theory to consider the plethora of everyday objects at the Skye Museum of Rural Life and in other small museums of the same type.[42] Macdonald's main concern is not with donations as such but with questioning the divide between gifts and commodities and she shows how objects that were initially traded and then subsequently bought by the curator, can carry the spirit of the original owner in manner more usually associated with gifts. At the Skye Museum the artefacts are used within a series of dioramas, and Macdonald notes that visitors are not told who owned a particular spade or mantle-clock, so the objects all contribute to a generalized picture of the immediate locale and the associated way of life. In contrast, the exhibition at the British in India Museum retains the link between the donor and the artefacts. Instead of being amalgamated into a diorama or absorbed into a thematic or historical display, most of the donations have been kept together to create an idealized object-portrait of the original owner. These objects are employed as metonyms for a person. The campbed on display does not represent the British Army's stint on the Burmese front or typify army kit, but stands for Captain A. F. Robinson, John's father.

Almost everybody who gave objects to the museum was a close relative of the original holder. More specifically, almost all the donors are women and they gave items that had originally belonged to their fathers or husbands, and to a lesser degree, fathers-in-law, grandfathers, and brothers. When men do make donations they generally present artefacts that belonged to their fathers, while both sexes give objects on behalf of childless uncles and aunts. There are no gifts given by men on behalf of their wives or sisters and the distribution of giving suggests that the responsibility for clearing someone's effects, keeping selected items, and hence for shaping a family's material history, usually lies with female descendants and that the history they construct is principally construed as male (although in this case Mr Nelson actively solicited items pertaining to official and military history and this impacted on the character of the display).[43] Nonetheless, whatever the gender of the giver or of the original owner of the objects, the

donations predominantly relate to individuals whom the donors knew, often intimately, and to whom they owed a degree of spousal or filial obligation. Here then, donors were ensuring that the objects that embodied and carried a trace of their relatives were kept; that bits of their family members were not simply thrown away.

There is also a degree of self-preservation in passing on the traces of close kin. While the donors were not physically present when their spouses caught elephants or their fathers saved men's lives, they tell these stories with considerable detail and verve. The owners must have recounted these tales to their partners and offspring and, judging from the tone of the letters, these exploits formed part of their family histories, as did anecdotes that other donors related about camp-beds, medical kits, or Japanese flags. In time, the objects themselves were inherited by the donors, sometimes displayed or used by them, and became linked to their identities and stories. Through storytelling and habit these artefacts and the exploits or achievements they involved became part of the donors' as well as the original owners' biographies. In giving, the donors also presented something of themselves.

The same logic operates when donors gave or bequeathed their own possessions. While this group also presents medals or objects that indicated their own attainments, they more often sent items that related to an ephemeral moment. Several of the photographs given to the museum show weddings and children's parties while Dr Leach tendered two cases of butterflies that he had caught near Kodaikanal around 1916–20. 'They are not in perfect condition', he wrote, 'but are amazingly preserved for 80 years. I can still remember the thrill of catching some of them – though these days I'd probably be prosecuted for doing so'.[44] Mrs Mulhall gave a watercolour sketch and wrote that 'the picture is of the lower Nilger hills where we spent happy times at a tea plantation of friends and played golf at the Ooty club', adding 'We spent some of the happiest years of our lives in India'.[45] The four railway tickets left by Lieutenant Colonel Wingfield appear to be no more than the detritus of a life, but he kept them for over half a century and took the trouble to leave them to the museum, which suggests that, for him, they brought an important time to mind. These donors are attempting to present the museum with a fragment of their idyllic childhood, their years spent in the hills, or of railway journies across the sub-continent.

Although some of the exhibits may initially appear to be little more than rubbish, these objects were closely intertwined with their owners' lives and those of their families. These slight, even motley objects are touchstones for individuals' biographies, their physical presence, and for the associated family histories (Figure 4.4). The question is, then, if the objects were so important why did the donors give them to the museum rather than keeping them in the family? What exactly did they expect the museum to do with their gifts?

FIGURE 4.4 *A small bowl, British in India Museum. Photograph by Alex Candlin.*

Keeping gifts

Annette Weiner has argued that inalienable objects are difficult to give away and, ideally, they are retained within the closed context of the family or clan because their loss diminishes the self and the group to which they belong. This principle applies here because most of the donors would have preferred to give their belongings to younger relatives. Mrs Pengree remarked: 'Had we larger houses, as was common fifty years ago, I would have left it (the tusks and gong) to a relation but now no one could really cope with it.'[46] Lieutenant Colonel Michael Pim also commented on the lack of available space. He wrote: 'I am so pleased you found the albums of interest. What one should do with old family albums must be of concern to many people like myself. As generation succeeds generation and homes become smaller with less space to house all the family artefacts, passing them over to safe keeping with museums seems the best course, although one still feels a wrench at parting with the photographs for good.'[47]

Unlike a gong and tusks, a photograph album takes up very little space, as indeed do the majority of the other donations and it may be that other correspondents diagnosed the situation more accurately. Mrs Richards wrote that 'my late husband was in India in the 1920s and again in 1945–47 and I have photos he took which my children are not interested in. Are they of any use to you?' while Mrs Ashton also sent photographs and wrote, 'I have

been having a turnout. I am now 87, I have no children and my nephews and nieces don't seem interested (of course they weren't born when all this was going on) and they will just throw out what they don't want when the time comes).[48] In 1972, Lieutenant Colonel Robert Wright reported that 'I have a C.I.E. decoration which I do not know what to do with. I am 88 and have no family or relatives who would give it a home and I don't like the idea of it being put in the dustbin when I die. The Commonwealth Office gave me your name; would you care for it for your museum?'[49] A few months later on the following New Year's Day when he was presumably thinking about the future, Wright contacted Mr Nelson again: 'I am taking the liberty of sending you two medals which I got at the end of my medical course . . . Perhaps they might find a place beside my other Indian Service things. If so, I shall be glad, as when I die I'm sure my relatives will not want them.'[50]

There may well have been personal reasons why Lieutenant Colonel Wright's relatives were indifferent to his medals, but it is also possible that younger generations may have been dubious of, or even embarrassed by mementoes of the Raj. The Visitors' Books at the museum give some indication of these attitudes. While the first visitors do little more than sign their names, and those who came in the 1980s left concise notes along the lines of 'fascinating', 'very interesting', and 'my grandfather served in India', lengthier and more acerbic remarks began to appear from 1991 onwards (possibly because the museum started providing books that had more space for writing comments). M. J. Cowling commented that 'the British have a lot to answer for', Nilufa Ali wrote 'It is clear from this museum how the Indians were persecuted by the British' and Lena Keshwari thought 'India would have been much better off without the British'.[51] It is possible that potential legatees agreed and while they would happily have found a space for a photograph album showing President Kennedy's election campaign or ornaments commemorating, say, World Cup football matches, they judged mementoes of the Raj to be less desirable. For whatever reason, they chose to disassociate themselves from their material and ideological inheritance.

Unwanted by members of extended families, or in the absence of any family, these artefacts were passed on to the museum. Within anthropology and sociology it has become commonplace to observe that giving and receiving incurs obligations and the British in India Museum is no exception because, in making their presentations, donors also transferred a range of expectations and responsibilities to the museum.[52] Lieutenant Colonel Pim gently reminded Mr Nelson of his duty of care when he concluded his letter by saying 'I am sure you will look after my small collection of albums safely'.[53] Mrs Case was far more direct stating that she wanted her uncle's and aunt's photographs to go 'to a good home where they will be preserved and treasured for years to come. I would like very much to see these artefacts preserved for posterity and if you would like to have them, kindly let me know if you can offer some kind of guarantee that they will be in good hands for generations to come.'[54]

Several donors gave instructions on how the museum should present their gift. Mrs Pengree specified that 'I should like a plaque to be put on the base

(of the gong and tusks) to say how (the elephant) was shot or rather who shot it although as the years go by no-one much cares'.[55] She reiterated her plea in a subsequent letter: 'it would be nice if a plaque could be put on its wooden stand to commemorate for all time my husband's effort'.[56] Other donors intimated that the museum should undertake repair work on their donations. Lisa Poirer noted that her mother's photographs, which she was sending on, were in dire need of restoration.[57] Elizabeth Shafer similarly wrote to say that her Uncle Fred's album was 'falling apart a bit and most of the photos have fallen out but I thought I would send it as it is because some of the photos might be matched to labels in the album by someone who was interested and could spend time sorting through them'.[58]

Donors also delegated decision-making to the museum. William MacFarlane inherited dress uniforms, swords, other regalia, and a package of letters from his uncle Major General Curtis, which he proposed to send to Colne. There was however 'a proviso that (Mr Nelson) personally read the letters, some of which are marked secret or confidential, and decide whether they should be shredded'.[59] Nobody else gave confidential letters, but donors routinely gave Mr Nelson the responsibility of determining the worth of the items concerned and whether to keep or to destroy them. When Dorothy Hayne contacted him with an offer of her grandparents' wedding photographs and relatives' watercolours she stated 'before committing these to the bonfire, I write to ask if they are of any use to you'.[60] Geoffrey Dempsey offered diaries concluding 'otherwise they seem destined for the skip'.[61] These remarks could be interpreted as diffidence; but other people actually sent articles and directed Mr Nelson to dispose of them if they were unwanted. Leila Richards posted her father's photographs with the instruction to 'use them or throw them out' and, sending the regimental tie that he had worn for fifty years, Major Smith told Mr Nelson to 'dump it if it is not of the required standard'.[62] Such sentiments do not necessarily mean that the objects were uncared for, indeed quite the opposite because the donor had gone to the trouble of sending the item. Rather, they suggest that the donors were unable to throw out the things in question. As Lieutenant Colonel Michael Pim wrote, it was a 'wrench' to part with the photographs that he nonetheless sent on to the museum.[63]

Most commonly, however, donors asked Mr Nelson and the museum to provide their artefacts with a home. Mrs Birrell was delighted to 'find a good home' for her father's camp bed before she moved into her retirement house and Mrs Pratt wrote that 'my family are also delighted that I have at last, we hope, found (the newspaper cuttings) a home'. Margaret, Mr Robinson's daughter and John's sister, left a note in the Visitors' Book which reads: 'Great to see my father's camp cot in a place as interesting and as meaningful as this. His chappals (sandals), travelled from U.S.A., have now found their home. He would be pleased.'[64]

Giving an object a 'home' is clearly a figure of speech, but it also sums up what donors wanted from the museum, namely that Mr Nelson would

shoulder the duties more normally expected from a close family member. They expected him to sort through objects, determine what was worth keeping, and to dispose of anything he chose to reject (although he almost never did). In doing so Mr Nelson would relieve donors of any 'wrench' involved in making such choices, avoid exposing them to information they may find upsetting, or even prevent them from knowing what had happened to their relatives' belongings. They assumed that if he elected to keep the artefacts, then he would give them a place which registered respect, that he would mend and take care of them, and make sure they were available should any member of the originating family come to visit. Some donors even hoped that Mr Nelson would 'love' their belongings as they had. In many respects, benefactors did not address the museum as a professional organization or as an institution for the public good, so much as replacement for their own domestic sphere or that of their extended families.

Mr Nelson was not envisaged as a curator or director but as a quasi-descendent. Together, Mr Nelson and the museum were surrogates for home and family. Even so, the blood family still took precedence and retained the right to retrieve their gift. Like the inalienable objects that Weiner describes, these objects are both given away and also, at some level, kept by the original owners and their kin. Six months after presenting her father's belongings to the museum, Samuel Hollins's daughter requested that the medals of larger size be returned since her nephew would like to have his grandfather's awards.[65] Mr Nelson complied replying that 'this sentiment is perfectly understandable to us and I feel sure that his owning them is most suitable'.[66] He was similarly amenable when Reg Renwick wrote to ask for his father's uniform back, having presented it to the museum some six years earlier.[67] Both the donors and Mr Nelson understood the originating family to have a stronger claim on their gifts than the museum.

The act of giving artefacts that have no historic or economic value, and which require care and storage in perpetuity, could easily be interpreted as an entirely self-interested calculation, especially when donors maintained moral ownership of their gifts. The effort and cost expended by Mr Nelson, and subsequently by his family, far outweighed the value or the historical significance of the gifts. In some ways the museum provides a comparable service to that of Jimmy's removal and storage business in that objects are taken away, looked after, and can be reclaimed at any moment by the original owners, the difference being that it is free of charge. Viewed from a different perspective, however, the donors took an immense risk with the things they cared about. Giving valuable items would have been far safer for the donor since they could be reasonably sure that an organization, curator, or his family would look after a Victoria Cross or a jewelled tiara. Consigning objects that are personally valuable but worthless on the open market requires a far greater degree of trust. Donors had to rely on the exhibition remaining open, Mr Nelson's good faith, and on his family assuming an unpaid caretaking role once he was no longer in a position to do so.

Henry Nelson understood what was being asked of him and met the donors' implicit needs and explicit demands with consummate grace. He replied to Lieutenant Colonel Wright, who was unsure about entrusting his medals to relatives, saying that he would be pleased to receive the CIE. and provided assurances that it would be well cared for. 'All our medals are in locked cases', he noted, 'and the museum has a burglar alarm system in place'.[68] After Wright sent the decoration, Mr Nelson responded by sending a book titled *A Short History of the Indian Army,* a gift which indicated that he understood the necessity for reciprocation and, when Wright sent more medals, Mr Nelson expressed 'our thanks to you for continuing to think about us and supporting us through your benefaction' and mentioned that his gifts had been displayed alongside each other (Figure 4.5).[69] He was similarly reassuring to other donors, variously informing them that the

FIGURE 4.5 *Lieutenant Colonel Wright's CIE, miniatures and medals for medicine, British in India Museum. Photograph by Alex Candlin.*

cases were all secure, that the collections would never be sold, and that the museum was deeply grateful to them for passing these objects on. Perhaps most importantly of all he kept donations together thereby ensuring that they retained their connection with their original owners. He was the perfect recipient; the museum, the ideal legatee.

Managing mortality

The British in India Museum is clearly not a memorial museum in the sense that those institutions are currently conceived. It does not commemorate mass suffering or warn against the mistakes of previous eras.[70] On the contrary, the British in India Museum resolutely ignores the injustice and the damaging aspects of imperial power to concentrate on military service, adventure, railways, and elegant living. The individuals it focuses on were the victors rather than the victims, and Indians only figure as servants, soldiers fighting for the British Army, or as aristocratic associates of the colonial ruling class. Nonetheless, it is a memorial insofar as it documents, celebrates, and implicitly regrets a past era as it is selectively represented by a particular set of people.

The exhibition also functions as a memorial to Henry Nelson. Instituted and arranged by him, his portrait photograph now hangs opposite the entrance (Figure 4.6). Just as children originally kept many of the exhibits in remembrance of their fathers, Jimmy keeps the museum in Mr Nelson's memory. There is a further parallel in that Mr Nelson's descendants will probably face the same dilemma as the people who gave their belongings to the museum. According to Jean Marsden, who was Mr Nelson's secretary for many years and now works for Jimmy's company, the museum will stay open as long as Dorothy, his widow is alive, while Jimmy has stated that it is no trouble to keep it going and that his father wanted it to continue.[71] Still, unless Jimmy's children are prepared to take responsibility for the museum, the Nelsons may begin to wonder whether they can keep these objects and, if not, who will take them. Like people who made donations to the museum, they may have to look for a surrogate family to take care of a collection that has little economic worth but which was important to its owner.

Significantly, donors rarely expected the museum to maintain the memory of particular individuals. Nor did they imagine that visitors would subsequently admire or even acknowledge their relatives' achievements and thus ensure that their names remain in circulation. On the contrary, the idea of remembrance rarely appears in forty years of correspondence and no-one ever mentions these articles being seen by people other than close kin. All the donors want is for the museum to keep their gifts intact. This suggests that the donors conceived of these items living on in their stead or

FIGURE 4.6 *Portrait of Henry Nelson, Founder, British in India Museum.*

that of their relatives' and hence as obviating the need for anyone to actively remember them. If Captain Robinson's camp-bed endures then a trace of the man remains; if Dr Leech's butterflies are shown then something of his childhood in Kodaikanal has a physical presence in the world. These objects represent the effort that the donors made to carry themselves, their relatives, and their family memories into the future.

Housing these objects is akin to keeping the remains of that individual. As I noted in Chapter Two, Theodore Adorno called museums the family sepulchres of works of art. The British in India Museum is a family sepulchre without the art, or more accurately, a series of family sepulchres and although no actual bodies are interred on the site, relatives do come to

pay their respects as they might at a graveyard. Having presented her 'very dear husband' Colonel Lord's uniforms and mess kit to the museum, his 85-year-old widow made the journey from Bury St Edmunds. Her nephew Major Davey accompanied her on the trip, and subsequently wrote to thank Mr Nelson for his kindness. In a lengthy and glowing letter he reported that Mrs Lord 'mentioned to us several times how *very pleased* she was at the way you had dealt with all her late husband's belongings. We think you would have noticed that she sat for almost one and a half hours just looking at this particular display' (Figure 4.7).[72]

FIGURE 4.7 *Cabinet containing uniforms and other belongings of Colonel Lord, British in India Museum. Photograph by Alex Candlin.*

Even if one has no personal connection with the collections, the venue still resembles a cemetery insofar as the individual exhibits function as a series of tombstones, each conveying some sparse information about the person's life; their name, rank, and dates – although in the museum these years usually pertain to a stay in India rather than their life span. The labels, like epitaphs, register the subjects' qualities or achievements and some of them follow memorial conventions in noting that they were a devoted father or a much-loved husband. As in a graveyard, a few individuals have been given elaborate memorials in the form of a whole display, others are marked by a single item, the equivalent of a small, plain headstone, and unattributed objects are analogous to weathered gravestones whereon the details of the occupants' identity are no longer legible. Wandering around, the viewers' attention may be caught by random names or phrases, and while it is possible to use these scant details as a basis for conjecture, like tombstones, the exhibits do little more than signify that someone has lived. Like walking in graveyards, the exhibition has a certain melancholy appeal, and although its emphasis on the Raj makes it a politically problematic collection, it is still a landmark to a certain kind of unexceptional achievement. These insignificant objects of little cultural value provide a slight testament to ordinary lives, some of which have been lived in extraordinary circumstances, and to the loyalties of family.

Contemporary museologists are extremely sceptical about museums that concentrate on storing objects and, over the past forty years, have vociferously argued in favour of them developing an educational and socially active role. Instead of just keeping objects, commentators have exhorted curators to ensure that their institutions actively serve the public. In this case, however, simply accepting and housing objects *is* a public service and it has enhanced the lives of the 'citizens' who made donations. Like curators in other micromuseums, Mr Nelson and his son have provided donors with a place to leave their treasures when no one else was willing to take care of them. They ensure that object-persons are not summarily destroyed and thereby enable donors to approach their own ends feeling that they have fulfilled obligations to their kin or that they have a guarantee against non-existence. The British in India Museum and micromuseums elsewhere help donors cope with the prospect of their own deaths, those of their relatives, and the fact that the things that they held dear are inevitably forgotten.

.

CHAPTER FIVE

Choosing clutter: Curiosity and the history of museums

In his book *Do Museums Still Need Objects?* Steven Conn remarked that there has been a dramatic reduction in the number of artefacts that are displayed in museums. To illustrate the point he reprinted a photograph of a nineteenth-century gallery where paintings cover the walls from floor to ceiling and compared it with contemporary art venues in which the pictures are arranged in single, well-spaced horizontal lines. Conn also noted that other museums have both decreased the number of exhibits on display and replaced artefacts from the collections with other types of things. For example, he described how natural history museums abandoned serried rows of cabinets that each contained numerous specimens in favour of dioramas, which in turn have been replaced by interactive technology.[1] Conn's observations on the shift in display techniques have been echoed elsewhere and commentators regularly note that objects have 'been displaced', 'have lost their central position within the museum', and have become one element alongside explanatory texts, photography, documentary footage, and multimedia presentations.[2] More radically, some scholars suggest that objects, by which they mean items from the collections, may be inessential to the core functions of museums.[3]

These comments are entirely justified in relation to most major institutions. It is indisputable that the displays in large museums feature far fewer objects from their collections than was previously the case, and that in some venues other kinds of exhibits have become more prominent. The same is not true of micromuseums wherein it is common to find rows of glass cases that are packed to overflowing, and for further artefacts to be arrayed along window-ledges, on shelves erected above doorways, or even hung from the ceiling. These abundant displays are sometimes labelled, albeit inconsistently, and they occasionally feature introductory wall texts, and some have dioramas, but it is very rare to find any photographic,

audio-visual, or interactive provision. In micromuseums, the quantities of objects from the collections have not been reduced and definitely have not been substituted with other kinds of material.

Previously, in my discussion of the Vintage Wireless Museum and the Lurgan History Museum I showed how the curators act as guides and weave narratives through the packed displays, and I also discussed the displays at The Valiant Soldier where masses of objects are arranged to create a mise-en-scène. In this chapter I turn to the Bakelite Museum in Williton, Somerset, where the plethora of barely annotated artefacts is neither verbally elucidated nor organized to create an in situ exhibition. This venue features several thousand plastic objects neatly arranged in cabinets and upon shelves and other supports and, while this profusion contravenes all recent thinking in museums practice and theory, the Bakelite Museum commands enthusiastic reviews in travel guides, averages 4.6 out of 5 stars on the website TripAdvisor, and is popular with bloggers. In this chapter, then, I investigate what is prohibited by cluttered displays, and conversely what they may enable for visitors. What are their limitations and their pleasures? In turn, I consider how dominant accounts of museum display are brought into question by the prevalence of abundantly arrayed micromuseums and ask whether there is a correlation between the neatness of conventional exhibitions and that of museological accounts.

Objects in abundance

Visitors to the Bakelite Museum make their way past St Peter's Church, which dates from the thirteenth century, over an old river-bridge, and down a rough track which has antiquated ploughs and seed drills parked along the verge. Beyond them is a 1950s caravan, fully fitted out in period style, and a number of tiny 'podcaravans' that are designed and made by the proprietor Patrick Cook. The drive leads to a handsome Georgian residence adjacent to which stands the seventeenth-century watermill that houses the collections (Figure 5.1). There is no reception or ticket office and entering into the building visitors find an honesty box with a note that specifies the rates of admission. No one is available to guide visitors and there is a single sign that indicates the entrance.

Although the ostensible subject of the museum is Bakelite (or polyoxybenzylmethylenglycolanhydride), which was invented in 1907, it actually contains objects made from many different types of plastic and from other materials. Parked at the mill door is an East German Trabant, made from Duroplast (a hard plastic similar to Bakelite), while the first room of the museum features a large display of early and mid-twentieth century cookers and refrigerators, which are all made from metal. These serve as shelves for numerous plastic models of Snoopy, the Mr Men, and

FIGURE 5.1 *The Bakelite Museum, Williton, Somerset.*

many other cartoon characters, while a glass display case contains Bakelite clocks, telephones, and miniaturized televisions that were probably made for dolls houses.

The second room is full of Bakelite wirelesses (Figure 5.2), some of which are arranged on the large horizontal wooden cogs that were restored when the mill was home to a museum of rural life. Full-sized telephones and televisions line the adjacent walls as do cabinet gramophones, some with vinyl records on their turntables. In the corner of the room is a vertiginously steep open-slat wooden staircase with a note that reads 'exhibition continues upstairs', and having gained the first floor visitors find a further three rooms. The first and smallest contains a mass of small plastic objects

FIGURE 5.2 *Wirelesses displayed on the mill's wheels, the Bakelite Museum.*

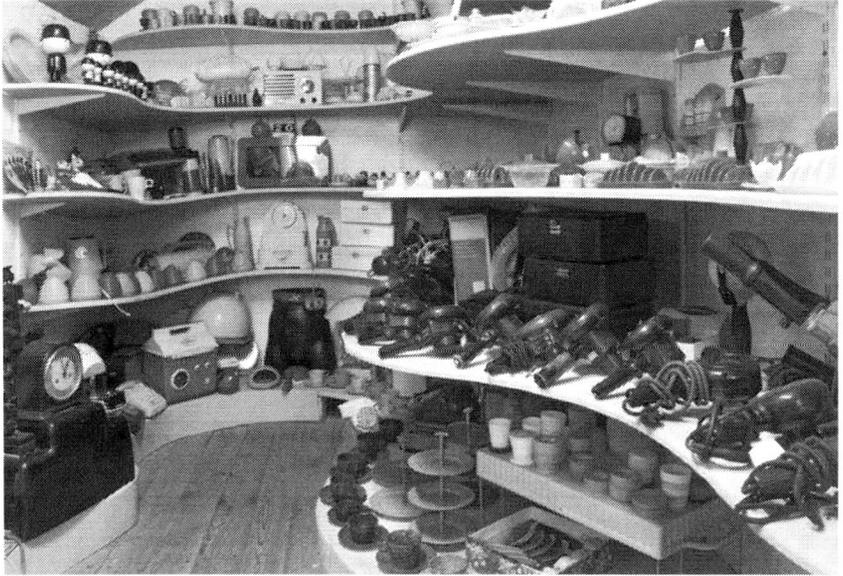

FIGURE 5.3 *Small upstairs gallery, the Bakelite Museum.*

(Figure 5.3). Eggcups, napkin-rings, candlesticks, hairdryers, and types of kitchen and household ware are arranged on wide shelves that sweep around two sides of the space, while leaning against the other walls, are five 1960s sit-in hairdryers, several teasmaids, some hospital equipment, and a

golf club with a model of a golfer attached to the end instead of a wooden head or iron face. The middle room is devoted to metal electric fires and vacuum cleaners although flasks, small heaters, and clothes brushes in the shape of ducks are arranged on the cogs of a mill wheel, an ironing board provides a display space for hot-water bottles, and food processors occupy the shelves.

The third room contains a copious variety of plastic domestic objects. Cabinets are filled with Bakelite dinner services, vases, and clocks. Figures of wandering minstrels, picture frames, elaborate hair combs, and cosmetic pots, all similarly made from plastic, fill other cases. A row of twenty or thirty picnic hampers, neatly packed with Bakelite plates, cups, and saucers are lined up beneath one set of wall-cases and on top of them are numerous plastic flasks. More flasks are perched on the wooden joists of the building, as are plastic radios and a plastic toilet seat. Another even steeper slatted staircase goes up to the second floor where the rooms have been left more or less as they were when the premises was occupied by a Museum of Rural Life. It is a warren of confined spaces, one of which contains wood working equipment and another a large washtub, while a third is virtually empty.

The exhibits are carefully laid out but the displays do not make much sense. It is unclear why cookers, fridges, vacuum cleaners, and electric heaters have been included in a museum devoted to plastic. A few have plastic dials and knobs but otherwise the material is not in evidence. It is hard to know why hairdryers and medical equipment, or Snoopy and refrigerators have been brought into close proximity, or why large groups of the same kind of object crop up in different rooms across the museum. Surely all the napkin rings ought to be displayed together? The galleries are organized in no perceptible chronological order, and when compared with conventional museums, they do not present clear themes.

For instance, the curved shelves in the small upstairs room are filled with objects respectively made from Urea Formaldehyde (tea-services, mainly mottled and dark in colour), Phenol-formaldehyde (brown hairdryers), Styren (bright, polka-dot tea services), Acrylic (all of which is pink), Urea (mainly lamp stands in several shades), and Phenol (mainly brown or white clocks). Without specialist knowledge or any advisory labels, however, it is impossible to discern that these are separate types of plastic or to establish what the visitors are supposed to be looking at. As each type of plastic is represented by a mass of duplicate objects the viewer might suppose that they had been positioned according to pattern or colour or type of object, and as I later discovered, when I introduced myself to Cook to ask about the display, he did take all these qualities into consideration when he arranged the room.[4] Even this multidimensional classificatory system may have had some logical coherence had it represented a chronological sequence, but the Phenol clocks on the top shelf are of a similar date to the Urea Formaldehyde plastic on the bottom shelf, and both are earlier than the

plastics occupying the middle shelves. The display is complicated further by a change in the curatorial strategy towards one end of the shelving. Whereas the area closest to the doorway is organized according to plastic/ colour/ pattern/ type, Cook has opted for a cultural orientation in the inner parts of the room. According to him, the Babycham glasses, the Valentine typewriter, Homepride 'Fred' flour-shakers, Bakelite Beehive knitting wool holders, and portable fans evoke 'BIBA, "Britain can make it", Concord, a sense of things happening, chic'. Another system is also in play because, as Cook explained, he inserted red objects into the 'Britain can make it' display in order to create a visual accent.[5]

Writing in 1928, when packed displays were common in public sector museums, Sir Henry Miers opined that the effort of looking at a vast number of unconnected objects meant that visitors came away 'with a museum headache', having learnt nothing whatsoever. In these circumstances he 'questioned whether such a museum [. . .] serves any useful purpose whatever and whether it should continue to exist'.[6] He was equally critical of displays that featured large numbers of identical objects and wrote that no matter how interesting these duplicate exhibits may be to the specialist, their 'excessive number [. . .] confuses the average visitor, serves no useful purpose educationally and is a flagrant waste of space'.[7]

For Miers, the chief function of museums was to instruct 'by means of exhibited objects'.[8] In order that this goal might be achieved he stressed the desirability of avoiding 'overcrowding and reduplication' and of exhibiting 'a few well-labelled typical specimens [. . .] with definite purpose'.[9] In a follow-up report of 1938, S.F. Markham reiterated Miers' advice, re-stated the pedagogic mission of museums, and appended some basic tenets of display. Every exhibit, he stated:

(a) Must have a story to tell, and

(b) Must tell that story simply and yet also purposefully.

Each stage or chapter of the story must lead convincingly from its predecessor to its successor; and the final denouement must carry conviction.[10]

For Miers and Markham, as for their peers, the visitor's ability to learn from exhibitions was predicated upon a process of selecting typical objects, creating reserve collections and separate storage, clearing away surplus objects, logically arranging the chosen items, and annotating them correctly. In this context, the singularity or uniqueness of the object on display was less important than its substitutability, that is, its ability to stand for other objects of the same type. 'Typical objects' could be placed within chronological or typological sequences, used to represent peoples, places, or histories, create narratives, and hence have an educative function.[11]

More recent practitioners and commentators have been sceptical about the techniques that Miers and Markham proscribed. While they have also recommended a reduction in the number of collection-objects placed on

display, their concern is the capacity of collections-based displays to convey complex information in an engaging manner. Writing in 2002, Julian Spalding conceded that displaying large collections gave visitors the chance to see more things but asked: 'what benefits do these sights bring? [. . .] Can looking at a stilled combustion engine, stilled in a display case, inspire one to think about man's appetite for speed, let alone the impact of pollution? If a museum wants to tackle such issues, would it not be better to go directly to the subject and only use objects if there is no better way of illustrating a point?'[12] Andrea Witcomb has also observed that some themes are best explained by other means. In a discussion titled 'the displacement of objects', she explains how the Australian National Maritime Museum had problems finding appropriate objects to tell the story of the maritime links between the United States and Australia. Many objects were unavailable on long-term loan, and Witcomb notes that 'the desired narrative was not always compatible with the use of traditional museum objects'.[13] In consequence, the curators decided that a televisual documentary would more effectively enable them to cover the relevant issues.

It would be possible for Cook to follow the blueprint provided by Miers and Markham. Given a sufficient budget he could warehouse two-thirds of the collection, select items, arrange them into sequences, and indicate what those displays represent. Eggcups or hairdryers could be marshalled to demonstrate technological development or to illustrate cultural contrasts between products from different regions. Given a more substantial budget he could follow the lead offered by Spalding and Witcomb and replace large portions of the displays with video and documentary footage, compose wall texts, and thereby seek to engage visitors in key narratives relating to plastics. As it is, the museum does not inform or instruct visitors on the historical circumstances from which the objects emerged, or in which they were used, or indeed what the issues relating to plastics might be. Indeed, it has no orthodox educational merit and so, to reiterate Spalding: 'what benefits do these sights bring'?

Pleasures of exploration

While the Bakelite Museum does not present a comprehensible history of plastic, much less a contemporary multimedia experience, it is very popular with visitors. Apart from the excellent tearoom, which is frequently recommended, reviewers make references to two main characteristics. First, visiting the Bakelite Museum involves exploration and discovery in relation to the space, the collection, and to individual objects. Online correspondents often comment on the experience of chancing upon the Bakelite Museum. For instance, Lelol_10 reported that that they 'found it by accident' and that it was 'one not to miss', SteveS referred to the museum as being 'outside

the usual tourist orbit', and LouL18 declared it 'a secret worth finding'.[14] In actuality there are numerous signposts to the Bakelite Museum and it is featured in several guidebooks but it is not well known in comparison to national and county museums so visitors feel that they have stumbled across it. The sense of discovery is also heightened by the disjunction between the subject of the collections and the location. Whereas the content of the exhibition at the Witchcraft Museum in Cornwall, which I discussed in Chapter Two, has a close connection to its setting, this huge array of plastics has no apparent link to the rural Somerset village in which it is situated. Intuitively it seems more likely to find the display close to a manufacturing plant, or to shops where plastics are sold, and its whereabouts can come as a surprise. In consequence, the venue is understood to be hidden and thus to be 'found' by the visitors.

Once inside the museum, there are no guidebooks, no attendants to ask for help, and a small notice that states that the exhibition continues upstairs provides the only aid to orientation. In the absence of institutional direction, visitors to the Bakelite Museum must find their own way around the storied building. This requires them to climb the steep staircases (which have caused Health and Safety inspectors some consternation) and to negotiate the slanting rooms on the uppermost floor.[15] Mo T wrote that 'I kept finding new rooms, nooks and crannies crammed full of wonderful stuff. I shall visit again when I have more time to spend there as I know that there was much that I missed', while under the heading 'Brilliant Bakelite Museum', one TripAdvisor contributor reported that although from the outside it 'looks like a tiny museum, it's like something out of Alice in Wonderland; go through one door and there's another'.[16]

Visitors are also free to explore the displays and individual objects. When Cook started acquiring Bakelite in the 1970s it was comparatively cheap and he bought many of the exhibits for little more than small change. Although it has since become collectible, it remains a relatively inexpensive commodity and there is no need to be particularly careful about policing the collections. Most of the objects are on open shelves and there are no plinths, rails, ropes, or other security measures to prevent visitors from approaching the displays. When cabinets are used they are left unlocked allowing visitors to open their doors and remove things from inside. Online reviewers commented that it was 'wonderful to be able to gently rummage around all of the items' and 'the fact that you can pick up things and explore to your heart's content is a huge plus'.[17] 'Much (of the collection) is unlabelled', wrote Caroline in her blog, 'but that all adds to the sense of discovery', while several reviewers refer to it as an 'Aladdin's cave', suggesting that its abundance verges on the mythic and that it may even house a magical lamp, if one could only find it.[18]

Although major institutions also use the rhetoric of exploration and discovery they have maps and signs to indicate routes and identify masterpieces as such, so the experience is standardized and can be superficial.

In contrast, visitors to the Bakelite Museum climb the steep wooden stairs, investigate the tiny interconnecting rooms, open cupboards, and drawers, peer under cabinets or into recesses, and proceed without knowing what they may turn up. Clearly the pleasure of this exploration is closely related to the abundance of the collection: sparsely arrayed displays present little potential for rummaging. Visitors may find nothing of interest as they look round the galleries, or they may discover an item that they specifically searched for, or alight on something entirely unexpected. Halstead, Hazeley, Morris, and Morris, the authors of the astute and humorous guidebooks *Bollocks to Alton Towers* and *More Bollocks to Alton Towers* were intrigued by a Bakelite coffin made by the Ultralite Casket Company of Manchester and by the Visible Woman Assembly Kit, an anatomical model that had an entirely smooth crotch and no reproductive system.[19] Other reviewers were surprised and amused by finding rude artefacts. One wrote that 'we laughed out loud at some of the exhibits' and asked: 'a cruet set fashioned like a lavatory and two potties anyone?'[20]

Visitors also find objects that were unlooked-for but are significant to them. Whereas many of the items in public museums come from other countries or belong to the distant past, Bakelite was readily available within the United Kingdom and was in common use until comparatively recently. Indeed, it is still used in some homes as are the more recent plastics that are on exhibition. Writing in *The Telegraph* Sophie Campbell reported that she overheard one woman fondly saying 'Mum's plates, they crop up all over the place' and on the TripAdvisor website, 'GloucestershireKaz' remarked that there is 'loads of stuff I remember my grandparents owning and even one or two [items] that I had'.[21] Likewise, in his online review Cavalino Rampante reported that the rooms were 'full of instantly recognisable memorabilia [. . .] you cannot walk around this museum without exclaiming: "We had one of those" every few minutes'.[22]

In the absence of conventional narrative structure, finding these familiar things provides visitors with a point of orientation within the packed display. Discovering recognizable objects in an unfamiliar and visually striking location also serves to re-present those objects, to render them fresh and worthy of comment. Visitors point out exhibits that resemble or are identical to items they once owned or knew and they explain their significance to their companions. John G wrote that 'we had great fun re-visiting the past and explaining to our teenage grandson what some of these items were for. We all loved it and would have no hesitation in recommending it to others'.[23] 'Look Jane', exclaimed the woman visitor whom Campbell eavesdropped on, 'This is a mangle. This is what we squeezed the washing with'.[24] Exploring the museum can also involve a process of re-discovery.

Having alighted upon a particular item, visitors may scrutinize it more closely, use, or play with it. They can sit on plastic chairs from the 1960s and listen to records of earlier eras playing on the gramophone or 'prance

about in the collection of popluxe sunglasses pretending to be Tippi Hedren' as the authors of *More Bollocks to Alton Towers* were tempted to do.[25] Alternatively, they may remove 'Mum's plates' from the cabinets, feel their texture and weight, and recall their place on the kitchen table. They can turn the wheel of the mangle and otherwise inspect the mechanisms of the artefacts on display. Campbell opened the lid of a music box that caught her attention and winding up the key saw 'little ballet dancers in scarlet tutus and tulle, who scissored their legs in the air as they twirled'. She also picked up a black-lacquer Chinese lantern with gold inlay and on investigating further found that its 'doors opened like a flower as it revolved to reveal a cigarette holder in each'.[26]

Again, visitors to major museums are often given the opportunity to handle objects but they have a legal obligation to preserve objects from their collection and are correspondingly careful about which objects they offer visitors to touch and how they are presented. Some institutions provide samples of objects, such as strips of fabric or pieces of china, which are secured to ledges in front of display cases, but these can only be stroked with the fingertips, thereby providing a completely different experience to that of exploring an object in its entirety. Others provide whole objects but these are either wired to stands to prevent them from being picked up, or they are handled under the guidance of museum staff who monitor and regulate the visitors' actions. The delicacy of the objects is also taken into account so visitors are unlikely to find the equivalent of the lacquer lantern on a handling table at a major museum. In addition, the numbers of available objects are limited and they have all been pre-selected by educators, often in order to concentrate visitors' attention upon a particular aspect of the exhibition or to generate specific 'learning outcomes'. Visitors cannot point at an exhibit on display and ask that it be removed so that they can look at it more closely. In short, the exploratory activities offered by major museums can be pleasurable but in comparison to those at the Bakelite Museum they are extremely limited in scope.[27]

Holiday surrealism

The second characteristic that visitors to the Bakelite Museum comment upon is that of visual pleasure. In the context of twentieth- and twenty-first-century museums, visual pleasure is often associated with aesthetic experience, which in turn has been linked to sparsely arrayed and not to packed displays. In his famous essay 'The Problem of Museums' which was published in 1925, Paul Valéry complained about crowded galleries at the Louvre. He wrote that showing so many disparate pictures together 'constitutes an abuse of space that does violence to the eyesight' and that

the 'close juxtaposition of outstanding works offends the intelligence'. The finer each artwork was, he continued, 'the more exceptional as landmarks of human endeavour, the more distinct must they necessarily be'.[28] For Valéry, the quantities of sculpture and the closely hung paintings annulled the effects of each individual work and stymied the possibility of aesthetic contemplation to such a degree that he left the Louvre 'with a splitting head'. [29]

Thinking similarly, later curators attempted to facilitate aesthetic experience by giving individual objects more space. When the new Gothic and Renaissance galleries opened at the Victoria and Albert Museum in 1950, *The Builder* applauded the 'new disposition of selected masterpieces sparsely displayed against restful backgrounds'.[30] A review in the *Burlington Magazine* was also effusive. The author commented that 'the greatest [three-dimensional] masterpieces have cases to themselves' so instead of 'having to contend with distracting neighbours [. . .] the work of art is left alone in its purity and calm'.[31] Twenty-five years later, the era of 'masterpieces as wallpaper' had long passed and the critic Brian O'Doherty wrote that 'the pedestal [had] melted away' leaving 'the spectator waist-deep in wall-to-wall space. The new god, extensive homogenous space, flowed as easily into every part of the gallery. All impediments except art were removed'.[32] In this model of curation, individual artworks were or are isolated in space and displayed in a manner that establishes them as masterpieces and thereby as worthy of focused, even exalted attention.

In complete contrast, the sheer mass of objects at the Bakelite Museum can prompt visual pleasure for many visitors. Writing on TripAdvisor Chris551953 remarked 'I found this place a surprising treat for the eyes. There are thousands of items'.[33] Other observers find that their attention is arrested by the combination of the quantity of objects, their layout, and colour. In *Nothing to See Here*, an online guide to 'places that still have a certain charm, a bit of je-ne-sais-quoi about them', Anne Ward remarked:

Up the steep stairs and into a little side room where I thought I'd died and gone to heaven. This is the colourful world of Bakelite eggcups, napkin rings and salt and pepper shakers, all perfectly lined up on curvaceous shelves. I shudder to think what the dusting overhead is like, but it looks wonderful.[34]

More usually, however, visitors comment on the visual wit of the exhibition and draw analogies to various art movements. Cavalino Rampante detected 'the influence of pop art' in 'the incongruity of serried objects arranged in the sea of eclectic Bakelite memorabilia', while the authors of *More Bollocks to Alton Towers* remarked on the multicoloured eggcups laid out with 'the precision of a terracotta army', and like several other reviewers noted the 1950s refrigerators that open to 'reveal plastic dinosaurs and Dali-esque lobsters' (Figure 5.4).[35]

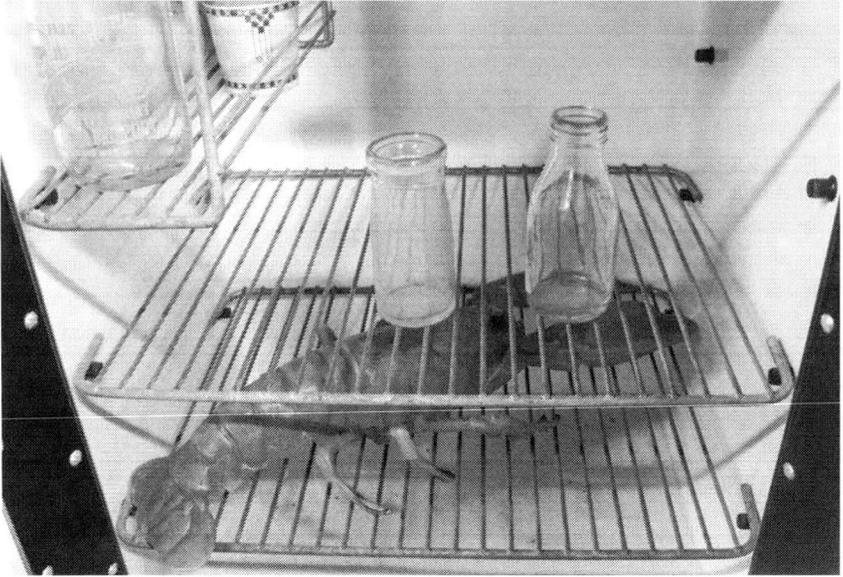

FIGURE 5.4 *Plastic lobster displayed in refrigerator, the Bakelite Museum.*

Having spotted the lobster in the refrigerator (or positioned on the top of a Bakelite telephone as it was when I first visited) visitors may look for further quotations or visual jokes. Some visually striking compositions create contrasts of scale – tiny plastic living room furniture that was made for a doll's house and which includes a television set, is placed on top of a television set (Figure 5.5) – while others concern transformation. A dentist's case of plastic false teeth and a clock embedded in a plastic ostrich with bendy legs are placed on a Bakelite coffin to form a *memento mori* (Figure 5.6). Numerous darning bulbs designed to light up at night so that the mender could see what he or she was sewing have been set in long rows on the floor. Catching the light, they seem to provide additional illumination and simultaneously create a tiny picket fence to keep visitors away from the mill machinery.

Further compositions involve the illusion of animation. Wooden shoe-trees surround electric heaters evoking images of footwear being kicked off and feet warmed. An electric fire shaped like a butterfly is fixed onto the wall so it lifts off above the ordinary heaters, as if taking flight, and next to the rafters in the top corner of a room a group of electricity meters are huddled together like nesting birds. Rows of flasks have been lined up with their handles facing backwards and their spouts pointing forward so they appear to march like massed legions across the tops of cabinets (Figure 5.7). Clothes brushes designed to look like ducks face outwards around the edge of a large horizontal wheel. It is easy to imagine the cog slowly starting to

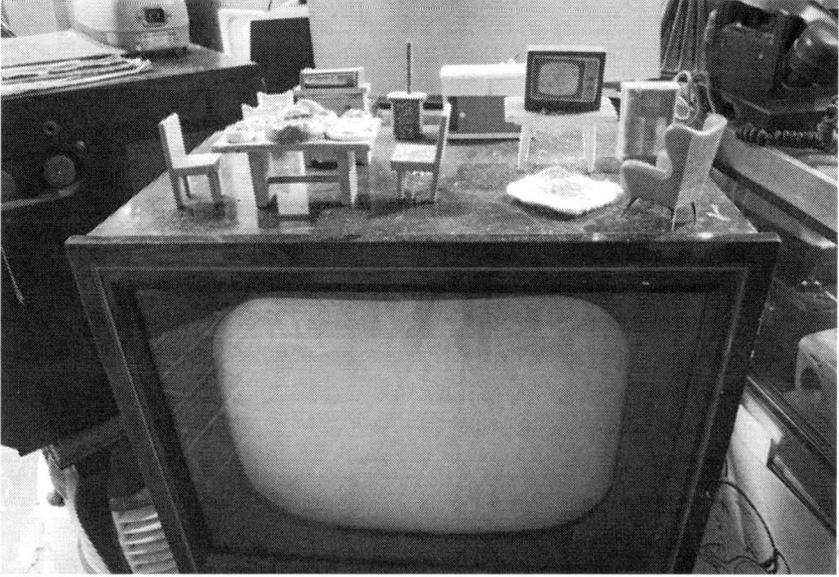

FIGURE 5.5 *Dolls' house furniture displayed on vintage television set, the Bakelite Museum.*

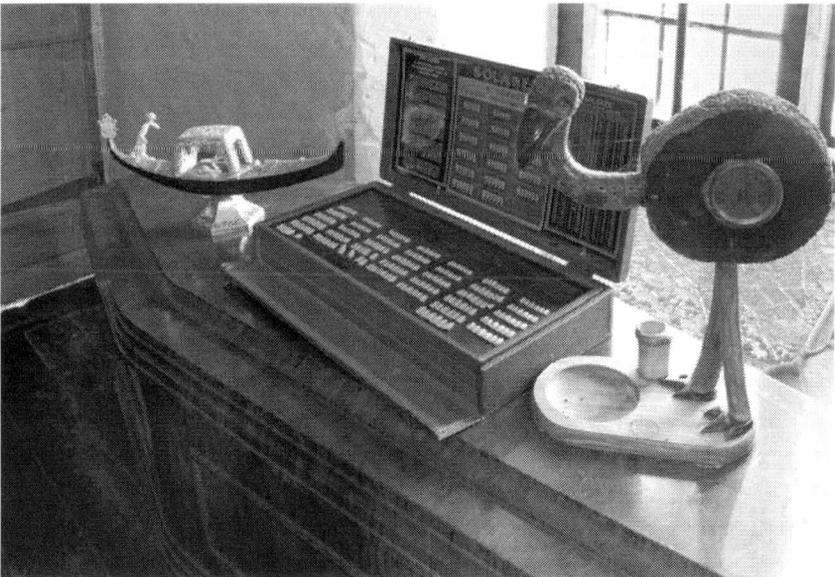

FIGURE 5.6 *(From left to right) plastic gondola, dentist's case of plastic teeth, clock in the shape of an ostrich, all displayed on Bakelite coffin, the Bakelite Museum.*

FIGURE 5.7 *Plastic flasks, the Bakelite Museum.*

turn and the startled birds taking flight. Many of these visual puns rely on repetition and could not be constructed within a museum that had selected a single object to represent each type of plastic. One flask could not be imagined to march and one meter would not assume the guise of a nesting bird. The surprise and humour of the exhibition is therefore predicated on the number of duplicate objects, and to some degree, on these arrangements being partially concealed within 'a sea of Bakelite'.

Elsewhere, the visual play concerns the mismatch between labels and objects and to my eyes it has a distinctly museological flavour. Upstairs, in the main gallery is an old haberdashery unit that is filled with the overspill from other displays. Each drawer is labelled and taken together they comprise a most unlikely set of categories:

Decorative boxes
Egg themes
Dolls house furnishing
Torches
Very small items, general, and spare radio knobs
Eggcups
Phenollic boxes
Jelly moulds
Boxes, general
Containers, cream
Urea picnic and cosmetic containers

Games
Cigarette cases
Marbled Urea
Cameras
Photographic and optical

This classificatory order is entirely askew. Cameras are not included within the category of 'photographic', eggcups are separated from 'egg themes', and 'very small objects' are allied with radio knobs (many of which are not particularly small). Even this typology breaks down when the visitor opens the drawers to find that there is little correlation between their contents and the labels: the drawer marked 'egg themes' contains cameras, that marked 'torches' is filled with 1970s Viewmasters, and there are no jelly moulds in the drawer bearing that label.

Whereas major museums classify objects and thereby allot one identity rather than another, label and display those objects accordingly, use the object-informational composite to stand in for people, progress, and cultures, and in doing so, produce objects that have a particular significance, the haberdashery drawers more closely resemble Magritte's *Interpretation of Dreams* (1927) in which a bag is labelled 'le ciel', a pocket-knife knife 'l'oiseau', and a leaf 'la table'. The links between objects and names have been undone and a Viewmaster is now a torch, while the radio knobs have become 'cigarette case'. Meaning is untied rather than fixed.

It is not always possible to tell whether these arrangements are deliberate or not. Cook trained in fine art at Goldsmiths College and at the Royal College of Art, has a strong interest in the work of Rene Magritte, and has clearly arranged the exhibition with care. Even so, visitors may have constructed some of the arrangements and others may be the result of random collisions. It is possible that the exhibitions are akin to an art installation in which individual items combine to produce witty collisions, but equally the haberdashery drawers may just be over-stuffed storage units and the displays could be viewed as oddly organized, even incomprehensible. Such judgements, and the possibility of the Bakelite Museum being a source of visual pleasure, depends upon how the visitor looks at the exhibition and a useful way of thinking through the relationship between the form of the display, the possibly accidental character of some of the arrangements, and visitors' perceptions is offered by the concept of 'natural', 'spontaneous,' or, perhaps most aptly, 'holiday' surrealism. I will accordingly take a brief detour through this material.

In 1936 the British artist and critic Paul Nash published an essay in *The Architectural Review* titled 'Swanage or Seaside Surrealism'. Here, he drew a distinction between art made by a member of the Surrealist groups and 'natural surrealism' (for which he used the lower-case) and suggested that this latter manifestation of surrealism was particularly common in English seaside resorts.[36] To illustrate the category further he proceeded to tell a

story wherein a shipwrecked man was washed ashore on the esplanade at Swanage. On making his way into town, Nash wrote, the stranger found a lop-sided stone column surmounted by a pyramid of cannonballs, and reading its inscription saw that it was raised to commemorate King Alfred's victory over the Danes. Convinced that he was dreaming, the stranger delighted in a Wren facade grafted onto the face of a late nineteenth-century Town Hall, a clockless clock tower, and two vast free-standing Corinthian pillars. As the day began to close, he saw a white stone globe inscribed with diagrams that were unreadable in the dimming light and glimpsed a painted notice in the shape of a hand. This directed him to the Tilly Whim caves and the name increased his growing apprehension. As darkness fell, the cry of Lop Lop (the magical bird invented by the French Surrealist Max Ernst) rang in his ears and, seized with panic, the stranger ran towards a castle in search of sanctuary. Pushing its great door open he stumbled into an immense deserted room, tenanted by hundreds of empty tables and chairs. A long counter curved into darkness and behind it stood another of Ernst's creations, *La Femme 100 Têtes*.

Like the other wonders that the ship-wrecked stranger saw, the Castle was an actual place, a huge folly that housed a restaurant, but Nash's story drew attention to the way that monuments, buildings, landscape ornaments, signposts, and rooms can all have an uncanny and estranging effect. Sometimes this depends upon them being set in an incongruous geographical context or in sharp contrast with their neighbours; qualities and techniques that are in evidence at the Bakelite Museum. Alternatively, a surreal, dream-like sense of disquietude is produced by incomprehensible text, curious names, and things that suggest body-parts or which recall absent human forms. Again these qualities are in evidence at the Bakelite Museum, not least in the Anatomical Woman that has no genitalia. It is also significant that Nash tells his story from the perspective of a stranger because it implies that natural surrealism is a quality that is habitually overlooked.

Nash and the editors of *The Architectural Review* were subsequently more explicit about the part played by observation in manifestations of natural surrealism. Encouraged by public interest in Nash's essay and in the contemporaneous International Surrealist Exhibition held in London, *The Architectural Review* launched a competition titled 'Holiday Surrealism' and offered small prizes 'for the best sets of four photographs showing examples of spontaneous Surrealism, *discernible* in English holiday resorts'. They 'hoped that pursuit of such examples will be found to be in itself an amusing and instructive holiday past time' and they cited Nash's writing about Swanage 'as an example of the kind of *perception* that competitors were expected to show'.[37] Nash and Roland Penrose were appointed judges and Luke Summers was duly awarded five guineas worth of books for photographs that showed 'the subtle, poetic aspects of surrealism' in Black Gang Chine, a country park on the Isle of White. Bill Brandt was chosen as

runner-up. Stating that his photographs of rock formations were 'almost the best example we have seen of natural objects photographed to show their disturbing surrealist content', the judges reiterated the idea that surrealism has to be detected as they did in remarking that Brandt's 'perception of Surrealism was more stereotyped than the winner's'.[38]

Nash's essay and the subsequent competition suggest that surrealist effect is connected to the qualities of particular objects, to their placing (whether that is intentional or accidental), and to a way of seeing. It neither self-evidently exists in the world nor is it simply projected or read onto particular sites. Here too, at the Bakelite Museum, there are particular artefacts that have an arresting quality, others that become so when placed in combination with other items, but visitors still have to notice those particular arrangements. For Cavalino Rampante and the authors of *More Bollocks to Alton Towers* the pleasure of the Bakelite Museum is partly connected to the oddness of the objects, partly to the witty and incongruous collisions but, for me and perhaps for other visitors, it was also linked to the activity of spotting such juxtapositions.[39] As the editors of *The Architectural Review* hoped, the active pursuit of such scenes is an amusing holiday past time in itself. So long as visitors are prepared to look with the eyes of a holiday surrealist, everyday plastic may provide a source of pleasure, wonder, or disquiet.

It is important to register that the displays in major museums also contain odd objects and strange juxtapositions. In following the history of a people or the development of a form, it is easy to forget the sheer strangeness of looking at pot-shards or axe-heads that originate from different times and places and which are shown in conjunction with other similarly disconnected items. In these situations however, the strangeness of bringing disparate or related objects together in another unconnected place is naturalized by the representational and narrative structure into which they are inserted. The museum itself provides a stabilizing ground or, to re-use the famous Surrealist image, the operating table on which a sewing machine and an umbrella meet.[40] This is not the case at the Bakelite Museum or in other micromuseums where the objects are largely unlabelled, packed together, and are either entirely uncategorized or are categorized in unconventional ways: into games, jelly moulds, and egg themes. It is in the absence of any coherent narrative or firm representational moorings, that ordinary things become unfamiliar and extraordinary, even transformed.

Critical curiosity

The question, then, is how to conceptualize the displays and possibilities of the Bakelite Museum, and indeed those of other densely packed micromuseums. In particular, how can such venues be understood in

relation to a progressive history that moves from more objects to less, and from unclassified, unlabelled displays to the sparse well-ordered exhibitions of the later twentieth and twenty-first centuries? Visitors and online commentators proffer one line of thought, namely that the Bakelite Museum is a latter day cabinet of curiosities.[41] Such a comparison, however, does require some initial qualification.

Douglas Crimp has been disparaging about the idea that curiosity cabinets are the progenitors of what might seem like their modern-day counterparts. For him, the selection of objects found in Wunderkammers and their system of classification are utterly incompatible with those of later collections. 'This late Renaissance type of collection did not evolve into the modern day museums', he stated. 'Rather it was dispersed; its sole relation to present-day collections is that certain of its rarities eventually found their way into our museums.'[42] Stephen Mullaney also argues that curiosity cabinets are not comparable with subsequent institutions because the former marked the final stage of an historical dynamic specific to the period in question rather than the starting point of the modern museum.[43] Stephen Bann is similarly careful about drawing too close a link between curiosity cabinets and modern museums. He writes that between the Renaissance and the late nineteenth century, paradigms of knowledge shifted in such a way as 'to ensure that collections of objects acquired a new epistemological status while being simultaneously adapted to new forms of institutional display. Even if we accept [. . .] that particular objects and classes of objects were transferred wholesale from the Renaissance cabinet into the nineteenth century museum', Bann continues, 'we need to appreciate when seeing them in the new context how completely different the earlier situation must have been'.[44]

Nonetheless, Bann does perceive certain continuities between cabinets of curiosity and some contemporary art exhibitions. He argues that for at least two centuries the classification and display of art had been dominated by historicism. Major galleries enshrined a pantheon of great modern artists and their works in due historical succession and ordered the applied arts by school and century. This paradigm, he suggests, has weakened and there has been a 'running back in time', 'a kind of historical *ricorso* to curiosity'.[45] One aspect of that tendency is that contemporary curators have sought to subvert triumphalist chronologies with more 'thematic and often (it must be admitted) haphazard association of ideas'.[46] In 'the Victorian period', Bann adds, '"curiosity" still had the force of a subversive paradigm whose potency threatened the benevolent ideal of useful instruction, and the progressive onward march of modern history'.[47] Pointing to Dickens's book *The Old Curiosity Shop*, published in 1841, Bann comments that the scene of curiosity is a chaotic, regressive domain, half hidden from the public eye, and packed with fantastic carvings, figures of china and wood, tapestry and strange furniture that might have been designed in dreams. Despite its ostensible morality of the story and the allegory of waste, Bann

writes that Dickens's narrative conveys the subversive attraction of this crowded space and its challenge to the imagination, and his implication is that some contemporary art exhibitions can do likewise.

Developing his theme, Bann reminds his readers that the assemblages in curiosity cabinets would have required considerable narrative exposition and that the humdrum circumstances of the collector's life regularly intruded on to the task of scrupulous description. He notes that like curiosity cabinets, contemporary thematic displays presume a subjective act of enunciation (rather than vesting authority in 'the objectivity of History itself'), but he also points out that the more existential and participatory elements of visiting cabinets of curiosities are lacking in present-day museums.[48] In the sixteenth and seventeenth centuries, he writes, cabinets were opened, objects removed from compartments, and passed from hand to hand so that visitors could investigate them manually by feeling their texture and weight and this is not possible in contemporary museums that place a high emphasis on conservation. Even so, Bann observes that in commercial art galleries it is possible to leaf through and read artists' books or to pick up and inspect artists' multiples. It may be, he suggests that 'the locus of curiosity migrates to institutions that elude the regime of the unique object, with their inevitable hierarchies of value, and favours such places of convergence between the multiple object and the artists' book'.[49]

Bann never pins down exactly what he means by curiosity, and one senses that such an endeavour runs contrary to the shifting, mutating notion of curiosity, but the implication of his essay is that it functions in several interrelated registers. Curiosity is a mode of display that eschews a progressive or historical narrative in favour of curatorial authorship and which enables unpredictable collisions between diverse images and things. As a form of display, curiosity also incorporates tactual interaction whether that is opening the cabinets in Renaissance collections or finding a felt postcard made by the artist Joseph Beuys tucked into an artists' book. As such, curiosity is a mode of practice on the part of the visitor as well as of the museum. In addition, Bann also suggests that curiosity is a way of knowing that combines both empirical investigation and imaginative leaps, that it concerns pleasure in exploration and surprise for its own sake, and as such, that it resists instrumentalism.

The Bakelite Museum offers similar challenges and pleasures. Just as Bann argued that the locus of curiosity has relocated to the artists' book, it can be understood to have migrated to micromuseums, which similarly elude the regime of the unique object. The exhibits at the Bakelite Museum are also handled and weighed, investigated and discussed. Like Dickens's curiosity shop, the museum is half-hidden and is packed with objects that are both marvellous and entirely ordinary. Bann also suggests that curiosity presumes an authored display and while Cook does not guide visitors round the collection and comment on particular objects as early modern collectors did, or indeed as many curators do in micromuseums elsewhere,

the exhibition is clearly constructed by someone. It is closer to a work of art than to an anonymous, apparently objective account of material and technology.

Importantly, like Victorian curiosity shops, the packed exhibitions at the Bakelite museum resist instrumental use. Furthermore, like some contemporary art exhibitions, the displays actively and explicitly challenge progressive histories. Whereas the jumbled haberdashery drawers may be a manifestation of holiday surrealism, the displays that contain objects that originally belonged to the Museum of Rural Life are deliberately contrary. Near the entrance of the current museum is a stone byre which houses a diorama showing a nineteenth-century workshop with a scarecrow-like couple, the male figure dressed in an old frock coat, the female figure in a sprigged print dress. The rather dilapidated figures stand either side of a piece of heavy machinery and appear to be scrutinizing a mid-twentieth-century Bakelite radio that sits in the centre of the display (Figure 5.8). By obviously conflating historical periods, the diorama breaks with the

FIGURE 5.8 *Figures from the Museum of Rural Life with machinery and a Bakelite radio, the Bakelite Museum.*

conventions of historical representation, and although we understand that the scarecrow figures are meant to stand for people from the past, they seem as arbitrarily exhibited as the wireless set.

The heavy horizontal mill cogs inside the building have also been used as shelves for twentieth-century radios, clothes brushes, and electric fires, while on the top floor some of Cook's sculptures have been subtly inserted into the extant displays of rural life. The collection of wooden hand-lathes is accompanied by an oilcan and by a hand-drill both of which Cook has carved from wood (Figure 5.9). The two objects are entirely useless. A small range fire with an iron on the hot plate, exactly the kind of exhibit a visitor might expect to find in a museum of rural life, are also carved, as is a pine tap that extrudes from a wall.

These objects and their place in the museum(s) are peculiarly complicated. In each case the sculpture has been put into the space it would occupy if it were a 'real' object. Expecting to see a stove in a workshop, one sees a stove, but eventually recognizes that it is actually a carving. A rough-edged model has usurped the real cooker, and just as Magritte's pipe was not a pipe, this stove is not a stove. The growing sense of disorientation only increases when one remembers that this display is not the remnant of a nineteenth-century workshop but was made in the 1970s. The workshop is not a workshop, it is a recreation of a workshop that in turn frames and conceals objects that show the scene to be a masquerade. To add to the hall of mirrors effect, these rough replica objects have been produced using the

FIGURE 5.9 *Sculpture of an oil can displayed with oil cans, the Bakelite Museum.*

skills and practices that are indicated by the nineteenth-century workshop, if only it really was such a thing. These displays make it impossible to accept an historical diorama as being in any way a reflection of the real. Historical representation is itself shown to be something of a masquerade.

It is a commonplace of museum studies to assert that museum histories are selective and that exhibition narrative is necessarily an exercise in construction.[50] Similarly museum curators know that in selecting objects and inserting them into sequences they are choosing to tell one story and not another. Even so, it is rare for museums to actively draw attention to their own process of fabricating (as in skilfully crafting and as in inventing) both objects and narratives.[51] The Bakelite Museum is self-reflective in this respect and, in creating this palimpsest of display, Cook implies that the whole apparatus of museums and their systems of meaning-making are as contrived as a wooden iron or clothes-brush birds perched on a millwheel.

Cook has said that he wants the Bakelite Museum 'to be the opposite of a traditional museum' and the experience of visiting is quite distinct from going to a mainstream venue but in many respects, this statement does not go far enough.[52] In addition to providing alternative experiences to those offered by major museums, the Bakelite Museum arguably deconstructs the exhibition techniques used in major venues. Rather than being a failure of meaning and representation, the Bakelite Museum can be read as a process of deliberate de-familiarization and an acerbic comment upon the way in which those systems and expectations have been naturalized within mainstream institutions.

Viewed in the terms that Conn and others outline, the packed exhibition is inevitably a throwback to an earlier era. By contrast, Bann's analogy between contemporary exhibitions and curiosity cabinets is useful in relation to my discussion because it entirely avoids any suggestion that such displays are anachronistic. Most significantly perhaps, Bann's discussion draws links between investigation, handling, imagination, and a certain kind of resistance to dominant orders of categorization and to all that these connote. In his terms, curiosity is a knowing and critical alternative to historical models of display that privilege education. Granted, other packed micromuseums do not have the wry deconstructive slant of the Bakelite Museum but the sheer quantity of objects on display regularly leads to incongruous juxtapositions which provide a similar source of visual pleasure and, importantly, their haphazard and profuse displays represent a conscious decision to supplement or eschew historical narrative in favour of different kinds of experience.

Recognizing the pleasures of packed displays is not meant to be a plea for all museums to abandon their educative mission and leave visitors to rummage through their collections. Rather, pointing to the pleasures of undirected exploration and visual play that micromuseums afford is to note that the conventional educative mission entails losses as well as gains. Both forms of display limit visitors in several important respects and present them

with differing opportunities. Crowded micromuseums can offer visitors something that collection-sparse institutions do not and vice versa.

Cluttering up history

To conclude, it is worth briefly returning to histories that propose that museums have moved from displaying more to less objects from the collections. Just as curators in mainstream museums select objects and arrange them so as to form a representative and comprehensible exhibition narrative, so scholars have concentrated on particular museums, and the neatness of the dominant museological account is analogous to that of the displays under scrutiny. By focusing on public sector institutions rather than micromuseums or small county museums, they have been able to deliver a coherent story that is easily communicated and assimilated. Like curators choosing a series of plastic artefacts from a mass of incongruous items and placing the remainder into storage, these academics have conceptually de-accessioned or warehoused organizations that do not support 'the desired narrative'.[53]

Notably, Steven Conn has discussed how the subject of the institution makes a difference to the rate at which collection-objects were removed and the extent to which they were replaced with other kinds of things, but micromuseums still remain too messy for this account. Conn is unusual in that he mentions micromuseums, specifically the Mount Horeb Mustard Museum and various kinds of barbed wire museums, but he dismisses them from his account on the basis that they 'aspire to encyclopaedic collection, organization, and display of their particular type of "knowledge"'.[54] This description does not approximate to the Bakelite Museum, which could hardly be described as having an encyclopaedic approach to organization and display, but even if it did, it is difficult to grasp why Conn would think such aspirations invalidate a museum's inclusion in a scholarly account. The issue, perhaps, is that if micromuseums are factored in, then the dominant narrative about the place of objects would become far messier and, rather like the displays in the micromuseums themselves, it would not progress in an orderly fashion.

Many micromuseums do put all the objects in the collections on display. In many cases they have no storage facilities. Following their lead in terms of writing would be impossible, academic essays would swell and bulge with accounts of exceptions and non-mainstream practices. They would follow odd tangents and traverse otherwise unrelated kinds of material, as I have done here. Still it is important to resist the urge to tidy up too much. There is an aesthetic appeal to the written equivalent of the spectacular vitrine, each object in its place, perfectly spot lit, the supporting mechanisms all but invisible, and the mass cohering into a beautiful, elegant whole. There

is also a purpose in writing that, like an introductory social history display, weaves image and text into a straightforward and easily assimilated account. Both approaches are valued and rewarded in academia but like those ordered displays, with their carefully selected objects, there can be a drastic loss of critical potential, surprise, exploration, and, indeed, of pleasure.

CHAPTER SIX

Other worlds: The distinct traits of micromuseums

I began this book as an experiment to see if researching micromuseums instead of national or large independent museums could, in Hudson's terms 'revolutionise' museum philosophy. More modestly, I wondered if it might provide a way of testing, refining, or expanding the associated academic debates, and in the preceding chapters I have shown how the study of micromuseums can offer alternative perspectives on specific areas of museological enquiry. I considered their funding, their accommodation in domestic spaces, and in turn the implications for their status as public venues, arguing that they can constitute public spheres, albeit on a small scale. Giving due consideration to micromuseums also demonstrated that exhibits are not automatically disconnected from their previous uses or circuits of belief, and contra received opinion, can elicit strong emotional and spiritual responses in visitors, even in those who come from outside the associated communities. Studying avowedly partisan micromuseums led me to question the validity of multi-perspectival approaches to curation and to suggest that there is a place for unilateral modes of display, while addressing small-scale gift-giving, a topic that is almost entirely unmentioned within museology, prompted me to consider donors' conceptions of museums and of the service that they offer. Finally, focusing on unfashionably packed exhibitions demonstrated that displays that do not conform to accepted curatorial standards can nonetheless be a source of pleasure to their audiences. That topic also led me to argue that museology needed to be more cluttered and to recognize the losses as well as the gains associated with professional development.

I also began by asking whether focusing on micromuseums could change ideas about what museums are, what they offer, and what happens therein. To some degree I have addressed that topic insofar as the micromuseums

that I have considered have a variety of purposes and roles. All of these venues exhibit artefacts and most of them seek to inform visitors about that particular topic, although how they do this varies. They may also offer meeting places for people who are committed to a particular subject or way of life or belief. The Vintage Wireless Museum provides a gathering place for radio and television engineers and for others with an interest in the subject. The objects provide a reason to visit and a focus for discussion while the kitchen and common room make that activity practicable. The Witchcraft Museum is a place of pilgrimage for practitioners, while members of the IRA and its subsequent factions have visited the Lurgan History Museum to sign the Irish flag on display. This latter museum is also concerned with making a strong political statement – in many respects that is its purpose.

In contrast, the British in India Museum does not provide a meeting place for enthusiasts of the Indian Raj, if such a category even exists, and nor does it make overtly political statements but instead functions as a holding area for the relics of dead relatives. It is apt that the museum is located next to a removals and storage business because it provides a similar service, taking and caring for things that can no longer be housed by a family. In doing so, the museum helps usher individuals through the experience of bereavement or the growing recognition of their own mortality. Like the Witchcraft Museum, there is a sense that this venue also deals with matters of the spirit, albeit more pragmatically so. The Bakelite Museum, the last of my case studies, is akin to a large art installation. The massed collections are arranged with wit and are intended to elicit visual pleasure, as indeed they do, to such an extent that visitors describe the Bakelite Museum as an Aladdin's Cave or Wonderland.

Another aspect of the question about whether researching micromuseums could change ideas about museums concerns their distinctive traits and the ways in which they differ from major institutions. After all, large museums can also be sites of enchantment, of spiritual encounter, or reflection. They similarly house the belongings of dead people, provide visual pleasures, serve as meeting places for special interest groups, and make political statements, although in larger institutions these tend to support establishment views or government policy and not Irish republicanism. Nonetheless, there are significant differences between the character and activities of micromuseums and those of major museums. In this concluding chapter I broaden my discussion to examine some of the qualities that recur across a range of micromuseums and that distinguish these venues from major institutions.

There are problems with such an enterprise because identifying differences between two types of organizations can minimize the traits and practices that they have in common. The carefully selected sculptures at the Andrew Logan Museum of Sculpture in Berriew, Powys, are valuable, beautifully presented, extremely well-lit, pristine, and would not look out of place in a major museum. Even so, it is distinguished from its major counterparts

by its location in a converted squash court and by its emphasis on a single living artist. Of course, there are many galleries that are devoted to the works of an individual – the Rodin Museum in Paris, the Henry Moore Foundation at Perry Green, or The Hepworth Wakefield among others – but these concentrate on artists who have died and who have a recognized place in an established canon, not artists who are still working and whose standing in history is less secure. Similarly, other micromuseums have social history exhibitions that would not look amiss in a public sector venue. The Fakenham Museum of Gas and Local History has a series of illustrated panels that explain the social and cultural factors that impacted upon the changing design of gas appliances while a second gallery has a video that describes the physics of gas production in an accessible and entertaining manner. The museum differs from mainstream organizations, however, in that subsequent galleries are not as professionally produced, the facilities are basic, and visitors are warmly greeted and engaged in conversation by the team of volunteers.

Conversely, some of the features that are common to micromuseums also occur in mainstream venues. Volunteers sometimes greet visitors to National Trust houses and in major museums there may be opportunities to meet with curators. However, there is a question of degree. While a curator in a major museum may explain the decisions that underpin an exhibition and even recount some anecdotes about the initial research for the project, they are unlikely to introduce their children, offer tea and biscuits, or publicly complain about the parlous state of the museum's finances. Thus, some of the features that I will consider in relation to micromuseums can also appear in some major museums although they tend to be limited or have less importance in these contexts.

Another issue is that comparing micromuseums with major museums can underplay the heterogeneity of both kinds of venues. The collections at the British Museum vary in type from those at Tate Modern and equally the architecture, staff expertise, and interpretative strategies are quite different, as indeed they are from those found at the Imperial War Museum or the John Soane Museum. Equally, micromuseums vary enormously and do not necessarily incorporate all of the distinguishing characteristics that I discuss below. These caveats aside, it is useful to try to determine how small, independent, single-subject organizations differ from other museums and to outline some of their distinctive traits. I undertake that task by discussing a large number of micromuseums and do so partly in the spirit of documentation because, as I noted in the introduction, there is no overall register or website devoted to these venues and covering a number of diverse venues allows me to give the reader a greater sense of their scope and diversity. More importantly for the purposes of this discussion, covering numerous venues allows me to examine how particular characteristics and patterns emerge across micromuseums in relation to their location,

accommodation, staff, visitors, collections, and displays. The sections below are devoted to those six themes in that order.

Micromuseums, in place

Lewis Mumford claimed that the museum is 'the most typical institution of the metropolis, as characteristic of ideal life as the gymnasium was of the Hellenic city or the hospital of a medieval city', and following his lead Michaela Giebelhausen comments that, like cathedrals, museums are 'fundamentally urban phenomena'.[1] It is, however, difficult to draw such conclusions about the location of museums when very small venues are taken into account.

Micromuseums *are* found in capital cities. The stationers and luxury goods retailer Smythson has a tiny museum in an art-deco rotunda to the rear of its flagship store on Regent Street in London, while Twinnings has a slightly skimpy exhibition of tea caddies in its historic Aldgate branch. Some professional associations also have micromuseums and these are similarly found in the centre of capital cities. The British Optical Association Museum has a slightly surreal and (perhaps unexpectedly) interesting collection of spectacles in the basement of its headquarters, which is just off the Strand in London, and the Chartered Insurance Institute Museum, which concentrates on private fire brigades that were maintained by insurance companies in the eighteenth century, is located in the heart of the City of London (the area that was settled by Romans and which is a city in its own right). Micromuseums linked to religious orders are also based in the capital, as are those aimed at tourists, such as the Sherlock Holmes Museum at 221b Baker Street or the Clink Prison Museum on the Embankment in Southwark. It is very unusual, however, to find micromuseums located in the centre of cities other than the capital. Although there are exceptions such as the Mustard Shop and Museum in Norwich, micromuseums are not generally found in county hubs and are instead located on the outskirts of cities, in the suburbs, or in small towns, villages, and hamlets.

There are various reasons why micromuseums are found in these locations. In many cases they have been established wherever the founder happened to live or work. Barometer World is in Merton, a small village in Devon because that is where Phillip Collins has his specialist barometer restoration business and similarly the Gordon Boswell Romany Museum is in Spalding, Leicestershire, because that is where Gordon Boswell lives. Elsewhere, founders established museums in order to stay in a particular location. Peter MacAskill opened the Giant Angus MacAskill Museum and the Colbost Croft Museum near where he grew up on the Isle of Skye as a means of trying to generate an income in an area where there is little employment.[2] His near-neighbours, Terry and Paddy Wilding opened a

Bed and Breakfast and the Glendale Toy Museum because they wanted to move to Skye and needed to find a means of supporting themselves financially.[3] Elsewhere, the founders have moved to an area because land and property were relatively cheap or because there was funding available for new businesses, as Paul and Hilary Kennelley did when they opened the West Wales Museum of Childhood in Llangeler, Camarthenshire.[4] Indeed, whether or not it is explicitly stated, property prices have a strong bearing on the location of micromuseums. While businesses or professional organizations can maintain premises in central London, private individuals are less likely to be able to afford such property.

Other museums have closer links to the places where they have been established. Museums that are dedicated to individuals are often housed in the places where that person once lived, although in some cases their residence at the address was relatively short. Charles Dickens only lived in the house that accommodates the Portsmouth Dickens Birthplace Museum for the first five months of his life.[5] Museums that are dedicated to a particular form of manufacture or service may also have a strong connection to their location; the Pencil Museum in Keswick is a subsidiary of the Cumberland Pencil Company, which operated in the town for 170 years before moving to new premises in Workington in 2008. Similarly, the Shoe Museum is located in Street, Somerset, which is where James Clark, the founder of Clark's shoes resided and the exhibition is located in the company's first factory. Elsewhere, the museum is site-specific insofar as a building has been preserved. The Fakenham Gas and Local History Museum is coterminous with the town's historic gas works and the Eden Camp Modern History Theme Museum is housed in the extant prisoners of war camp on the outskirts of Malton in Yorkshire.

Attending to these settings is important partly because they show that museums have a place outside the civic heartlands and partly because it matters whether a micromuseum is reached along city streets, via a suburban close, or down a lane that winds from a wooded ridge to a shadowed valley floor. These places are laden with cultural significance and they dispose visitors to act and respond in particular ways.[6] In Chapter Two I described how the dramatic landscape of Boscastle and the social milieu of North Cornwall have a strong impact on the way that the artefacts at the Museum of Witchcraft are perceived by visitors, and the same dynamic relationship between location and collections is evident elsewhere.

For example, visitors to the Irish Republican History Museum have to travel along the Falls Road, an area of Belfast that became synonymous with republican insurgency and protest during the Troubles (the period of conflict that lasted from the late 1960s until the Good Friday Peace Agreement in 1998). Signs of that conflict and of ongoing discontent with the political situation are evident in the Irish flags that fly from the lampposts and in the extensive political murals that cover the gable ends of the terraces that abut the street (Figure 6.1). When I first visited in September 2012 the murals

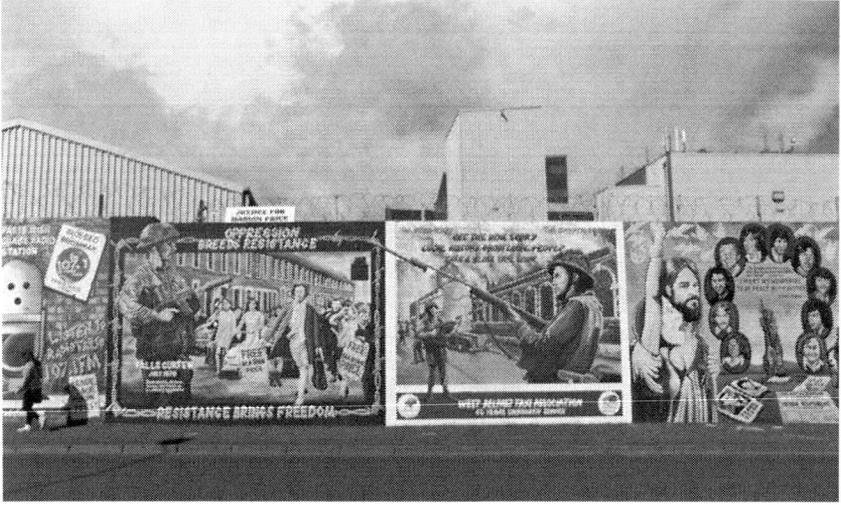

FIGURE 6.1 *Political murals on the Falls Road, Belfast.*

included vignettes of the hunger strikers of 1981 and a black and white painting of British Army troops on patrol in the street (the troops withdrew in 2007) yet despite the historical allusions, the inclusion of signs reading 'Free Marian Price' situated the murals in the contemporary context. An IRA veteran, Price had her release licence revoked in May 2011 after she held a script from which a masked man read at the Commemoration of the 1916 Easter Rising against the British. Her lawyers argued that she had been issued with a royal pardon, and hence was not on a licence that could be revoked, but it transpired that the Old Bailey had destroyed the paperwork and so her legal status could not be confirmed which made her incarceration contentious.[7]

Having passed the murals, prospective museum visitors turn off the Falls Road onto Conway Street, and then turn again into the precincts of a converted mill. Behind that is an anonymous prefabricated building which houses the museum. Inside, is a large room that is packed with pictures, posters, photographs, medals, plaques, weapons, insignia, badges, prison handicrafts, and mannequins dressed in uniforms. There is a huge amount of information available in large folders filled with newspaper reports and there is also a library and resource room. As in many micromuseums, however, there is little basic introductory material that would orient the newcomer, and the exhibition does not present a strong textual narrative. This is of little import for visitors who are familiar with the history of republicanism, or for those people who arrive as part of a group and are given a verbal introduction to the displays, but for other viewers the significance of the multifarious images and numerous artefacts is not self-evident. Who, for instance, were the women of Mban and why is one of their gold broaches

on display? What did the 'Blanketmen' have in common with the 'women of Armagh' and why were both parties invited to a reunion dinner, the invitation to which is on show? Even when visitors know something of those groups, the sheer quantity of exhibits and the lack of a clear time-line means that the artefacts float free of each other to such an extent that if the same museum was in a hypothetically neutral situation, it would be difficult to know how to interpret the exhibition. An uninformed viewer could quite possibly see the collection as little more than random political images, mainly from the 1970s and 1980s, and artefacts pertaining to Irish history. Importantly, it is the location in the Falls Road that indicates that the exhibition is intended to document, celebrate, and advocate republicanism; that the pictures of graves belong to the Catholic fallen and that the British Army uniforms are there to demonstrate establishment might and not as a means of, say, asserting their legitimate presence in the area.

More profoundly, the museum's surroundings place the objects within the contemporary sphere. Had they been shown somewhere that was disinterested, it would be easier to look at artefacts relating to the period following the War of Independence or even to the hunger strikes of the 1970s and 1980s and to see them as belonging to an era that was now over. In such a context, these items would be the documents or tokens of a past conflict. As it is, the flags and murals along the Falls Road make it difficult to ignore the political dissension and social unrest in Northern Ireland and thus the objects retain ongoing currency with respect to the contemporary political and social environment of Northern Ireland.

Many micromuseums have a direct connection to their location in that the subject of exhibitions relates to a local industry, activity, or history. The place, in the sense of a physical, cultural, and social environment, orients visitors' perceptions of the museum and its display: visitors see the collection at the Irish Republican History Museum in relation to its setting. At the same time, micromuseums can shape perceptions of the area in question. As I discussed in Chapter Two, there is no substantial history of witchcraft in Cornwall (in comparison with Pendle or Chelmsford where there were witch trials in the seventeenth century) but the Museum of Witchcraft has become an element in that particular geography and has actively re-shaped that area. Practising witches now come to visit the museum and local businesses have responded accordingly by selling magical apparatus, offering themed events and otherwise catering to their needs. Micromuseums that focus on a particular individual similarly contribute to and create that locale. The association between the eighteenth-century writer Laurence Sterne and the village of Coxwold in north Yorkshire was underlined when his previous residence was opened in 1967 as Shandy Hall (Tristram Shandy being the name of his most famous character) and the Jane Austen House Museum in Alton similarly aligns the place with the novelist.

The most striking examples of micromuseums shaping visitors' perceptions of that area occur when the exhibitions explicitly construct

a narrative of their locale, as is the case at the Dad's Army Museum in
Thetford, Norfolk. Although the exhibitions in this venue are ostensibly
devoted to the long-running television comedy of that name in which a
group of hapless civilians have joined the Home Guard and will form the
first line of defence should German forces cross the English Channel, they
actually concentrate on the programme as it pertains to Thetford, which
is where many of the episodes were filmed. Alongside photographs of the
cast and a recreation of the fictional vicar's study, which regularly featured
in the series, there are images of the neighbourhood with texts detailing
their role in the drama. The largest gallery in the museum focuses on local
inhabitants who appeared as extras in the programme and interviews with
them reminiscing about their appearances or meeting cast members are
played on video loop. Rather than providing an overview of the series,
the museum is principally concerned with the area and with residents'
experience of making the programme.

The museum establishes that Thetford is important because it hosted the
Dad's Army series. More particularly, the exhibitions and a linked map of
the town, draw a symbolic geography that includes the Bell Hotel, where
the cast stayed when they were filming, a parade of flint cottages known as
Nether Row that appeared in four different episodes, and the Palace Cinema
where the cast and crew watched the rushes on a weekly basis (Figure 6.2).
Civic buildings, including the museum and the town hall also appear on
the map but in these cases their identity has been reassigned. Instead of
indicating county status or cultural standing the museum is included for

FIGURE 6.2 *Map of the Dad's Army Trail issued by the Dad's Army Museum,
Thetford, Norfolk.*

having been the subject of an episode titled 'Museum Piece', in which the Home Guard raided its historic collections for armaments that they could use against the invading Germans, while the Town Hall is pictured because it featured in 'Time On My Hands' wherein a pilot was left dangling when his parachute was caught on the clock tower.

The way in which micromuseums are shaped by and shape their location varies according to the subject of the museum and their settings, but whatever the precise delineation of that geography, the single subject character of micromuseums can convey the impression that they provide *the* story of the area when in fact other narratives or exhibitions are equally possible. After all, Boscastle was also the setting for several of Thomas Hardy's love poems, while the Falls Road was a centre of linen production during the nineteenth century and the Irish Republican History Museum is located in the precincts of a renovated linen mill. In addition to providing the backdrop to Dad's Army, Thetford is traditionally thought to be the royal residence of Boudicca, Queen of the Iceni and it is tempting to imagine a rival exhibition being established that depicts women driving chariots rather than making teas for their men. As it is, these different histories go unmentioned and the exhibitions contribute to one narrative version of that area, establishing and reinforcing the links between the locale and the subject in hand.

Accommodating micromuseums

There is an established architectural vocabulary for the accommodation of major museums. They routinely take the form of neoclassical temples, modernist white cubes, and glimmering postmodern edifices; idioms that are generally not shared with, say, supermarkets or schools. Major museums are built in specific configurations, being clustered together, or with cultural institutions, or with the institutions of state. On London's Southbank the Hayward Gallery sits alongside the National Film Theatre, the National Theatre, the Royal Festival Hall, and the Queen Elizabeth Hall, the latter two venues playing host to literary readings, recitals, and concerts. Similarly, the huge neoclassical terrace on William Brown Street in Liverpool houses the Liverpool Central and Picton libraries, the Walker Art Gallery, the World Museum, a College of Technology, and the County Sessions Courts, while St George's Hall, which encompasses both a court and a concert hall stands opposite. The architecture and their position in relation to other buildings enables passers-by to identify these edifices as public institutions while clear signage indicates the precise function and contents of each.

When major museums stand alone they often face onto a park or forecourt or are bounded by a perimeter wall. Grouped together, they are usually sited on wide boulevards, squares, or else look out over pedestrianized areas or gardens. In order to enter major museums, visitors have to cross these

open spaces, leaving behind other sections of the city such as transport hubs, pubs, shops, office blocks, or homes, and then ascend flights of steps or ramps to pass through series of lobbies before finally reaching the collections. This architectural arrangement creates a physical separation between the exhibitions and the buildings outside, and is a form of design that is underpinned by the idea that artefacts are best understood in isolation from the concerns of the immediate setting. This is both practical in that the sound of city buses or the sight of office workers might distract viewers and detract from the experience of visiting, and ideological in that the works and the exhibitions are supposed to be unrelated to the activities and concerns outside the building. The architecture both establishes and symbolizes a material and a conceptual break between the exhibitions and the social and economic environment of the museum. In recent decades some curators have made links between exhibits and the milieu within which they are situated but it is usually against rather than with the grain of the museum's architecture.

These conditions rarely, if ever, hold true for micromuseums. Not only are they scattered across the country, the kinds of buildings that they occupy are quite different to those associated with major museums. Internal Fire: Museum of Power in Ceredigion and the Gordon Boswell Romany Museum both occupy agricultural steel frame buildings that are indistinguishable from the structures found on nearby farms (Figure 6.3),

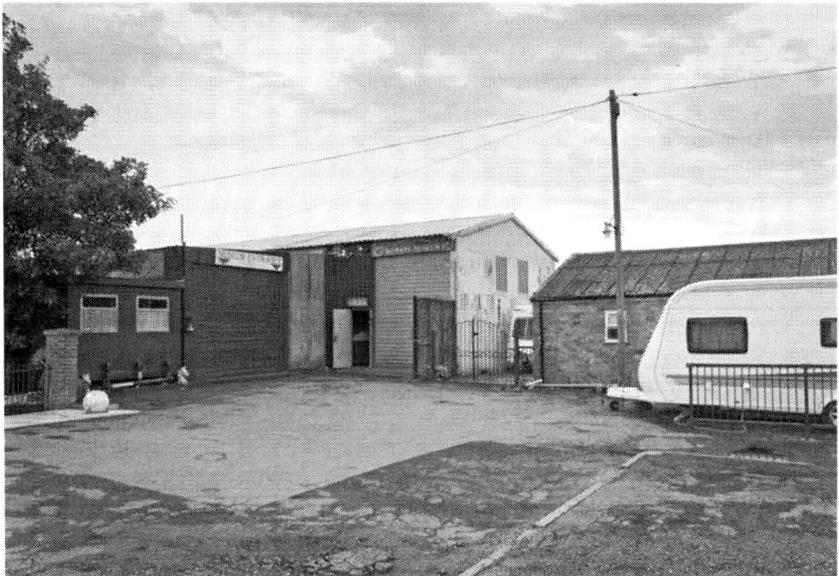

FIGURE 6.3 *Exterior of Gordon Boswell Romany Museum, Spalding, Lincolnshire.*

while the Museum of Straw and Basketwork in Buck Brigg, takes the form of a series of large garden sheds. In all these cases, buildings that are commonly used for other purposes have been purposefully erected to house the displays. Other exhibitions are located in premises that were previously used for something else. The Gem Rock Museum in Creetown is in a Victorian village school, the Laurel and Hardy Museum in Ulverston in an old cinema, and the Dad's Army Museum in a decommissioned fire station. Unlike major museums that occupy extant warehouses or power stations, these micromuseums rarely have a large budget and apart from some interior redecoration their buildings still resemble the shops, offices, mills, and schools that they once were. Alternatively micromuseums are housed, even hidden, inside a parent organization. For instance, the London Sewing Machine Museum in Balham is in a light industrial block that otherwise belongs to the Wimbledon Sewing Machine Company, while the Bank of England Museum is on the premises of that London institution. Despite their differences, the only way to identify either of these museums is by the boards outside.

In contrast with major institutions, micromuseums are materially and visually embedded in their environment. They are not removed from other types of buildings and are not immediately recognizable as museums. Instead of standing out as separate, distinct institutions they segue with the buildings around them and, by extension, with the groups and activities therein. This arrangement operates slightly differently depending on the precise accommodation and on the relationship between the exhibition and the museum's immediate surroundings.

When the subject of the exhibition has a direct connection to its surroundings, the absence of practical-symbolic architectural markers allows the parameters of the museum to slide. For example, at the Canal Museum in London the main object on display is a large section of a barge that has been cut away so that visitors can walk through, and inspect the living quarters. Beyond it, at the far end of the small gallery, are glass doors that open onto Regent's Basin, a marina on one of the city's northern canals. Numerous boats are moored on the waterfront and stepping outside it is not obvious where the museum precincts stop. It is not clear which, if any, of the boats moored outside the museum are exhibits and this arrangement makes it difficult to know how to respond. When I visited I was unsure if the barges were relatively inconsequential vessels that just happened to be tied up in that spot or were they deserving of sustained attention and, equally, it was not clear if I was allowed to board the boats and inspect them further, as is permitted in the museum, or if they belonged to private individuals who might be perturbed at the intrusion.

The glass doors to the rear of the Canal Museum, the view of the barges on the marina, and absence of signage created the impression that the museum extended out into the marina, encompassing boats and a quayside that were still in use. Conversely the lack of physical demarcation suggested

that the boat on display in the museum had simply been moved in from the waterways outside. Without any sharp divide between the spaces inside and outside of the building, the museum expands into the surrounding waterways, those sites seem to flow into the gallery, and objects migrate in both directions over the threshold. This slippage serves to root the museum in its environment. Rather than being about the waterways and its linked activities, it manifests as part of those sites and practices. A linked and corollary effect is that the exhibits are naturalized as belonging to that site. The barge on display may well have been shipped from Leeds and never plied its trade on this particular waterway, but it is easy to imagine that it was simply left behind by the people who had lived and worked here. The museum, exhibits, and surroundings appear to be all of apiece, in a way that it would not if a neat aluminium fence divided the museum from the houseboat moorings, or if labels indicated which boats were exhibits, or if signs politely requested visitors to stay within the museum's section of the towpath.

At the Canal Museum the accommodation allows visitors to make connections between the objects on display and those outside the museum, and this process affirms the authenticity of the museum and its collections. In other venues, the accommodation demonstrates and permits a high degree of continuity between the museum and a linked community or organization. This is particularly noticeable when the museum is located within another premises. For instance, the Museum of Freemasonry in London is housed inside the Freemason's Hall, which also accommodates the offices, meeting and ceremonial rooms of the United Grand Lodge of England. This venue treats its borders seriously and visitors have to negotiate a series of entry requirements, the first being to find the correct door because the imposing front entrance is kept closed apart from on ceremonial occasions, and the more modest entrance in daily use is recessed into a long blank side wall. Once inside, non-masons must first report to the reception desk in the central lobby, where they are issued with a pass and then directed up a magnificent staircase. On reaching the third floor, a sign points along a dimly lit corridor that is lined with a sequence of mahogany doors and occasionally, one stands open to reveal elegant conference rooms occupied by men wearing sober suits. At the end of the passageway is the library where a black-suited assistant asks visitors to leave belongings in a locker and to sign a register, noting the Lodge they belong to if appropriate. Only then may they proceed into the library and through to the museum.

Here, the huge blank walls draw a sharp line around the Freemason's Hall, separating it from the street outside. The museum is contained within that space and further protected from the exterior world or casual intrusion by its position within the building. The museum is wrapped by, nested within, the hall and this architectural arrangement makes it clear that the museum is part of the broader organization of freemasonry, and more specifically

of the United Grand Lodge of England, this being the headquarters. The admissions protocols – it is unusual to be asked to sign in twice and wear a pass in order to visit a museum – reinforce its secure status and further establish that this space is private and is only open to non-masons under certain conditions. Thus in visiting, one is not simply going to a museum about freemasonry, rather one is entering into the environs of freemasonry, both in terms of the building as a whole and the museum itself. When I visited, I felt as if I had inadvertently been allowed into an inner sanctum, which gave the otherwise staid exhibitions a frisson that they would not otherwise have had.

Until recently, the Museum of Freemasonry was not open to the general public and was run as a department within the Grand Lodge. It is still reliant on them for its core funding and the collections are on long-term loan from the Lodge.[8] Even so, the apparently seamless relationship between the museum, freemasonry in general and the Grand Lodge in particular does need treating with some caution. It is constituted as an independent charity, the (female) director is an experienced museum professional, and not all the curators or trustees are masons.[9] The two organizations are closely linked but they are not synonymous. Equally, the slippage between the inside and outside of other micromuseums must be treated with an element of caution. While micromuseums may seem to segue with a place, exhibits do not simply arrive, but have been acquired, chosen, or rejected by particular individuals or committees. Members of staff may not necessarily be affiliated to the group or organization to which the museum pertains, the museum itself may be an object of indifference to the linked community, and there may be considerable internal dissension within the group itself.

Despite these caveats, it is also important to recognize that the embedded quality of micromuseums indicates a close relationship to that organization or group. These venues are often practically and ideologically woven into the surrounding sites, organizations, and activities. Thus, in going to micromuseums, visitors are given views over or access into the spaces used and occupied by those groups. In some instances, micromuseums provide the sole entry point into otherwise private territory. The only way to see the houseboats on Regent's Basin is to sail in, that is to have access to a boat, or to enter the marina through the Canal Museum and, equally, visiting the Museum of Freemasonry gives visitors license to walk through and inspect the Freemasons' Hall. Once inside, the accommodation, and the consequent relationship to neighbouring sites and activities ensure a degree of authenticity. Visitors look at objects that seemingly and often do retain a connection to *this* building and were used by *this* group. While it would be a mistake to think that such micromuseums provide access to all aspects of an organization or community, or that they are the organic entities that they sometimes appear, they do create both a physical and a conceptual point of entry for visitors and enable a view into a different and unfamiliar situation.

When micromuseums concentrate on a subject that has connections to the immediate organization or to a linked site, then the embedded accommodation reinforces links to that community and site. The lack of separation between museums and non-museum spaces functions rather differently when the subject of the exhibition does not match the situation of the museum, although like micromuseums that focus on an organization, they may still give visitors a sense of stepping into an unfamiliar environment. In this case, however, one is not presented with a point of entry to something so much as a separate world in itself.

For example, the Cotton Mechanical Music Museum in Suffolk occupies a huge prefabricated building at the back of an unmetalled parking lot and like the Canal Museum and the Museum of Freemasonry this museum is visually and materially embedded in its surroundings. Situated alongside farms and fields, it could easily be a store for tractors. Apart from the sign outside, the plain building gives little hint of what lies within, and in the absence of any hallways or antechambers, visitors make an abrupt transition from the nondescript yard to a densely packed and intensely colourful display. As soon as they cross the threshold they enter into a room the size of a large school gym that is lined with fairground organs. The pink, blue, and green organs are lit with strings of coloured lights and covered in gilded curlicues, mirror tiles, carousel horses, model bandleaders, and paintings of roses. Smaller barrel organs on handcarts and electric organs have been parked in front of their more elaborate counterparts and the walls above are plastered with sheet music, mainly from the 1950s. Higher-up, innumerable vinyl records are nailed to the rafters. The adjacent rooms are filled with pianolas, gramophones, and musical boxes. While such spectacle might be expected in Blackpool, its presence in this village and in this building is deeply incongruous and creates a sense of disjunction.

Similarly, there is little connection between the site and the subject of the Shell Museum in Glandford, Holt. This collection occupies a pretty, flint building with Flemish gables and echoes the style of the cottages in this tiny Norfolk village, but is rather oddly located in the graveyard of the parish church (Figure 6.4). Even so, if the museum was devoted to Celtic crosses, as is the case at the Margam Stones Museum, which is in a similar building on the grounds of Margam Abbey, or if its exhibits had comprised of stained glass as they are at Ely Cathedral Museum, then its position would have made sense. As it is, visitors find a small double-height room that is lined with white wooden cases filled with beautifully arranged, subtly coloured shells (Figure 6.5). Daylight streams in from the high clerestory windows, and at the far end of the room, a mirror catches your reflection. The museum is exquisite but the gabled building and its presence in the graveyard is somewhat incomprehensible, even eerie.

In both cases, the difference between the site and the collections is strong enough to create a momentary feeling of having shifted in place. Outside the Glandford Shell Museum one is standing in a church graveyard.

FIGURE 6.4 *Exterior of Shell Museum, Glandford, Norfolk.*

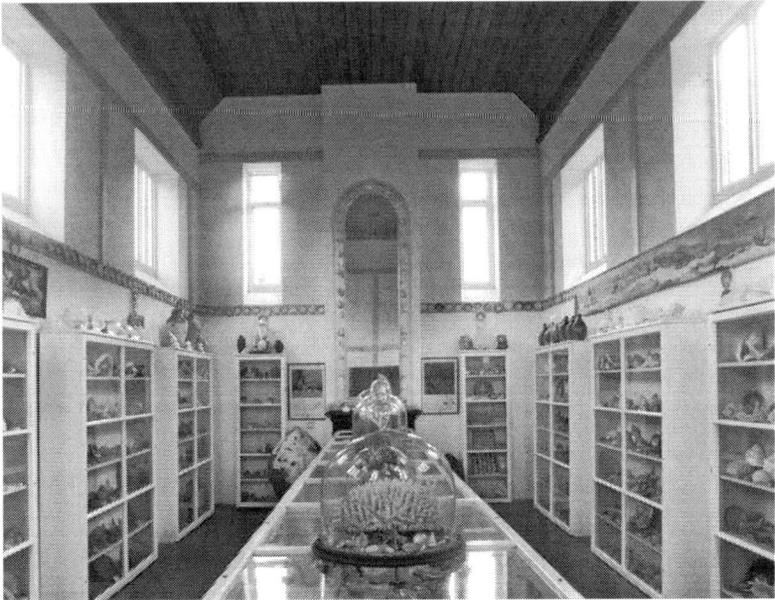

FIGURE 6.5 *Interior of Shell Museum.*

Inside, one is standing in a strangely beautiful and completely unrelated environment. It could be a scene from a fairy story or the subject of a surrealist painting and indeed, pinned to the far wall is a print of 'Shells', by Tristram Hilliard, one of the English seaside surrealist painters.[10] Like the Musuem of Mechanical Music where one makes a quick shift from a tarmac car park into the otherworldly space of the fairground and cinema, the Shell Museum is utterly removed from its surroundings.

Quite clearly, there is a similar disparity between the collections and the accommodation and location at many major museums. There is no symbiotic relationship between the Egyptian mummies on display at the British Museum and its neoclassical architecture or its situation on Great Russell Street. Here, however, the architecture not only separates museums from their surroundings, but creates transitional spaces that link disparate environments. If one approached the Shell Museum across a plaza and through a portico, then the shift from the village of Glandford to its aesthetic displays would be signalled in advance, as it is when visitors are steered from busy London thoroughfares across the square and through the entrance halls of the British Museum. It is the lack of bridging structure that produce the surprise, the sudden transition, and hence the sense of being dropped into a radically other environment.

The curators of micromuseums

With very few exceptions, the staff in micromuseums are experts in their subjects. Curators at Barometer World, the Museum of Knots and Sailors' Ropework in Ipswich, Cuckooland in Tabley, Cheshire, and the Bakelite Museum in Williton, Somerset have published on their specialist areas, writing books on the histories of objects or their manufacture. In the ten years after he opened the Museum of Power in 2003, Paul Evans compiled an extensive archive of online technical manuals and company records that is used by the Massachusetts Institute of Technology and other universities. Des Pawson at the Museum of Knots and Sailors' Ropework has lent artefacts to the Military Museum in Brussels and has assisted with object identification at Greenwich Maritime Museum; the Piekarski brothers at Cuckooland have met with horologists from the British Museum and have discussed the possibility of sending clocks to London, while in the course of researching his landmark book *Of Bicycles, Bakelite and Bulbs: Towards a Theory of Sociotechnical Change*, the eminent Danish academic Wiebe Bijker contacted Patrick Cook at the Bakelite Museum.

Bearing in mind the question of how micromuseums differ from major museums, it is important to note that whereas curators in major museums have studied at university and increasingly have doctoral degrees, those working in micromuseums rarely acquire their expertise through scholarly

learning and indeed it would be difficult to know where to study some of the subjects covered in these collections.[11] Instead, their knowledge has been established through independent research and lived experience. As a young man Paul Evans worked on the steam engines in Bolton mills, Des Pawson knows about knots partly because he makes and sells maritime and decorative ropework, the Piekarski brothers are professional clock restorers, and so on. In turn, the curators' knowledge is developed through collecting and curating. Des Pawson, commented that his museum provided him with a reference collection, while Max Piekarski observed that having acquired and worked with so many Black Forest clocks, they had no difficulties in spotting fakes.[12] Many curators, including the Piekarski brothers, Gordon Boswell at the Romany Museum and Phillip Collins at Barometer World, undertake extensive restoration work, as do staff at transport museums where vintage vehicles are stripped down and rebuilt using techniques and materials that are appropriate to their era. More generally, all of these curators handle their collections in order to clean or rearrange them, and in so doing come to know the qualities and flaws of individual objects and the differences between them.

Micromuseums also differ from major museums in that visitors are likely to meet the staff. Visitors are usually greeted when they arrive and are often invited to ask staff if they have any questions; in some venues admission involves a more formal tour, and on quiet days curators may approach visitors and strike up conversations to alleviate their boredom or out of curiosity, but whatever the interaction, the staff will often mention their own connections to the subject of the museum and correlative experience. At the Vintage Wireless Museum in Dulwich, which I discussed in Chapter One, Gerry Wells explained that he was taught to mend radios at remand school, later working as a repairman, but at other venues the curators' expertise is enacted rather than recounted. For example, the 'Crank Up' days at Internal Fire: Museum of Power in Ceredigion attract numerous volunteers who travel from the across the country to set the early twentieth-century diesel engines running. During the morning a dozen or so boiler-suited men spray the engines with oil, check air pressure and fuel levels, and adjust numerous valves, and by lunchtime are ready to start firing up the engines. In some cases this involves inserting long metal bars into sockets and physically turning their heavy iron wheels, which as the machines are old and worn, requires both delicacy and effort.

When I visited on Easter weekend 2013, the Allen 3S30 engine, which is one of the oldest in the collection and is rarely started, was a particular subject of comment. Having set it working, a group of volunteers continued to stand around the engine with their hands on the top of the casing listening to the sound it made. After a pause one of the men said 'It's chiming on all three'. 'Still a bit knocky' someone else replied.[13] They listened and then began making slight changes to the machine, and continued the process of listening and adjusting until finally one of them declared 'she's sounding sweet'

(Figure 6.6). Watching them, it was obvious that they could hear and feel how the machine was working, that each of them understood what their colleagues were doing and that they knew how to make the requisite alterations.

Once the Allen 3S30 was running smoothly I asked the volunteers what exactly they had been doing. Roland, a retired engineer, told me that having worked with engines for a long time, the volunteers could all hear how the different components meshed together, and that each type of engine had a particular sound depending on whether it was two stroke and fired on every revolution of the crank-shaft, or four stroke and fired on alternate rotations. Paul Evans, the owner, commented that 'a two stroke is like an excited teenager but the four strokes are like laid-back old gentlemen', while Roland continued saying that the number of cylinders also makes a difference. On a six bore engine the cylinders are positioned at sixty degree intervals around a central crankshaft, which he explained is 'inherently balanced and sounds smooth'. Another volunteer mildly disagreed saying that an eight-cylinder engine has a more consistent sound. 'More of a rumble' replied Roland, adding that 'four-cylinder engines are like a heartbeat and the twin cylinder is just a thud. The engines with odd numbers of cylinders are sweeter sounding' he said, 'a three-cylinder engine has a toe-tapping note. It's syncopated, like listening to jazz'.

FIGURE 6.6 *Paul Evans listening to the Allen 3S30, Internal Fire: Museum of Power, Tanygroes, Ceredigion.*

Turning back to the Allen 3S30, Roland said 'Usually you'd work out how the cylinders are working from temperature gauges on the back of the machine, but they're all missing so they were doing it by feel and sound.' 'We were feeling for the extent of the knock' he added and, seeing my incomprehension, he elucidated: 'by putting their hands on the injector pipe they can feel from the vibration that the third cylinder is over-fuelling. Also they can hear it knocking a bit more than the others.' When Paul returned to the conversation I commented that starting these engines and keeping them running was a precise art, to which he replied that engineers could detect the slightest change in engine speed – 'you can hear a 2–3 rpm shift at 200 rpm. You get used to the rhythm' – and told me that in the Bolton mills which were still in operation when he was young, the engine room was warm and the sound was that of a loud heartbeat so the men responsible for the machine would usually doze off, but that they would always wake if the sound altered. 'They could hear the changes unconsciously' he said, 'you know it in your sleep'.

At Museum of Power, the owner and volunteers' knowledge of the machines was acquired over time and is deeply embodied. Through long experience, engineers could detect the uneven beat of a machine through their fingertips and hear the syncopation of a smoothly running engine. Their knowledge was embedded in their hands, ears, legs, and feet, in how their bodies were oriented towards a machine. That expertise was made evident at Crank-Up and served to link the museum collections to a wider community of skill and practice.

Visitors do have the opportunity to meet the staff at these museums, but other venues more closely resemble major museums in that there is little interpersonal contact. Even so, micromuseums are distinct in that the labels often have a distinctly autobiographical tenor and act as proxies for the owners or volunteers, providing clues or direct information about their expertise. At the Manchester Transport Museum dozens of early and mid-twentieth-century buses are packed into serried rows. All the vehicles are individually labelled and these texts adhere to a standard format that starts with the name of the original operating body and is followed by the vehicle's specifications. One typical text reads:

Salford City Transport

Fleet 112

Registration TRJ 112

Body Metro-Cammell

Chassis Daimler CVG6

Engine Gardner 6LW, 8.4 litres

Seats 65

Entered Service 1962

Withdrawn 1977

The labels also carry a brief commentary that expands upon each local council's transport provision and the manufacture of the vehicles concerned. In this case it states:

> Like Manchester 4634 this bus has a pre-selector gearbox. However unlike the Manchester equivalent whose operation was assisted by air pressure, the selector panel on 112 is completely mechanical.

As visitors may deduce, and the staff confirm, most of the labels were written by drivers who worked on the South and East Lancashire bus routes and who now volunteer at the museum. Notably, they have not confined their texts to technical matters and the labels also incorporate the drivers' memories of the physical effort and the pleasures involved in operating these vehicles. Readers are informed that 'one drawback of' the 112 was that, if the aforementioned 'pedal was not pressed properly, it would kick back with great force against the driver's shin'. Likewise, the text affixed to vehicle number 280 of the Rochdale fleet states that they were 'easy to drive although the visibility through the nearside window over the high bonnet was poor'. The Ashton Under-Lyne 44 had a 'sliding door on the cab' that 'makes this bus very pleasant to drive on a summer's day'. Over the course of their working lives, the drivers had accommodated to or enjoyed the idiosyncrasies of individual buses and the references that they made to their experience serve to establish systems of localized value. The buses are not rated according to rarity or age but according to how easy they were to drive, and the volunteers' lives and perspective on the subject have been written into the displays.

In other micromuseums the curators' knowledge is not based in long-term technical know-how but in a different kind of lived experience: that of the family and personal life. Here too, systems of value and the curators' relation to the subject of the museum are made clear in a way that is not common within major institutions. When I first visited the Ty Twt Dolls House and Toy Museum in Newport, Pembrokeshire, the owners, two sisters Val and Pam Ripley, showed me into the first room which contains a chronological display of dolls houses, and commented on the history of interior decoration as evinced by their collection, but they also explained that a large Edwardian model complete with servant's quarters was given to Val for her eighth birthday in 1932. In the next gallery, a stuffed bear on wheels stands next to an annotated picture of the infant Pam with the same toy and elsewhere Pam is shown in her pram clutching 'Pip-squeak' which is also on exhibition. One display is labelled 'Our own dolls from the 1920s and 30s', while another is announced as 'The Rimmer Group: Our mother's toys (her dolls are on the sofa). Together a 100 years' (Figure 6.7). Both these displays are accompanied by photographs of the young girls and of their mother as a child holding the said toys, while their father makes an appearance as a boy in formal Highland costume, a large bear in his arms. A final photograph shows dozens of cuddly toys arranged over the steps of

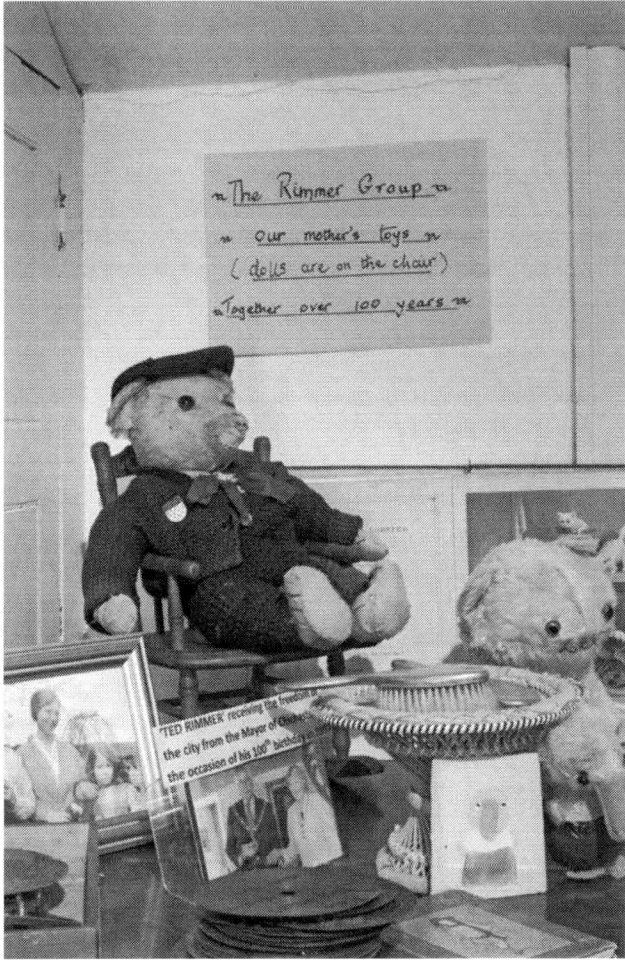

FIGURE 6.7 *The Rimmer group of toys, Ty Twt Dolls' House and Toy Museum, Newport, Pembrokeshire.*

a garden patio. The label states that 'many of those toys are on display in the museum' and indeed several are arrayed close by. Apparently the two sisters had rediscovered the dolls' house and many of their childhood toys in their mother's attic in the 1970s and then, some years later, decided that building the collection would provide a shared pursuit for their retirement. This led to them opening the museum in 2010.[14]

At Ty Twt the collections do not aspire to be and are not presented as representative collections of an era or as prime specimens of their type. These objects are not on exhibition because they are exceptional items, but because they belonged to the sisters. The displays are proffered as somebody's collection that has grown from particular interests that are rooted in longer

family histories. As in other micromuseums, this approach provides a striking contrast to the exhibitions in major museums, which are presented as neutral assessments of a subject. Even when an exhibition includes information about different perspectives on a given topic, institutions assume the position of the neutral arbiter who can present disparate material in an apparently objective manner. Objects may be annotated according to their provenance but museums rarely explain how exactly an object came into their possession or why it is being lent, especially when that may prove contentious. Likewise, individual curators may be named but the reasons why they have chosen to specialize in that area and what their position is in relation to it are not elucidated and the institutions' connection to the topic remains opaque. If the level of transparency encountered in micromuseums was transposed to major museums then one might find, say, the director of the Imperial War Museum standing next to a case that contained her mother's WAF uniform, her father's air raid warden's helmet, and a plastic gun she played with as a child, while talking about her unswerving respect for the armed forces.

Again, the curator does not necessarily need to be present in order for visitors to understand why they have opened a museum on a particular subject and to make an educated guess about their perspective on that topic. At the Gordon Boswell Romany Museum two poster-size photographs show a large family standing in front of a camp that consists of a wooden caravan and a pair of temporary benders (Figure 6.8). The text beneath reads: Gordon's

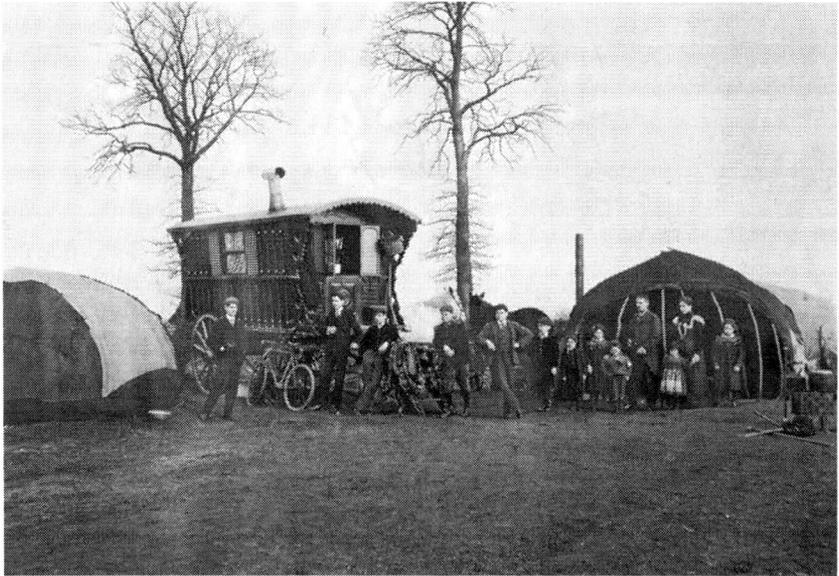

FIGURE 6.8 *Photograph of Gordon Boswell's grandparents, father, aunts and uncles, the Gordon Boswell Romany Museum, Spalding, Lincolnshire. Photographer unknown.*

grandparents, father, aunts, and uncles 1902. The museum also includes a small cinema which shows a short film about the owner's family, and should visitors not have time to attend to the movie, there is a notice which reads: 'The Gordon Boswell Romany Museum was opened on the 25th February 1995 in memory of my father Sylvester Gordon Boswell who was born in a red tent on the sands, south shore, Blackpool, 25th February 1895, 100 years ago'.

A similar correlation between the subject of the exhibition and the owner's family history is also evident at the London Sewing Machine Museum where there is a recreated shop front (Figure 6.9). Next to it is a notice that reads:

London Sewing Machine Museum

Dedicated to:

Thomas Albert Rushton

1900–1974

Founder of Wimbledon Sewing Machine Co Ltd London

The name Thomas Rushton is emblazoned across the shop front while the museum is accessed via the entrance hall of the Wimbledon Sewing Machine

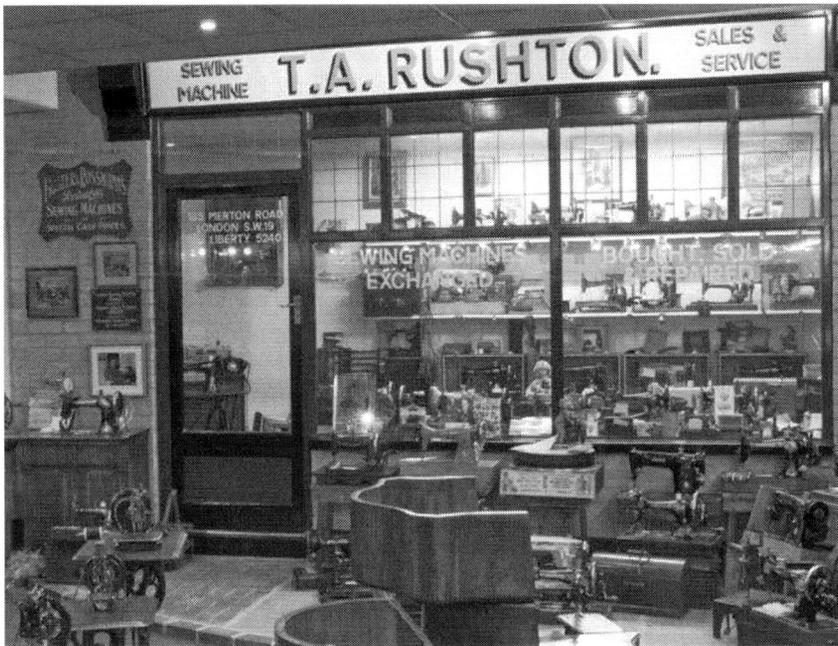

FIGURE 6.9 *Re-created shop front, the London Sewing Machine Museum, Balham, London.*

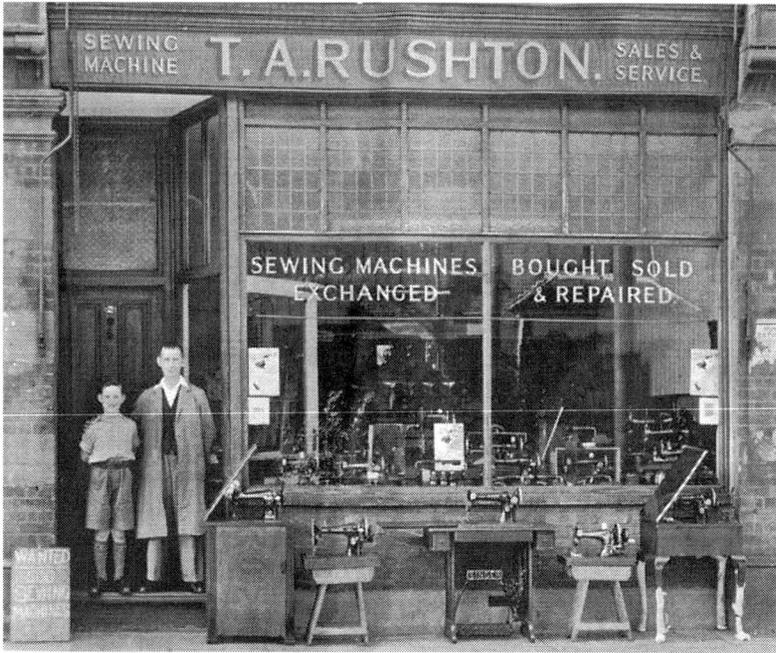

FIGURE 6.10 *Photograph of Thomas Rushton with his son, Ray Rushton, the London Sewing Machine Museum. Photographer unknown.*

Company so it is clear that there are links between the two premises: the museum is dedicated to the same person who founded the neighbouring company and it includes a re-creation of his early premises. Next to the dedication are a further three photographs, one showing a man, presumably Thomas Rushton, standing in front of the original shop-front and holding the hand of a small boy (Figure 6.10); the second is a later image of a young man astride a motorbike which is parked next to a van that bears the company logo; and the third is a photograph of a smiling middle aged woman which is marked as being 'Mrs M. A. Rushton, Ray's mother'. It does not take much guesswork to deduce that the child and young man in the photographs is Ray and that he founded the museum in honour of his father. Like Gordon Boswell, Ray Rushton may have had various motivations for actually opening a museum, but the dedications, photographs, and spoken introductions clarify why the museum is devoted to that particular subject.

Whether or not visitors meet the owners or their families, personal photographs, labels, and dedications combine to give them a good indication of who established a given museum and in what personal and social circumstances. The relative wealth of the staff, where they grew up, what their families did for a living, their ethnic and class identity, marital status, educational level, political and religious views may all be in evidence; as are the reasons why the owner has concentrated on a particular field or

selected a specific topic as the subject for an exhibition or why volunteers may have chosen to work in that venue. We know that the owner of Internal Fire: Museum of Power worked on a generator in a mills in Bolton, that the volunteers who crank-up the diesel engines were or are engineers, that the staff at Manchester Transport Museum are retired bus drivers and conductors, that the Ripley sisters had an affluent upbringing, that Gordon Boswell is Romany and that his father was born in a tent on the Blackpool sands, that Ray Rushton rode motorbikes and owns the Sewing Machine factory beneath the museum, and so on. This kind of information explains how these collections came about, where the objects come from, why these particular objects form the subject of the exhibition, and what investment the owner has in that topic. In short, visitors gain a good sense of who has authored these exhibitions and in what context.

Working through the list of qualities that are common to micromuseums, it is clear that many of these venues are firmly rooted in a particular location (whether that is because they speak to that site or because they have in some respects created it, or both), and that this sense of connection is reinforced by their accommodation. As importantly, micromuseums are located in the sense of being tied to particular people and histories. Their displays and modes of interpretation are inextricably linked to communities, families, or to individuals who are in turn embedded in social networks and pasts. The displays and the interpretation do not seek to provide an overview of a subject but manifest someone's perspective, delivered from their standpoint and situation.

Visitors to micromuseums

The fourth area in which micromuseums evince distinct traits concerns the contributions of visitors. While staff often enter into conversation or tell stories, it is important to recognize that many of these spoken communications happen in response to visitors' questions and comments. Even when the interaction takes the form of a tour or lecture, visitors' queries and interruptions will prompt incursions onto other topics and rather than being passive consumers of an exhibition or of the curators' narratives, they are active agents in shaping the event and producing knowledge.[15] The degree to which visitors' interests and identities can contribute to the content and form of their stay in micromuseums was vividly illustrated by a series of visits I made to Shandy Hall in Coxwold, North Yorkshire.[16]

Shandy Hall, the home of the eighteenth-century author Laurence Sterne, is a medieval building that is managed and occupied by Patrick Wildgust and his partner Chris Pearson, who jointly offer bi-weekly guided tours of the building. The first time that I visited, I was in a group of three and on arriving Patrick invited us into the old kitchen. The room has a low ceiling supported by massive wooden beams, a large

brick hearth where a coal fire was burning, and is filled with comfortable armchairs and antique cabinets bearing china ornaments and bowls of flowers. Patrick introduced himself, announced that 'the tour depends on who comes', and asked who we were. The other woman on the tour was staying in the village for the weekend, had not previously known that the house was here, but was an admirer of Sterne's work, while a man in his late twenties reported that, as a teenager he was awarded an 'A' for an essay on early novels and in order to challenge him further, his teacher had handed him a copy of Sterne's *The Life and Opinions of Tristram Shandy, Gentleman*. I admitted to never having read Sterne and that I was mainly interested in small museums.

From here we progressed through to a tiny study where the author worked and which now contains first editions of all the versions of his books. The other two visitors immediately began to look for and identify some of the volumes that they had read, while I stood looking slightly nonplussed. In response, Patrick began to outline *Tristram Shandy* and explained something about its experiments with both literary style and visual devices. Picking up the different editions he showed us how various editors had interpreted the black page which marks the death of Parson Yorick, one of the characters of the tale. Developing his theme, Patrick drew our attention to the contemporary artworks hanging on the walls, all of which referred to or echoed ideas within *Tristram Shandy* and described a recent exhibition at the linked art gallery for which he had commissioned seventy artists to produce their version of the black page.

The second time I visited was for a candlelit tour in mid-December when more of the house was open to the public than was usually the case. Chris, who introduced the tour, announced that we would be able to see the wall painting that was hidden behind panelling in their bedroom. 'You live here?' a visitor asked in surprise. 'Yes', she replied and started to talk about other residents who had occupied the premises and how the building had changed over the centuries. At this point, Patrick interjected with a story about a visitor who returned to the house having been evacuated there as a child. Apparently, the man stumbled as he entered and asked: 'where is the second step?' As Patrick explained, Shandy Hall had been a farmhouse for most of the nineteenth and twentieth centuries and that the floor had then comprised of wood planks laid on earth. In the 1960s, after the Laurence Sterne Trust took over, it was replaced with salvaged stone flags, the floor had been raised by a few inches, and thus the returning resident wrongly anticipated the drop. Moving on from stories of past residents to anecdotes about other visitors' interactions with the architecture of the house, Patrick pointed to the hearth and said 'the beam is the oldest visible thing in the house and the hole cut into it is where the spit hung. A carpenter who visited told me they must have reused the beam because the dovetail joint is upside down. That's why visitors are important – they tell you things – we've

had at least four architectural historians come and visit and each of them are entirely convincing'. This statement garnered laughter, because Patrick's implication was that they all had given different accounts of the house.

Once away from the fire, and particularly when we went upstairs to the bedroom, members of the group commented on the cold, which led to long conversations about the problems of installing modern central heating in a listed building and about a terrible leak that had almost ruined the medieval wall paintings. It was only when we reached the dining room and someone enquired about a closed doorway that Patrick touched on the subject of Sterne and then only obliquely. He explained that the doorway had originally opened into a cupboard that contained a chamber pot, went on to elucidate the etiquette of pissing in the eighteenth century, and as the absence of a chamber pot provides a crucial plot device in *Tristram Shandy*, ended by bemoaning this particular aspect of the building's conversion. Later, when the group convened over sherry and mince pies in the kitchen, I spoke to Patrick and commented that the tour was quite different from the one before. 'Good' he said. 'A lot depends on what people ask. It would be rude not to answer and they take the talk in different ways. Anyway, I'd go mad if I had to keep saying the same things.'

The third visit was different again. Early on in the tour one visitor had confessed to hating *Tristram Shandy*. 'Why' asked Patrick? 'Well it's very tedious and I got the joke straight off – that he never gets to the point', the man replied. For most of the rest of the tour Patrick emphasized the entertaining aspects of the story and recounted numerous amusing tales from the book, prompting the unhappy visitor to mutter 'he's picking out all the best bits'. That same evening, the tour also included a group of Goths and playing to the crowd, Patrick ushered the group into a small dark antechamber where he told them the story of how Sterne had been buried three times; once when he died, once after his cadaver was stolen by grave-robbers and identified on the anatomists' table, and then when the cemetery was acquired by developers in the 1960s and his body was disinterred and moved. The group duly shivered and made their way by torchlight to visit Sterne's final resting place in St Michael's Church, Coxwold.

Museum visitors always interpret material from their own perspective, and if they are in company, they may discuss their responses with their companions. In micromuseums, however, visitors may also be called upon to introduce themselves and to participate in the proceedings. The degree to which they do this depends upon the individuals concerned, the subject matter, and the structure of the museum visit, which at Shandy Hall deliberately echoes the tangential narrative of the novel. Even if visitors remain relatively quiet, as was the case on my first visit to this venue, the curator may take his or her lead from their actions, in this case, the evident attention they paid to the collection of first editions. Whether the visitors' contribution is in a minor or major key, they help shape the content of

the spoken exchange and the objects upon which it concentrates. The material that is discussed and points that are made are partly premised on their input and in each case the tour would be different without those specific visitors. In this sense the visitors are not the passive recipients of information but actively assist in the generation and the communication of knowledge.

Visitors may also contribute new knowledge to the museum in question. As Patrick reported, some of his information was derived from visitors and his narrative included the observations that they had made about the dovetail joint, the structure of the building, and the re-flagged stone floor. The visitors' expert knowledge and lived experience thereby became part of the story of the venue. Anecdotes about visitors and the comments that they made are similarly incorporated into the narratives of other micromuseums. The Ripley sisters at the Ty Twt Dolls' House and Toy Museum recalled visits by 'Bunny' Campion, one of the experts from the television programme *Antiques Roadshow* and her assessment of their Cathy Cruise doll, while Captain Beany recalls the television presenter, Danny Wallace arriving at his Baked Beans Museum of Excellence and there is a signed photograph to mark the event.

Not all micromuseums offer visitors the opportunity for conversation or recount stories about their arrival. Even so, labels and texts may invite visitors to contribute to the collective knowledge of the museum. In Chapter Two I noted that a rabbit skin amulet on display at the Museum of Witchcraft in Boscastle carries a short text which states that staff are unaware of the object's exact purpose and asks: if you are familiar with this type of charm please let us know. At the Cobbaton Combat Museum in Devon, a Second World War newspaper cartoon shows a doctor attempting to strangle Hitler and attached to it is a handwritten message that reads: 'Any suggestions who the physio is?' and likewise a label at the Muckleburgh Military Collection museum asks visitors if they can identify any of the people in an old military photograph (Figure 6.11). As is the case elsewhere, it is assumed that some visitors will be privy to information that the curators do not possess and that they can assist in the interpretation of the collections.

While the displays at micromuseums are often presented from a specific and often highly personal standpoint, it is important to remember that visitors can cut across and add to these narratives, introducing new perspectives or possibilities. There are exhibitions where visitors are subjected to spoken or textual monologues but more usually there is an exchange. Visiting micromuseums is not necessarily a standardized experience, rather who comes can alter what happens, the information that is exchanged, and the ensuing interpretation of the collection. Conversations may start with the artefacts or site, or with the views of the curator, but can then proceed and unravel in numerous, unpredictable directions.

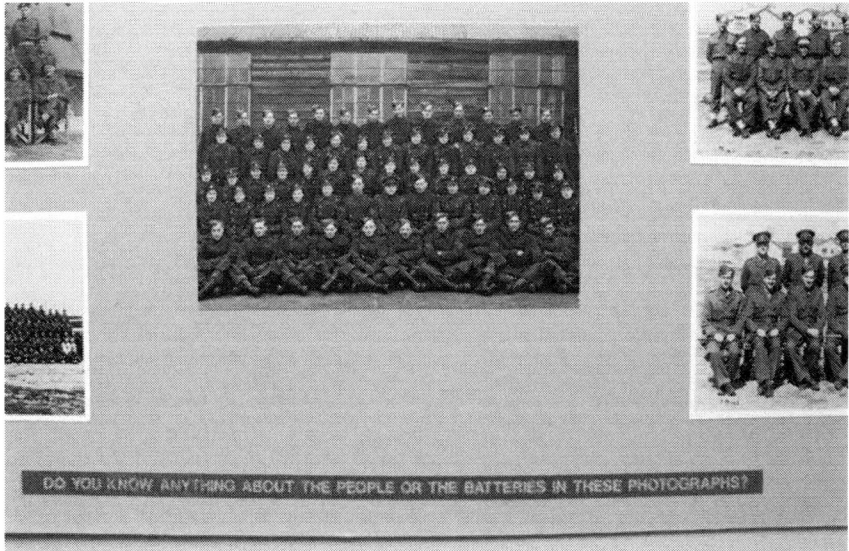

FIGURE 6.11 *Label reading 'Do you know anything about the people or the Batteries in these photographs?' Muckleburgh Military Collection, Norfolk.*

Displays in micromuseums

The fifth category to consider in relation to the distinct characteristics of micromuseums is that of display. In her book *Destination Culture*, the American scholar Barbara Kirshenblatt-Gimblett usefully distinguished between in situ and in-context forms of display.[17] The former variety, which includes period rooms, photomurals, and dioramas is mimetic and consists of objects arranged in recreated settings. The later type of display is when objects are organized according to a classificatory or schematic framework based on typologies of form or proposed historical relationships. Alternatively, or additionally, objects can be set in context through the use of long labels, audio commentary, catalogues, and booklets. Both these types of display are found in micromuseums, sometimes in the same venue. One room at the West Wales Museum of Childhood has been furnished in the manner of an early twentieth-century school room complete with rows of wooden desks, a teacher's table and blackboard, school caps and blazers hanging on coat pegs, cricket bats leaning against the walls, and a dunce's hat awaiting a wearer. Another gallery has been organized chronologically with a series of large cases containing toys from each successive decade of the twentieth century, while further rooms are organized thematically and includes groups of toys that pertain to 'Wales', were made by Dinky or which were produced as television tie-ins.

Micromuseums also use display techniques that are not routinely found or are not seen to the same extent in major museums. One such mode of curation involves arranging the whole collection to create an aesthetic effect. Clearly, exhibitions in major museums are also arranged with an eye for visual pleasure, but it would be unusual to see a display that was solely organized on those grounds, as is the case in some micromuseums. At the Bakelite Museum, which I discussed in Chapter Five, the artefacts are arranged to follow the lines of the shelves or to create swathes of single colours rather than to communicate an idea or history. An equally striking aesthetic display is found at the Shell Museum in Norfolk where scallop shells form a border around the room and the walls are lined with plain double-fronted wooden cases filled with shells. One cabinet contains a row of large pink–white spider conches that are arranged with their finger-like spines curving in the same direction, a long razor clam is placed horizontally to create a line beneath them and, below that, two halves of a bright yellow Queen's shell are laid side by side. In another display, silvery mother of pearl shells lean against the back of the case, and in the foreground striped conus shells are organized according to colour. The author of a mid-twentieth-century guidebook to Norfolk justifiably noted that it is 'a rare little museum for all those who love beautiful things', but it is impossible to tell whether the shells have been gathered from different parts of the world or whether some are rare and others common.[18]

In other micromuseums, the exhibitions have no particular structure. Whereas the individual cases at the British in India Museum are all coherently and carefully arranged, visitors move from a cabinet of Indian folk models to one containing the accoutrements of a retired general in the British Army, and there is little or no apparent relationship between one section and the next. Likewise, the buses at Manchester Transport Museum are parked in serried ranks but (so far as I could tell) they are not grouped in any particular order. One does not progress from early to late vehicles or from buses that plied the South and East Lancashire routes versus those that worked in the city centre.

Major museums regularly employ a modernist style of display that is never seen in micromuseums. Operating in this mode, major museums and particularly art galleries make a judgement about what is worth seeing and select key items from their collections, hanging each piece at some remove from the next. In the strongest version of this style, an individual work is given a wall or room to itself, which indicates that this piece is especially deserving of sustained, uninterrupted attention. In contrast, micromuseums are far less selective and tend to put most if not all of their collection on show, a tactic that results in objects that are conventionally considered to be more valuable or more significant than others being subsumed within the display. Sometimes, curators at micromuseums deliberately conceal their prize exhibits. At Cuckooland the original hall and classroom of an old school are lined with hundreds of cuckoo clocks. According to the co-owner

Roman Piekarski a few of the pieces on display are extremely costly but for reasons of security he declined to point them out.[19] The staff at Paperweight World were similarly reluctant to identify their star exhibits, although when I later commented on a particular globe the proprietor replied 'oh you have a good eye: that's our most expensive piece'.[20] This very collectible item was placed alongside a series of mass produced plastic weights imported from China. When I visited the Vintage Wireless Museum the owner indicated a row of near-identical early gramophones and challenged me to spot the most significant object – the prototype that had been donated by John Paul Getty Jr. I failed miserably, prompting him to comment, 'It would take an expert thief to pick this one out'.[21]

The volume of objects on display and concerns about security mean that it is often impossible to tell if any one exhibit is valuable or significant. The quantity of exhibits can also obscure the logic of chronological or thematic arrangements, especially when there are no introductory texts to tell viewers how the exhibition has been conceived. Even when objects have been sorted into categories and arranged logically, the initial impression created by such packed displays is of a relatively undifferentiated mass and sometimes the objects *are* in an undifferentiated mass. This non-classificatory and non-mimetic approach to display means that only a connoisseur of cuckoo clocks, paperweights, or gramophones could confidently navigate the displays to pick out exceptional versions of the type. As I have noted, curators often guide visitors around exhibitions and help them make sense of the gathered artefacts, but not all museums provide a guide. In these circumstances visitors might leave feeling baffled and frustrated, but rather than attempting to 'read' the display, it is also possible to view such exhibitions as single entities and experience them as a whole.

For instance, the Cornice Museum of Ornamental Plasterwork in Peebles, a small town on the Scottish borders contains some 3,000 plaster originals (the models used to make moulds) all of which have been produced by the family business Grandison & Sons. The museum is adjacent to the plaster workshops and the door opens from a working yard onto a series of small rooms that are completely bedecked with grey–white ornaments. Sections of Victorian cornicing have been fixed to the ceiling so that the plaster fruit and flowers hang downwards like dusty grapes from an overhead trellis (Figure 6.12). The walls are lined with panels, elaborate rosettes, and sconces that are covered with myriad forms so that men with bows and arrows collide with cavorting cherubs, and large sections of classical friezes, urns, and pediments lean against shelves that are already filled with death masks of women and laurel-wreathed busts of elderly patriarchs. A hand clutching a letter is propped on top of a large oval slab covered by an abstract vine and the torso of a sphinx rests on a large plinth, its head missing. Every available space is full of plaster models, all gleaming slightly in the light that filters down from two small skylights.

FIGURE 6.12 *Cornice Museum of Ornamental Plasterwork, Peebles, Scottish Borders.*

The types of plaster casts on display are familiar to anyone who has ever set foot in an eighteenth- or nineteenth-century stately home or public buildings, but packed together and displayed thus, curious juxtapositions provide the fuel for imagined narratives and I was reminded of the story of the Medusa whose glance turned everything to stone. Extending across the floors, up the walls, and over the ceiling, the plasterwork also coheres into a decorative shell that encases the room. Barely skimming one's head, the thousands of exhibits act as a buffer to the outside world and there is a sense of being separated off from ordinary life, immersed in an unusual and even enchanted environment.

Packed exhibitions of undifferentiated objects can be highly immersive and this effect is further intensified when micromuseums put their exhibits into action. At the Museum of Power a single bench is placed opposite the Lee Howl Water Pump, which is started up on a daily basis, and although I am not particularly interested in diesel engines I found it oddly hypnotic, even meditative, to sit, watch, and listen to the huge iron wheel on this massive twin cylinder engine. Later, I commented on the fact to Paul Evans, the owner, who laughed and said that its beat was exactly the speed of a resting human heart. He had deliberately set the machine at this relatively slow rate in order to induce a sense of calm in the visitors.[22] The Cotton Mechanical Music Museum has less subliminal effects. Shortly after opening the doors to the public, volunteers dim the overhead lighting and play each of the

fairground organs in turn. 'I'm getting married in the morning', 'Wouldn't it be lovely', and 'Could have danced all night' are pumped out of the pipes at a considerable volume, while the miniature band-leaders conduct and the mechanical girls that decorate the front of the machine twirl among the coloured spotlights. Small children who are visiting keep their eyes intently fixed on the spectacle and dance in time to the music. After all the machines have been played, the lights over the stage at the far end of the hall are raised, and somewhat incredibly, a cinema wurlitzer emerges from the floor. The tail-coated organist begins by playing along to a short silent film titled 'Helen is Here to Help' that is projected overhead and then shifts into a composition that represents a boat journeying through a storm. It starts with the sound of bagpipes, changes to a theremin and then transforms into a sailors' hymn which gets louder and louder. Throughout the recital the cinema screen shows giant footage of the organist's feet and hands, which are moving at great speed and with hyper-mobile dexterity. Finally, with the tones of a church organ ringing out, the wurlitzer descends back into its pit.

As at the Cornice Museum of Ornamental Plasterwork, the space of the Mechanical Music Museum is enclosed by objects, and with no windows, there is a sense of having stepped out of the ordinary run of daily life into a separate sphere. Then, when the sound builds and the lights shine, the museum takes on the immersive other-worldly character of the cinema and fairground. This quality is shared by some major museums, such as the Pitt Rivers Museum in Oxford, the Enlightenment Gallery in the British Museum, and the John Soane Museum, which is also in London. These venues are similarly filled with large quantities of objects, and while there is some guiding information, the visual spectacle of so many things supersedes any textual direction. At the same time there are also obvious differences. The objects on display in these major institutions (while the John Soane Museum is relatively small it has national status) are of higher value, they vary in type to greater degree than those shown in micromuseums, they are much more carefully disposed, and the apparatus of display is more professional.

There are also key differences in the character of this other world or alternate environment. When I visit the Pitt Rivers Museum, I do not feel as if I am being imaginatively transported to the places from which those objects derived and nor does the British Museum Enlightenment Gallery conjure a connection with Hans Sloane whose collection forms the basis for the display. Rather, these institutions provoke wonder in their own right. As a visitor, one is struck by the display itself. The display at the John Soane Museum is equally enthralling but it also evokes Soane as the architect and resident of the building, and as the author of the display. Something similar happens in micromuseums where the immersive environment is tangibly connected to someone or to something in particular. Stepping into the Cornice Museum I was aware that the packed space was the physical embodiment of 125 years of commissions, the material output of four generations of Grandison men and their employees (Figure 6.13). The thousands of hours spent slaking

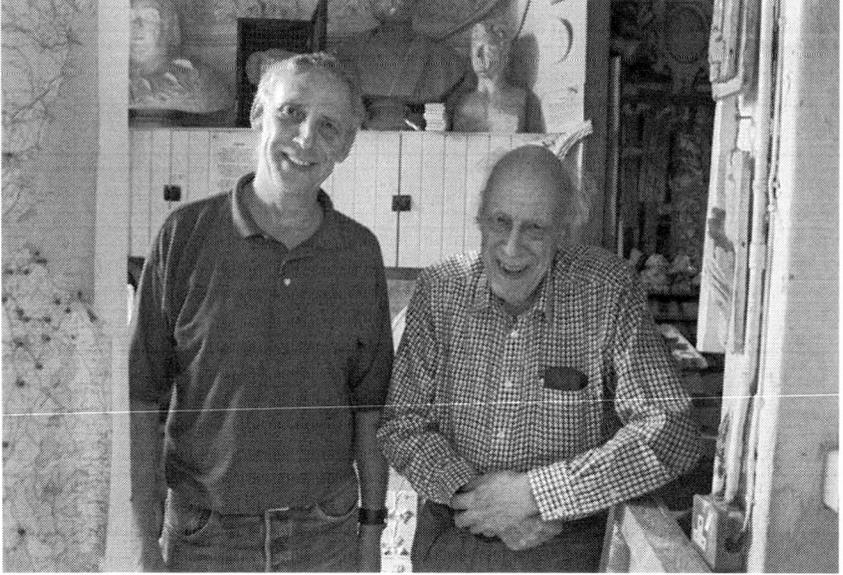

FIGURE 6.13 *John and Leonard Grandison, owners of the Cornice Museum of Ornamental Plasterwork.*

lime and beating the putty, carving models, creating moulds, casting and drying the plasterwork has slowly produced this mass of ornament. That expenditure of time has taken on a decorative form and as production continues over subsequent decades, the carapace will become thicker and the available space will narrow. Surrounded by these accumulated exhibits one sees and feels a history of the family's skilled labour and like many micromuseums it is clear that this place is also somebody's place.

Artefacts in (and outside of) micromuseums

The last category under consideration concerns the objects owned by micromuseums. Unlike major museums, micromuseums have objects that pre-date the twentieth century or which are of significant economic value, although there are exceptions such as the Clockmakers' Museum in London Guildhall which has a stunning array of watches and clocks dating from between 1600 and 1845, and Cuckooland in Cheshire where there is a world-leading collection of Black Forest cuckoo clocks. There are also a few micromuseums that have artefacts that were once extremely expensive but became redundant and hence less valuable. The massive diesel generators on show at Museum of Power or the tanks at Cobbaton Combat Museum in Devon would be a case in point (Figure 6.14). More commonly, however,

FIGURE 6.14 *Cobbaton Combat Museum, Devon.*

the collections tend towards the ordinary, and often comprise of things that have been mass-produced and are available in multiples. The rows of plastic napkin rings on display at the Bakelite Museum would provide a case in point, as would the serried Roberts radios at the Vintage Wireless Museum and the exhibits at the Lawnmower Museum in Southport. Other micromuseums have collections of objects that are handmade, sometimes beautifully so, but which are not generally considered to be works of art, such as the painted caravans at the Gordon Boswell Romany Museum (Figure 6.15), or the elaborately knotted maritime fenders at the Museum of Knots and Sailors' Ropework (Figure 6.16). In some cases, including the Peter Coke Shell Gallery in Cromer and the Museum of Straw and Basketwork in Buck Brigg, the owner or their peers have made the vast majority of items on display.

While these relatively inexpensive, modern objects contrast with the works of art on show at the National Gallery or the rare and valuable artefacts in, say, the Renaissance galleries at the Victoria and Albert Museum, it is important to remember that major museums also collect mass produced, craft, and manufactured objects, and that many of the artefacts shown in micromuseums have their counterparts in their larger institutions. Some of the tanks on exhibition at the Cobbaton Combat Museum can also be seen at the Imperial War Museum London, the same model of lawnmower is in the collection at the London Science Museum and at Southport Lawnmower Museum, and there are crossovers between

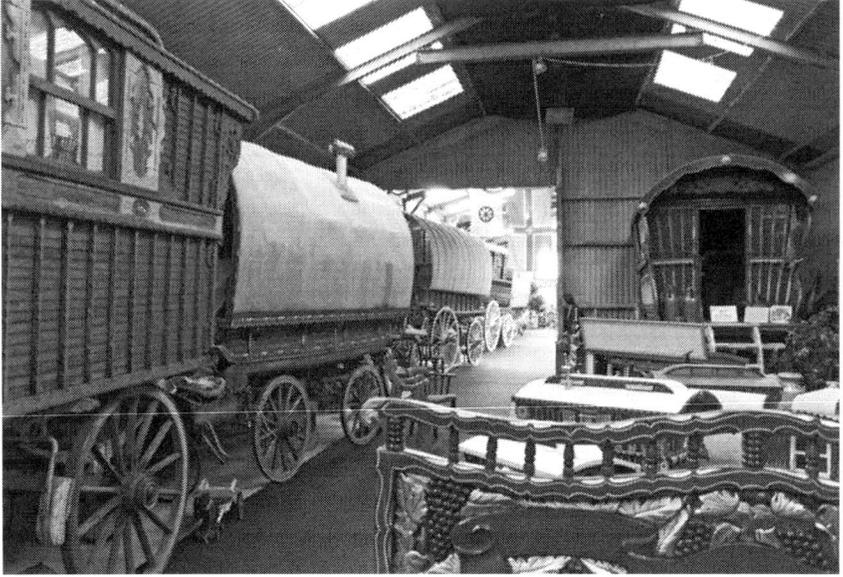

FIGURE 6.15 *Romany caravans, Gordon Boswell Romany Museum.*

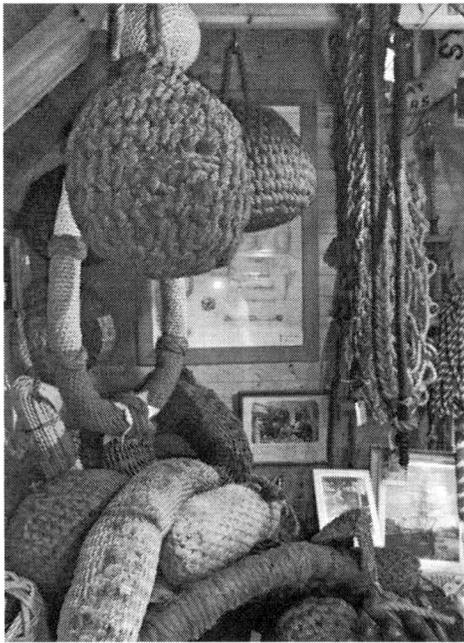

FIGURE 6.16 *Rope fenders, the Museum of Knots and Sailors' Ropework, Ipswich, Suffolk.*

the collection at the Museum of Science and Industry in Manchester and those at the Museum of Power. There are also samples of rope-work in the National Maritime Museum, just as there are at the Knot Museum, while the Geffrye Museum (which has non-national status) and the Vintage Wireless Museum (which does not) both have early television sets, and there are comparable overlaps elsewhere.

One crucial difference, however, is that the Science Museum does not show multiple lawnmowers and the National Maritime Museum does not have a room full of ropework. Another point of divergence is that in major museums these single objects are placed within a clear educative narrative, which is not always the case in micromuseums, and their presentational techniques work to create different kinds of objects. The lawnmowers on display in the Lawnmower Museum may be materially similar to that on show at the London Science Museum but they are not the same interpretative objects. Those at the latter venue testify to British achievements in technological development and the displays make objects into lessons whereas those on exhibition at Southport are more closely related to the repair shop downstairs and to local lawnmower races.

There are also some artefacts on show in micromuseums that have no obvious counterparts in a major museum or where it is difficult to imagine any circumstances in which such things could be exhibited. So far as I know, there are no Romany caravans on display in a major museum. Given that travellers are not generally represented and that there is almost no coverage of English folk art in major museums, it is doubtful that the painted vehicles will be shown soon. The lack of attention paid to English folk culture also means that many of the items on show in the Peter Coke Shell gallery (which shows fabulously baroque sculptures made of shells), the Museum of Straw and Basketwork, or the Museum of Witchcraft would be unlikely to find a place in the established museum sector, although even if there was such a venue some of the artefacts from the Museum of Witchcraft's collection would be too contentious to show. Professional museum curators might have concerns about the ethics of showing the human remains on display at that venue, particularly the skull that is lodged inside a bible box and was apparently unearthed from a graveyard during the last war. They would also probably avoid three communion wafers that are inscribed with the words *Pater + pax + Adonai + filius vita + sabbaoths + spiritus sanctus + tetragrammaton* and which were intended to be eaten as a charm against ague (Figure 6.17) because, while the spell clearly seeks to capitalize on the power of a Christian god, the act of writing on a communion wafer would be deeply shocking to many practicing Catholics.

Contentious objects are also found elsewhere and perhaps most notably in Irish republican museums. The Ulster Museum, which is one of the national museums of Northern Ireland, recently decided not to show any artefacts relating to the Troubles and although the National Museum of Ireland does have a case of objects relating to that period, they all pertain

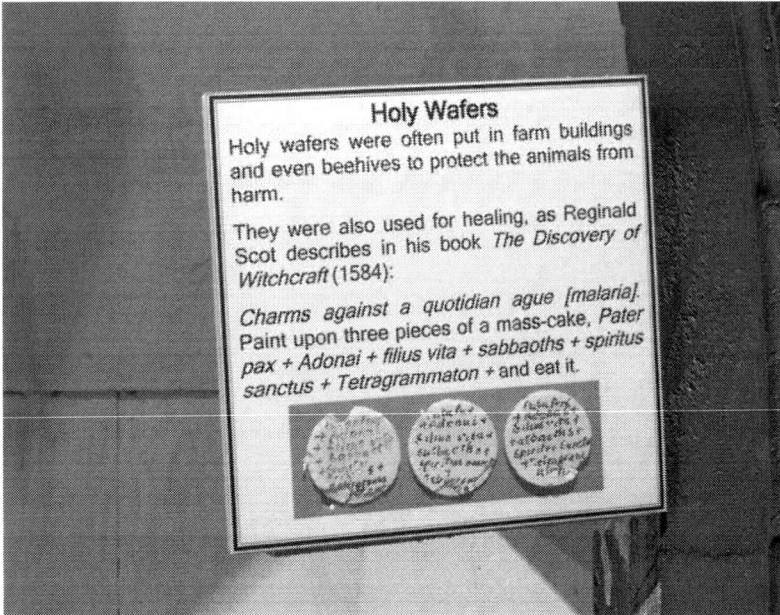

FIGURE 6.17 *Spell for ague written on communion wafers, the Museum of Witchcraft, Boscastle, Cornwall.*

to the security forces. Exhibiting items that relate to armed insurgency or to the republican experience could be perceived as validating that campaign and would be highly inflammatory. It is therefore almost unimaginable that a major museum (at least in the UK or Republic of Ireland) would show the model of the 1973 bomb attack on Lurgan police station that is on display at Lurgan History Museum or the badge reading 'Strip Search the Queen!' from the Irish Republican History Museum (Figure 6.18). The matchstick windmills inset with Irish flags, that were made by men who are currently serving time for terrorist offences and which are on exhibition in that venue and at the Irish Republican History Museum would similarly remain off limits.

Micromuseums differ from major museums in terms of what they collect and show. Even more strikingly, they differ with respect to the artefacts' permanent status as a museum object. As I discussed in Chapter Two, objects have a life cycle. They may be prized and employed as new commodities, re-used or re-cycled in various capacities, and finally become waste. Major museums generally seek to arrest this cycle by removing objects from systems of commodity exchange and to preserve them by means of careful conservation and collections management. Granted, major museums do put some objects from their collections into action. The Manchester Museum of Science and Industry 'Power Hall' contains working engines that were

FIGURE 6.18 *Pro-republican badges, the Irish Republican History Museum.*

used in mills. The difference is that the machines are now run from the electricity mains rather than using diesel or oil, as was originally the case, while the steam train that runs outside only covers a small distance and does not serve to transport anyone or anything from one place to another. Here, then, as in other major institutions, there are partial demonstrations of how the objects were once put into action and, notably, these objects are not used as such. They do not produce power to run looms for cotton or deliver travellers to their destinations.

In exceptional circumstances, objects in major museums are actively employed in ways that are comparable to how they were used before they were acquired. The British Museum gave permission to Greek Orthodox clergy to use an icon from their collection in a special service, and other major institutions sometimes allow religious communities to attend to or use sacred items held within their precincts. In these instances, dispensation for use is linked to the sacred character of the object in question; the faith-group either believe the object to be unique and essential to particular ceremonies or to embody divine power. Such dispensations do not usually extend to other types of objects.

Micromuseums also demonstrate objects in their collections, although unlike major museums, they tend to use the original power sources, for instance, the generators at the Museum of Power are run on oil and diesel. In addition, objects of all kinds are actively used in the manner for which

they were originally intended. Sometimes these are employed in situ, as is the case at the Museum of Witchcraft where visiting practitioners consult the scrying mirror that belonged to the founder Cecil Williamson. More often, objects are removed from exhibition and are put back into service. Once a year, the garden gramophone on display at the Vintage Wireless Museum is taken outside and played at the venue's fund-raising garden party and, until recently, Gordon Boswell, owner of the Gordon Boswell Romany Museum, would drive one of the traditional caravans to the annual Appleby Horse fair in Cumbria.

At the Vintage Wireless Museum and the Gordon Boswell Museum, the objects are taken off display and put into use on an occasional basis. That process occurs in a more sustained fashion at the Citadel of Miniatures, which is a museum of the models used in the table-top fantasy war game Warhammer World. The museum, which resembles an exquisite if slightly kitsch jeweller's shop from the 1980s, is lined with glass and metal cases backed with mirrors and illuminated with inset lights. Inside, thousands of tiny figurines are arranged onto transparent plinths. Some of them resemble armoured humans mounted on pimped-out motorbikes and flanked with mini-banners, while others are fantastical creatures or aliens. In the centre of the room are a series of miniature sets including one of a ruined castle populated by similarly alien creatures. When I visited two of the large cases were empty.

The museum is located in the Warhammer World centre and as the exhibition is unequivocally aimed at dedicated enthusiasts there are no wall texts, labels, or other introductory explanations. Having no such experience of the game I was nonplussed by the exhibits and by the empty cases and asked a fellow visitor for some guidance. He introduced himself as Ben Greaves, a teacher, and explained that the plastic miniatures are bought in a frame with individual parts that can be combined to make models with different weapons or in various poses.[23] Almost all the models on display had been produced by the Games Workshop in-house team, 'Eavy Metal, who are are considered the best artists in this genre. 'The models are all very good', Ben said, 'but some are phenomenal', and he pointed out the banners of battle standards and paintings on the side of a tank, saying that they had been painted freehand (i.e., the pattern is not dictated by the shape of the model).

Ben explained that the models were well known among gamers because they were regularly featured in *White Dwarf*, the Warhammer magazine, and said 'I've seen pictures of some of the miniatures and it's fantastic to see them for real'. Fans also like to see these key pieces in action and the miniatures on show in the museums are regularly removed so that they can be used in massive demonstration battles staged by the company. Looking at the empty cases, Ben said 'you'd be disappointed if you'd come to see the Blood Angels because they're all missing' but Joe Cox, one of the shop assistants whom I also spoke to, remarked that the Citadel 'is

a living museum' by which he meant things were taken out, used, and put back. Using the miniatures inevitably leaves them open to wear from handling grease, sweat, and abrasion. Every now and again items are damaged, but nonetheless Games Workshop and the gamers think it more important to see the figures in action than to preserve them in perpetuity. The miniatures are not kept suspended in time but are used by a linked community.

At the Vintage Wireless Museum, Gordon Boswell Museum, and Citadel of Miniatures the exhibits continue to be used for the purposes for which they were intended. The garden gramophone is played in the garden, the caravan is driven to a horse fair, and the models are used in war-games. In other instances the exhibits are removed from exhibition and put into new and different circuits of use. For example, the vehicles on display at the Cobbaton Combat Museum are hired out to film companies and the curator drives them on various tours organized by the Military Vehicles Tour group. Over the last decade he has taken a Ford Laat (which is a tractor for light anti-aircraft guns), a water supply tank or 'Hippo', and a Willys MB Jeep to various anniversaries of the D-Day landings in Normandy, covering a distance of some thousand miles on each trip. These outings have a memorial function and in that sense there is a link between the tours and museums as keepers of memory, but the gatherings are also opportunities for collectors to meet and mutually show off their wares. The vehicles have become status symbols and objects of enthusiasts' attention. Thus, at Cobbaton Combat Museum, as elsewhere, the tanks and jeeps are reinvented. Instead of being exhibits and instead of being returned to battle, they become props for film sets and collectibles for military vehicle enthusiasts. These objects have not been stilled but sporadically acquire new roles and enter into a further stage of their life cycles before returning to the museums.[24]

Continuing to use exhibits maintains or furthers their ties with the associated communities. Putting the generators into action at the Museum of Power requires the help of several experienced engineers. Playing the garden gramophone at the Vintage Wireless Parties creates the social conditions wherein people continue to meet. Taking the horse-drawn caravan to Appleby keeps Gordon Boswell in contact with kin and with fellow traders. Using the most skilfully produced miniatures in demonstration war-games helps attract current and potential players and it raises the profiles of the artists who made them. Driving military vehicles from Cobbaton Combat Museum to memorial ceremonies builds links between veterans, while taking them to re-enactments contributes towards the success of those events. When the exhibits are used for commercial purposes and re-enter the circuits of capital, their commercial exploitation helps museums survive or even flourish and hence helps maintain the families or groups that run or manage with those venues. Thus, the exhibits in micromuseums pertain to groups and practices that are rarely represented in major institutions, while

the use of these exhibits means that they remain part of the associated communities' lived experience and have a role in securing those groups as communities.

Other worlds

In his article 'Of Other Spaces: Utopias and heterotopias' Michel Foucault writes that heterotopias are spaces that lie outside all places and are simultaneously localizable.[25] He identifies their various forms, including museums, which he considers heterotopias of time that aim at enclosing all eras, forms, and styles within a single place and simultaneously keeping that place outside of time, removed from the wear of the years. The scope and breadth of the institutions that Foucault outlines suggest that he has universal museums in mind because, in contrast, micromuseums are not always concerned with the preservation of histories, and if they are, they tend to concentrate on particular junctures and events rather than eras.[26] Nor do they necessarily keep the artefacts removed from the wear of the years. On the contrary, the objects in some micromuseums are left to gather dust, and in others they are actively used.

Following Foucault's argument, some micromuseums are a type of heterotopia in that they create a real space that is simultaneously removed from ordinary cultural spaces. When the subject of the collection is disassociated from its location and especially when there is no curator available to situate the exhibition in a context, micromuseums provide a world apart. This rather uncanny quality is intensified when the visitor is surrounded by packed displays that prohibit any narrative construction. Like the theatre, where radically alternate spaces appear upon the stage, some micromuseums juxtapose incompatible zones: the graveyard and shells, the industrial barn, and fairground organs.

Micromuseums that are connected to place or a group function differently to those that are out of step with their surroundings. Neither the Dad's Army Museum nor the Irish Republican History Museum could be said to lie outside of all places. Nonetheless, when the museum is about the local area or is linked to a particular community (or both) it can provide visitors with a point of entry to the concerns of that place or group. Alternatively, in micromuseums that are run by families or individuals, visitors are unequivocally presented with the subject from their perspective. Most micromuseums are a view from somewhere in particular and in entering those venues visitors are invited to see the world from the perspective of an engineer, a bus driver, an Irish republican, a settled Romany traveller or an extra from Dad's Army. In that sense then, micromuseums have a rather paradoxical character. They are by someone, about something, of somewhere, and precisely because they are so distinct, so situated, they

provide a view over unfamiliar terrain. Indeed many micromuseums are both entirely located and utterly otherworldly. The Cornice Museum of Ornamental Plasterwork is like a surreal subterranean grotto detached from the Peebles High Street outside and also is distinctly related to the Grandison family business.

When I conducted the initial research for this project, the staff in micromuseums repeatedly asked me 'Why are you here?' and I'd explain that I was writing a book. Now I can answer that question a little more specifically. Unlike major museums, micromuseums can be and often are dynamic environments. Organs play, engines rumble, clocks tick, and information is exchanged verbally. Curators tell me and other visitors about the objects on display, but they also banter, reminisce, gossip, tell jokes, recount stories, proffer opinions, and engage in conversation. We respond in kind and the dialogue tacks and turns accordingly. In these spaces there are no clear boundaries between subjective and objective information and there is little distinction between personal and professional exchange, or between staff and visitors. The net result is that learning and pleasure emerge in the interactions between staff, visitors, and objects, often with surprising or moving or amusing or fascinating results. And, perhaps above all, I am given glimpses into particular worlds that I would never otherwise encounter. Irrespective of whether I am drinking tea with Manchester bus drivers, hearing about spell casting from the witches in Boscastle, being told about the legacy of the Troubles by Irish republicans, or being shown the quick-lime pit at the Grandison family's plasterworks, I see and learn something of that place and those people's concerns and I can ask questions of them. Micromuseums provide a radically particular view on something, somewhere, or someone, and for a few hours at least I am shown the world from the perspective of a bus driver, a witch, an Irish republican, or a specialist plasterer. That's why I'm there.

NOTES

Introduction

1 At the end of the 1960s the total number of museums in the UK was approximately 900. In 1988 it was estimated at 2,500. Museums & Galleries Commission, 'Report 1987–88: Specially Featuring Independent Museums' (London: Museums & Galleries Commission, 1988), 10.

2 Kenneth Hudson, 'The Museum Refuses to Stand Still', in *Museum Studies: An Anthology of Contexts*, ed. Bettina Messias Carbonell (Malden, MA and Oxford: Blackwell, 2004), 90. Other commentators concurred on their size. Denford et al. noted that 'they were small by any standards'. Geoffrey T. Denford, Elizabeth R. Lewis, and David J. Viner, 'Small Museums', in *Manual of Curatorship: A Guide to Museum Practice*, ed. John M. A. Thompson (London: Butterworths, 1984), 92. Victor Middleton noted that during the 1980s and early-to-mid-1990s, the major growth area was in venues that attracted less than 10,000 visitors a year. Victor T. C. Middleton, *New Visions for Museums in the 21st Century* (Chichester: Association of Independent Museums [AIM], 1998). There are no available statistics on how many of small independent museums concentrate on single-subjects although Christine Redington's *Guide to the Small Museums of Britain*, which only lists single-subject independent venues, has over 600 entries. Christine Redington, *A Guide to the Small Museums of Britain* (London; New York: I. B. Tauris, 2002).

3 Hudson, 'The Museum Refuses to Stand Still', 90.

4 Texts that concentrated on large institutions of the period include: Bob West, 'The Making of the English Working Past: A Critical View of the Ironbridge Gorge Museum', in *The Museum Time-Machine: Putting Cultures on Display*, ed. Robert Lumley (London; New York: Routledge, 1988). Tony Bennett, 'Museums and "the People"', in *The Museum Time-Machine: Putting Cultures on Display*, ed. Robert Lumley (London; New York: Routledge, 1988). For a full discussion of how the 1980s and 1990s heritage debates positioned the new museums, see: Fiona Candlin, 'Independent Museums, Heritage, and the Shape of Museum Studies', *Museums and Society* 10, no. 1 (2012).

5 Robert Hewison, *The Heritage Industry: Britain in a Climate of Decline*, A Methuen Paperback (London: Methuen London, 1987), 9; Neal Ascherson, 'Why "Heritage" Is Right-Wing', *Observer*, 8 November 1987.

6 Raphael Samuel, *Theatres of Memory* (London: Verso, 1999), 3.

7 For discussions on small independent community museums in Africa and Latin America, see contributions to Ivan Karp, *Museum Frictions: Public Cultures/Global Transformations* (Durham, NC; London: Duke University Press, 2006). For discussions of small independent single-subject museums in the west, see: Elizabeth M. Crooke, *Museums and Community: Ideas, Issues and Challenges*, Museum Meanings (London; New York: Routledge, 2007); Sheila Watson, 'History Museums, Community Identities and a Sense of Place', in *Museum Revolutions: How Museums Change and Are Changed*, ed. Simon J. Knell, Suzanne Macleod, and Sheila E. R. Watson (London: Routledge, 2007).

8 For notable exceptions to the orthodoxy of addressing micromuseums in relation to themes of community, see: Simon Goldhill, *Freud's Couch, Scott's Buttocks, Bronte's Grave* (Chicago; London: University of Chicago Press, 2011). Sharon Macdonald, 'On "Old Things": The Fetishization of Past Everyday Life', in *Cultural Heritage: Critical Concepts in Media and Cultural Studies*, ed. Laurajane Smith (London: Routledge, 2007); Ralph Rugoff, *Circus Americanus* (London; New York: Verso, 1995); Silke Arnold-de Simine, 'The Ghosts of Spitalfields: 18 Folgate Street and 19 Princelet Street', in *Mediating Memory in the Museum. Empathy, Trauma, Nostalgia* (Basingstoke: Palgrave Macmillan, 2013); Andrea Witcomb, 'The Politics and Poetics of Contemporary Exhibition Making: Towards an Ethical Engagement with the Past', in *Hot Topics, Public Culture, Museums*, ed. Fiona Cameron and Lynda Kelly (Newcastle: Cambridge Scholars, 2010). To my knowledge, the only other book on micromuseums in particular is Tammy Stone-Gordon, *Private History in Public: Exhibition and the Settings of Everyday Life* (Lanham, MD: AltaMira Press, 2010).

9 The larger Jewish Museum is in Camden, London, the other is in Ancoats, Manchester. The Gordon Boswell Romany Museum is in Spalding, Lincolnshire, and the Romany Museum is in Marden, Kent, although this closed, perhaps temporarily, in 2014.

10 Samuel, *Theatres of Memory*, 147; Fath Davis Ruffins, 'Revisiting the Old Plantation: Reparations, Reconciliation, and Museumizing American Slavery', in *Museum Frictions: Public Cultures/Global Transformations*, ed. Ivan Karp (Durham, NC; London: Duke University Press, 2006), 399.

11 Macdonald, 'On "Old Things": The Fetishization of Past Everyday Life', 271.

12 'Salary Guidelines in Museum', (London: Museums Association, 2009), 11.

13 'Survey of Visitors to Museums' Web Space and Physical Space' (Canadian Heritage Information Network, 2005); Appendix B. [CHIN classify large museums as having fifty or more employees and medium as three to forty-nine employees]. Arminta Neal, *Help! For the Small Museum; a Handbook of Exhibit Ideas and Methods* (Boulder, CO: Pruett, 1969), ix.

14 Association of Independent Museums, 'The Economic Value of the Independent Museum Sector', Association of Independent Museums, http://www.aim-museums.co.uk/pages/pg-18-aim-economic-impact-paper/. Tables 2.4 and 4.6 http://www.aim-museums.co.uk/downloads/d333555f-da49–11e1-bdfc-001999b209eb.pdf. For the purposes of membership AIM understand a small museum to have up to 20,000 visitors per annum. See http://www.aim-museums.co.uk/content/membership_costs/ (accessed 8 December 2013).

15 'Small Museums Committee and Affinity Group', American Association for State and Local History, http://www.aaslh.org/SmallMuseums.

16 Denford, Lewis, and Viner, 'Small Museums', 91. Anne Ambourouè Avaro and with the contribution of Gaël de Guichen and Alain Godonou, 'A Guide for Documentation Work for Museums in Developing Countries' (UNESCO, ICCROM, and EPA, 2009), 1.

17 Steven Conn, *Do Museums Still Need Objects?* (Philadelphia: University of Pennsylvania Press, 2010), 22.

18 The Museum of Methodism was substantially refurbished in 2013.

19 Neil Cossons, 'Independent Museums', in *Manual of Curatorship: A Guide to Museum Practice*, ed. John M. A. Thompson (London: Butterworths, 1984), 84.

20 Ibid.

21 Commission, 'Report 1987–88: Specially Featuring Independent Museums', 12.

22 'Policy in Progress', *Museums Association Journal* (1998), 38.

23 The question of what constitutes a museum, particularly in relation to independent organizations is usefully thematized in Gretchen Jennings, 'Is It a Museum? Does It Matter: Special Issue', National Association for Museum Exhibition, http://name-aam.org/resources/exhibitionist/back-issues-and-online-archive.

24 Alison Coles, Bethan Hurst, and Peter Windsor, 'Museum Focus: Facts and Figures on Museums in the UK', (London: Museums and Galleries Commission, 1998), 7.

25 For an example of the category of 'private' museums being included in official publications, see: Helen Greenwood and Sally Maynard, 'Digest of Statistics', Museums Libraries Archives Council, http://www.lboro.ac.uk/departments/dis/lisu/downloads/Digest06.pdf.

26 For the history of Grandison & Sons, see: Leonard S. Grandison, *L. Grandison & Sons: 100 Years on 1886–1986* (Peebles: [self-published], 1987).

27 Conversation with Gerry and Eilean Wells, the Vintage Wireless Museum, London, 16 August 2012.

28 Besides, as Eugene Dillenberg has pointed out, the visiting public do not particularly care about the legal status of the venues they visit. Eugene Dillenburg, 'What, If Anything, Is a Museum?', 9, http://name-aam.org/resources/exhibitionist/back-issues-and-online-archive.

29 For example, Jyotindra Jain, 'Museum and Museum-Like Structures: The Politics of Exhibition and Nationalism in India', name-aam.org/resources/exhibitionist/back-issues-and-online-archive. Micromuseums with no charitable status are referred to as 'organizations that call themselves museums' in Museums Libraries Archives Wales, 'A Museums Strategy for Wales' (Cardiff: Welsh Assembly Government, 2010), 9.

30 'Code of Ethics for Museums: Ethical Principles for All Those Who Work for or Govern Museums in the U.K.' (London: Museums Association, 2008), 12.

31 For a discussion of these points in a broader heritage context, see: Laurajane Smith, 'Class, Heritage and the Negotiations of Place', in *Missing Out on*

Heritage: Socio-Economic Status and Heritage Participation (LSE, London: English Heritage, 2009).

32 Samuel, *Theatres of Memory*, 27.

33 Institutional biographies include Anthony Burton, *Vision and Accident: The Story of the Victoria and Albert Museum* (London: V & A Publications, 1999); Jonathan Conlin, *The Nation's Mantelpiece: A History of the National Gallery* (London: Pallas Athene, 2006); David M. Wilson, *The British Museum: A History* (London: The British Museum Press, 2002).

34 Conversation with Peter MacAskill, The Giant Angus MacAskill Museum, Dunvegan, Skye, 11 September 2012; Conversation with Phillip Collins, Barometer World, Merton, Devon, 24 September 2010.

35 For a detailed discussion of the etymology of 'museology', see J. Lynne Teather, 'Museum Studies: Reflecting on Reflective Practice', *Museum Management and Curatorship* 10 (1991). For a response to Teather's paper, see: Suzanne MacLeod, 'Making Museum Studies: Training, Education, Research and Practice', *Museum Management and Curatorship* 19, no. 1 (2001).

36 Hunter Davies, *Behind the Scenes at the Museum of Baked Beans: My Search for Britain's Maddest Museums* (London: Virgin Books, 2010). See also: Saul Rubin, *Offbeat Museums: The Collections and Curators of America's Most Unusual Museums* (Santa Monica, CA: Santa Monica Press, 1997). For attributions of eccentricity and strangeness more generally, see: *Strangest Museums in Britain and the Best Worldwide* (England: Strangest Books, 2006). Also the Saturday *Guardian* column *Emma's Eccentric Britain*: Emma Kennedy, 'Teapot Island, Kent', http://www.guardian.co.uk/travel/2011/nov/18/teapot-island-museum-kent; 'Museum of Brands', http://www.guardian.co.uk/travel/series/emma-kennedys-eccentric-britain; 'Museum of Celebrity Leftovers', http://www.guardian.co.uk/travel/2012/may/18/museum-of-celebrity-leftovers-emma-kennedy.

37 In almost all cases I have used real names since blogs, TripAdvisor entries, and visitor books are all in the public sphere. Chapter 5 presented a slightly different case because the letters I draw upon were written to the owner of the British in India Museum, Henry Nelson, and since the venue is not held in public trust, the archive is private. Nonetheless, I decided to keep the writers' names, partly because it adds to the texture of the account, but mainly because the correspondents wanted to keep alive the memories of their families or of themselves. To substitute the names of others would run counter to this enterprise. Apart from one instance where their comments touched on sensitive material and I have anonymized the speaker, I have also used the real names of the visitors whom I met.

38 Clifford Geertz, *The Interpretation of Cultures: Selected Essays* (London: Hutchinson, 1975), 27.

39 Ibid., 28.

40 Rodney Harrison has pointed out that studies of museums have concentrated on the politics of representation and have under-played the affective quality of things. Rodney Harrison, Sarah Byrne, and Anne Clarke, *Reassembling the Collection: Ethnographic Museums and Indigenous Agency*, 1st ed. (Santa Fe: School for Advanced Research Press, 2013), 3.

41 Carlo Ginzburg, *The Cheese and the Worms : The Cosmos of a Sixteenth-Century Miller* (London: Routledge & Kegan Paul, 1980); Carlo Ginzburg, John Tedeschi, and Anne Tedeschi, 'Microhistory: Two or Three Things That I Know About It', *Critical Inquiry* 20, no. 1 (1993).

42 Richard D. Brown, 'Microhistory and the Post-Modern Challenge', *Journal of the Early Republic* 23, no. 1 (2003): 13.

43 Charles W. Joyner, *Shared Traditions : Southern History and Folk Culture* (Urbana: University of Illinois Press, 1999), 1.

44 Jane Gallop, *Anecdotal Theory* (Durham, NC; and London: Duke University Press, 2002), 2.

45 Ibid., 16.

46 While questions of affect are being taken into account within museum studies there is very little writing that uses or builds on the author's emotional responses or indeed those of others. A notable exception is provided by Andrea Witcomb, 'Remembering the Dead by Affecting the Living: The Case of a Miniature Model of Treblinka', in *Museum Materialities: Objects, Engagements, Interpretations*, ed. Sandra Dudley (New York: Routledge, 2010).

47 The notion of assemblages in this sense derives from the work of Bruno Latour. See, for example, Bruno Latour, *Reassembling the Social: An Introduction to Actor-Network-Theory* (Oxford: Oxford University Press, 2005); Bruno Latour and Peter Weibel, 'From Realpolitik to Dingpolitik or How to Make Things Public', in *Making Things Public: Atmospheres of Democracy* (Cambridge, MA; London: MIT, 2005).

48 In each case I sent a draft version of the chapter to the curator of the micromuseum that was the main focus of study. They pointed out errors and in some asked for changes to the text, which we then discussed and I responded to as agreed. I am very grateful for their help in this regard but take full responsibility for any mistakes or misapprehensions in the text.

Chapter 1

1 Tony Bennett, 'Difference and the Logic of Culture', in *Museum Frictions: Public Cultures/Global Transformations*, ed. Ivan Karp (Durham, NC; London: Duke University Press, 2006), 49. On claims that public sector museums do constitute a public sphere, see: Jennifer Barrett, *Museums and the Public Sphere* (Oxford: Wiley-Blackwell, 2011).

2 Jürgen Habermas, 'The Public Sphere: An Encyclopaedia Article', *New German Critique* 3 (1974): 49.

3 Nancy Fraser, 'Rethinking the Public Sphere: A Contribution to the Critique of Actually Existing Democracy', *Social Text*, no. 25/26 (1990): 57. See also, Craig J. Calhoun, *Habermas and the Public Sphere* (Cambridge, MA; London: MIT Press, 1992).

4 Hannah Arendt, *The Human Condition* (Chicago: Chicago University Press; Cambridge: Cambridge University Press, 1958).

5 On the idea of the museum as a forum, see: Duncan F. Cameron, 'The Museum, a Temple or the Forum', *Curator: The Museum Journal* 14, no. 1 (1971); Ivan Karp and Steven D. Lavine, 'Introduction: Museums and Multiculturalism', in *Exhibiting Cultures: The Poetics and Politics of Museum Display* (Washington; London: Smithsonian Institution Press, 1991).

6 Conversations with Sandra Coleman, Manager of The Valiant Soldier, Buckfastleigh, Devon, 27 September 2010 and 21 December 2012.

7 Information taken from wall panel in the reception block of The Valiant Soldier.

8 Conversation with Michael Davis, Chairman of the Andrew Logan Museum of sculpture, the Glasshouse, London, 8 August 2012.

9 Davis has most recently employed a business consultant to consider the viability of extending the Museum and creating a permanent space which can be used for workshops or events and which will provide some accommodation for visiting speakers and artists. This research is being supported with seed funding from GLASU, a rural development fund, and from Powys County Council.

10 Powys County Council, 'Powys: Portfolio Holder for Regeneration and Culture'. Vol 5, County Hall, Llandrindod, Powys (report), 2011.

11 Powys County Council, 'Aelod Portffolio Adfywio a Diwylliant', County Hall, http://www.powys.gov.uk/bul_2011–06–21phrc_cy.pdf?id=10810&L=1.

12 Museums, 'The Economic Value of the Independent Museum Sector', table 2.4.

13 Ibid. 48.8 per cent of the respondents were medium or large museums whereas only 22.4 per cent of members qualify as such.

14 MLA Yorkshire, *Mission, Models, Money: Exemplar Case Study* (Leeds: MLA Yorkshire, 2007), 6.

15 Ibid., 5. It is not clear how many museums in this sample have *any* staff.

16 Some of the world's major museums began in similar ways. Hans Sloane's private collection became one of the founding collections of the British Museum, the Tradescants' collection was foundational for the Ashmolean Museum in Oxford, and the Dulwich Picture Gallery opened with pictures collected by Edward Alleyn.

17 Museums, 'The Economic Value of the Independent Museum Sector', 5.7.

18 Arts Council England, 'Renaissance Major Grants Programme: Guidance for Applicants', Arts Council England http://www.artscouncil.org.uk/media/uploads/pdf/Renaissance_Major_Grants_guidance.pdf; Museums, 'The Economic Value of the Independent Museum Sector', 5.6.

19 Arts Council England, *Culture, Knowledge and Understanding: Great Museums and Libraries for Everyone* (London: Arts Council England, 2011), 20–21. My emphasis.

20 Museums, 'The Economic Value of the Independent Museum Sector', 5.2.

21 Arts Council England, 'Renaissance Major Grants Programme: Guidance for Applicants', 6; Arts Council England, 'Renaissance Support Fund: Information Document', Arts Council England, 4, http://www.artscouncil.org.uk/funding/apply-for-funding/renaissance/strategic-support-fund/.

22 Clore Duffield, 'Main Grants Programme', http://www.cloreduffield.org.uk/page_sub.php?id=73&parent=35.

23 Arts Council England, 'Accreditation Scheme', Arts Council England, http://www.artscouncil.org.uk/what-we-do/supporting-museums/accreditation-scheme/.

24 Museums Libraries Archives, *The Accreditation Scheme for Museums in the United Kingdom: Accreditation Standard* (London: Museums Libraries Archives, 2004), 15.

25 Museums Libraries Archives Wales, *A Museums Strategy for Wales* (Cardiff: Welsh Assembly Government, 2010), 2.2.2; Arts Council England, 'Renaissance Support Fund: Information Document', 4; Arts Council England, 'Renaissance Major Grants Programme: Guidance for Applicants', 5. In addition, foundations such as the Esmée Fairburn expect that a museum either has been accredited or is working towards accreditation. 'Esmee Fairburn Collections Fund: Application Guidance', Museums Association, 3.

26 Stephen Weil, 'From Being *About* Something to Being *for* Somebody: The Ongoing Transformation of the American Museum', *Daedalus* 128, no. 3 (1999): 230.

27 Conversation with Phillip Collins, Barometer World, Merton, Devon, 24 September 2010.

28 Conversation with Rosemary Rigby, Violet Szabo Museum, Herefordshire, 7 September 2010.

29 I first visited and the conversation reported below took place on 30 October 2010. Sadly, Gerry Wells died in December 2014.

30 Gerry has written about Red Bank in his autobiography. See Gerry Wells, *Obsession: A Life in Wireless* (London: The Vintage Wireless Museum, 2002).

31 For example, the introductory wall text in the first room of *Romantics*, at Tate Britain (from 9 August 2010 to 9 April 2012) noted that the 'display has been devised by curator David Blayney Brown'.

32 Conrad Lashley and Alison J. Morrison, *In Search of Hospitality: Theoretical Perspectives and Debates* (Oxford: Butterworth-Heinemann, 2000).

33 Fraser, 'Rethinking the Public Sphere: A Contribution to the Critique of Actually Existing Democracy', 74.

34 Markman Ellis, *Eighteenth-Century Coffee-House Culture*, 4 vols., vol. 1 (London: Pickering & Chatto, 2006), xvi; Fraser, 'Rethinking the Public Sphere: A Contribution to the Critique of Actually Existing Democracy', 67.

35 Some salons were arguably extensions of court life so they do not invariably count as public spheres in the Habermasian sense. For discussions of this topic, see: Dena Goodman, *The Republic of Letters: A Cultural History of the French Enlightenment* (Ithaca, NY; London: Cornell University Press, 1994); Jolanta T. Pekacz, *Conservative Tradition in Pre-Revolutionary France: Parisian Salon Women: Jolanta T. Pekacz* (New York: Peter Lang, 1999).

36 Arendt, *The Human Condition*, 52.

Chapter 2

1 There are numerous types of magic and of witchcraft including Dianic, Gardnerian, Ceremonial Magick (also known as high or ceremonial magic), Voodoo, and Wicca. Contemporary wayside witches commonly assume a continuous tradition of folk magic but this claim has been contested by Ronald Hutton, *The Triumph of the Moon: A History of Modern Pagan Witchcraft* (Oxford: Oxford University Press, 2000). For a discussion of witches' conceptions of their past which mentions the Boscastle Museum, see: Helen Cornish, 'Cunning Histories: Privileging Narratives in the Present', *History and Anthropology* 16, no. 3 (2005).

2 Although one protection spell on display at the Museum of Witchcraft apparently needs to be renewed once a year.

3 Arizona, 'Living Proof', in *The Museum of Witchcraft: A Magical History*, ed. Kerriann Godwin (Bodmin The Occult Art Company with The Friends of Boscastle Museum of Witchcraft, 2011). Judith Noble, 'Dark Light', in *The Museum of Witchcraft: A Magical History*, ed. Kerriann Godwin (Bodmin: Occult Book Company with Friends of the Boscastle Museum of Witchcraft).

4 Document 341, Museum of Witchcraft Archive.

5 Document 289, Museum of Witchcraft Archive.

6 Comments date from between 2009 and 2012.

7 Jenny Wei, 'Bringing a Museum Object to Life: The John Bull Locomotive', Smithsonian, http://blog.americanhistory.si.edu/osaycanyousee/2011/03/bringing-a-museum-object-to-life-the-john-bull-locomotive.html.

8 National Museum of Scotland, 'Preloaded: The Royal Museum Project', http://preloaded.com/work/national-museums-scotland/.

9 'Talking Objects', The British Museum, http://www.britishmuseum.org/channel/object_stories/talking_objects/video_swimming_reindeer.aspx.

10 Moira G. Simpson, *Making Representations: Museums in the Post-Colonial Era* (London: Routledge, 1996). See also Christina F. Kreps, *Liberating Culture: Cross-Cultural Perspectives on Museums, Curation, and Heritage Preservation* (London: Routledge, 2003).

11 Simpson, *Making Representations: Museums in the Post-Colonial Era*, 195.

12 Stephanie Berns, 'Religious and Secular Ways of Seeing Sacred Objects in the British Museum' (PhD, University of Kent, 2015).

13 H. Cheape, '"Charms against Witchcraft": Magic and Mischief in Museum Collections', in *Witchcraft and Belief in Early Modern Scotland*, ed. Julian Goodare, Lauren Martin, and Joyce Miller (Basingstoke; New York: Palgrave Macmillan, 2008).

14 Andrew McClellan, *Inventing the Louvre: Art, Politics, and the Origins of the Modern Museum in Eighteenth-Century Paris* (Cambridge: Cambridge University Press, 1994).

15 *The Art Museum from Boullée to Bilbao* (Berkeley; London: University of California Press, 2008).

16 M. Quatremère de Quincy and Henry Thomson, *The Destination of Works of Art and the Use to Which They Are Applied, Considered with Regard to Their Influence on the Genius and Taste of Artists, and the Sentiment of Amateurs.*, trans. Henry Thomson (London, 1821), 62.

17 Ibid., 64.

18 Ibid., 67.

19 Ibid., 59.

20 Ibid., 87.

21 Ibid., 87.

22 For other versions of this position, see: Hans-Georg Gadamer, *Truth and Method*, trans. Joel Weinsheimer and Donald G. Marshall. (London; New York: Continuum, 2004); Maurice Merleau-Ponty, 'Indirect Language and the Voices of Silence', in *The Merleau-Ponty Aesthetics Reader*, ed. G. A. Johnson (Evanston: Northwestern University Press, 1993); Paul Valéry, 'The Problem of Museums', in *Degas, Manet, Morisot* (New York: Pantheon Books, 1960); Andre Malraux, *The Voices of Silence*, trans. Stuart Gilbert (London: Secker & Warburg, 1954).

23 Theodor W. Adorno, 'Valery Proust Museum', in *Prisms* (Cambridge, MA: Neville Spearman, 1967), 185.

24 Daniel J. Sherman, 'Quatrèmere/Benjamin/Marx: Art Museums, Aura and Commodity Fetishism', in *Museum Culture: Histories, Discourses, Spectacles*, ed. Daniel J. Sherman and Irit Rogoff (London: Routledge, 1994). Philip Fisher, *Making and Effacing Art: Modern American Art in a Culture of Museums* (New York; Oxford: Oxford University Press, 1991), 12.

25 Ibid., 18.

26 Ibid., 13.

27 My account of the history of the Museum of Witchcraft is taken from Cecil Williamson, 'Witchcraft Museums – and What It Means to Own One', *Quest: A Quarterly Review of the Occult*, no. 28 (1976); Graham King, *The Museum of Witchcraft: 50 Years of Controversy* (Boscastle: Museum of Witchcraft 2002); *Museum Guide* (Boscastle: Museum of Witchcraft, 2007). An account which differs in some details is provided in Cecil Williamson, 'How the Witchcraft Museum Came into Being', in *The Museum of Witchcraft: A Magical History*, ed. Kerriann Godwin (Bodmin and King's Lynn: The Occult Art Company and The Friends of the Boscastle Museum of Witchcraft, 2012). A detailed account of Cecil Williamson's life and his contribution to modern witchcraft can be found in Steve Patterson, *Cecil Williamson Book of Witchcraft* (London: Troy Books, 2014).

28 Graham King retired in 2013. He has retained ownership of the buildings but at midnight on Halloween of that year oversight of the collection was transferred to Simon Costin, director of the National Museum of Folklore.

29 Uncatalogued correspondence, Museum of Witchcraft archives.

30 On continuum of belief and Celtic spirituality, see: Amy Hale, 'Whose Celtic Cornwall: The Ethnic Cornish Meet Celtic Spirituality', in *Celtic Geographies:*

Old Culture, New Times, ed. David Harvey (London: Routledge, 2002); John Lowerson, 'Celtic Tourism – Some Recent Magnets', *Cornish Studies* 2 (1994).

31 Amy Hale, 'The Land near the Dark Cornish Sea: The Development of Tintagel as a Celtic Pilgrimage Site', *Journal for the Academic Study of Magic*, no. 2 (2004).

32 Ibid., 207. Helen Cornish, 'Recreating Historical Knowledge and Contemporary Witchcraft in Southern England' (PhD thesis, Goldsmiths College, 2005).

33 2011 Conference Report, http://www.paganfederationdevonandcornwall. co.uk/pages/conferencereport2011.htm.

34 Arthur Mee, *Cornwall: England's Farthest South* ([S.l.]: [s.n.], 1937), 28.

35 Julian Vayne, who is an occultist and author of numerous publications on that subject, pointed out that the story of my journey featured three different types of archetype. The loss of telecommunications is a standard trope of contemporary horror films; the circling buzzards are akin to totemic animals; while early modern accounts of witchcraft often include stories of how the laws of nature have been reversed.

36 Christopher Tilley, *The Materiality of Stone: Explorations in Landscape Phenomenology* (Oxford: Berg, 2004), 219.

37 Conversation with Graham King, The Museum of Witchcraft, Boscastle, 23 April 2012.

38 Ibid., 24 September 2010.

39 Conversation with Sandra Coleman, The Valiant Soldier, Buckfastleigh, 27 September 2010.

40 On the use of mannequins, see: Mark B. Sandberg, *Living Pictures, Missing Persons: Mannequins, Museums, and Modernity* (Princeton, NJ; Oxford: Princeton University Press, 2003).

41 Macdonald, 'On "Old Things": The Fetishization of Past Everyday Life'.

42 This visit to Dartmoor Prison Museum took place on 4 October 2010.

43 David Rowe, *Boscastle: 16 August 2004 – the Day of the Flood* (St Agnes, Cornwall: Truran, 2011), 6; Noble, 'Dark Light', 31. When I joined the Friends Association for their Annual General Meeting held 8–10 November 2013, I observed some members consulting the tarot card reader and they told me that they did so on every visit.

44 Michel de Certeau, *The Practice of Everyday Life* (Berkeley: University of California Press, 1984).

Chapter 3

1 Eilean Hooper-Greenhill, *Museums and the Interpretation of Visual Culture* (London; New York: Routledge, 2000), xi.

2 Ibid., 151.

3 Ibid.

4 Ibid., 152.

5 On the advantages of multi-perspectival approaches to exhibition-making, see: Andrea Witcomb, *Re-Imagining the Museum: Beyond the Mausoleum* (London: Routledge, 2003); Helen Coxall, 'Open Minds: Inclusive Practices', in *Museum Philosophy for the Twenty-First Century*, ed. Hugh H. Genoways (Lanham, MD; Oxford: Altamira Press, 2006). James M. Bradburne, 'Visible Listening: Discussion, Debate and Governance in the Museum', in *Routledge Companion to Museum Ethics: Redefining Ethics for the Twenty-First Century Museum*, ed. Janet Marstine (London: Routledge, 2011).

6 Fiona Cameron, 'Contentiousness and Shifting Knowledge Paradigms: The Roles of History and Science Museums in Contemporary Societies', *Museum Management and Curatorship* 20 (2005): 230. For a much more sceptical assessment of multi-perspectival approaches, see: Michael M. Ames, 'Museology Interrupted', *Museum International* 57, no. 227 (2005).

7 In his insightful essay on unilateral displays held in micromuseums and community centres in Northern Ireland, Kris Brown uses the term 'sectional', which means pertaining to a section and is less pejorative than 'sectarian', whereas Elizabeth Crooke refers to 'community' museums in her discussion of venues in Northern Ireland. Since this book has a wider reach than sectional or sectarian museums I have chosen not to adopt this term. Equally, not all partisan micromuseums are community-based and not all community-based displays are partisan, which is why I have opted for 'partisan'. Kris Brown, 'Living with History: Conflict, Commemoration and Exhibitions in Northern Ireland – the Case of Sectional Displays', *Social History in Museums* 32 (2008); Elizabeth Crooke, 'The Politics of Community Heritage: Motivations, Authority and Control', *International Journal of Heritage Studies* 16, no. 1–2 (2010).

8 'An Exploration of the Connections among Museums, Community and Heritage', in *The Ashgate Research Companion to Heritage and Identity*, ed. B. J. Graham and Peter Howard (Aldershot: Ashgate, 2008), 422.

9 Ibid.

10 'The Politics of Community Heritage: Motivations, Authority and Control', 27.

11 'An Exploration of the Connections among Museums, Community and Heritage', 422, 420.

12 Henry McDonald, 'Irish Republicans Honour Heroes of the Troubles in a Garden-Shed Museum', http://www.guardian.co.uk/uk/2011/aug/30/irish-republicans-garden-shed-museum.

13 All quotations are from my conversation with Jim McIlmurray, Lurgan History Museum, Lurgan, 19 September 2012.

14 Martin Melaugh, 'Internment – Summary of Main Events', Conflict Archive on the Internet (CAIN), University of Ulster, http://cain.ulst.ac.uk/events/intern/sum.htm.

15 Ibid.

16 For media coverage of Martin Corey's case, see: Alan Erwin, 'Police Killer Martin Corey Remains in Jail as Bail Hearing Halted', http://www.

belfasttelegraph.co.uk/news/local-national/northern-ireland/police-killer-martin-corey-remains-in-jail-as-bail-ruling-halted-28770104.html; 'Time to Free Martin Corey', Socialist Worker, socialistworker.org/2012/08/14/time-to-free-martin-corey; In January 2014 Corey was released after serving almost four years in prison without charge. See 'Martin Corey Released from Prison', BBC News Northern Ireland, http://www.bbc.co.uk/news/uk-northern-ireland-25744626. During this period Jim McIlmurray was his official spokesperson. On extending the use of secret evidence in UK courts, see: 'For Their Eyes Only', *Liberty*, http://www.liberty-human-rights.org.uk/campaigns/for-their-eyes-only/for-their-eyes-only-faqs.php.

17 A loyalist paramilitary group claimed responsibility but a subsequent enquiry was critical of the RUC for failing to respond to death threats made against her and for legitimizing her as a target by publicly abusing and assaulting her in Portadown two years before her death. The official report also stated that they could not rule out the possibility that rogue individuals from the state security forces had been involved in her assassination. 'Rosemary Nelson Inquiry: "No Collusion" in Murder', BBC News Northern Ireland, http://www.bbc.co.uk/news/uk-northern-ireland-13500047.

18 The strike aimed at gaining political standing for the republican prisoners and was halted after William Whitelaw, then secretary of state granted them 'Special Category Status'. The sheet was signed after their release and was subsequently acquired by Jim.

19 In January 2013 the Ombudsman launched a new investigation launched into allegations that police officers may have contributed to the death of republican informer Denis Donaldson. See Vincent Kearney, 'Denis Donaldson: Ombudsmen Launches New Investigation,' BBC News Northern Ireland, http://www.bbc.co.uk/news/uk-northern-ireland-21260672.

20 In 1978, the European Court of Human Rights ruled that the men had been subjected to inhumane and degrading treatment, but not torture. However, the men and their lawyers have now said that documents, recently discovered in the public records office in London, could lead to that decision being reversed. See 'Former Internees Claim "New Evidence" of Army Torture', BBC Northern Ireland, http://www.bbc.co.uk/news/uk-northern-ireland-25137411. For a contemporaneous discussion of the case, the effects of torture in this instance, and the government enquiries, see: William Ristow and Tim Shallice, 'Taking the Hood Off British Torture', *New Scientist* (1976).

21 After a subsequent visit Jim clarified this point explaining that some republicans think that their participation in the Troubles should be documented by historians and that several did record their experiences as part of the Belfast Project that gathered oral testimonies about the period. The interviews were granted on the condition that they would not be released until after the participants' deaths and were held by Boston University, but the police requested the tapes and the American courts granted their release, which led to a number of arrests. Few are now willing to talk about their experiences. Email correspondence with Jim McIlmurray 31 May 2014. For details on the Boston project, see: http://www.bbc.co.uk/news/uk-northern-ireland-27238797.

22 Following Jane Gallop, Natalie Loveless notes that 'anecdote is fundamentally unverifiable' because if it were vetted and verified it would cease to be anecdotal. Here, the narrative has not been vetted as such but it has been verified. Natalie S. Loveless, 'Reading with Knots: On Jane Gallop's Anecdotal Theory', *Journal of the Jan Van Eyck Circle for Lacanian Ideology Critique* 4 (2011): 24.

23 'Republicans' are by definition 'nationalist', but the former term is often allied to groups who engage in armed struggle, whereas the latter is used to refer to those people who wish to see a united Ireland gained through peaceful methods. 'Unionists' want Northern Ireland to remain part of the UK while the term 'loyalist' usually refers to those who engaged in conflict to retain that status.

24 Joan Scott is concerned about the appeal to the evidence of personal experience because, within identity politics, it can become evidence for fact of difference rather than a way of exploring how difference is established. Arguably, Jim does not present his experience as 'the truth' but as his truth and he also recognizes that of others. In addition, the dialogic structure of this visit and of other visits to micromuseums does allow for the exploration of the construction of difference. Here, however, my main concern is not with the deconstruction of difference in relation to identity but with the manifestation of different ideological positions within exhibitions. Joan W. Scott, 'The Evidence of Experience', *Critical Enquiry* 17, no. 4 (1991).

25 Cameron, 'Contentiousness and Shifting Knowledge Paradigms: The Roles of History and Science Museums in Contemporary Societies', 213.

26 Donna Haraway, 'Situated Knowledges: The Science Question in Feminism and the Privilege of Partial Perspective', *Feminist Studies* 14, no. 3 (1988): 582.

27 Liz Curtis, *Ireland: The Propaganda War: The Media and the 'Battle for Hearts and Minds'* (London: Pluto, 1984), 10.

28 'A Catalogue of Censorship 1959–1993', in *War and Words: The Northern Ireland Media Reader*, ed. Bill Rolston and David Miller (Belfast: Beyond the Pale, 1996).

29 Anthony Buckley and Mary Kenney, 'Cultural Heritage in an Oasis of Calm: Divided Identities in a Museum in Ulster', in *Culture, Tourism and Development. The Case of Ireland*, ed. Ullrich Kockel (Liverpool: Liverpool University Press, 1994).

30 Ibid.

31 Quoted in Gemma Reid, 'Redefining Nation, Identity and Tradition: The Challenges for Ireland's National Museums', in *Ireland's Heritages: Critical Perspectives on Memory and Identity*, ed. Mark McCarthy (Aldershot: Ashgate, 2005), 217.

32 William Blair, 'Engagement and Empathy: "Post Conflict" Interpretation of the Troubles in Northern Ireland', in *Intercom 2011 – Museums and Politics* (Copenhagen 2011), 3, http://www.intercom.museum/conferences/2011/conference_papers.html.

33 Fionnula O'Connor, 'Troubles Display Highlights Problem of Contested Past', *Irish Times*, 24 December 2009; Fionola Meredith, 'Minimal Troubles at Ulster Museum', *Irish Times*, 24 October 2009.

34 'Minimal Troubles at Ulster Museum'. See also: Karine Bigand, 'How Is Ulster's History Represented in Northern Ireland's Museum? The Cases of the Ulster Folk Museum and the Ulster Museum', *E-rea: Revue électronique d'études sur le monde anglophone* 8, no. 3 (2011): 12.

35 'How Is Ulster's History Represented in Northern Ireland's Museum?', 12.

36 The Rt Hon Lord Saville of Newdigate, *The Report of the Bloody Sunday Inquiry* (London: House of Commons, 2010).

37 'David Cameron on Bloody Sunday: "I Am Deeply Sorry",' BBC News, http:// news.bbc.co.uk/1/hi/northern_ireland/8742073.stm.

Chapter 4

1 Campaign for Private Giving, 'Private Giving for Public Good' (London: Arts Council; National Museum Directors Council; Museums, Libraries Archives Council, 2008). Unpaginated (Inside cover).

2 'Promoting Philanthropy: Private Giving for the Public Good. A Campaign Group Briefing: Lifetime Gifts', National Museum Directors' Council, 1, http:// www.nationalmuseums.org.uk/media/documents/publications/private_giving_ public_good_briefing_jul08.pdf.

3 'Private Giving for the Public Good: Press Release', National Museum Directors' Conference, http://www.nationalmuseums.org.uk/resources/ press_releases/private_giving_apr08/.

4 Ibid., 11.

5 'Gifts of Pre-Eminent Objects', HM Revenue and Customs, http://www.hmrc. gov.uk/tiin/tiin618.pdf.

6 'Promoting Philanthropy', National Museum Directors' Conference, http:// www.nationalmuseums.org.uk/what-we-do/philanthropy/. Accessed 17 April 2013.

7 'Code of Ethics for Museums: Ethical Principles for All Those Who Work for or Govern Museums in the U.K.' (London: Museums Association, 2008), 14.

8 Ibid., 15.

9 Jean Marsden, Mr Nelson's long-term secretary, and Kathryn Marsden, voluntary curator both requested that I refer to 'Mr Nelson', rather than just to 'Nelson' as is more usual in academic texts. Adopting this form of address also helps distinguish Nelson the man from Nelson the place.

10 See, for instance: Neil G. Kotler, Philip Kotler, and Wendy I. Kotler, *Museum Marketing and Strategy: Designing Missions, Building Audiences, Generating Revenue and Resources*, 2nd ed. (San Francisco, CA: Jossey-Bass, 2008); Marcia Brennan et al., *A Modern Patronage: De Menil Gifts to American and European Museums* (Houston, TX; New Haven, CT: Menil Foundation, 2007); Arthur MacGregor, *Sir Hans Sloane : Collector, Scientist, Antiquary – Founding Father of the British Museum* (London: British Museum, 1994). Patrick J. Boylan, *Museums 2000: Politics, People, Professionals and*

Profit (London: Routledge, 1992); Hans Haacke, 'Museums: Mangers of Consciousness', *Parachute* 46 (1987).

11 Exhortations for museums to offer forms of public service include: Gail Anderson, *Reinventing the Museum: Historical and Contemporary Perspectives on the Paradigm Shift* (Walnut Creek, CA; Oxford: AltaMira Press, 2004); Stephen E. Weil, *Rethinking the Museum and Other Meditations* (Washington [London]: Smithsonian Institution Press, 1990); Eilean Hooper-Greenhill, *The Educational Role of the Museum* (London: Routledge, 1999).

12 Andrea Witcomb makes a direct link between the museum as storehouse and the museum as mausoleum. Witcomb, *Re-Imagining the Museum: Beyond the Mausoleum*, 104.

13 The sources for this chapter are principally the files marked 'Interesting Letters' (IL) and 'Gifts' and the collection registers, which are known as Gifts Books (GB). Unless otherwise specified the references are from letters in the Gifts files. Illegible handwriting is denoted by a question mark in brackets. I have retained the mode of address used in the correspondence.

14 February–May 1968, GB.

15 Robert A. D. Cran, Department of Oriental Antiquities, British Museum, London, 11 May 1978; Major General MacLennan, Royal Army Military Corps Historical Museum, Aldershot, 5 November 1970; Brigadier L. R. Macgreg, Centre for South Asian Studies, Cambridge, 24 July 1972.

16 Veronica Murphy, Victoria and Albert Museum, 11 July 1980.

17 The museum registration scheme was introduced in 1988. In 1995 Nelson enquired about a bequest that Doncaster Museum Service was distributing to interested organizations. The Senior Museum Officer replied stating that precedence would be given to registered museums. Carolyn Wingfield, Doncaster, 6 June 1995.

18 Miss McGregor and Mrs Albeck both spotted an advertisement in *The Lady*, W. H Cazaly and Mrs Hardy were both readers of *The Times*; while Mrs Kay took *The Daily Express* and Mr Ulph from Prescot read his local paper. William Dales and Major Arthur Smith saw advertisements in the Indian Army Association newsletter. Helen Anderson, Harrogate 21 May 1969; Miss McGregor, Lymington, 15 August 1969; Mrs Albeck, Broadstairs, 9 October 1969; W. H. Cazaly, Illford, 18 June 1972; Mrs Hardy, Altrincham, 21 June 1972; Mrs Kay, Bolton, undated June 1971; Mr Ulph, Prescot, September 1971; William Dales, New Mexico, 22 December 1992; Major Arthur Smith, 22 May 2003.

19 'Koh-I-Noor Diamond "Staying Put" in UK Says Cameron', BBC News, http://www.bbc.co.uk/news/uk-politics-10802469.

20 Nick Lloyd, 'The Amritsar Massacre and the Minimum Force Debate', *Small Wars and Insurgencies* 21, no. 2 (2010).

21 Iris Butler, 'The Wellesleys in India', in *The British in India* ed. Henry Nelson (Colne: The British in India Museum, 1971).

22 Iris Portal (formerly Butler) Norfolk, 25 August 1985 (86?).

23 Yvonne Lewis, Friern Barnett, 18 October 1987.

24 Mrs Pett, Oldham, 7 September 1973.

25 Mrs Doris L. Birrell, Westhill of Culloden, undated letter 1993.

26 Mrs Doris L. Birrell, Balloch, undated letter 1993.

27 Mrs Blacklaws, Coulsdon, August 1979.

28 Thelma Munckton, Taunton, 14 May 1978; Mrs Phyllis Pengree, Chichester, 14 April 1980.

29 Mrs Phyllis Pengree, Chichester, 22 September 1983; Thomas Eggar & Son Solicitors, Chichester, 29 March 1984. The tusks are not in the museum and I can find no record of them ever arriving.

30 Mrs J. Gray, Nelson, 20 May 1970; Mr T. M. Hards, Worthing, 24 February 1978.

31 Mr T. M. Hards, Worthing, 6 March 1978.

32 Henry Nelson, Colne, 15 March 1978.

33 Mrs E. M. Hill, Hampstead, 7 July 1969.

34 Prof W. J. H. Sprott, Cambridge, 22 October 1970.

35 Mrs J. Gray, Nelson, 20 May 1970. Emphasis in original text.

36 Mrs D. E. Townsend, Salcombe, September 1972.

37 Mrs Mary Rowland, Burnley, 10 September 1985.

38 D. W. Helling, London, 18 February 1997.

39 Mrs Phyllis Pengree, Chichester, 22 September 1983.

40 Annette B. Weiner, *Inalienable Possessions: The Paradox of Keeping-While-Giving* (Berkeley: University of California Press, 1992), 6.

41 Marcel Mauss, *The Gift: Forms and Functions of Exchange in Archaic Societies* (London: Routledge & Kegan Paul, 1969), 10.

42 Sharon Macdonald, 'On "Old Things": The Fetishization of Past Everyday Life', in *Cultural Heritage: Critical Concepts in Media and Cultural Studies*, ed. Laurajane Smith (London: Routledge, 2007), 89–106.

43 For an anthropological discussion of women's role in giving and hence in legitimating authority, see: Weiner, *Inalienable Possessions: The Paradox of Keeping-While-Giving*.

44 Ralph Leech, Lymington, 27 June 1997.

45 Mrs D. Mulhall, Baxenden, 25 August 1997.

46 Mrs Phyllis Pengree, Chichester, 14 April 1980.

47 Lieutenant Colonel Michael V. F. Pim, Collingbourne Ducis, 9 August 1992.

48 Mrs Ashton, Accrington, undated 1997.

49 Lieutenant Colonel Robert Wright, Aldershot, 3 August 1972.

50 Lieutenant Colonel Robert Wright, Aldershot, 1 January 1973.

51 M. J. Cowling, Colne, 5 August 1991; Nilufa Ali and Najima Ali, Waddington, 26 June 1991.

52 For an overview of the literature, see: Mark Osteen, *The Question of the Gift : Essays across Disciplines* (London: Routledge, 2002).

53 Lieutenant Colonel Michael V. F. Pim, Collingbourne Ducis, 9 August 1992.

54 Mrs Barbara Duckworth Case, Washington, 5 November 2007.

55 Mrs Phyllis Pengree, Chichester, 14 April 1980.

56 Mrs Phyllis Pengree, Chichester, 22 September 1983.

57 Lisa Poirier, Coquitlam, Canada, 3 January 1998.

58 Dr Elizabeth Schafer, Surrey, 19 November 1994.

59 William MacFarlane, Uckfield, 15 September 1993.

60 Mrs Dorothy H. Hayne, Lymington, 17 August 1970.

61 Geoffrey Dempsey, London, 13 April 1992.

62 Leila Richards, Sherringham, 7 March 1979; Major Arthur Smith, Boston, 22 May 2003.

63 Mrs Barbara Duckworth Case, Washington, 5 November 2007.

64 Margaret Robinson, 17 August 2009. Visitors' Book.

65 Mrs Ethel McKendree-Wright, Basingstoke, 17 November 1980.

66 Henry Nelson, Colne, 7 January 1981.

67 Henry Nelson, Colne, 12 June, 16 June 2006.

68 Henry Nelson, Colne, 8 August 1972.

69 Henry Nelson, Colne, 10 January 1973.

70 This definition of contemporary memorial museums is taken from Paul Williams, *Memorial Museums: The Global Rush to Commemorate Atrocities* (Oxford: Berg, 2007), 8.

71 Conversations with Jean Marsden and Jimmy Nelson, the British in India Museum, Nelson, 19 March 2013.

72 Major P. H. S. Davey, Bury St Edmunds, 18 May 1983. Emphasis in the original text.

Chapter 5

1 Steven Conn, *Do Museums Still Need Objects?* (Philadelphia: University of Pennsylvania Press, 2010), 22–26.

2 Hilde S. Hein, *The Museum in Transition: A Philosophical Perspective* (Washington, DC; London: Smithsonian Institution Press, 2000), 66; Andrea Witcomb, *Re-Imagining the Museum: Beyond the Mausoleum* (London: Routledge, 2003), 117; R. Parry quoted in Sandra Dudley, *Museum Materialities: Objects, Engagements, Interpretations* (London: Routledge, 2010), 3.

3 Elaine Heumann Gurian, 'What Is the Object of This Exercise', in *Reinventing the Museum: Historical and Contemporary Perspectives on the Paradigm Shift*, ed. Gail Anderson (Oxford: Altamira, 2004), 270. The objects under discussion are from collections and are not the other kinds of objects that are routinely displayed in contemporary museums. Dioramas, props, interactive stations,

wall-texts mounted on boards are also objects, while videos, light projections, audio effects, or guides, require considerable hardware. It is therefore more accurate to say that objects from museum collections have been partially or completely superseded by objects that are not from the collections. In order to make the distinction clear I refer to 'objects from the collections' and to 'collection-dense' and 'collection-sparse' displays.

4 Conversation with Patrick Cook, Williton, 25 September 2010.

5 Ibid.

6 H. A. Miers, 'A Report on the Public Museums of the British Isles (Other Than the National Museums)', (Dumfermline: Carnegie United Kingdom Trust, 1928), 40.

7 Ibid., 25.

8 Ibid., 37–38.

9 Ibid., 66, 70.

10 S. F. Markham, *A Report on the Museums and Art Galleries of the British Isles (Other Than National Institutions) for the Carnegie United Kingdom Trustees* (Edinburgh: T. A. Constable, 1938), 84.

11 On the substitution of objects, see: Tony Bennett, *Pasts Beyond Memory: Evolution, Museums, Colonialism* (London and New York: Routledge, 2004), 77.

12 Julian Spalding, *The Poetic Museum: Reviving Historic Collections* (Munich; London: Prestel, 2002), 51.

13 Witcomb, *Re-Imagining the Museum: Beyond the Mausoleum*, 117.

14 Lelol_10, 'Brilliant Bakelite', TripAdvisor, http://www.tripadvisor.co.uk/ Attraction_Review-g504145-d649573-Reviews-or20-Bakelite_Museum-Williton_Somerset_England.html#REVIEWS; SteveS, 'Quirky, Most Unusual', TripAdvisor, http://www.tripadvisor.co.uk/Attraction_Review-g504145-d649573-Reviews-or10-Bakelite_Museum-Williton_Somerset_England. html#REVIEWS; LouL18, 'A Secret Worth Finding', TripAdvisor, http://www. tripadvisor.co.uk/Attraction_Review-g504145-d649573-Reviews-Bakelite_ Museum-Williton_Somerset_England.html.

15 'Bakelite Museum – Safety Demands "Illogical"', http:// www.somersetcountygazette.co.uk/news/8407158. Bakelite_Museum___safety_demands__illogical_/.

16 MoT, 'Loved It!', TripAdvisor, http://www.tripadvisor.co.uk/Attraction_ Review-g504145-d649573-Reviews-Bakelite_Museum-Williton_Somerset_ England.html, accessed 11 December 2013; Shandy64, 'Brilliant Bakelite Museum', http://www.tripadvisor.co.uk/Attraction_Review-g504145-d649573-Reviews-Bakelite_Museum-Williton_Somerset_England.html.

17 GloucestershireKaz, 'Quirky and Plastic Fantastic', http://www.tripadvisor. co.uk/Attraction_Review-g504145-d649573-Reviews-Bakelite_Museum-Williton_Somerset_England.html.

18 Caroline, 'Caroline's Miscellany', http://carolineld.blogspot.co.uk/2009/09/ bakelite-museum.html; Cavalino Rampante, 'We Had One of Those!', http://

www.tripadvisor.co.uk/Attraction_Review-g504145-d649573-Reviews-Bakelite_Museum-Williton_Somerset_England.html; Shandy64, 'Brilliant Bakelite Museum'.

19 Robin Halstead et al., *More Bollocks to Alton Towers: Far from the Sodding Crowd* (London: Penguin, 2008), 149–50.

20 saucepanlyd, 'Brilliant Bakelite', http://www.tripadvisor.co.uk/Attraction_Review-g504145-d649573-Reviews-or10-Bakelite_Museum-Williton_Somerset_England.html#REVIEWS.

21 Sophie Campbell, 'This Is Bakelite, Do Not Adjust Your Dial,' http://www.telegraph.co.uk/travel/737553/This-is-Bakelite-do-not-adjust-your-dial.html; GloucestershireKaz, 'Quirky and Plastic Fantastic'.

22 Cavalino Rampante, 'We Had One of Those!', http://www.tripadvisor.co.uk/Attraction_Review-g504145-d649573-Reviews-Bakelite_Museum-Williton_Somerset_England.html.

23 John G., 'Quirky, Interesting and Full of Nostalgia! Well Worth a Visit', http://www.tripadvisor.co.uk/Attraction_Review-g504145-d649573-Reviews-or10-Bakelite_Museum-Williton_Somerset_England.html#REVIEWS.

24 Campbell, 'This Is Bakelite, Do Not Adjust Your Dial'.

25 Halstead et al., *More Bollocks to Alton Towers: Far from the Sodding Crowd*, 151.

26 Campbell, 'This Is Bakelite, Do Not Adjust Your Dial'.

27 For a detailed discussion of handling provision in museums, see: Fiona Candlin, *Art, Museums and Touch* (Manchester: Manchester University Press, 2010), 139–46.

28 Paul Valéry, 'The Problem of Museums', in *Degas, Manet, Morisot*, trans. David Paul (New York: Pantheon Books, 1960), 204.

29 Ibid., 205.

30 M. S. Briggs, 'New Galleries at the V&A,' *The Builder* (1950).

31 B. N., 'Late Gothic and Renaissance Art at the Victoria and Albert Museum', *The Burlington Magazine* 93, no. 574 (1951): 130.

32 Brian O'Doherty, *Inside the White Cube : The Ideology of the Gallery Space*, expanded ed. (Berkeley; London: University of California Press, 1999), 87.

33 Chris551953, 'Great Display of Everyday Items from Bygone Days', TripAdvisor, http://www.tripadvisor.co.uk/Attraction_Review-g504145-d649573-Reviews-or20-Bakelite_Museum-Williton_Somerset_England.html#REVIEWS.

34 Campbell, 'This Is Bakelite, Do Not Adjust Your Dial', http://www.nothingtoseehere.net/places/england/; MoT, 'Loved It!'; Anne Ward, 'Nothing to See Here', http://www.nothingtoseehere.net/about.html.

35 Rampante, 'We Had One of Those!'; Halstead et al., *More Bollocks to Alton Towers: Far from the Sodding Crowd*, 147; Rampante, 'We Had One of Those!'.

36 Paul Nash, 'Seaside Surrealism', *The Architectural Review* 79 (1936): 151.

37 'The Architectural Review Competition: Holiday Surrealism,' *The Architectural Review*, 42, my emphasis; Valéry, 'The Problem of Museums'.

38 Paul Nash and Roland Penrose, 'Competition Result: Holiday Surrealism', *The Architectural Review* 79, (November 1936).

39 The term 'natural' implies that surrealism is an inherent quality, and 'spontaneous' suggests it occurs irrespective of any onlookers, whereas 'holiday surrealism' connotes being away from home and hence the role of the observer. It also betokens pleasure and playfulness, which is appropriate to micromuseums, which are often found in or near tourist destinations and because a large proportion of their visitors are on vacation.

40 This analogy comes from Michel Foucault's discussion of Jorge Luis Borges's essay 'Labyrinths'. Michel Foucault, *The Order of Things* (London and New York: Routledge, 2003).

41 On comparisons between curiosity cabinets and the Bakelite Museum, see: 'Top 10 Quirky Museums', BBC, http://www.countryfile.com/countryside/top-10-quirky-museums. For indicative comparisons between curiosity cabinets and micromuseums more generally, see: Saul Rubin, *Offbeat Museums: The Collections and Curators of America's Most Unusual Museums* (Santa Monica, CA: Santa Monica Press, 1997), 6–7; Susan A. Crane, 'Curious Cabinets and Imaginary Museums', in *Museums and Memory* (Stanford, CA: Stanford University Press, 2000).

42 Douglas Crimp and Louise Lawler, *On the Museum's Ruins* (Cambridge, MA: MIT Press, 1993), 225.

43 Steven Mullaney, 'Strange Things, Gross Terms, Curious Customs: The Rehearsal of Cultures in the Late Renaissance', *Representations* 3 (1983).

44 Stephen Bann, 'The Return to Curiosity: Shifting Paradigms in Contemporary Museum Display', in *Art and Its Publics : Museum Studies at the Millennium*, ed. Andrew McClellan (Malden, MA; Oxford: Blackwell, 2003), 118.

45 Ibid., 120, 118.

46 Ibid., 118.

47 Ibid., 119.

48 Ibid., 123.

49 Ibid., 125.

50 A point forcefully made by Eugenio Donato, 'The Museum's Furnace: Notes toward a Contextual Reading of Bouvard and Pecuchet', in *Textual Strategies: Perspectives in Post-Structuralist Criticism*, ed. J. V. Harari (Ithaca, NY: Cornell University Press, 1979), 223.

51 A notable account of a museum exhibition reflecting on the means by which it produces objects is given by Susan Vogel, 'Exhibiting Culture: Always True to the Object in Our Fashion', in *The Poetics and Politics of Museum Display*, ed. Ivan Karp and Steven D. Lavine (London: Routledge, 1996). Museums and galleries regularly commission artists to reflect on the collections or spaces but the critique does not, as it were, come directly from within. For examples of such projects, see: James Putnam, *Art and Artifact : The Museum as Medium*, Rev. ed. (London: Thames & Hudson, 2009).

52 574eJones, 'The Opposite of a Museum', TripAdvisor, http://www.tripadvisor.
co.uk/ShowUserReviews-g504145-d649573-r136462750-Bakelite_Museum-
Williton_Somerset_England.html.

53 Witcomb, *Re-Imagining the Museum: Beyond the Mausoleum*, 117.

54 Conn, *Do Museums Still Need Objects?*, 22.

Chapter 6

1 Michaela Giebelhausen, 'Introduction: The Architecture of the Museum –
Symbolic Structures, Urban Contexts', in *The Architecture of the Museum:
Symbolic Structures, Urban Contexts* (Manchester; New York: Manchester
University Press, 2003), 6.

2 Conversation with Peter MacAskill, Giant Angus MacAskill Museum,
Dunvegan, Isle of Skye, Scotland, 11 September 2012.

3 Conversation with Terry and Paddy Wilding, Glendale Toy Museum, Glendale,
Isle of Skye, Scotland, 12 September 2012.

4 Conversation with Paul and Hilary Kennelley, West Wales Museum of
Childhood, Llangeler, Camarthenshire, Wales, 2 July 2012.

5 Claire Tomalin, *Charles Dickens: A Life* (London: Viking, 2011).

6 On this point, see: Nigel Thrift, 'Intensities of Feeling: Towards a Spatial
Politics of Affect', *Geografiska Annaler* 86, no. B (2004); Paul Williams,
Memorial Museums: The Global Rush to Commemorate Atrocities (Oxford:
Berg, 2007), 77–79.

7 Eamonn McCann, 'The Detention of I.R.A. Veteran Marian Price Harks Back
to Internment', http://www.guardian.co.uk/commentisfree/2012/jan/18/ira-
marian-price-internment.

8 *The History of English Freemasonry: A Souvenir of a Permanent Exhibition
in the Library and Museum of the United Grand Lodge of England at
Freemason's Hall, London* (Chichester: Chichester Press, 1986).

9 Conversation with Diane Clements, Director of the Museum and Library of
Freemasonry, London, 20 March 2012.

10 On English seaside surrealism see: Andrew Causey and Paul Nash, *Paul Nash*
(Oxford: Clarendon Press, 1980), 206.

11 On curators' education and how it has changed see Fiona Candlin, *Art,
Museums and Touch* (Manchester: Manchester University Press, 2010),
104–6.

12 Conversation with Des Pawson, Museum of Knots and Sailors' Ropework,
Ipswich, Suffolk, 8 August 2011; Conversation with Max Piekarski,
Cuckooland, Tabley, Cheshire, 5 July 2012.

13 Conversations with Paul Evans, Roland, and un-named volunteers, Internal
Fire: Museum of Power, Tanygroes, Ceredigion, 31 March 2013.

14 Conversations with Pam and Val Ripley, Ty Twt Dolls' House and Toy
Museum, Newtown, Pembrokeshire, Wales, 4 July 2012.

15 On accounts which imply that visitors are relatively passive, see: Laurajane Smith, *Uses of Heritage* (London; New York: Routledge, 2006), 31–32.

16 I attended the guided tours of Shandy Hall, Coxwold, on 5 September, 8 and 9 December 2012.

17 Barbara Kirshenblatt-Gimblett, *Destination Culture: Tourism, Museums, and Heritage* (Berkeley; London: University of California Press, 1998), 19–23.

18 Cited in the Shell Museum publicity leaflet.

19 Conversation with Roman Piekarski, Cuckooland, Tabley, Cheshire, 5 July 2012.

20 Conversation with David and Joan Hunter Paperweight Centre and Museum, Yelverton, Devon, 27 September 2010.

21 Conversation with Gerry Wells, Vintage Wireless Museum, Dulwich, London, 30 October 2010.

22 Conversation with Paul Evans, Internal Fire: Museum of Power, Ceredigion, 4 July 2012.

23 Conversation with Ben Greaves, Citadel of Miniatures, Warhammer World, Nottingham, 23 October 2010.

24 On the life cycle of objects, see: Ivor Kopytoff, 'The Cultural Biography of Things: Commoditization as Process', in *The Social Life of Things : Commodities in Cultural Perspective*, ed. Arjun Appadurai (Cambridge: Cambridge University Press, 1986).

25 Michel Foucault, 'Of Other Spaces: Utopias and Heterotopias', in *Rethinking Architecture: A Reader in Cultural Theory*, ed. Neil Leach (New York and London: Routledge, 1997).

26 Foucault notes that the notion of the museum as a heterotopia of time is itself historically contingent and pre-enlightenment museums were expressions of individual choice rather than an attempt to accumulate everything. On this point, see: Beth Lord, 'Foucault's Museum: Difference, Representation, and Genealogy', *Museum and Society* 4, no. 1 (2006).

BIBLIOGRAPHY

574eJones. 'The Opposite of a Museum'. TripAdvisor, http://www.tripadvisor.
co.uk/ShowUserReviews-g504145-d649573-r136462750-Bakelite_Museum-
Williton_Somerset_England.html.

'*The Accreditation Scheme for Museums in the United Kingdom: Accreditation
Standard*'. London: Museums Libraries Archives, 2004.

Adorno, Theodor W. 'Valery Proust Museum'. In *Prisms*. Cambridge, MA:
Neville Spearman, 1967.

Ames, Michael M. 'Museology Interrupted'. *Museum International 57*, no. 227
(2005): 44–51.

Anderson, Gail. *Reinventing the Museum: Historical and Contemporary
Perspectives on the Paradigm Shift*. Walnut Creek, CA; Oxford: AltaMira
Press, 2004.

Anne Ambourouè Avaro, and with the contribution of Gaël de Guichen and Alain
Godonou. 'A Guide for Documentation Work for Museums in Developing
Countries'. UNESCO, ICCROM and EPA, 2009.

'The Architectural Review Competition: Holiday Surrealism'. *The Architectural
Review* 79 (July 1936): 1.

Arendt, Hannah. *The Human Condition*. Chicago: Chicago University Press;
Cambridge: Cambridge University Press, 1958.

Arizona. 'Living Proof'. In *The Museum of Witchcraft: A Magical History*,
edited by Kerriann Godwin, 112. Bodmin The Occult Art Company with The
Friends of Boscastle Museum of Witchcraft, 2011.

Ascherson, Neal. 'Why 'Heritage' Is Right-Wing'. *Observer*, 8 November
1987.

B. N. 'Late Gothic and Renaissance Art at the Victoria and Albert Museum'. *The
Burlington Magazine* 93, no. 574 (January 1951): 130.

'Bakelite Museum – Safety Demands "Illogical"'. http://www.somersetcountygazette.
co.uk/news/8407158.Bakelite_Museum___safety_demands__illogical_/.

Bann, Stephen. 'The Return to Curiosity: Shifting Paradigms in Contemporary
Museum Display'. In *Art and Its Publics : Museum Studies at the
Millennium*, edited by Andrew McClellan, 117–32. Malden, MA; Oxford:
Blackwell, 2003.

Barrett, Jennifer. *Museums and the Public Sphere*. Oxford: Wiley-Blackwell,
2011.

Bennett, Tony. 'Difference and the Logic of Culture'. In *Museum Frictions: Public
Cultures/Global Transformations*, edited by Ivan Karp, 46–69. Durham, NC;
London: Duke University Press, 2006.

Bennett, Tony. 'Museums and "the People"'. In *The Museum Time-Machine: Putting Cultures on Display*, edited by Robert Lumley. London; New York: Routledge, 1988.

Bennett, Tony. *Pasts Beyond Memory: Evolution, Museums, Colonialism*. London and New York: Routledge, 2004.

Berns, Stephanie. 'Religious and Secular Ways of Seeing Sacred Objects in the British Museum'. PhD, University of Kent, 2015.

Bigand, Karine. 'How Is Ulster's History Represented in Northern Ireland's Museum? The Cases of the Ulster Folk Museum and the Ulster Museum'. *E-rea: Revue électronique d'études sur le monde anglophone* 8, no. 3 (2011).

Blair, William. 'Engagement and Empathy: "Post Conflict" Interpretation of the Troubles in Northern Ireland'. In *Intercom 2011 – Museums and Politics*. Copenhagen, 2011. http://www.intercom.museum/conferences/2011/conference_papers.html.

Boylan, Patrick J. *Museums 2000: Politics, People, Professionals and Profit*. London: Routledge, 1992.

Bradburne, James M. 'Visible Listening: Discussion, Debate and Governance in the Museum'. In *Routledge Companion to Museum Ethics: Redefining Ethics for the Twenty-First Century Museum*, edited by Janet Marstine, 275–84. London: Routledge, 2011.

Brennan, Marcia, Alfred Pacquement, Ann Temkin, and Josef Helfenstein. *A Modern Patronage: De Menil Gifts to American and European Museums*. Houston, TX: Menil Foundation; New Haven, CT: Yale University Press, 2007.

Briggs, M. S. 'New Galleries at the V&A'. *The Builder* (January 1950).

Brown, Kris. 'Living with History: Conflict, Commemoration and Exhibitions in Northern Ireland – the Case of Sectional Displays'. *Social History in Museums* 32 (2008): 31–37.

Brown, Richard D. 'Microhistory and the Post-Modern Challenge'. *Journal of the Early Republic* 23, no. 1 (2003): 1–20.

Buckley, Anthony, and Mary Kenney. 'Cultural Heritage in an Oasis of Calm: Divided Identities in a Museum in Ulster'. In *Culture, Tourism and Development. The Case of Ireland*, edited by Ullrich Kockel, 129–47. Liverpool: Liverpool University Press, 1994.

Burton, Anthony. *Vision and Accident: The Story of the Victoria and Albert Museum*. London: V & A, 1999.

Butler, Iris. 'The Wellesleys in India'. In *The British in India* edited by Henry Nelson, 28–30. Colne: The British in India Museum, 1971.

Calhoun, Craig J. *Habermas and the Public Sphere*. Cambridge, MA; London: MIT Press, 1992.

Cameron, Duncan F. 'The Museum, a Temple or the Forum'. *Curator: the Museum Journal* 14, no. 1 (1971): 11–24.

Cameron, Fiona. 'Contentiousness and Shifting Knowledge Paradigms: The Roles of History and Science Museums in Contemporary Societies'. *Museum Management and Curatorship* 20 (2005): 213–33.

Campbell, Sophie. 'This Is Bakelite, Do Not Adjust Your Dial'. http://www.telegraph.co.uk/travel/737553/This-is-Bakelite-do-not-adjust-your-dial.html.

Candlin, Fiona. *Art, Museums and Touch*. Manchester: Manchester University Press, 2010.

Candlin, Fiona. 'Independent Museums, Heritage, and the Shape of Museum Studies'. *Museums and Society* 10, no. 1 (2012): 28–41.

Caroline. 'Caroline's Miscellany'. http://carolineld.blogspot.co.uk/2009/09/bakelite-museum.html.

Causey, Andrew, and Paul Nash. *Paul Nash*. Oxford: Clarendon Press, 1980.

Certeau, Michel de. *The Practice of Everyday Life*. Berkeley: University of California Press, 1984.

Chris551953. 'Great Display of Everyday Items from Bygone Days'. TripAdvisor, http://www.tripadvisor.co.uk/Attraction_Review-g504145-d649573-Reviews-or20-Bakelite_Museum-Williton_Somerset_England.html-REVIEWS.

'Code of Ethics for Museums: Ethical Principles for All Those Who Work for or Govern Museums in the U.K.'. London: Museums Association, 2008.

Coles, Alison, Bethan Hurst, and Peter Windsor. 'Museum Focus: Facts and Figures on Museums in the UK'. London: Museums and Galleries Commission, 1998.

Commission, Museums & Galleries. 'Report 1987–88: Specially Featuring Independent Museums'. London: Museums & Galleries Commission, 1988.

Conlin, Jonathan. *The Nation's Mantelpiece: A History of the National Gallery*. London: Pallas Athene, 2006.

Conn, Steven. *Do Museums Still Need Objects?* Philadelphia: University of Pennsylvania Press, 2010.

Cornish, Helen. 'Cunning Histories: Privileging Narratives in the Present'. *History and Anthropology* 16, no. 3 (2005): 363–76.

Cornish, Helen. *Recreating Historical Knowledge and Contemporary Witchcraft in Southern England*. PhD thesis, Goldsmiths College, 2005.

Cossons, Neil. 'Independent Museums'. In *Manual of Curatorship: A Guide to Museum Practice*, edited by John M. A. Thompson, 84–90. London: Butterworths, 1984.

Council, Powys County. 'Powys: Portfolio Holder for Regeneration and Culture'. Vol 5, County Hall, Llandrindod, Powys (report), 2011.

Council, Powys County. *Corporate Improvement Plan Stage 1: 2008–2011*. Llandrindod Wells: County Hall, 2008.

Coxall, Helen. 'Open Minds: Inclusive Practices.' In *Museum Philosophy for the Twenty-First Century*, edited by Hugh H. Genoways, 139–50. Lanham, MD; Oxford: Altamira Press, 2006.

Crane, Susan A. 'Curious Cabinets and Imaginary Museums'. In *Museums and Memory*, 60–80. Stanford, CA: Stanford University Press, 2000.

Crimp, Douglas, and Louise Lawler. *On the Museum's Ruins*. Cambridge, MA: MIT Press, 1993.

Crooke, Elizabeth. 'An Exploration of the Connections among Museums, Community and Heritage'. In *The Ashgate Research Companion to Heritage and Identity*, edited by B. J. Graham and Peter Howard, 415–24. Aldershot: Ashgate, 2008.

Crooke, Elizabeth. 'The Politics of Community Heritage: Motivations, Authority and Control'. *International Journal of Heritage Studies* 16, no. 1–2 (2010): 16–29.

Crooke, Elizabeth M. *Museums and Community: Ideas, Issues and Challenges*. Museum Meanings. London; New York: Routledge, 2007.

Curtis, Liz. 'A Catalogue of Censorship 1959–1993'. In *War and Words : The Northern Ireland Media Reader*, edited by Bill Rolston and David Miller. Belfast: Beyond the Pale, 1996.

Curtis, Liz. *Ireland : The Propaganda War : The Media and the 'Battle for Hearts and Minds'*. London: Pluto, 1984.

'David Cameron on Bloody Sunday: "I Am Deeply Sorry"'. BBC News, http://news.bbc.co.uk/1/hi/northern_ireland/8742073.stm.

Davies, Hunter. *Behind the Scenes at the Museum of Baked Beans: My Search for Britain's Maddest Museums*. London: Virgin Books, 2010.

Denford, Geoffrey T., Elizabeth R. Lewis, and David J. Viner. 'Small Museums'. In *Manual of Curatorship: A Guide to Museum Practice*, edited by John M. A. Thompson, 91–97. London: Butterworths, 1984.

Dillenburg, Eugene. 'What, If Anything, Is a Museum?' http://name-aam.org/resources/exhibitionist/back-issues-and-online-archive.

Donato, Eugenio. 'The Museum's Furnace: Notes toward a Contextual Reading of Bouvard and Pecuchet'. In *Textual Strategies : Perspectives in Post-Structuralist Criticism*, edited by J. V. Harari, 213–38. Ithaca, NY: Cornell University Press, 1979.

Dudley, Sandra. *Museum Materialities: Objects, Engagements, Interpretations*. London: Routledge, 2010.

Duffield, Clore. 'Main Grants Programme'. http://www.cloreduffield.org.uk/page_sub.php?id=73&parent=35.

Ellis, Markman. *Eighteenth-Century Coffee-House Culture*. 4 vols. Vol. 1. London: Pickering & Chatto, 2006.

England, Arts Council. 'Accreditation Scheme'. Arts Council England, http://www.artscouncil.org.uk/what-we-do/supporting-museums/accreditation-scheme/.

England, Arts Council. '*Culture, Knowledge and Understanding:Great Museums and Libraries for Everyone*'. London: Arts Council England, 2011.

England, Arts Council. 'Renaissance Major Grants Programme: Guidance for Applicants'. Arts Council England, http://www.artscouncil.org.uk/media/uploads/pdf/Renaissance_Major_Grants_guidance.pdf

England, Arts Council. 'Renaissance Support Fund: Information Document'. Arts Council England, http://www.artscouncil.org.uk/funding/apply-for-funding/renaissance/strategic-support-fund/.

Erwin, Alan. 'Police Killer Martin Corey Remains in Jail as Bail Hearing Halted'. http://www.belfasttelegraph.co.uk/news/local-national/northern-ireland/police-killer-martin-corey-remains-in-jail-as-bail-ruling-halted-28770104.html.

'Esmee Fairburn Collections Fund: Application Guidance'. Museums Association.

Fisher, Philip. *Making and Effacing Art: Modern American Art in a Culture of Museums*. New York; Oxford: Oxford University Press, 1991.

'For Their Eyes Only'. Liberty, http://www.liberty-human-rights.org.uk/campaigns/for-their-eyes-only/for-their-eyes-only-faqs.php.

Foucault, Michel. 'Of Other Spaces: Utopias and Heterotopias'. In *Rethinking Architecture: A Reader in Cultural Theory*, edited by Neil Leach, 330–36. New York and London: Routledge, 1997.

Foucault, Michel. *The Order of Things*. London and New York: Routledge, 2003.

Fraser, Nancy. 'Rethinking the Public Sphere: A Contribution to the Critique of Actually Existing Democracy'. *Social Text*, no. 25/26 (1990): 56–80.

G, John. 'Quirky, Interesting and Full of Nostalgia! Well Worth a Visit'. http://www.tripadvisor.co.uk/Attraction_Review-g504145-d649573-Reviews-or10-Bakelite_Museum-Williton_Somerset_England.html–REVIEWS.

Gadamer, Hans-Georg. *Truth and Method*. Translated by Joel Weinsheimer and Donald G. Marshall. London; New York: Continuum, 2004.

Gallop, Jane. *Anecdotal Theory*. Durham, NC and London: Duke University Press, 2002.

Geertz, Clifford. *The Interpretation of Cultures: Selected Essays*. London: Hutchinson, 1975.

Giebelhausen, Michaela. 'Introduction: The Architecture of the Museum – Symbolic Structures, Urban Contexts'. In *The Architecture of the Museum : Symbolic Structures, Urban Contexts*, 1–16. Manchester; New York: Manchester University Press, 2003.

'Gifts of Pre-Eminent Objects'. HM Revenue and Customs, http://www.hmrc.gov.uk/tiin/tiin618.pdf.

Ginzburg, Carlo. *The Cheese and the Worms : The Cosmos of a Sixteenth-Century Miller* [in Translation of: Il formaggio e i vermi.]. London: Routledge & Kegan Paul, 1980.

Ginzburg, Carlo, John Tedeschi, and Anne Tedeschi. 'Microhistory: Two or Three Things That I Know about It'. *Critical Inquiry* 20, no. 1 (1993): 10–35.

Giving, Campaign for Private. 'Private Giving for Public Good'. London: Arts Council; National Museum Directors Council; Museums, Libraries Archives Council, 2008.

GloucestershireKaz. 'Quirky and Plastic Fantastic'. http://www.tripadvisor.co.uk/Attraction_Review-g504145-d649573-Reviews-Bakelite_Museum-Williton_Somerset_England.html.

Goldhill, Simon. *Freud's Couch, Scott's Buttocks, Bronte's Grave*. Chicago; London: University of Chicago Press, 2011.

Goodman, Dena. *The Republic of Letters: A Cultural History of the French Enlightenment*. Ithaca, NY; London: Cornell University Press, 1994.

Grandison, Leonard S. *L. Grandison & Sons: 100 Years on 1886–1986*. Peebles: (self-published), 1987.

Greenwood, Helen, and Sally Maynard. 'Digest of Statistics'. Museums Libraries Archives Council, http://www.lboro.ac.uk/departments/dis/lisu/downloads/Digest06.pdf.

Gurian, Elaine Heumann. 'What Is the Object of This Exercise'. In *Reinventing the Museum: Historical and Contemporary Perspectives on the Paradigm Shift*, edited by Gail Anderson. Oxford: Altamira, 2004.

H.Cheape. '"Charms against Witchcraft": Magic and Mischief in Museum Collections'. In *Witchcraft and Belief in Early Modern Scotland*, edited by Julian Goodare, Lauren Martin and Joyce Miller, 227–48. Basingstoke; New York: Palgrave Macmillan, 2008.

Haacke, Hans. 'Museums: Mangers of Consciousness'. *Parachute* 46 (March–May 1987): 84–88.

Habermas, Jürgen. 'The Public Sphere: An Encyclopaedia Article'. *New German Critique* 3 (1974): 49–55.

Hale, Amy. 'The Land near the Dark Cornish Sea: The Development of Tintagel as a Celtic Pilgrimage Site'. *Journal for the Academic Study of Magic*, no. 2 (2004).

Hale, Amy. 'Whose Celtic Cornwall: The Ethnic Cornish Meet Celtic Spirituality'. In *Celtic Geographies: Old Culture, New Times*, edited by David Harvey, 157–70. London: Routledge, 2002.

Halstead, Robin, Jason Hazeley, Alex Morris, and Joel Morris. *More Bollocks to Alton Towers: Far from the Sodding Crowd*. London: Penguin, 2008.

Haraway, Donna. 'Situated Knowledges: The Science Question in Feminism and the Privilege of Partial Perspective'. *Feminist Studies* 14, no. 3 (Autumn 1988): 575–99.

Harrison, Rodney, Sarah Byrne, and Anne Clarke (eds). *Reassembling the Collection : Ethnographic Museums and Indigenous Agency*. Santa Fe: School for Advanced Research Press, 2013.

Hein, Hilde S. *The Museum in Transition: A Philosophical Perspective*. Washington, DC; London: Smithsonian Institution Press, 2000.

Hewison, Robert. *The Heritage Industry: Britain in a Climate of Decline*. A Methuen Paperback. London: Methuen London, 1987.

The History of English Freemasonry: A Souvenir of a Permanent Exhibition in the Library and Museum of the United Grand Lodge of England at Freemason's Hall, London. Chichester: Chichester Press, 1986.

Hooper-Greenhill, Eilean. *The Educational Role of the Museum*. London: Routledge, 1999.

Hooper-Greenhill, Eilean. *Museums and the Interpretation of Visual Culture*. London; New York: Routledge, 2000.

Hudson, Kenneth. 'The Museum Refuses to Stand Still'. In *Museum Studies: An Anthology of Contexts*, edited by Bettina Messias Carbonell, 85–91. Malden, MA and Oxford: Blackwell, 2004.

Hutton, Ronald. *The Triumph of the Moon: A History of Modern Pagan Witchcraft*. Oxford: Oxford University Press, 2000.

Jain, Jyotindra. 'Museum and Museum-Like Structures: The Politics of Exhibition and Nationalism in India', name-aam.org/resources/exhibitionist/back-issues-and-online-archive.

Jennings, Gretchen. 'Is It a Museum? Does It Matter: Special Issue'. National Association for Museum Exhibition, http://name-aam.org/resources/exhibitionist/back-issues-and-online-archive.

Joyner, Charles W. *Shared Traditions : Southern History and Folk Culture*. Urbana: University of Illinois Press, 1999.

Karp, Ivan. *Museum Frictions: Public Cultures/Global Transformations*. Durham, NC; London: Duke University Press, 2006.

Karp, Ivan, and Steven D. Lavine. 'Introduction: Museums and Multiculturalism'. In *Exhibiting Cultures: The Poetics and Politics of Museum Display*, x and 468. Washington; London: Smithsonian Institution Press, 1991.

Kearney, Vincent. 'Denis Donaldson: Ombudsmen Launches New Investigation'. BBC News Northern Ireland, http://www.bbc.co.uk/news/uk-northern-ireland-21260672.

Kearney, Vincent. 'Former Internees Claim "New Evidence" of Army Torture'. BBC Northern Ireland, http://www.bbc.co.uk/news/uk-northern-ireland-25137411.

Kennedy, Emma. 'Museum of Brands'. http://www.guardian.co.uk/travel/series/emma-kennedys-eccentric-britain.

Kennedy, Emma. 'Museum of Celebrity Leftovers'. http://www.guardian.co.uk/travel/2012/may/18/museum-of-celebrity-leftovers-emma-kennedy.

Kennedy, Emma. 'Teapot Island, Kent'. http://www.guardian.co.uk/travel/2011/nov/18/teapot-island-museum-kent.

King, Graham. *The Museum of Witchcraft: 50 Years of Controversy*. Boscastle: Museum of Witchcraft 2002.

Kirshenblatt-Gimblett, Barbara. *Destination Culture: Tourism, Museums, and Heritage*. Berkeley; London: University of California Press, 1998.

'Koh-I-Noor Diamond "Staying Put" in UK Says Cameron'. BBC News, http://www.bbc.co.uk/news/uk-politics-10802469.

Kopytoff, Ivor. 'The Cultural Biography of Things: Commoditization as Process'. In *The Social Life of Things : Commodities in Cultural Perspective*, edited by Arjun Appadurai, 64–94. Cambridge: Cambridge University Press, 1986.

Kotler, Neil G., Philip Kotler, and Wendy I. Kotler (eds). *Museum Marketing and Strategy: Designing Missions, Building Audiences, Generating Revenue and Resources*. 2nd edition. San Francisco, CA: Jossey-Bass, 2008.

Kreps, Christina F. *Liberating Culture: Cross-Cultural Perspectives on Museums, Curation, and Heritage Preservation*. London: Routledge, 2003.

Lashley, Conrad, and Alison J. Morrison. *In Search of Hospitality: Theoretical Perspectives and Debates*. Oxford: Butterworth-Heinemann, 2000.

Latour, Bruno. *Reassembling the Social: An Introduction to Actor-Network-Theory*. Oxford: Oxford University Press, 2005.

Latour, Bruno, and Peter Weibel. 'From Realpolitik to Dingpolitik or How to Make Things Public'. In *Making Things Public: Atmospheres of Democracy*. Cambridge, MA; London: MIT, 2005.

Lelol_10. 'Brilliant Bakelite'. TripAdvisor, http://www.tripadvisor.co.uk/Attraction_Review-g504145-d649573-Reviews-or20-Bakelite_Museum-Williton_Somerset_England.html–REVIEWS.

Lloyd, Nick. 'The Amritsar Massacre and the Minimum Force Debate'. *Small Wars and Insurgencies* 21, no. 2 (2010): 382–403.

Lord, Beth. 'Foucault's Museum: Difference, Representation, and Genealogy'. *Museum and Society* 4, no. 1 (2006): 1–14.

LouL18. 'A Secret Worth Finding'. TripAdvisor, http://www.tripadvisor.co.uk/Attraction_Review-g504145-d649573-Reviews-Bakelite_Museum-Williton_Somerset_England.html.

Loveless, Natalie S. 'Reading with Knots: On Jane Gallop's Anecdotal Theory'. *Journal of the Jan Van Eyck Circle for Lacanian Ideology Critique* 4 (2011): 24–36.

Lowerson, John. 'Celtic Tourism – Some Recent Magnets'. *Cornish Studies* 2 (1994): 128–37.

Macdonald, Sharon. 'On "Old Things": The Fetishization of Past Everyday Life'. In *Cultural Heritage: Critical Concepts in Media and Cultural Studies*, edited by Laurajane Smith, 89–106. London: Routledge, 2007.

MacGregor, Arthur. *Sir Hans Sloane : Collector, Scientist, Antiquary – Founding Father of the British Museum*. London: British Museum, 1994.

MacLeod, Suzanne. 'Making Museum Studies: Training, Education, Research and Practice'. *Museum Management and Curatorship* 19, no. 1 (2001): 51–61.

Malraux, Andre. *The Voices of Silence* Translated by Stuart Gilbert. London: Secker & Warburg, 1954.

Markham, S. F. *A Report on the Museums and Art Galleries of the British Isles (Other Than National Institutions) for the Carnegie United Kingdom Trustees.* Edinburgh: T. A. Constable, 1938.

'Martin Corey Released from Prison'. BBC News Northern Ireland, http://www. bbc.co.uk/news/uk-northern-ireland-25744626.

Mauss, Marcel. *The Gift : Forms and Functions of Exchange in Archaic Societies* [in Trans.]. London: Routledge & Kegan Paul, 1969.

McCann, Eamonn. 'The Detention of I.R.A. Veteran Marian Price Harks Back to Internment'. http://www.guardian.co.uk/commentisfree/2012/jan/18/ira-marian-price-internment.

McClellan, Andrew. *The Art Museum from Boullée to Bilbao.* Berkeley; London: University of California Press, 2008.

McClellan, Andrew. *Inventing the Louvre: Art, Politics, and the Origins of the Modern Museum in Eighteenth-Century Paris.* Cambridge: Cambridge University Press, 1994.

McDonald, Henry. 'Irish Republicans Honour Heroes of the Troubles in a Garden-Shed Museum'. http://www.guardian.co.uk/uk/2011/aug/30/irish-republicans-garden-shed-museum.

Mee, Arthur. *Cornwall: England's Farthest South.* [S.l.]: [s.n.], 1937.

Melaugh, Martin. 'Internment – Summary of Main Events'. Conflict Archive on the Internet (CAIN), University of Ulster, http://cain.ulst.ac.uk/events/intern/sum.htm.

Meredith, Fionola. 'Minimal Troubles at Ulster Museum'. *Irish Times*, 24 October 2009.

Merleau-Ponty, Maurice. 'Indirect Language and the Voices of Silence'. Translated by M. B. Smith. In *The Merleau-Ponty Aesthetics Reader*, edited by G. A. Johnson. Evanston: Northwestern University Press, 1993.

Middleton, Victor T. C. *New Visions for Museums in the 21st Century.* Chichester: Association of Independent Museums (AIM), 1998.

Miers, H. A. 'A Report on the Public Museums of the British Isles (Other Than the National Museums)'. Dumfermline: Carnegie United Kingdom Trust, 1928.

MoT. 'Loved It!' TripAdvisor, http://www.tripadvisor.co.uk/Attraction_Review-g504145-d649573-Reviews-Bakelite_Museum-Williton_Somerset_England.html.

Mullaney, Steven. 'Strange Things, Gross Terms, Curious Customs: The Rehearsal of Cultures in the Late Renaissance'. *Representations* 3 (1983): 40–67.

Museum Guide. Boscastle: Museum of Witchcraft, 2007.

Museums, Association of Independent. 'The Economic Value of the Independent Museum Sector'. Association of Independent Museums, http://www.aim-museums.co.uk/pages/pg-18-aim-economic-impact-paper/.

Nash, Paul. 'Seaside Surrealism'. *The Architectural Review* 79 (April 1936): 151–54.

Nash, Paul, and Roland Penrose. 'Competition Result: Holiday Surrealism'. *The Architectural Review* 79 (November 1936): 2.

Neal, Arminta. *Help! For the Small Museum; a Handbook of Exhibit Ideas and Methods.* Boulder, CO: Pruett, 1969.

Newdigate, The Rt Hon Lord Saville of. *The Report of the Bloody Sunday Inquiry.* London: House of Commons, 2010.

Noble, Judith. 'Dark Light'. In *The Museum of Witchcraft: A Magical History*, edited by Kerriann Godwin, 31. Bodmin: Occult Book Company with Friends of the Boscastle Museum of Witchcraft, 2011.

O'Connor, Fionnula. 'Troubles Display Highlights Problem of Contested Past'. *Irish Times*, 24 December 2009.

O'Doherty, Brian. *Inside the White Cube : The Ideology of the Gallery Space.* Expanded edition. Berkeley; London: University of California Press, 1999.

Osteen, Mark. *The Question of the Gift : Essays across Disciplines.* London: Routledge, 2002.

Patterson, Steve. *Cecil Williamson Book of Witchcraft.* London: Troy Books, 2014.

Pekacz, Jolanta T. *Conservative Tradition in Pre-Revolutionary France: Parisian Salon Women: Jolanta T. Pekacz.* New York: Peter Lang, 1999.

'Policy in Progress'. *Museums Association Journal* (November 1998): 38.

'Private Giving for the Public Good: Press Release'. National Museum Directors' Conference, http://www.nationalmuseums.org.uk/resources/press_releases/private_giving_apr08/.

Proceedings of Grand Lodge of England. London: Freemason's Hall.

'Promoting Philanthropy'. National Museum Directors' Conference, http://www.nationalmuseums.org.uk/what-we-do/philanthropy/.

'Promoting Philanthropy: Private Giving for the Public Good. A Campaign Group Briefing: Lifetime Gifts'. National Museum Directors' Council, http://www.nationalmuseums.org.uk/media/documents/publications/private_giving_public_good_briefing_jul08.pdf.

Putnam, James. *Art and Artifact: The Museum as Medium.* Revised edition. London: Thames & Hudson, 2009.

Quatremère de Quincy, M., and Henry Thomson. *The Destination of Works of Art and the Use to Which They Are Applied, Considered with Regard to Their Influence on the Genius and Taste of Artists, and the Sentiment of Amateurs.* Translated by Henry Thomson. London, 1821.

Rampante, Cavalino. 'We Had One of Those!' http://www.tripadvisor.co.uk/Attraction_Review-g504145-d649573-Reviews-Bakelite_Museum-Williton_Somerset_England.html.

Redington, Christine. *A Guide to the Small Museums of Britain.* London; New York: I. B. Tauris, 2002.

Reid, Gemma. 'Redefining Nation, Identity and Tradition: The Challenges for Ireland's National Museums'. In *Ireland's Heritages: Critical Perspectives on Memory and Identity*, edited by Mark McCarthy, 205–22. Aldershot: Ashgate, 2005.

Ristow, William, and Tim Shallice. 'Taking the Hood Off British Torture'. *New Scientist* (5th August 1976): 272–74.

'Rosemary Nelson Inquiry: "No Collusion" in Murder'. BBC News Northern Ireland, http://www.bbc.co.uk/news/uk-northern-ireland-13500047.

Rowe, David. *Boscastle: 16 August 2004 – the Day of the Flood.* St Agnes, Cornwall: Truran, 2011.

Rubin, Saul. *Offbeat Museums: The Collections and Curators of America's Most Unusual Museums.* Santa Monica, CA: Santa Monica Press, 1997.

Ruffins, Fath Davis. 'Revisiting the Old Plantation: Reparations, Reconciliation, and Museumizing American Slavery'. In *Museum Frictions: Public Cultures/ Global Transformations*, edited by Ivan Karp. Durham, NC; London: Duke University Press, 2006.

Rugoff, Ralph. *Circus Americanus.* London; New York: Verso, 1995.

'Salary Guidelines in Museum'. London: Museums Association, 2009.

Samuel, Raphael. *Theatres of Memory.* London: Verso, 1999.

Sandberg, Mark B. *Living Pictures, Missing Persons : Mannequins, Museums, and Modernity.* Princeton, NJ; Oxford: Princeton University Press, 2003.

saucepanlyd. 'Brilliant Bakelite'. http://www.tripadvisor.co.uk/Attraction_ Review-g504145-d649573-Reviews-or10-Bakelite_Museum-Williton_ Somerset_England.html–REVIEWS.

Scotland, National Museum of. 'Preloaded: The Royal Museum Project'. http:// preloaded.com/work/national-museums-scotland/.

Scott, Joan W. 'The Evidence of Experience'. *Critical Enquiry* 17, no. 4 (1991): 773–97.

Shandy64. 'Brilliant Bakelite Museum'. http://www.tripadvisor.co.uk/Attraction_ Review-g504145-d649573-Reviews-Bakelite_Museum-Williton_Somerset_ England.html.

Sherman, Daniel J. 'Quatrèmere/Benjamin/Marx: Art Museums, Aura and Commodity Fetishism'. In *Museum Culture: Histories, Discourses, Spectacles*, edited by Daniel J. Sherman and Irit Rogoff, 123–43. London: Routledge, 1994.

Simine, Silke Arnold-de. 'The Ghosts of Spitalfields: 18 Folgate Street and 19 Princelet Street'. In *Mediating Memory in the Museum. Empathy, Trauma, Nostalgia* Basingstoke: Palgrave Macmillan, 2013.

Simpson, Moira G. *Making Representations : Museums in the Post-Colonial Era.* London: Routledge, 1996.

'Small Museums Committee and Affinity Group'. American Association for State and Local History, http://www.aaslh.org/SmallMuseums.

Smith, Laurajane. 'Class, Heritage and the Negotiations of Place'. In *Missing Out on Heritage: Socio-EconomicStatus and Heritage Participation.* LSE, London: English Heritage, 2009.

Smith, Laurajane. *Uses of Heritage.* London; New York: Routledge, 2006.

Spalding, Julian. *The Poetic Museum: Reviving Historic Collections.* Munich; London: Prestel, 2002.

SteveS. 'Quirky, Most Unusual'. TripAdvisor, http://www.tripadvisor.co.uk/ Attraction_Review-g504145-d649573-Reviews-or10-Bakelite_Museum- Williton_Somerset_England.html–REVIEWS.

Stone-Gordon, Tammy. *Private History in Public: Exhibition and the Settings of Everyday Life.* Lanham, MD: AltaMira Press, 2010.

Strangest Museums in Britain and the Best Worldwide. England: Strangest Books, 2006.

'Survey of Visitors to Museums' Web Space and Physical Space'. Prepared by the Statistical Consultation Group Statistics Canada for the Canadian Heritage Information Network, February 2005, http://www.rcip-chin.gc.ca/contenu_ numerique-digital_content/2004survey-2004survey/index-eng.jsp.

'Talking Objects'. The British Museum, http://www.britishmuseum.org/channel/object_stories/talking_objects/video_swimming_reindeer.aspx.

Teather, J. Lynne. 'Museum Studies: Reflecting on Reflective Practice'. *Museum Management and Curatorship* 10 (1991): 403–17.

Thrift, Nigel. 'Intensities of Feeling: Towards a Spatial Politics of Affect'. *Geografiska Annaler* 86 no. B (2004): 57–78.

Tilley, Christopher. *The Materiality of Stone: Explorations in Landscape Phenomenology*. Oxford: Berg, 2004.

'Time to Free Martin Corey'. Socialist Worker, socialistworker.org/2012/08/14/time-to-free-martin-corey.

Tomalin, Claire. *Charles Dickens: A Life*. London: Viking, 2011.

'Top 10 Quirky Museums'. BBC, http://www.countryfile.com/countryside/top-10-quirky-museums.

Valéry, Paul. 'The Problem of Museums'. In *Degas, Manet, Morisot*, translated by David Paul. New York: Pantheon Books, 1960.

Vogel, Susan. 'Exhibiting Culture: Always True to the Object in Our Fashion'. In *The Poetics and Politics of Museum Display*, edited by Ivan Karp and Steven D. Lavine, 191–204. London: Routledge, 1996.

Wales, Museums Libraries Archives. *A Museums Strategy for Wales*. Cardiff: Welsh Assembly Government, 2010.

Ward, Anne. 'Nothing to See Here'. http://www.nothingtoseehere.net/about.html.

Watson, Sheila. 'History Museums, Community Identities and a Sense of Place'. In *Museum Revolutions: How Museums Change and Are Changed*, edited by Simon J. Knell, Suzanne Macleod, and Sheila E. R. Watson. London: Routledge, 2007.

Wei, Jenny. 'Bringing a Museum Object to Life: The John Bull Locomotive'. Smithsonian, http://blog.americanhistory.si.edu/osaycanyousee/2011/03/bringing-a-museum-object-to-life-the-john-bull-locomotive.html.

Weil, Stephen. 'From Being *About* Something to Being *for* Somebody: The Ongoing Transformation of the American Museum'. *Daedalus* 128, no. 3 (1999): 229–58.

Weil, Stephen. *Rethinking the Museum and Other Meditations*. Washington [London]: Smithsonian Institution Press, 1990.

Weiner, Annette B. *Inalienable Possessions: The Paradox of Keeping-While-Giving*. Berkeley: University of California Press, 1992.

Wells, Gerry. *Obsession: A Life in Wireless*. London: The Vintage Wireless Museum, 2002.

West, Bob. 'The Making of the English Working Past: A Critical View of the Ironbridge Gorge Museum'. In *The Museum Time-Machine: Putting Cultures on Display*, edited by Robert Lumley, 35–62. London; New York: Routledge, 1988.

Williams, Paul. *Memorial Museums: The Global Rush to Commemorate Atrocities*. Oxford: Berg, 2007.

Williamson, Cecil. 'How the Witchcraft Museum Came into Being'. In *The Museum of Witchcraft: A Magical History*, edited by Kerriann Godwin, 12–19. Bodmin and King's Lynn: The Occult Art Company and The Friends of the Boscastle Museum of Witchcraft, 2012.

Williamson, Cecil. 'Witchcraft Museums – and What It Means to Own One'. *Quest: A Quarterly Review of the Occult*, no. 28 (December 1976): 25–28.

Wilson, David M. *The British Museum: A History*. London: The British Museum Press, 2002.

Witcomb, Andrea. 'The Politics and Poetics of Contemporary Exhibition Making: Towards an Ethical Engagement with the Past'. In *Hot Topics, Public Culture, Museums*, edited by Fiona Cameron and Lynda Kelly, 245–64. Newcastle: Cambridge Scholars, 2010.

Witcomb, Andrea. *Re-Imagining the Museum: Beyond the Mausoleum*. London: Routledge, 2003.

Witcomb, Andrea. 'Remembering the Dead by Affecting the Living: The Case of a Miniature Model of Treblinka'. In *Museum Materialities: Objects, Engagements, Interpretations*, edited by Sandra Dudley, 39–52. New York: Routledge, 2010.

Yorkshire, MLA. *Mission, Models, Money: Exemplar Case Study*. Leeds: MLA Yorkshire, 2007.

INDEX

27495237R00134

Printed in Great Britain
by Amazon